The GRAND TOUR

REVISED EDITION

A TRAVELER'S GUIDE TO THE SOLAR SYSTEM

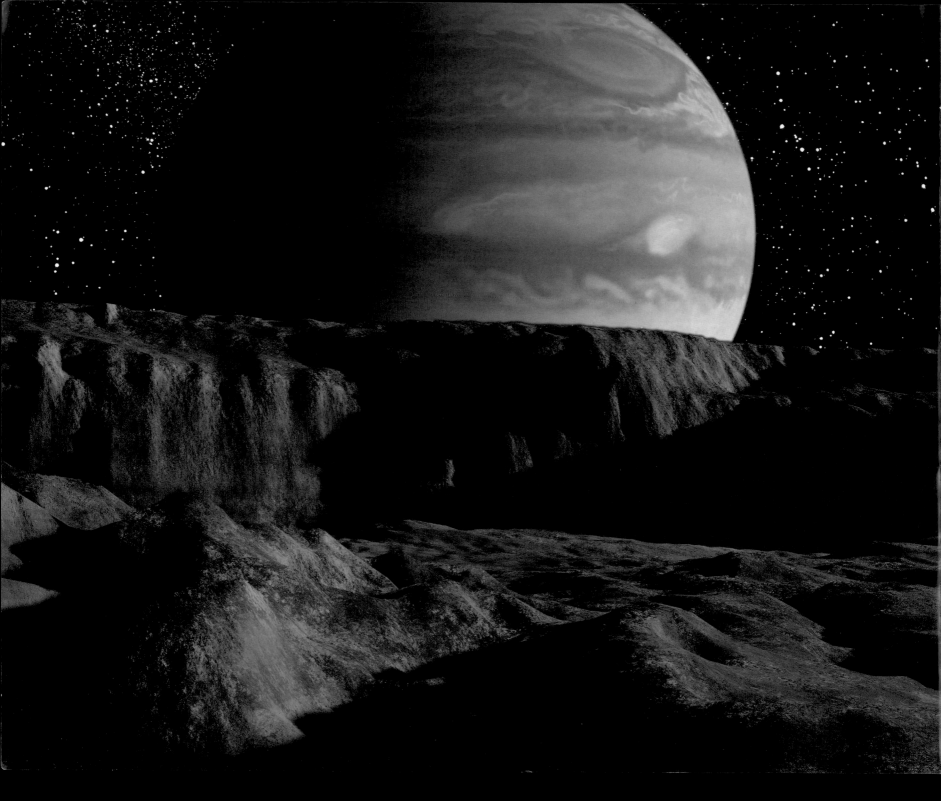

Revised Edition

The GRAND TOUR

A Traveler's Guide to the Solar System

By Ron Miller and
William K. Hartmann

WORKMAN PUBLISHING · NEW YORK

Library of Congress Cataloging-in-Publication Data is available.

ISBN-13 978-0-7611-3547-0
ISBN-10 0-7611-3547-2

Workman books are available at special discounts when purchased in bulk for premiums and sales promotions as well as for fund-raising or educational use. Special editions of book excerpts can also be created to specification. For details, contact the Special Sales Director at the address below.

Workman Publishing Company, Inc.
708 Broadway
New York, NY 10003-9555
www.workman.com

Printed in Thailand
3rd Edition
First printing May 2005

10 9 8 7 6 5 4 3 2 1

DEDICATION

This book is dedicated to the three Grand Masters of Space Art: Chesley Bonestell (1888-1986), Lucien Rudaux (1874-1947), and Ludek Pesek (1919-1999). The authors grew up being inspired by their art and vision. We can only hope that this book helps repay our debt to them.

We also dedicate this book to the International Association of Astronomical Artists and all our friends and associates in the IAAA who have inspired and challenged us over so many years.

ACKNOWLEDGMENTS

The authors thank Kathleen Komarek, Dan Berman, and Elaine Owens for assistance at the Planetary Science Institute, Richard Rosen and Janet Vicario at Workman Publishing, Matt Fairclough for developing Terragen, and Gayle and Amy Hartmann, Kelly Rehm, and Judith Miller for encouragement. Special thanks to Gayle for some last-minute proofreading on deadline!

Contents

Contents

Part 3

BEYOND THE SOLAR SYSTEM277

Extrasolar Planets

Preface

The first edition of our book appeared in 1981, and it was followed a dozen years later by a second edition in 1993. Now, a dozen years later, here we are again.

How far we've come in these last dozen years! On Mars, we've landed three rovers that have nuzzled boulders, descended into craters, climbed hills, and sent us confirmation that ancient Mars had lake beds with sedimentary strata that may hide secrets of a long-gone alien world. An orbiter circling Jupiter has mapped erupting volcanoes, ice flows, and craters on the moons of the giant planet. We've flown by several asteroids and landed a probe on one of them. We've photographed comets at close range. We've seen a comet crash into Jupiter—an event so cataclysmic that backyard telescopes could observe its effects. Recently, we've put a new Euro-American spacecraft in orbit around Saturn and seen the first images that show surface detail on the surface of the ringed planet's unique, murky moon, Titan—the only satellite in the solar system shrouded by a thick atmosphere. All these developments and more are described and illustrated in our new edition.

In the meantime, astronomical artists themselves have evolved. Many, including one of us (R.M.), have converted from paintbrush to digital art, rendered on a computer. Others (including W.K.H.) have continued to enjoy working with paint for its own sake. Some of our images in this book combine both media. We hope that the mix of spacecraft and other photo images, our digital images, and our paintings will provide an exciting introduction to what the known worlds might look like to human beings who may, some day, reach some of them—human beings who may include some of our readers.

Ron Miller
William K. Hartmann

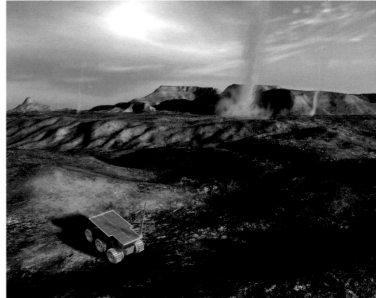

Exploring other worlds: A future automated rover, topped by solar panels, reconnoiters hilly canyonlands on dusty Mars.

A newly formed planet, its crust just congealed,
hangs against a backdrop of interstellar
nebulosity in a star-forming region of our galaxy.

Introduction

The Really Big Picture

A New Look at the Solar System

Imagine that we are cruising far out in interstellar space, our ship flying among millions of stars strewn along one curving arm of a spiral galaxy. As we admire the stars, we pick out an average one. It turns out to be the sun. We discover that it has not only planets but also many other bodies circling it. Each planet is a large nonluminous body that shines by virtue of reflected sunlight. Countless smaller bodies (less than about 1,000 kilometers, or 620 miles, across) are traditionally divided into three categories: asteroids, comets, and tiny meteoroids.

The goal of our book is to set out to explore those bodies, one by one, to see our own planetary system as a new visitor might perceive it—not centered around Earth, but with Earth as only one planet out of many. Like Charles Darwin voyaging inquisitively from island to island, we want to see what all these places are like. What grandeur, desolation, power, silence, resources, or loneliness does each offer?

We scrutinize the approaching star. At first we can see no planets at all. Because the sun is vastly brighter and more massive than any of them, the planets are swallowed up by the sun's glare.

We try our radio. It picks up faint signals at radio, TV, and other wavelengths. These signals don't necessarily reveal intelligent life in the system; they might be network TV broadcasts, or the random snaps, crackles, and pops of electrical activity, such as lightning in the atmospheres of Jupiter, Venus, and Earth. But at least they suggest the presence of planets.

We can also detect planets at this distance by looking for their gravitational effects. As they orbit around the sun, the planets tug it slightly to and fro. Sensitive instruments can pick up this "wiggle" in the sun's position. The major wiggle is due to the largest planet, massive Jupiter. Jupiter has more mass, hence gravity, than all the other planets put together. So at first we notice only Jupiter's effect and conclude that the sun is essentially a double system. The largest object in our system—the sun—is said to have 1 solar mass. The second largest object—Jupiter—has about 0.001 solar mass. The rest of the planets put together have only 0.0004 solar mass—easy to overlook from our perch out in space.

With both radio and gravity data indicating planets in this system, we come in for a closer look. When we first catch sight of a planet, it

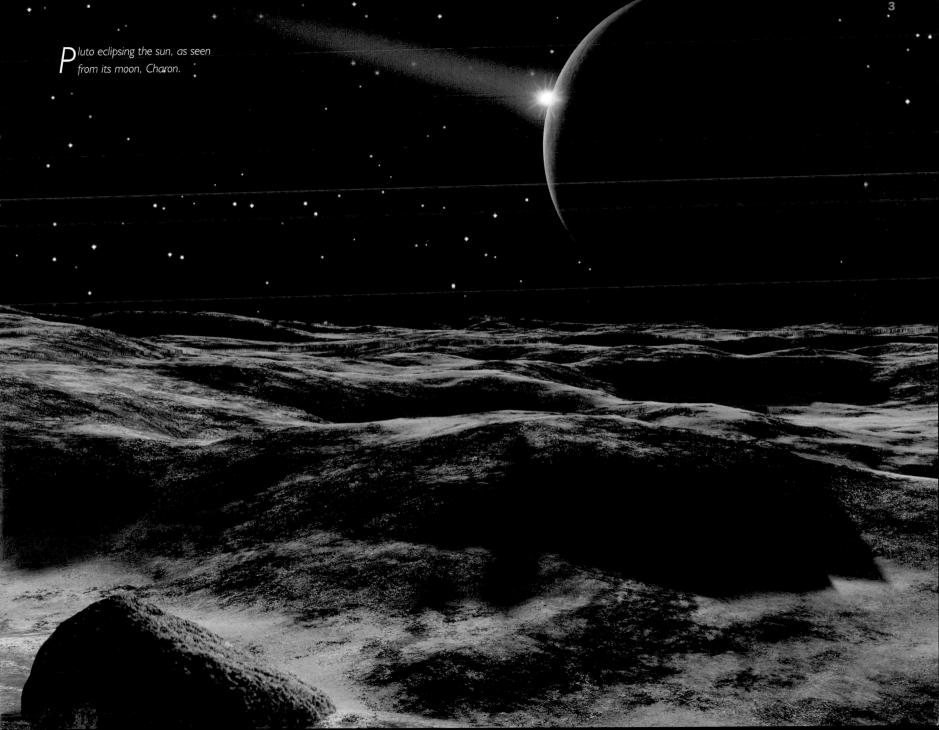

Pluto eclipsing the sun, as seen from its moon, Charon.

Planetary Family Portrait
The Sun, planets and moons to scale.

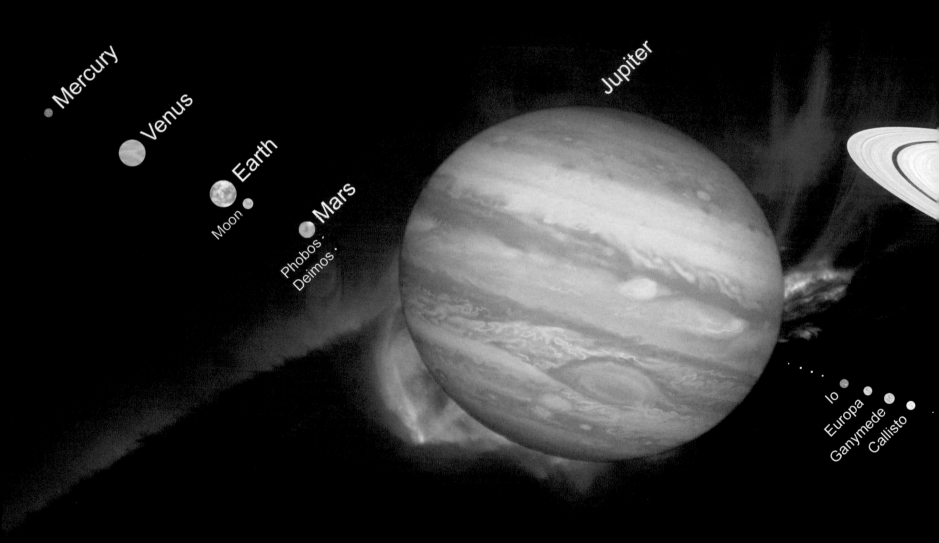

Mercury

Venus

Earth

Moon

Mars

Phobos
Deimos

Jupiter

Io
Europa
Ganymede
Callisto

is again Jupiter, five times as far from the glaring sun as Earth. Astronomers, following the Earth-centric tradition of our forebears, defined the standard unit of distance in the solar system as the distance from the sun to Earth: 150 million kilometers, or 93 million miles. This is called one *astronomical unit*. So we say that Earth is 1 AU from the sun; Jupiter is 5.2 AU from the sun.

Most stars have companions orbiting around them. Usually these companions are smaller stars, not planets. As we catch sight of Jupiter, we wonder whether this object should be classified as a planet or a small companion star to the sun. What is the difference? Stars shine by means of nuclear reactions inside them. Planets are not big enough to generate the heat and pressure necessary to cause nuclear reactions in their centers, so planets shine only by reflecting the sun's light. You might think it is obvious that Jupiter is a planet, but telescopic observers discovered in the 1960s that Jupiter radiates several times more energy than it receives from the sun. This means that energy is being created somehow inside Jupiter, and in that sense Jupiter is like a star. But theoretical work shows that the energy is not coming from nuclear reactions inside Jupiter. Instead, it is being generated by a slow contraction that has been going on since Jupiter was formed. Jupiter's gravity is so strong that it keeps pulling itself inward, liberating a modest amount of heat at the same time.

So where is the boundary line between a planet and a star? The theoretical work also indicates that a body must be about eighty times as massive as Jupiter in order to generate enough central heat and pressure to initiate nuclear reactions and become a true star. Jupiter has not nearly enough material to become a star. If more material had been available to proto-Jupiter during the ancient days of planet formation, the solar system might have had two suns, making our astronomical climate strikingly different.

Beyond the Nine Planets

If you study the sky from night to night, you will find that the planets—such as diamond-bright Venus or ruddy Mars—move among the stars. This is why the Greeks gave them the name *planets*, or "wanderers." They thought that the planets moved around Earth in complicated loops. In 1543, the Polish astronomer Nicolaus Copernicus showed that the planets' movement could be better understood by postulating that they moved around the sun. Acceptance of this idea came to be called the Copernican revolution. It was an epoch-making breakthrough because it affected how we think about ourselves in relation to the universe. For the first time, we were forced to face the idea that the universe doesn't revolve around us. We are just a part of it.

Many people seem to assume that the Copernican revolution was the one and only revolution in our view of the solar system, and that things have been stable since then. More planets have been discovered in more or less circular orbits around the sun, of course. And more moons have been found in orbits around planets. Bur for years, textbooks have reported that there are nine planets, and most people have the impression that the hierarchy of planets, moons, and interplanetary debris is very clear-cut, with the planets being the big, important objects, the moons lesser, and so on.

Today, we are beginning to look at the solar system in a new way, a break from the "nine planets paradigm." Recent spacecraft voyages have made us realize that the solar system has many more than nine large worlds. Most planets, for example, are orbited by moons—also called *satellites* (from a Latin word for "companions"). Some moons are bigger than some planets. About two dozen worlds are larger than a thousand kilometers, or 621 miles, across. These are bodies big enough to have their own distinctive geologic "personalities." We will visit these worlds.

TERRESTRIAL PLANETS **ASTEROIDS** **GAS GIANTS** **ICY BODIES**

ROCKS & METALS DOMINATE **CARBON COMPOUNDS DOMINATE** **ICE DOMINATES**

Thousands more interplanetary bodies, neither planets nor moons, range up to a thousand kilometers across. We will also visit the most interesting of these smaller worlds. They are traditionally classified as *asteroids, comets,* and *meteoroids.* According to the traditional observational distinctions, asteroids are stony bodies ranging from about 100 meters (109 yards) to a thousand kilometers in size, situated mostly between Mars and Jupiter. Comets, from one to a few hundred kilometers in size, are icy bodies that are mostly located in the outermost solar system, but at times drop into the inner solar system, where the sun melts off some of their ices and releases the gas and dust that streams out to form the cometary tail. Meteoroids are fragments of asteroids and comets, typically microscopic to 1 meters in size. Meteoroids that strike planetary surfaces are called *meteorites* and are composed of various types of stone or nickel-iron metal.

Interplanetary bodies are too numerous to count. Catalogs of objects with well-defined orbits include more than four thousand asteroids and several hundred comets. The solar system contains thousands of bodies big enough to land on, though the gravity of the small ones is so weak that you might want to tether your spacecraft so it doesn't drift off. And you should be careful not to launch yourself off such a body by an overenthusiastic jump.

Data from the 1980s and 1990s make us realize that the traditional practice of distinctly categorizing each object as a planet, moon, aster-

oid, comet, or meteoroid is misleading. Observations made by means of the spectrograph, for instance, show a wide range of different rock types among asteroids. (The spectrograph does this by spreading the light coming from the object into a rainbow-like spectra. Since different elements are related to patterns of specific colors, scientists can determine the composition of an object by studying the light it reflects or emits.) Some asteroids may have enough ice content that they mark transitional objects between ordinary asteroids and full-fledged iceball comets. Scientific arguments have been fought over whether certain "asteroids" are really asteroids at all, or simply burnt-out comets. Moons and planets also show a range of densities, compositions, and surface types. Some moons seem more closely related to some asteroids than to other moons. Other research focuses on whether meteorites are pieces of comets, asteroids, or a mixture of fragments from both sources.

If we reject the distinct categories that were made in the past, we begin to see the variety and relationships of planetary bodies more clearly.

The Three Compositional Zones

One relationship we find among major planetary bodies is a sequence of compositions determined primarily by the object's distance from the sun. The planets were formed by an aggregation of dust grains condensed out of cooling gases that surrounded the newly

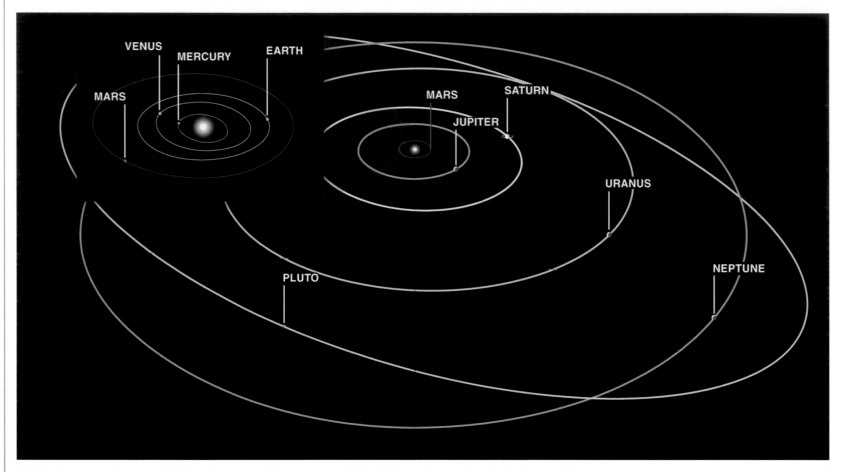

The solar system drawn to scale. The inner, terrestrial planets are so tightly packed near the sun that the detail is needed to show their arrangement, inside the orbit of Mars.

formed sun. These gases were hottest near the sun and coolest away from the sun.

Mineral grains requiring low temperatures to condense could not do so near the sun; those that condense at higher temperatures were the only ones to solidify in the inner solar system. These included metal grains and particles of various silicate minerals like those found in Earth rocks, lunar rocks, and meteorites. Farther from the sun, such grains were accompanied by lower-temperature compounds, such as sooty black, carbon-rich minerals and hydrated minerals (minerals that contain water molecules within their crystal structure). Beyond the asteroid belt, the gas was cold enough for frozen water, frozen carbon dioxide, and other ices to form. Thus, the bodies that began to

form in the outermost solar system were combinations of three materials: silicate/metals, black carbonaceous minerals, and ices.

We can now recognize three compositional zones in the solar system. The inner zone, sometimes called the zone of terrestrial planets, extends out to the middle of the asteroid belt and has light-colored bodies made of familiar silicate minerals and rocks. The middle zone, which includes the outer asteroid belt, has black bodies rich in soot-like carbonaceous material. The outer zone, from Jupiter outward, has bodies that originally contained much ice.

Now we see a new way to perceive the asteroid/comet distinction. Asteroids are the small, rocky objects that originally formed in the inner two zones. Comets are the ice-rich bodies that formed in the outer zone. Gravitational perturbations by the massive planets threw many of these small bodies into parts of the solar system far from where they first formed. Thus, some stony stragglers may be found today in the outer solar system, while icy comets drop into Earth's vicinity for an occasional visit.

Current data suggest that large satellite systems, like Jupiter's, may have formed like miniature solar systems, and may share the same compositional patterns. From the measured densities of Jupiter's large moons, we know that the inner ones have mostly rocky interiors, while the outer ones have icy interiors. Jupiter's radiation was probably a significant heat source during the formation of satellites around it, just as the sun heated the inner solar system.

When an inner planet experiences internal melting (generally due to radioactivity heating its interior), it produces silicate lavas like those of Earth and its moon. But when an outer world melts, the erupted "lava" may well be water, and the "frozen lava flows" sheets of ice. This probably explains why many worlds in the outer solar system have icy surfaces. In particular, some of the inner moons of giant planets,

though they may have stone-rich interiors, seem to have been heated enough to produce watery eruptions that left ice on their surfaces.

Evidence from meteorites and the moon shows that planets aggregated from cool, solid material 4.5 billion years ago. Evidence from lunar rocks indicates that they had molten layers at their surfaces almost as soon as they formed, but that these so-called magma oceans cooled quickly, by about 4.4 or 4.3 billion years ago. All rocky planetary material contained small amounts of radioactive minerals, which produced small amounts of heat. The smallest planets could radiate this heat easily and cool quickly. Therefore, planetary bodies smaller than a few hundred kilometers across probably never melted or developed volcanoes; their surfaces are much the same as they were when they were formed, still preserving the impact scars of the meteorites that fell on them and helped mold them.

The larger worlds could not shed their heat so easily, because planetary bulk insulated their hot centers. These centers got hotter and hotter. In the zone of terrestrial planets, the insides of worlds larger than 1,000 kilometers melted around 4 billion years ago, allowing heavy molten iron to sink into them, forming metal cores. The light "slag" of silicates and watery material floated to the top. These planets thus gained crusts of silicate-rich rocks that tend to have low densities and light coloration.

Volcanism broke through these crusts, covering parts of the surfaces with lava flows. On the smaller worlds, interiors soon cooled and volcanism declined. Volcanism continued for a longer period of time on larger worlds.

Often, the last eruptions were from deeper in the planet and produced rocks poorer in silicates and darker in color than the crustal rocks. On the moon (3,476 kilometers, or 2,159 miles, in diameter), such eruptions formed dark lava plains covering about 15 percent of its

surface. They ended about 3 billion years ago, as the moon's interior cooled. On Mars (diameter 6,786 kilometers, or 4,220 miles), internal heat lasted longer, promoting volcanic eruptions as recently as 1 billion years ago or less. These eruptions resurfaced about half the planet. On Venus (diameter 12,100 kilometers, or 7,514 miles), continuing eruptions have resurfaced the entire planet within the last 500 to 800 million years. On Earth (diameter 12,756 kilometers, or 7,921 miles), the eruptions have continued through geologic time. The primeval crust has been totally destroyed, and volcanoes continue to erupt.

Size Matters

In addition to internal evolution, atmospheric evolution also depends on the size of the planet. Small planets have too little gravity to retain atmospheres. Gases released by small planets' volcanoes escape into space. Worlds with a diameter greater than 4,000 to 6,000 kilometers (2,484 to 3,726 miles), depending on their temperature, have enough gravity to hold down the heavier volcanic gases such as carbon dioxide. Mars, for instance, has a thin atmosphere of carbon dioxide; some of the molecules escape into space, one at a time. Venus has a thick carbon dioxide atmosphere. Earth has a more complex atmosphere, in which much of the carbon dioxide has been broken down by plants, thus releasing oxygen. Light gases, such as hydrogen, have mostly risen to the top of our atmosphere and leaked into space, while only heavier gases have been retained. Giant Jupiter, 142,984 kilometers across (88,793 miles—eleven times bigger than Earth), has a deep, dense atmosphere. Even hydrogen, the most abundant but lightest element in the solar system, is retained by Jupiter. Because the larger planets have denser atmospheres, their surfaces are more modified by erosion. Earth has lost virtually all of its meteorite impact craters to erosion and tectonics; Mars has dust dunes and dry streambeds. Only airless bodies like the moon preserve surfaces saturated with craters formed during the early days of the solar system.

Our Itinerary

If we organized our tour of the solar system according to tradition, we might start close to the sun and work our way outward. But then we would go from moonlike Mercury to cloud-shrouded Venus; from tiny asteroids to massive Jupiter. The scenery would be a chaotic hodgepodge, because scenery is controlled by the evolutionary state of a world, and evolutionary state is controlled largely by size.

So we propose a tour in order of size. First comes massive Jupiter, the sun's principal companion. Next is the second most massive planet, Saturn, and so on. This approach allows us to progress from energetic, massive, active, evolved worlds to dormant, small, primitive worlds with empty craters that seem to echo with the explosions of meteorite impacts billions of years old.

There is a second advantage of touring our solar system in this order. It will soon become clear that our planetary neighborhood does not consist of the traditional nine planets and insignificant, smaller worlds. We will visit all twenty-six major worlds larger than 1,000 kilometers across (as well as the largest asteroid, almost that size), of which fifteen are planets or moons bigger than the planet Pluto.

We are about to embark on a tour of worlds—a tour that will change our ways of thinking about planets. We are going to try to see each world on its own terms, one at a time.

What we are really looking for is a new perspective on our solar system, and a new sense of the fantastic variety of wilderness areas that surround us, waiting just over the horizon. . . .

In the Beginning
A Star is Born

Once upon a time, in a part of our galaxy far, far away, a star was born. The time was about 4,560 million years ago. The star was our own personal star, the sun. It was surrounded by dusty debris, and the dusty debris aggregated into a whole solar system of planets, moon, asteroids, and comets—and one of the planets would eventually spawn humanity.

There was nothing very special about the birth of the solar system, nor did these events coincide with the beginning of the universe, or even our galaxy. The universe began in some sort of creative explosion—a cataclysm called the Big Bang—around 14,000 to 16,000 million years (MY, for short) ago. Galaxies, including our Milky Way galaxy, began to take shape a billion years or so later, about 13,000 MY ago. By 4,560 MY ago, 100 million stars had already formed in our galaxy. Another 100 million have formed since. . . .

A Million Years Is but a Day

Our unit of time, a million years, or 1 MY in our parlance, deserves a special comment. It is a very good unit of time to use in discussing planetary history. Early human ancestors, for example,

A view in the primordial solar nebula 4,550 MY ago. The nebula was mostly obscured by dust as seen from the position where Earth is today. In the foreground, dust grains have condensed and are beginning to aggregate into planetesimals.

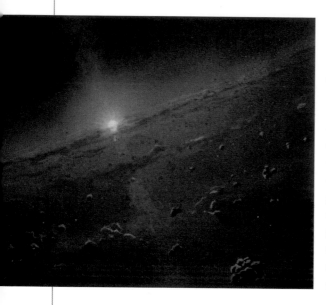

By 4,545 MY ago, within the dusty depths of the solar nebula, planetesimals grew as small aggregates collided and merged with larger objects. The surfaces of these bodies, like those of asteroids today, were heavily cratered due to the repeated collisions. The distant sun is partially obscured by the gas and dust of the solar nebula, giving it the same reddish colors we see at sunset when we observe the sun through a dusty atmosphere.

appeared about 4 MY ago. A million years seems like an inconceivably long period of time. A million trips around the sun, fifty thousand human generations. And yet 1 MY is merely a blink of the cosmic eye, a fraction of the age of the universe.

How can we relate these cosmic timescales to our ordinary experience? The age of the universe is, as we said, about 14,000 to 16,000 MY (14 to 16 billion years), and the universe as we know it is only partway through its existence. Our sun, for example, is a middle-aged star. So let's ask: If we represent the age of the universe as equivalent to that of a middle-aged man or woman, how much time would 1 MY represent out of the life of that person? A minute? A week? A year? It turns out that on your fortieth birthday, you will have lived nearly fifteen thousand days. In other words, 1 MY in the life of the universe is almost exactly the same as one day in the life of a middle-aged person. So, each time we use the MY designation in discussing cosmic time, you can think of it as something like a day out of your own life.

The solar system has been around for only the last third of cosmic time—4,560 MY. In terms of our analogy to a middle-aged person, it is as if the universe formed when you were born, and the solar system formed when you reached voting age, when your "real adult life" began, and humans evolved from apes in only the last four days.

Archaeology of the Solar System

How can we reconstruct the details of the solar system's biography? Astronomers who reconstruct the formation of our sun and its planets are cosmic archaeologists. They have to piece together ancient events from whatever clues they can find. There are four distinct categories of clues:

- Direct observations with telescopes reveal parts of our galaxy where stars are forming even today, and also reveal examples of new-forming stars still surrounded by dusty clouds where planets are apparently forming.

- Theoretical calculations—some of which follow from, others of which precede the observational discoveries described above—lead to computer simulations that show how stars form from nebulae of gas and dust, and how the circumstellar dust condenses and aggregates into planets.

- Studies of planetary bodies (not to mention Earth itself!) from space probes and telescopes reveal diagnostic surface features, such as impact craters, rocks, fractures, and volcanoes, that reveal their histories and internal heat sources—chapters and verses from the biographies of worlds.

- Meteorites—the fragments of asteroids and comets that have fallen onto Earth—date back as far as 4,550 MY. Their chemistry and microscopic structure reveal many clues about the formative processes going on in our planetary system at that time.

Putting together all four sets of clues, scientists have reconstructed with reasonable confidence how our planetary system was born, and how it evolved into the diverse collection of worlds we see around us today.

Here Comes the Sun

As Isaac Newton figured out in the 1600s, every particle in the universe attracts every other particle by a mysterious force called gravity, and the smaller the separation distance between the particles, the stronger the attraction. In the depths of interstellar space hang enormous clouds of atoms, molecules, and tiny dust grains. The atoms, molecules, and grains attract each other, but if they are spread too thinly across the near-vacuum of interstellar space, the force of attraction will be too weak to overcome the random, somewhat orbital motions of the gas clouds around the center of our massive galaxy, and the particles will go on their own way. On the other hand, if some random event, such as the explosion of a nearby supernova, compresses a cloud, the particles find themselves closer together; Newton's gravitational attractive forces take charge, and the particles begin a long, slow, inexorable fall toward each other. In other words, the nebular clouds begin to contract.

The basic contraction took something like 100 or 200 MY—a number that can be estimated by calculation and also by observing distant stars. In terms of our analogy of 1 MY equals a day, this took a few months. In other words, our future planetary system was "conceived" once the contraction process began, and the period of contraction was the "gestation period" of the solar system, leading to the birth of our local system's central star, the sun.

As a giant interstellar cloud begins its contraction, its internal conditions guarantee that it will not contract smoothly into a single massive object, but rather fragment into several hundred individual contracting objects, each with the mass of a typical star—the resulting group of stars is known as a cluster. You can see such clusters scattered around the sky. The Pleiades, or "Seven Sisters," are the most famous example, members of a star cluster that formed roughly 50 or 100 MY ago (50 or 100 days in our analogy—"recently"!). The Seven Sisters are merely the seven brightest stars in this cluster, which you can count if you have good eyesight. A backyard telescope will quickly reveal many dozens of other stars scattered around this cluster, like gemstones placed by a master jeweler. Near the Pleiades in the winter sky is the constellation of Orion, and the clumping of stars around the belt and sword of Orion represents another star-forming region. Amateur astronomers with backyard telescopes are familiar with the Orion Nebula, a glowing, interstellar gas cloud surrounding a tight grouping of stars and dark knots of interstellar dust—a prime example of a star-forming region in our galaxy. Some of the dark knots, or so-called "globules," of dusty gas are contracting, on the path to becoming new stars a few million years from now.

If we focus on one of the "fragments" of the contracting cloud—the embryo of a single new-forming star—we can watch it over the course of a few million years as it continues to contract under the influence of gravity. Like a figure skater spinning faster as she pulls in her arms, the cloud spins faster as the outlying portions draw in toward the center (according to principles discovered centuries ago by good old Isaac Newton and his contemporaries). The centrifugal/centripetal forces associated with the fast spin transform the original ragged shape of the cloud into the shape of a spinning wheel, or disk. This is not just a theoretical conclusion derived from Newtonian physics; the reality can actually be observed among new, forming stars. The Hubble Space Telescope and other instruments reveal spinning disks of gas and dust, with stars forming at their centers. By 4,550 or 4,500 MY ago, this was the state of the

primordial solar system—a spinning disk of dust and gas with the sun being born at the center. In the case of our system, this disk of dust and gas, surrounding the newly forming sun, is called the solar nebula.

What turned the central part of the contracting gas cloud into a star? Or, to put it another way, what defines a star? Most of the mass in a contracting, disk-shaped cloud falls to the center and forms a massive central object, the proto-sun. As this mass of gas contracts into a star-sized object, it gets hotter, and the temperature continues to rise as the atoms cram together in the center. "Temperature" is merely a measure of how fast atoms are moving: the higher the temperature, the faster the atomic motions. Eventually, the atoms at the center of the proto-sun crowded together so tightly, smashing into each other so hard, that the atoms started to fuse together into new combinations. The hot central core of the sun effectively turned into an enormous hydrogen bomb, in which hydrogen atoms (the simplest and most common atoms in the universe, being composed of one proton and one electron) started to fuse into heavier atoms such as helium (two protons and two electrons).

This is the birth process of every star. What defines a normal star is that it is a spherical mass of hydrogen gas in which hydrogen atoms are fusing into helium atoms in a long-term, stable nuclear fusion reaction. We can feel the result when we step outside under a clear sky—our skin is warmed by radiation from the nuclear leviathan in the sky.

The Solar Nebula: Planetary Placenta

The key process in forming the planets involved events in the "leftover" disk of dust and gas around the newly-born sun—the solar nebula. The time was now about 4,650 MY ago. The nebula, especially its inner parts, had been heated by the contraction to temperatures exceeding 1,200°C (2,200°F) and perhaps as high as 1,700°C (3,100°F). But once the sun turned on, its heat and expanding gas stopped the contraction and the solar nebula became a fairly stable, cooling disk of gas and dust grains, such as astronomers can observe around other newborn stars.

What happened as the solar nebula cooled? You are already familiar with a similar process. Visualize a massive thunderhead cloud, rising above a mountain. As the air mass moves upward and cools, the water vapor in the cloud (which comprises only a small percentage of the air itself) condenses into solid or liquid particles: hailstones, snowflakes, or raindrops. In exactly the same way, as the gas of the disk cools, atoms and molecules of various heavier elements (which comprise only a small percentage of the nebular gas) condense into solid particles: tiny grains of metal and silicate mineral crystals, such as silicates. Examples of these include enstatite ($MgSiO_3$), feldspars (aluminum-silicate minerals of varied composition), and olivine (a mixture of Fe_2SiO_4 and Mg_2SiO_4). At lower temperatures, sootlike particles of carbon-rich material are created. Finally, when the nebula gets cold enough, the condensation process produces grains of ices such as water ice (H_2O), carbon dioxide ("dry") ice (CO_2), methane ice (CH_4), and ammonia ice (NH_3).

Imagine the solar nebula at a particular moment late in the process of cooling and condensation of grains. The three compositional zones mentioned earlier stem from the sequence of mineral condensation. The inner part of the nebula—from Mercury out to the inner part of the asteroid belt, called the zone of the terrestrial planets—is hottest, and so only familiar silicate rock-forming minerals have condensed. As we know from ordinary day-to-day observation, these are typically gray or tan in color. In the middle zone—the region from the middle of the asteroid belt out to Jupiter—the temperatures are lower because we are farther from the sun, and the condensed material contains not only

silicates, but the black sooty carbonaceous materials. The latter dominate, and so the material has a blackish color. In the outer zone, beyond Jupiter, it is so cold that the silicates, carbonaceous material, and ices condense, with the latter dominant. The freshly condensed material is still colored black by the black soot, but is mostly icy in composition and has a low density like ice as opposed to rock.

This picture is confirmed by all sorts of evidence. Direct telescopic observations of disk-shaped nebulae around other stars have identified, using spectrometers, mineral grains of silicates and ices in the nebular dust. Calculations and experiments in chemical laboratories have shown that as cosmic gas cools, this is the sequence of mineral grains that would condense. Indeed, according to the calculations, the warmest parts of the solar nebula would be dominated by rock-forming mineral silicate and metal-rich grains, while the coldest, outer parts would be richest in ice. Finally, direct observation and sampling of fragments from comets and asteroids, as well as pieces of the moon and Mars (collected by astronauts or blasted from their surfaces by impacts and which have fallen to Earth as meteorites), confirm that the inner solar system planets are formed of gray and tan metal-rich silicate rocks, asteroids in the asteroid belt between Mars and Jupiter are black-colored and made of carbonaceous materials as well as silicates, while bodies in the outer solar system are dominated by ices and carbonaceous materials. Everything checks.

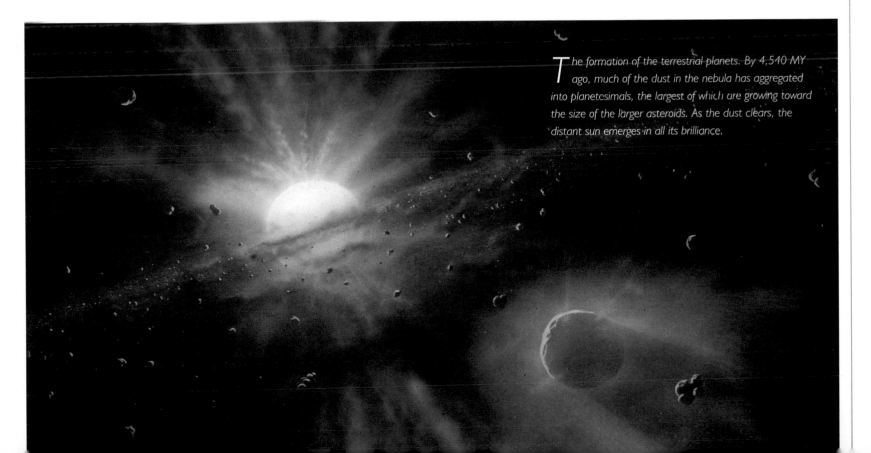

The formation of the terrestrial planets. By 4,540 MY ago, much of the dust in the nebula has aggregated into planetesimals, the largest of which are growing toward the size of the larger asteroids. As the dust clears, the distant sun emerges in all its brilliance.

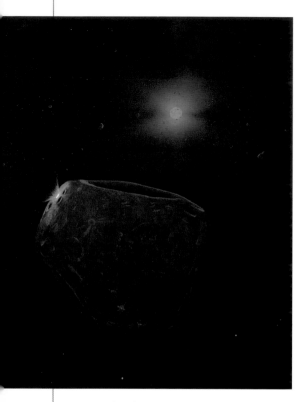

The solar nebula was therefore a kind of placental medium for growing planets. In the dusty gaseous medium, mineral grains collided and stuck together, like aggregates of falling snowflakes in a snowstorm. Some so-called "primitive" types of meteorites—ones whose parent material never melted—preserve this aggregate granular structure. The bigger an individual aggregate grew, the broader cross section it presented as it moved among the dust grains, and so the more rapidly it accumulated "hits" by smaller grains, like a car windshield getting splattered by snowflakes on a wintry day. In other words, the bigger the embryo, the faster it grew. This process is known to theorists as runaway growth. Calculations suggest that within a few million years, asteroid-sized bodies, a few hundred kilometers in diameter, began to appear within the solar nebula disk. This is confirmed by studies of meteorites as well. Radiometric dating (a dating technique using radioactive isotopes) confirmed that their parent asteroidal bodies all formed about 4,560 to 4,540 MY ago, within 20 MY of each other. One might say that these primordial objects, the bodies that were about to become planets, appeared within the first 20 "days" of the solar system's life.

From Planetesimals to Planets

The early, basketball-sized to moon-sized bodies from which the planets aggregated are called *planetesimals*. Once these planetesimals formed, further consolidation into planet-sized bodies continued at a "rapid" pace—at least in terms of cosmic time. Some studies of Earth, using radioactive minerals to date the duration of its formative process, suggest that the planet had reached its present size just 50 MY after the earliest solid material began to form in the solar nebula. Perhaps by 4,520 MY ago, the solar system was beginning to look more like a system of planets than a nebula of dust and rocks. And probably by about 4,510 MY ago, Earth was about as large as it is today.

Not all the planetesimals were absorbed by the planets. Between Jupiter and Mars, and also just beyond Neptune, are belts of leftover planetesimals that never made it to planetary status. In both cases, they range in size from less than a kilometer in diameter (very abundant) to 1,000-kilometer scale (rare). The better-known such group is the one between Mars and Jupiter, the *asteroid belt;* its planetesimals never

Above left:

An asteroid-sized planetesimal, or planetary building block, undergoes a small impact, with the dust-shrouded sun in the distance.

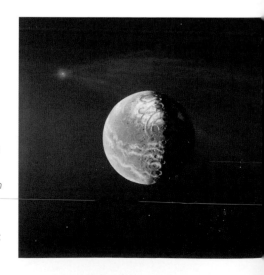

A half-formed Earth, 4,530 MY ago. As the terrestrial planets grew, they began to have enough gravity to retain thin atmospheres. Here we see a proto-Earth with a cratered surface, thin clouds, and red flashes caused by impacts on the night side. A comet passes in the distance.

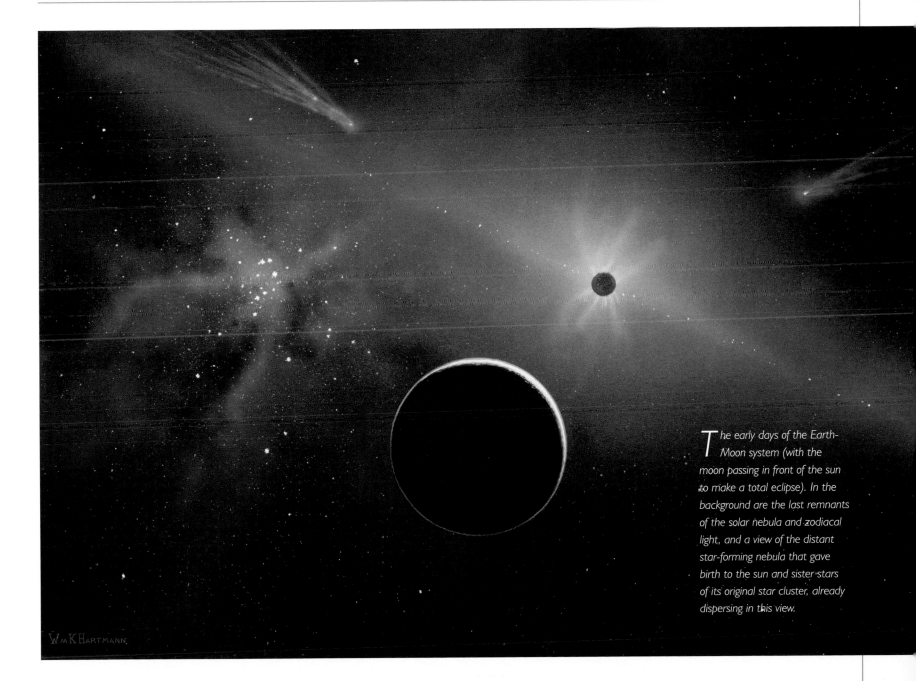

The early days of the Earth-Moon system (with the moon passing in front of the sun to make a total eclipse). In the background are the last remnants of the solar nebula and zodiacal light, and a view of the distant star-forming nebula that gave birth to the sun and sister stars of its original star cluster, already dispersing in this view.

WM K HARTMANN

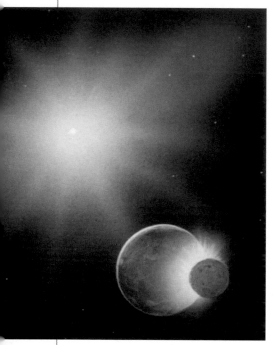

A cosmic collision. The newly born planets were constantly being bombarded by the last of the remaining planetesimals. The largest of these could have made spectacular explosions as they hit full-fledged planets, as in this view of early Earth, with the sun in the background. The hazy band of light across this view (lower left to upper right) is the "zodiacal light," caused by sunlight reflected off the remaining thin dusty debris in the solar system plane—a faint glow still visible to the naked eye today, along the ecliptic, best seen about 1 ½ hours after sunset from very dark, nonurban sites.

finished aggregating because their motions were disturbed by gigantic Jupiter, largest planet in the solar system, located just next door. The asteroid belt's largest known member is Ceres—at about 1,000 kilometers across, it was the first asteroid to be discovered; the next-largest asteroids are about half that size. The more distant group, beyond Neptune, is called the *Kuiper Belt*, for the Dutch-American astronomer who hypothesized its existence in the 1950s. Located on the fringe of the solar nebula, the Kuiper Belt may not have had enough material to finish the job of growing planets in that region. Its largest known member is Pluto, about 2,300 kilometers in diameter; the next-largest known examples, discovered mostly since the 1990s, are again about half that size. Astronomers have not developed a very satisfying nomenclature for these objects. A debate rages as to whether Pluto, smaller than our own moon, should still be called a planet. From a modern perspective,

it is "merely" the largest object in the Kuiper Belt. The other objects are not usually called asteroids because they are probably icier in composition than the classic asteroids, which are rocky and metallic. Icy bodies are properly called comet nuclei, so the Kuiper Belt might have been called a belt of comets (although they are too far away for the sun to heat the ice and cause them to develop comet features like tails, as we will see). For these reasons, astronomers usually just refer to these bodies with the unwieldy term *Kuiper Belt objects* or KBOs.

The asteroids and Kuiper Belt objects are among the best proofs that planets formed by the processes described above. They provide fossil tableaux of the solar system as it existed about 4,530 MY ago, during the planet-building process. Ceres and Pluto made it partway to being full-fledged planets, but the proof of the aggregation theories is that both belts still contain thousands of other smaller objects that existed when the growth process ran out of steam in those regions. Ceres and Pluto may be thought of as half-planets that left the rest of their building material scattered on the cosmic workbench, while the rest of the planets grew to full size, sweeping up and incorporating all the leftover debris.

The Possibility of Lost Planets?

A few years ago, most astronomers thought this was the end of the story. The solar system formed as the asteroidlike objects accreted into planets. More recent study has revealed that some interesting "fine-tuning" continued, the result of an orderly formation process periodically being interrupted by chaotic, sometimes catastrophic events. Favoring as we do a theory of orderly formation, we know that the present solar system preserves the silicate-carbonaceous-ice compositional sequence, moving outward from the sun, and so the planets and major asteroids have not strayed too far from the positions where they were formed. On the other hand, since multiple planet-sized

bodies were forming at the same time at similar distances from the sun, other moon-, Mars-, or even Earth-sized bodies may have formed, then experienced near-miss encounters with another larger planet, and ended up being thrown out of the solar system into interstellar space, due to the gravitational forces during the encounter. Some of "our" planets may be wandering, cold and dark, in interstellar space! Alternatively, in some cases, they may even have collided with another planet, leaving only a ghostly crater-scar on the larger body.

Even stranger and more subtle processes may have been at work. The orbits of some planets may have shifted outward somewhat from their original position to their present location, due to complex gravitational forces in the solar nebula. A small outward shift may not seem important, but it relates to another gravitational effect called *resonance*. If the revolution period of a large planet makes a simple ratio with the revolution of a smaller planet (like 1:2, 1:3, 2:3, etc.), then gravitational forces between them will be repeated every few times around the sun. This in turn disturbs the motions of the small body, in some cases causing its orbit to change dramatically. For example suppose a large planet like Jupiter makes one circuit around the sun in twelve years, and another planet, "X," closer to the sun, makes a circuit in six years. Suppose we start the two planets on the same side of the sun, side by side and "next door" to each other in their orbits. Every time "X" goes around the sun twice, arriving back at the starting point in its orbit, massive Jupiter will be located in the same spot, "next door," exerting a gravitational tug in the same direction. This repeated gravitational force can push "X" out of its original orbit into a wildly different one.

The situation is not unlike pushing a friend on a swing. If you give a push at irregular, random intervals, not much will happen. But if you push at just the right "resonant" interval—the same periodicity as the pendulum motion of the swing—then the amplitude of the swing will grow greater and greater. Resonant forces produce dramatic increases in movement! The smaller planet or planetesimal, "X", can have its orbit disturbed until it intersects a neighboring planet, causing a catastrophic collision, or—if it misses all neighboring planets—it is thrown clear out of the solar system.

To summarize, the solar system is not radically different today than when it formed 4,500 MY ago, but it may feature subtly different planetary spacings, and some planets that existed in the first 50 MY may have been destroyed by collisions or lost to the depths of interstellar space.

An Earth-like planet (and its off-stage star) has been ejected from the background star-forming nebula that spawned the solar system.

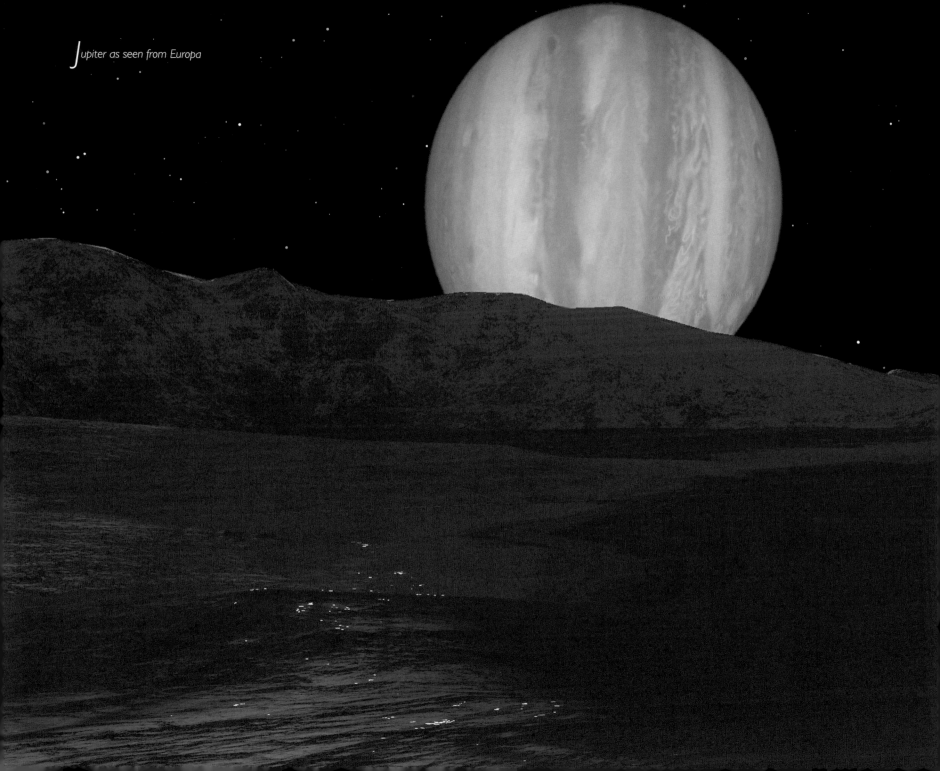

Jupiter as seen from Europa

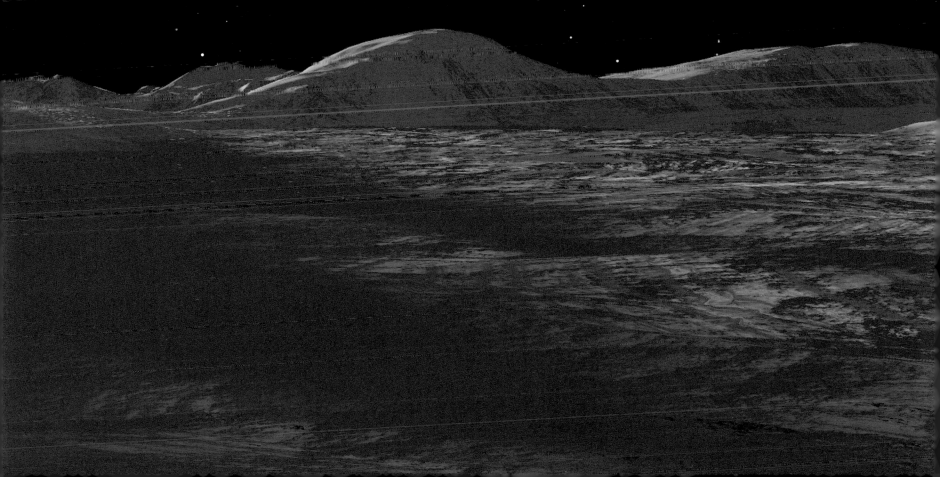

THE MAJOR WORLDS

Jupiter
Planet of the Gods

Largest Planet

Average distance from the sun:
778,300,000 km

Length of year: *11.86 years*

Length of day: *9 hours 55 minutes*

Diameter: *142,984 km*

Surface gravity: (Earth = 1): *2.3*

Composition:
hydrogen; ices; hydrogen-helium atmosphere

Jupiter, the giant among gods, is the giant among planets. It has about two and a half times the mass of all other planets combined, and so it has by far the strongest gravitational pull, affecting the motions of many other planets and interplanetary bodies. The second largest planet, Saturn, is only 84 percent the diameter of Jupiter and less than one-third its mass. Earth would comfortably nest inside the largest oval storm system that swirls in Jupiter's skies.

Jupiter is covered with dense clouds of different colors that stretch in ragged belts parallel to its equator, broken here and there by oval storm systems. The atmosphere is much thicker than Earth's. About 86 percent of its molecules are hydrogen, and nearly 13 percent are helium. Minor constituents include methane, ammonia, water, and other compounds. All the planets originally formed in a nebula are made up of these gases. Jupiter grew so big that its strong gravity trapped and held the nebular hydrogen and helium, while on Earth the light, fast-moving hydrogen and helium molecules escaped into space. Earth's atmosphere thus thinned and evolved in composition; Jupiter's remains in nearly its original state.

Many of Jupiter's hydrogen atoms, which are chemically active, have combined with less abundant elements to form exotic, brightly colored compounds. These lend their vivid hues to the clouds, which are composed primarily of ammonia "snowflakes," water "snowflakes," and "snowflakes" of compounds such as ammonium hydrosulfide. Red and orange clouds merge with white and tan clouds formed in other regions. Jupiter rotates more quickly than Earth, in about 10 hours, and its rotational dynamics shear the cloud patterns out into long bands and

The icy surface of Europa glints in the orange glow of the sun as it emerges from behind giant Jupiter. Jupiter's deep atmosphere—still backlit by the distant sun—appears as a red ring surrounding the planet.

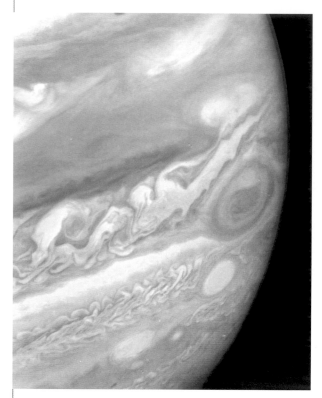

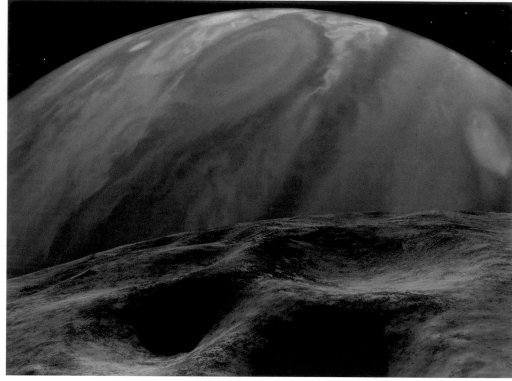

Above:

*J*upiter's Great Red Spot is an enormous hurricane large enough to engulf Earth.

Above right:

*T*he Great Red Spot glares like a baleful eye over the surface of Metis, a tiny moon orbiting scarcely 56,000 kilometers from the giant planet.

zones that run around the planet parallel to its equator. The two most prominent dark bands of clouds are the North and South Equatorial Belts, a few degrees on either side of a lighter Equatorial Zone. Additional dark belts and light zones also ring the planet.

Restless Planet

When we plunge into Jupiter's atmosphere, the sky turns lighter and bluer as we approach the cloudtops because of scattered sunlight in the air—the same process that makes the sky blue on Earth. We begin to encounter high clouds at a level where the pressure is almost equal to that on Earth's surface, but the temperature is only around -123°C (-189°F).

What lies below the clouds? In an audacious 1995 space mission, NASA's Galileo spacecraft approached Jupiter and released a probe that parachuted below Jupiter's cloudtops. It was

designed to radio back information on conditions in the unseen nether regions. Astronomers had already measured the frigid conditions at the cloudtops, but they knew that the temperatures would increase below the clouds, just as on Earth. The question was how far down the probe could descend until high temperatures and pressures would destroy it.

As it turned out, the probe measured conditions more than 100 kilometers below the cloudtops, some distance beyond the designers' target. The last signals came back from a level where the pressure was a crushing twenty-four times that at Earth's surface, and the temperature had risen to 151°C (304°F).

Between these extreme levels, an intriguing circumstance arises. As you descend into Jupiter's atmosphere, at the level where the pressure equals Earth's surface conditions, the Jupiter air temperature hovers around an ultrafrigid -110°C (-166°F), but by the time you reach a lower level with pressure about five or six times Earth's sea-level atmospheric pressure, the temperature has risen to room temperature! In other words, there is a range of levels in Jupiter's atmosphere where conditions approach those found in Earth's atmosphere. Some Jovian temperature/pressure regimes would match those of our oceans—although the medium would be a gas of hydrogen, helium, methane, and other materials, rather than liquid water.

As we continue downward, what do we find? Is there a dark, alien, hidden surface lurking somewhere down there, far below the clouds at hot temperatures?

Unfortunately, the answer is no. Jupiter's thick clouds obscure the deep layers, but theoreticians have calculated conditions as we drop below the clouds. Their analysis suggests that the atmosphere simply gets denser and denser, turning into a thick, dark fog that grades imperceptibly into a sluggish ocean of liquid hydrogen, tainted by trace amounts of other compounds.

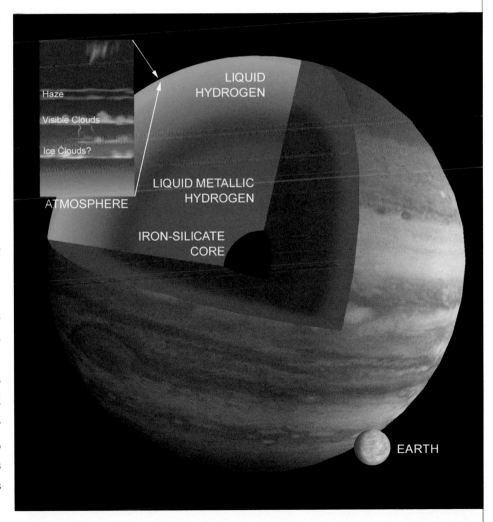

Haze

Visible Clouds

Ice Clouds?

ATMOSPHERE

LIQUID HYDROGEN

LIQUID METALLIC HYDROGEN

IRON-SILICATE CORE

EARTH

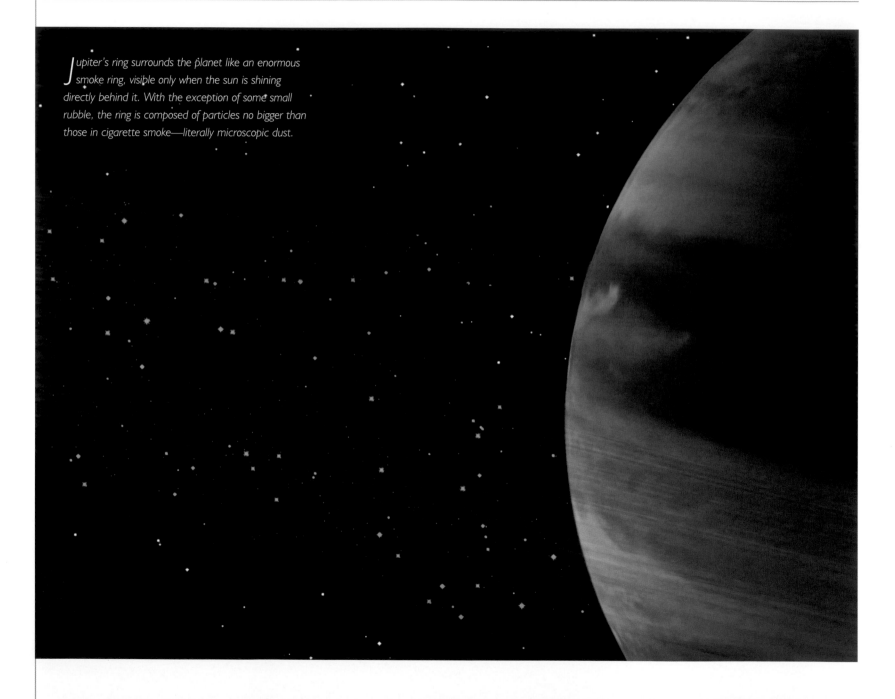

*J*upiter's ring surrounds the planet like an enormous smoke ring, visible only when the sun is shining directly behind it. With the exception of some small rubble, the ring is composed of particles no bigger than those in cigarette smoke—literally microscopic dust.

A Fire Within

Jupiter's atmosphere is restless. Atmospheric dynamics depend partly on the amount of heat flowing through an atmosphere. On Earth, this heat comes almost entirely from the sun, entering the atmosphere from above and reradiating off the ground. Jupiter and the other giant planets are very different. In the 1960s, astronomers were surprised to discover that Jupiter radiates several times more energy that it absorbs from sunlight. The extra energy must be coming from Jupiter's interior. Further theoretical studies showed that this energy release probably involves a slow contraction of the planet—a long-term process that began as Jupiter formed, creating heat by compressing the inside of the planet. Some of the heat that was initially produced is still leaking out, and new heat is constantly being generated.

Shortly after sunset, above the cloudtops in Jupiter's polar regions, an eerie auroral display flutters its multicolored curtains. Electrically charged particles, having made the three-quarters-of-a-billion-kilometer (half-billion-mile) journey from the sun, are sucked into Jupiter's powerful magnetic whirlpool. They then slam into molecules of the atmosphere, which begin to glow like the gases in neon lights. The aurora hisses, crackles, and flickers like a garish sign in front of a seedy hotel. The orange sphere is Io, lit by the setting sun. Io appears three times the size of our moon in Earth's sky.

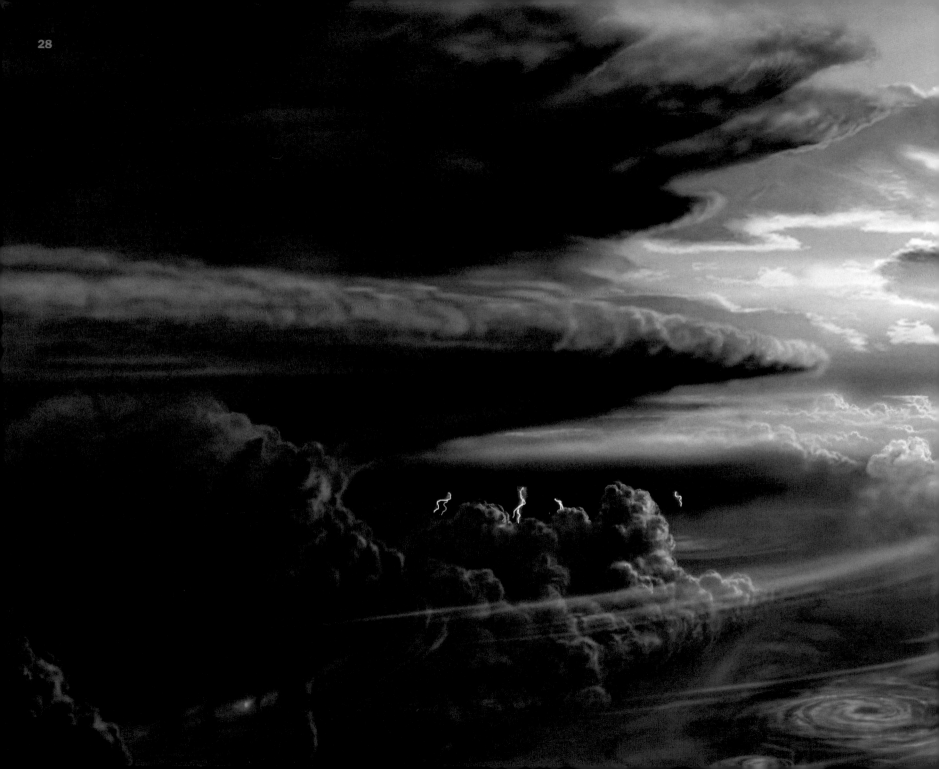

Preceding pages:

We are hovering deep within a vast canyon of clouds. Curving cloud walls dozens of kilometers high sweep away from us toward a horizon that is still straight and level, even though we are high in the atmosphere, and can see for hundreds of kilometers. This deep in the atmosphere, the warm clouds glow with orange, red, yellow, and brown chemical compounds. At this level, the air is as thick as Earth's, but the sun is a brilliant point only a fifth its size as seen from Earth. The clear atmosphere is hydrogen, helium, and ammonia. The sun is surrounded by bright "sun dogs," created as light refracts thorough the crystals of water ice and ammonia ice. The dark clouds in front of us are made of ammonium hydrosulfide, a substance that smells like both ammonia and rotten eggs. Wispy tendrils and graceful cirrus clouds are actually icy crystals of ammonia. Below us, lightning bolts powerful enough to incinerate a city flash in the gloom.

Opposite page:

Jupiter looms over the surface of one of its innermost moons, Amalthea. The white streaks on the heavily cratered surface may be either debris from a meteor impact or a ridge of ice protruding through the reddish sulfur that covers the surface. Amalthea orbits very close to Jupiter, which is only 181,000 kilometers (112,473 miles) away. While this is still about half the distance that separates Earth and its moon, Jupiter is forty times wider than the moon, so it fills Amalthea's sky. Lightning flashes dot its night side.

This extra energy contributes a certain amount of warmth from below Jupiter's clouds and increased activity in the cloud layer. If you heat a pan of water or cooking oil on the stove, you will note that the material begins to circulate long before any boiling starts. This thermally created movement is called a convection current. Similarly, convection due to the heat from below the clouds stirs giant, rapidly moving masses of gas in the atmosphere. This may bring colored material up from below and initiate condensation of new clouds, just as water condenses into thick clouds in updrafts in Earth's atmosphere.

Generally, the dark brownish and bluish belts and spots on Jupiter are relatively low, with bright cloud zones, red clouds, and wispy white ammonia clouds located higher.

The most famous cloud is the Great Red Spot, a relatively high, cool, brick-red cloud system larger in diameter than the planet Earth. Voyager observations showed vigorous circulation in the Red Spot. Smaller clouds passing nearby get sucked into it, circulate in it for several hours, and finally get torn apart. Other clouds are almost sucked in, circulate around the periphery, and are then spit out into adjacent zones. The Red Spot has existed for at least several centuries. Other disturbances, not quite as large, may last for many years. The huge mass and size of Jupiter's storm systems probably contribute to the enormous momentum that keeps them defined for long periods of time.

Jupiter probably has a central core of rocky material resembling an oversized Earth, overlaid by an enormous mantle of high-pressure liquid hydrogen called liquid metallic hydrogen, which can conduct electric current and may be involved in producing Jupiter's very strong magnetic field. Covering this is an ocean of liquid hydrogen in an ordinary molecular state. Whether the surface of this ocean is clearly defined is uncertain. It may simply blend into the nearly liquid atmosphere.

Ghostly Auroras and Lightning Blasts

As *Voyagers 1* and *2* flew close to Jupiter in 1979, they discovered two interesting luminous phenomena in Jupiter's atmosphere. First, ghostly auroras play high over Jupiter's polar regions. Like Earth, Jupiter has *Van Allen belts* of ions, or charged particles from the sun, trapped in its magnetic field. These can't easily escape, but can move along the magnetic field toward either the north or south magnetic pole of Jupiter. As a result, swarms of ions sometimes crash

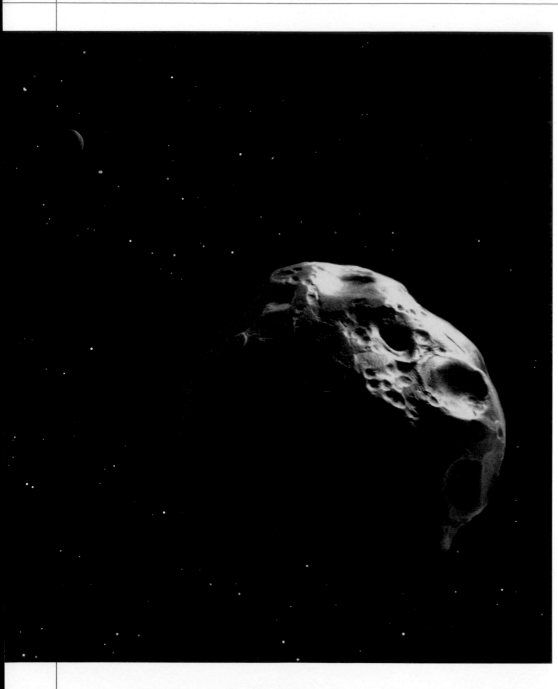

into the upper atmosphere, colliding with air atoms and molecules and making them glow with strange colors. These colors depend upon the types of atoms involved and the energies of their collision. The auroras of both Jupiter and Earth are formed in the same manner.

The second discovery was of a pattern of bright glimmers on time-exposure photos of Jupiter's night side. These are believed to be lightning blasts in the clouds. As on Earth, turbulent cloud motions probably cause atmospheric charges, leading to eventual discharges in stupendous lightning bolts.

Decades before the *Voyager* flybys in 1979, a few astronomers had raised the possibility that Jupiter might have a thin ring around it, too thin and faint to show up clearly from Earth. This idea was largely ignored because it couldn't be proven at that time and wasn't required by any proposed theories of planet formation. Nonetheless, as *Voyager* approached Jupiter, NASA scientists planned to take some pictures of the region near Jupiter to check for possible rings of faint inner moons. It was a long shot, but it paid off beyond their wildest dreams. The first pictures, and several subsequent views, revealed a beautiful narrow ring, brightest at its outer edge. It is clearest when viewed from the far side of Jupiter, backlit, with sunlight coming through it toward the cameras. Primarily composed of a swarm of microscopic particles, it looks rather like a thin cloud of cigarette smoke—dim in the middle of a room with the light behind you, but bright where it hangs in front of a lamp with light shining through it.

The same photos also showed a small satellite, previously unknown, at the outer edge of the newly discovered ring. The implication is that the ring is fed by tiny particles that get blasted off this moon by small meteorites. Dynamical studies show that these particles spiral in toward Jupiter, thus augmenting the ring. The ring seems, then, to be not a static feature, like a rock or a hill, but dynamic, like a river. The ring we will see years from now will be different from the one we see today, because new material is constantly flowing through it.

Jupiter remains one of the most alien wildernesses in the solar system—a reminder of the awesome environments that nature can create.

Opposite page:

Little Sinope is the moon with the greatest average distance from Jupiter. It is in a noncircular orbit and reaches a distance of 30 million kilometers from the planet. At this distance, mighty Jupiter looks only half the angular size of our moon as seen from Earth. Sinope is an estimated 40 kilometers (25 miles) across. Its small size, dark surface, high orbit inclination and eccentricity, and backward—referred to as retrograde*—motion all suggest that it originated not as part of Jupiter's system but as a wandering asteroid that was captured by Jupiter's gravity.*

Right:

Jupiter seen from Europa. An icy crust covers all of this world, with rare topographic relief, such as the distant pingo, a hill created by ice being squeezed up from below.

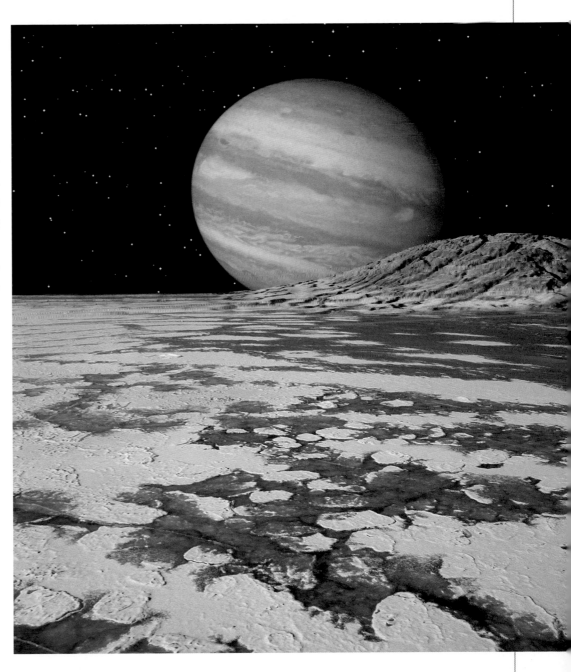

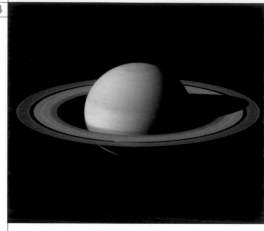

Saturn
Lord of the Rings

Planet

Average distance from the sun:
1,427,000,000 km

Length of year: *29.46 years*

Length of day: *10 hours 40 minutes*

Diameter: *120,660 km*

Surface gravity (Earth = 1): *0.93*

Composition:
hydrogen; ices; hydrogen-helium atmosphere

Opposite page:
Saturn seen from its satellite Rhea. From most of the satellites, the rings are seen nearly edge-on, but as the Saturnian seasons change they cast interesting shadow patterns on the cloud bands.

Saturn is a smaller-scale, colder, and calmer version of Jupiter, and is most famous for its rings. We are so used to the verbal and visual picture of "Saturn, the ringed planet" that it is hard to focus on the planet itself—the yellowish-tan ball that floats in the center of the ring system.

A brief examination of the size and mass of Saturn reveals that it is the least dense planet in the solar system. In fact, it is less dense than water; if there were a large enough ocean, Saturn could float in it. As on Jupiter, the atmosphere is mostly hydrogen. *Voyager* spacecraft measurements indicate that about 90 percent of the molecules are hydrogen. About 9 percent are helium, with a smattering of methane and other gases. Also as with Jupiter, the cold upper atmosphere warms below the clouds and grades into hot liquid hydrogen, and the center is occupied by a rocky core with an estimated mass 10 to 15 times the mass of Earth.

Viewed from space, Saturn's clouds lack the vivid colors and contrasting swirls of Jupiter's, but they do have the same general arrangement of dark bands and lighter zones paralleling the equator. Close-up photos by *Voyagers 1* and *2* in 1980 and 1981, respectively, showed some turbulent swirls, and telescopic observers from Earth see occasional dark and light disturbances that erupt for some months before fading. As on Jupiter, the main two dark bands straddle a lighter equatorial region.

Saturn, like Jupiter, radiates measurably more heat from its interior than it receives from the sun. This heat flow may help stir the clouds. As on Jupiter, the main clouds are composed of ammonia crystals, with water ice clouds lying far below. Saturn's clouds look less colorful than Jupiter's, the colors perhaps muted by high haze overlying the main cloud decks.

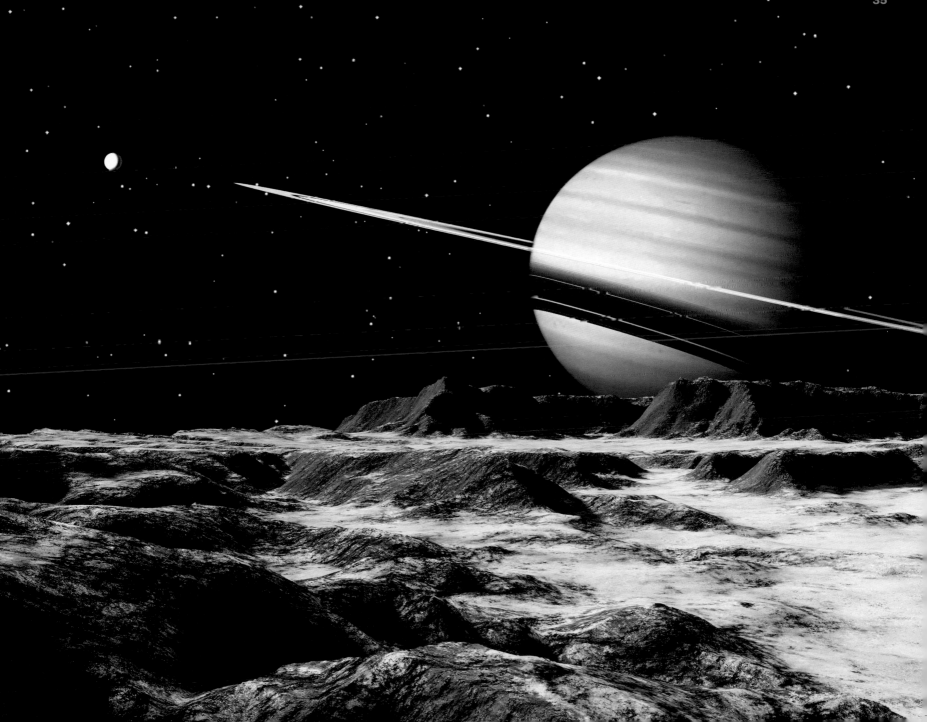

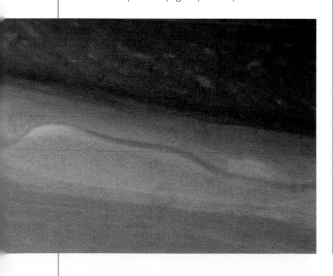

Ribbonlike clouds are stretched across Saturn by 800-kilometer (500-mile) winds. Below, wavy cloud forms can be seen in this close-up. Both images were taken by the Voyager spacecraft.

Saturn has the grandest ring system of all the planets. Unlike Jupiter's, Saturn's rings are very prominent, even as seen from Earth through small telescopes. The particles of Saturn's rings are larger than those in Jupiter's rings.

Spectroscopic observations in the 1960s proved that the ring particles are composed of (or at least coated with) frozen water. Other testing methods, such as the bouncing of radar signals off the rings, indicate that the particles range primarily from marble- to basketball-sized; some larger ones may reach sizes of 1 to 100 kilometers (.6 to 62 miles) in diameter. These larger particles (or moonlets) orbit among the swarm of smaller particles and may possibly determine the distances between them. Observations from Earth and space vehicles between 1969 and 1980 revealed several small moons, on the order of 40 to 200 kilometers across, orbiting at the very edge of the ring. Gravitational forces from these moons, and also from the more distant satellites of Saturn, are important in maintaining the edges of the rings and the divisions within them.

Structure Within the Rings

Although early observers had little physical information about Saturn and its rings, they were able to perform many interesting geometric studies of the ring configuration. As early as 1865, the British observer Richard Proctor realized that the sky of Saturn, at least from the level of the cloudtops, must present an extraordinary sight, with the ring system arching through the firmament like a midnight rainbow.

The rings are tipped relative to Earth's position, and as Saturn orbits around the sun we see them from different angles. This varying perspective reveals that they are extremely thin and flat; they are about 275,000 kilometers (170,775 miles) in diameter, but their thickness is probably less than 1 kilometer and may be only a few hundred meters. Visiting the rings is quite a feat.

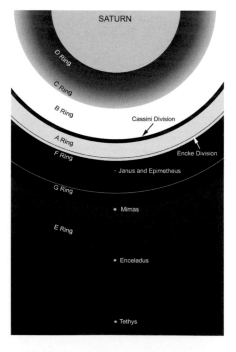

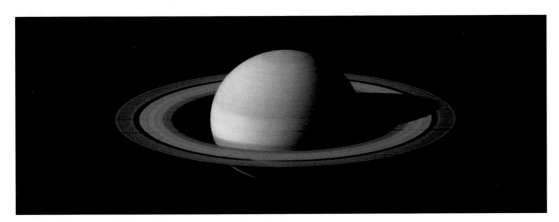

Left:

A magnificent view of Saturn by the Cassini spacecraft as it approached the planet.

If we fly into the Saturn ring system at normal spacecraft speeds (i.e., on an unpowered orbit falling toward or around Saturn), we will pass through the rings in less than a tenth of a second unless we approach at a very shallow angle to the ring plane. And if we do that, we will be within the rings for a long time and stand a fairly good chance of hitting a dangerously large body.

But if we slow down, using retro-rockets, and move into the rings, what a sight we'll see! In the most heavily populated parts of the rings, much of the sunlight is blocked out by whirling bodies that cause a thousand twinkling eclipses. Clouds of hailstones spin by, snow-white and glittering. And the sky is filled with passing bodies stretching off to a strange horizon, the distant vanishing point defined by the ring plane—a virtual highway in the sky.

Earthbound telescopic observers have long known that the rings were structured. In the 1600s, Italian-French astronomer Jean-Dominique Cassini discovered a prominent gap. Other, and finer, gaps, called divisions, have also been seen. Cassini's Division forms the boundary between the outer

Below:

Ring Structure

The extraordinary details of Saturn's rings are vividly illustrated in these photographs taken by the Cassini orbiter. The separation and structure of these rings, and the gaps between them, are caused by gravitational effects of the planet's many moons.

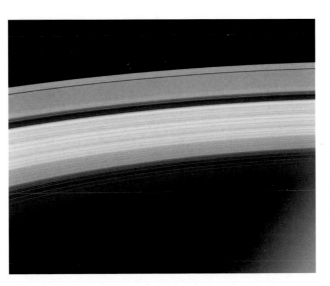

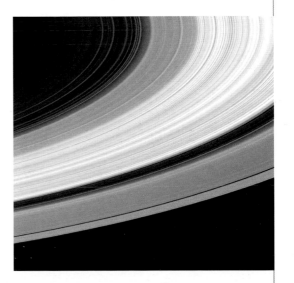

ring, called the A ring, and the inner B ring, which is somewhat brighter than its own counterpart. Inside the B ring is a much fainter division of rings called the C ring. Other ring portions have been tentatively identified by various observers, including the so-called D, E, and F rings.

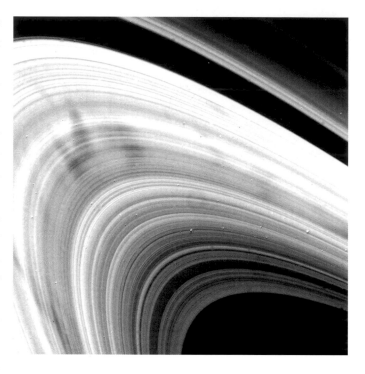

When *Voyager 1* flew by in 1980, it revealed a vastly more intricate structure than the old theories could ever explain. For example, in one of the obscure divisions inside the rings, a very narrow ring was found that was not circular but rather elliptical in profile. On one side of Saturn it seemed to be centered in its division, but on the other side it was well off-center, toward the edge of the division. This finding may help explain some very puzzling observations: Various telescopic observers have drawn pictures of divisions in different positions in the rings at different times. Perhaps changing configurations of satellites actually change positions of ring divisions. Or perhaps rotation of the rings brings different structures into view.

This last possibility seemed to be established by the *Voyagers* when they discovered strange, radial streaks in the rings that could be seen rotating around Saturn in time-lapse movies made by the probes' cameras. These spokes, similar to markings sketched by observers as long ago as the 1800s, have never been explained. Since the particles in any ring system move at different speeds (those closer to a planet move more rapidly than those farther from it), it seems impossible for a radial pattern to be maintained, since the part of the spoke closer to Saturn should be moving more rapidly than its outer end.

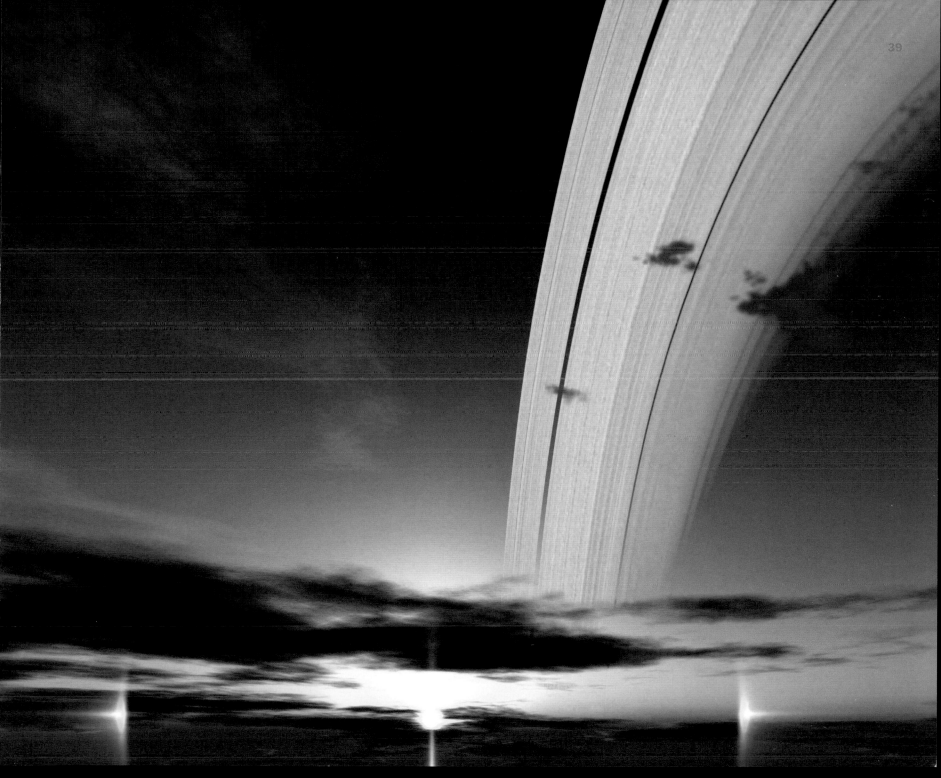

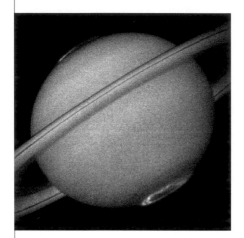

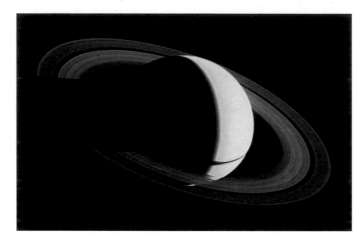

Above left:

Like Jupiter, Saturn's powerful magnetic field attracts particles of the solar wind, causing the upper atmosphere at its poles to glimmer with shimmering auroras, as seen in this Hubble Space Telescope image.

Above center:

A view of Saturn impossible from Earth. A crescent Saturn photographed by Voyager 2 when on the far side of Saturn, looking back toward the sun.

Above right:

The enigmatic F ring and its intriguing lumps and braids. These are probably due to the gravitational effects of the small moons that shepherd the ring, though the exact mechanisms have yet to be worked out.

Right:

The Cassini spacecraft caught this image of the tiny outer moon, Phoebe, while on its way to rendezvous with Saturn. Variations in brightness are due to the existence on some crater slopes and floors of bright material—thought to contain ice—on what is otherwise one of the darkest known bodies in the solar system.

A Large Intricacy

The complexity of the rings was further made apparent by the *Voyagers'* discovery of an intricate structure of filaments, seemingly braided in appearance, in a narrow ring just outside the A ring. How swarms of ring particles can arrange themselves in filaments is not known, but gravitational forces exerted by Saturn's satellites on the ring particles are surely involved. Gravitational forces also control the gross structure of the rings and define the system's outer edge. Saturn's rings, like the rings of Jupiter and Uranus, are located mostly within a critical distance from the planet—called *Roche's limit.* This is the distance within which the stretching forces associated with a planet would break apart a large, weak object. Just as the moon raises tidal forces in the oceans of Earth, any planet can stretch and raise bulges on the surface of a satellite.

Most satellites are outside Roche's limit and therefore are too far away for tidal forces to do any structural damage. However, inside Roche's limit, this

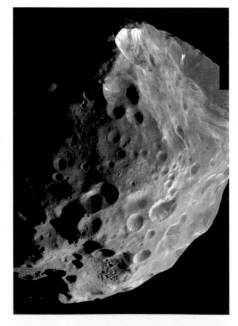

stretching can pull a weak moon to pieces. Therefore, if small particles are formed inside this zone, they are unable to aggregate into a single satellite.

Some scientists believe that because of this effect, the Saturn ring material may have been left from primeval days. However, it now seems likely that a large comet or asteroid may have passed so close to Saturn that it hit one of the inner satellites, spewing swarms of particles inside Roche's, where they were too close to Saturn to aggregate into a moon.

Whatever the origins and history of Saturn and its rings, the system reminds us that nature can not only create bizarre and beautiful environments on planetary surfaces, but may also create astonishing environments in orbit around those worlds.

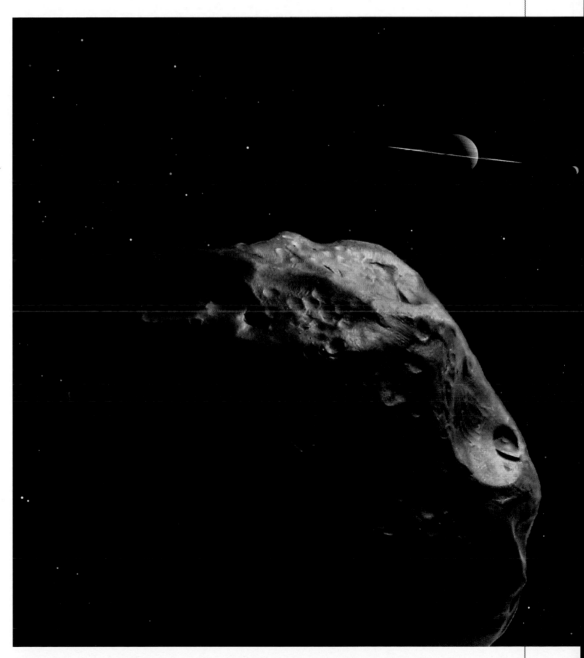

Seen from Hyperion in this artist's rendering, Saturn is nearly three times farther from us than Earth is from the moon. Still, the ringed planet appears 10 times larger than our moon does. Only 257,600 kilometers (159,712 miles) away is the giant moon Titan, looking like a tiny tangerine. Saturn, here, is tilted seasonally to almost its greatest extent in relation to the sun. Hyperion is one of Saturn's smallest satellites, only 350 by 200 kilometers (218 by 125 miles) in diameter. Its surface is moderately bright and probably contains a mixture of ice and soil.

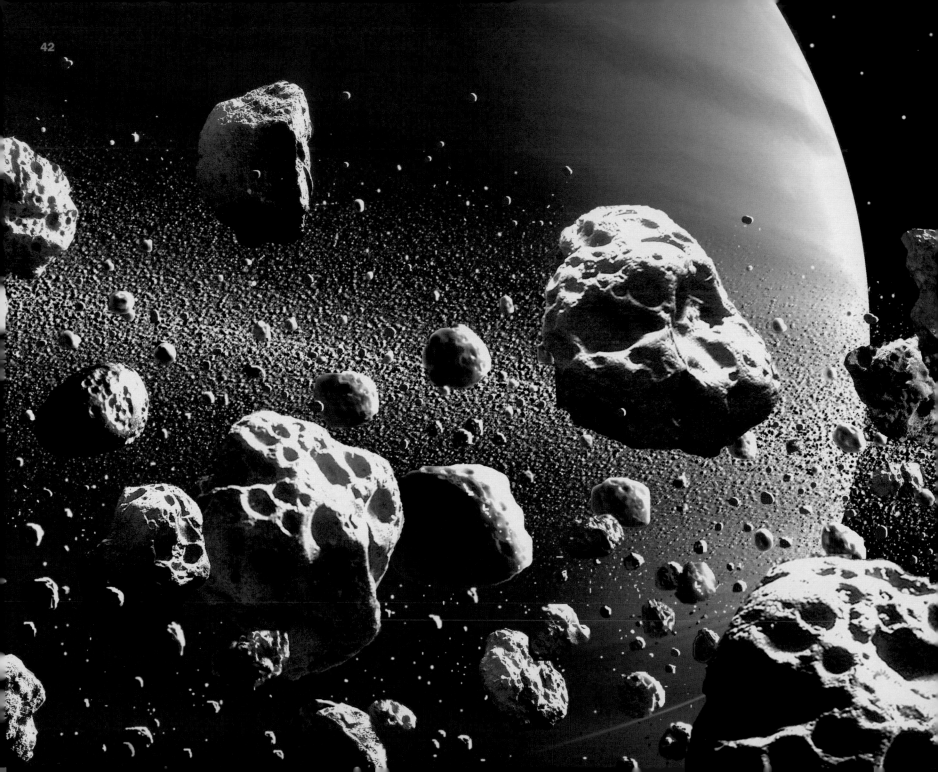

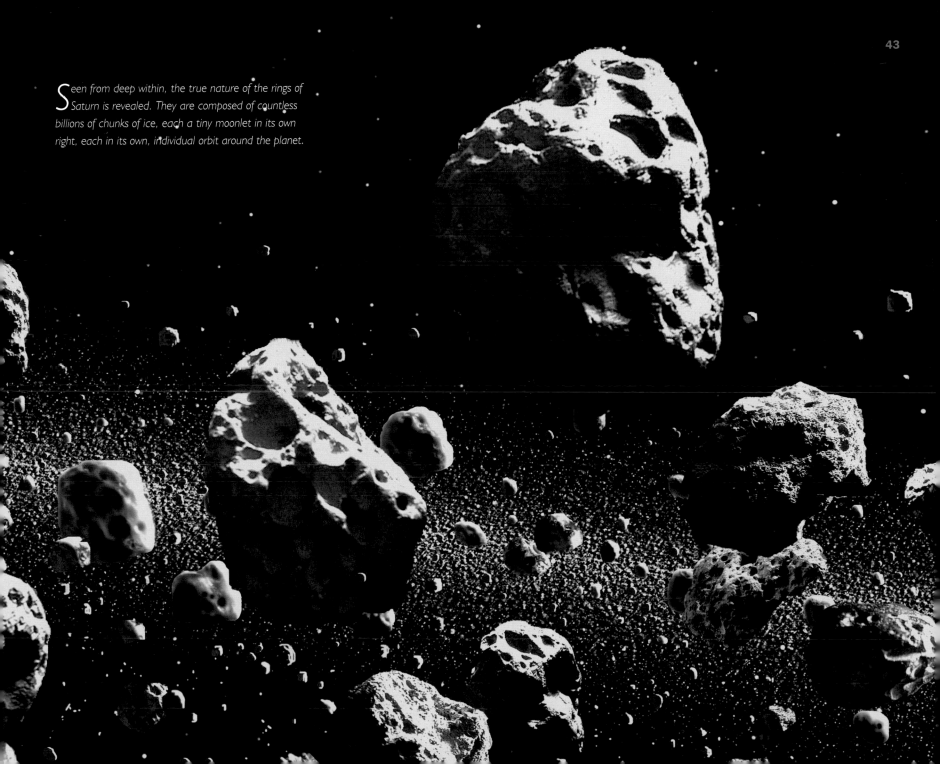

*S*een from deep within, the true nature of the rings of
Saturn is revealed. They are composed of countless
billions of chunks of ice, each a tiny moonlet in its own
right, each in its own, individual orbit around the planet.

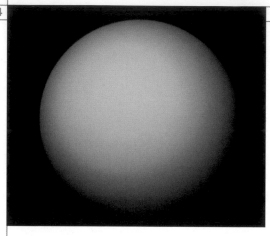

Uranus
A Sideways World

Planet

Average distance from the sun:
2,870,000,000 km

Length of year: *84 years*

Length of day:
17 hours 54 minutes

Diameter: *51,120 km*

Surface gravity (Earth = 1): *0.79*

Composition: *ice, hydrogen, helium; hydrogen-helium-methane atmosphere*

Above and right:

*T*wo *views of the nearly featureless blue globe of Uranus, photographed by Voyager 2. In the first picture, Uranus is shown from the sunward side, almost fully illuminated. Because of Uranus's extreme axial tilt, the south pole was pointed nearly at the sun, lying just below the center of the disk. The second view looks back at the dark side, with the globe illuminated as a very thin crescent.*

U ranus (pronounced *YOUR-uh-nus*) is the first planet to have been discovered since prehistoric times. The discovery was made by the English astronomer-composer William Herschel in 1781, while he was charting stars with his six-inch-diameter telescope.

Uranus is so far from Earth that it appears only as a tiny disk in the largest telescopes. *Voyager 2* is the only probe to reach a planet as far away as Uranus. *Voyager 2* flew past Uranus in 1986 and gave us our first intimate look. No cloud markings are prominent; the disk presents only a nearly featureless, greenish-blue face. The color arises for two reasons. First, the clouds are seen through a deep haze layer that scatters bluish light like the light of our own sky. Second, methane in this deep haze layer absorbs red and orange light from the sun, imparting a greenish-blue color.

Voyager 2 revealed that Uranus, like Jupiter and Saturn, has an atmosphere composed mostly of hydrogen and helium. About 83 percent of the molecules are hydrogen and about 15 percent helium. Methane and trace gases constitute the rest.

Uranus and its neighbor, Neptune, give us good examples of transitions between the "gas giant" planets, Jupiter and Saturn, and the rocky Earth. The diameter of Uranus is only four times Earth's, whereas Jupiter's diameter is eleven times that of Earth. Theoretical studies suggest that the interior material is a mixture of roughly

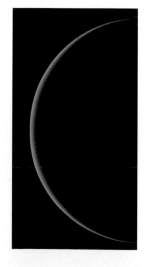

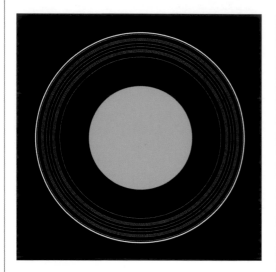

Above:

Unlike Saturn's rings, Uranus's are dark and threadlike.

Above right:

A detailed close-up photo of Uranus's rings reveal their delicate nature. In this unusual view from Voyager 2, the rings are silhouetted against sunlit Uranus, showing up as dark ribbons of dust.

one-half water, one-quarter methane, and one-quarter rocky material. The rocky material forms a central core that resembles planet Earth. This is overlaid by a layer of high-pressure solid water, methane, and ammonia, grading upward into a mushy ocean of these materials, and a foggy, hydrogen-rich atmosphere. As with Jupiter and Saturn, there may be no well-defined surface. With its weaker gravity, Uranus was not able to trap as thick a hydrogen atmosphere as Jupiter and Saturn.

Voyager 2 discovered that Uranus's magnetic field, unlike that of most planets, is tilted at an odd angle of 60 degrees to the axis of rotation. It would be as if a compass on Earth, instead of pointing north, pointed to a spot in Mexico.

Rings Revealed

On March 10, 1977, a group of astronomers convened in Africa to watch Uranus pass in front of a star. The plan was to monitor the starlight as the star passed behind Uranus's atmosphere, which would reveal information about the planet's atmospheric composition and structure.

The astronomers were in for a surprise. The star went through a pattern of brief dimmings before Uranus passed in front of it and then repeated the same pattern in reverse on the other side. Something that existed on both sides of the disk, in a uniform pattern, was blocking the starlight. This "something" was surmised to be a series of narrow rings around the planet.

Voyager 2 photographed the rings from close range and confirmed that they are beautiful, delicate, and unusual.

These rings are very different from Jupiter's or Saturn's. Jupiter's ring system looks like a single, moderate-width band. Saturn's rings are a wide system divided by more than a hundred narrow gaps. Uranus, in contrast, has several very narrow rings separated by wide gaps. Their structure is believed to relate to forces exerted on the rings by nearby satellites, located within the ring system. The exact physical mechanism that causes the spacing of rings is still uncertain. Some theorists suggest that each Uranian ring is associated with a small, as yet undiscovered moonlet located in or near the ring.

A distinctive feature of Uranus and its ring system is that the whole system is "tipped over." Most planets' equators lie nearly in the plane of the solar system, with their polar axes of rotation pointing "up" or "down," nearly perpendicular to the plane of the solar system. Jupiter's

Unlike the brilliant rings that encircle Saturn, Uranus's are narrow, faint hoops. They are barely visible until you are virtually within them—as we are here. We are positioned near a small moon that orbits between two of the nine rings. One of these moons may be within each gap, responsible for keeping these spaces swept clear of dark rock and dust. The shadows of all nine rings are cast on the planet itself just below the dusty rings. While Uranus's rings lack the almost mystic grandeur of Saturn's, we can appreciate their simplicity: They are drawn like a vast geometric exercise around the placid, sky-blue planet.

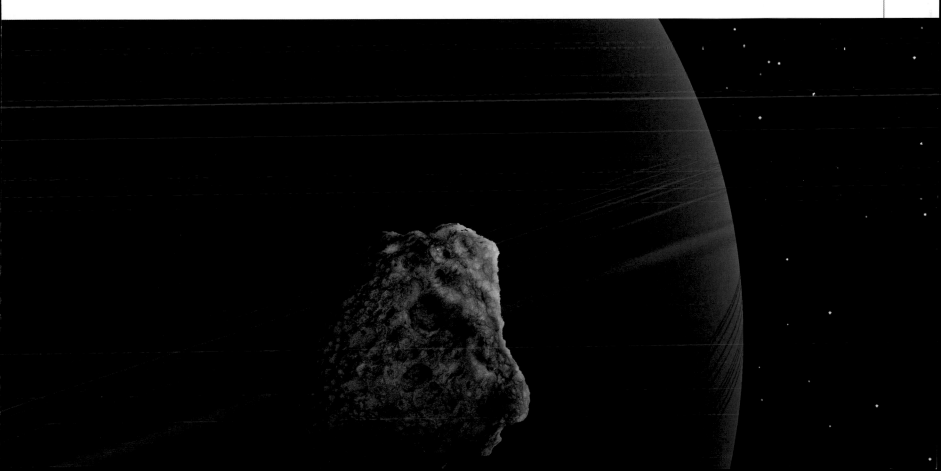

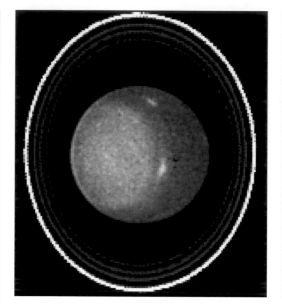 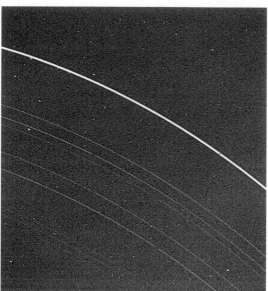

equator and rings, for instance, are only a degree or so off the plane of the solar system. Earth is 23.5 degrees off, meaning Earth's northern hemisphere, for instance, gets a relatively large amount of direct sunlight for part of the year—summer—and considerably less sunlight six months later—winter. The seasons thus arise because Earth's hemispheres are tipped toward the sun for half the year and away for the other half.

Forty-Two-Year Nights

In contrast, Uranus's pole lies almost in the plane of the solar system. This means that Uranus has extraordinary seasons. For one-quarter of the Uranian year, the north pole gets direct sun. During this season, the equator is in perpetual twilight. After a quarter of its trip around the sun is completed, we find the sun rising and setting over the equator during each of Uranus's eighteen-hour days; the north pole at this time is just grazed by light. After another quarter of a year, the northern hemisphere is deep in night. The north pole's night lasts half of a Uranus "year." After another quarter-year, the sun is over the equator again and summer begins to return to the northern hemisphere.

On Earth, the north (or south) pole is plunged into night for half the year, but on Uranus this long winter night happens to much of each hemisphere. At the height of summer, the sun shines continually almost directly above the north pole. Because Uranus takes eighty-four years to go around the sun, the night at the pole lasts a frigid, black forty-two years, followed by a polar "day" equally as long.

Other planets are illuminated by sunlight that comes only from "the side," that is, from a direction nearly in the equatorial plane. Uranus can be lit from almost any direction, above the equator or above the pole. Uranus's rings lie around its equator, so they, too, can be lit edge on and sometimes from directly above or below. The changing phases of the globe, the ever-shifting light on both Uranus and the rings, and the slipping of the rings' shadow back and forth across the globe present an endlessly changing panorama to all who are close enough in nearby space or on one of Uranus's moons.

*U*ranus's axis is tipped nearly 90 degrees; twice during its year, one of its poles points directly at the sun.

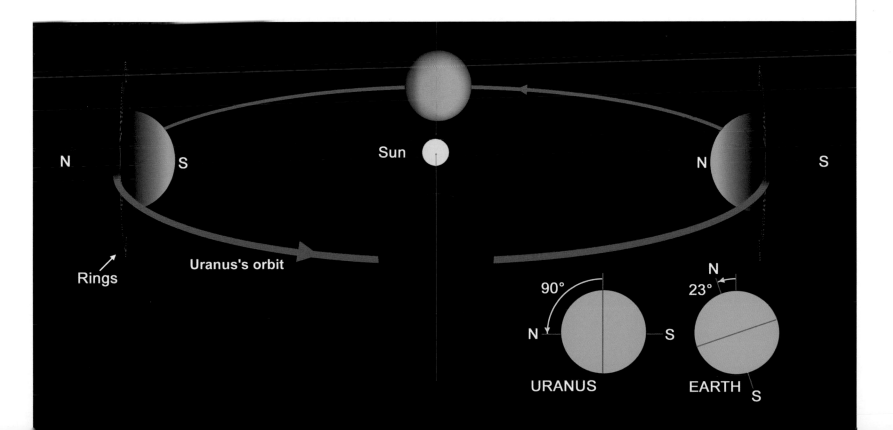

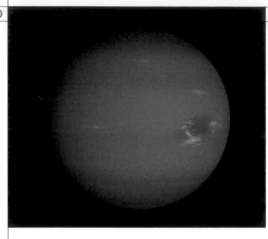

Neptune
The Last Giant

Planet

Average distance from the sun:
4,497,000,000 km

Length of year: *165 years*

Length of day:
19 hours 12 minutes

Diameter: *49,530 km*

Surface gravity (Earth = 1): *1.12*

Composition: *ice, hydrogen, helium; hydrogen-helium-methane atmosphere*

Right:
Close-up of the Great Dark Spot storm cloud system, discovered on Neptune by Voyager 2. High white clouds overlie the system.

Neptune was discovered telescopically in 1846 after calculations showed that Uranus's motions were being disturbed by a still more distant planet. Neptune is too far away to be seen by the naked eye, but when dynamicists calculated the orbit that seemed to be required by the hypothetical planet's effect on Uranus, the planet was soon located telescopically. Telescopes reveal little information about this outermost large planet, but in 1989 *Voyager 2* flew close by and revealed its secrets.

One of the most wonderful surprises of space exploration is the variety of "personalities" that have become evident among different planets and satellites, and Neptune is no exception. Although Neptune is about the same size as Uranus, it has its own distinctive features.

The atmosphere is colder than those of the other giant planets, because Neptune is so much farther from the sun. For example, it is estimated that if we could descend to the level where the air pressure equals

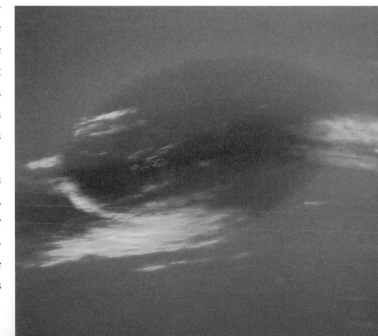

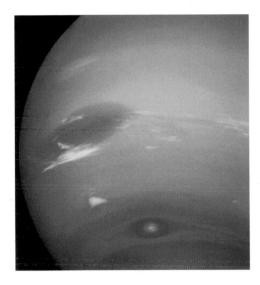

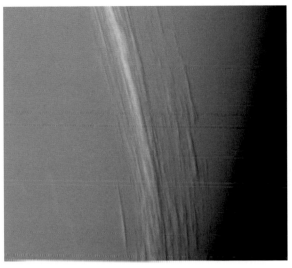

that on Earth's surface, the temperature would be an ultrafrigid -204°C (335°F). This is 78°C colder than the estimate for the same pressure-level among the clouds of Jupiter.

The Great Dark Spot

Scientists expected Neptune to have even less cloud activity than Uranus because it is so cold. But *Voyager* cameras discovered prominent cloud belts and a huge, dark blue oval spot. It's a storm system as big as the whole Earth. Reminiscent of Jupiter's Red Spot, it came to be called the Great Dark Spot. It's flanked by white cirrus clouds and shares the planet with several smaller white and dark blue oval storm systems.

What powers the storms? *Voyager* showed that Neptune has the highest ratio of internal heat outflow to external incoming sunlight of any planet—a ratio of about 2:7. (In contrast, Uranus has the lowest such ratio among the four giant planets.) So Neptune's atmospheric unrest may be powered by warm currents ascending from below. The planet's interior structure and atmospheric composition are probably similar to those of Uranus.

Another surprise from *Voyager* was the discovery of three narrow rings with a unique feature —the outer ring is not uniform, but contains three broad, arclike concentrations of particles along its circumference. These are called *ring arcs*. The forces that maintain the ring arcs are

Left:

The cloud-swept blue globe of Neptune, photographed by Voyager 2 in 1989. Unlike featureless Uranus, Neptune surprised scientists by the wealth of its cloud and storm features. The Great Dark Spot is a storm mimicking Jupiter's Red Spot. A smaller oval storm is seen at bottom, along with scattered white clouds. The storms circulate around Neptune at different rates and only rarely appear together, as in this view.

Below:

A portion of Neptune's bizarre ring system is seen in this Voyager 2 photo, in which part of Neptune's crescent is strongly overexposed at lower left. The rings are very narrow and, like Uranus's rings, composed of millions of tiny, dark dust particles. But unlike Uranus's, they have bright concentrations of particles, known as ring arcs (right), whose cause is uncertain.

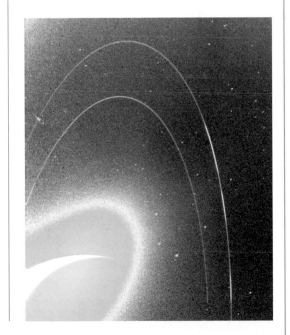

mysterious. Remember that all rings consist of millions of small particles, each moving independently around the planet. Something makes Neptune's outer ring particles "bunch up" into ring arcs, most probably gravitational pulls from tiny unseen moonlets among the rings.

Voyager also discovered that each giant planet has small moonlets just outside its ring system. In the case of Neptune, Voyager found six previously unknown satellites, from about 50 to 400 kilometers (31 to 248 miles) across, just outside or within the rings.

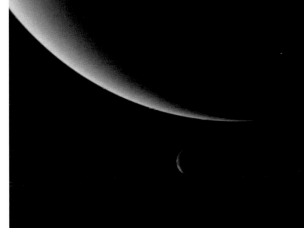

As it flew past Neptune, Voyager 2 snapped this impressive view of the planet's largest moon, Triton (bottom), hanging beyond the polar tip of the crescent-lit planet.

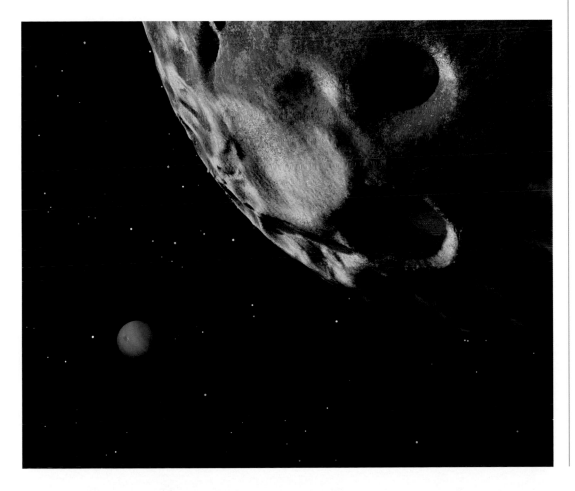

Left:

Neptune seen from near its distant, small moon, Nereid.

Opposite page:

Deep in the frigid, hazy atmosphere of Neptune, we watch its giant moon Triton glimmer in the light of a tiny, chilly sun. Thick clouds—similar to those that blanket Jupiter and Saturn—roll sluggishly. An ocean of haze surrounds us. It is fairly clear and scatters blue light the way Earth's atmosphere does. Triton appears almost half again larger than Earth's moon, while the shrunken sun is reduced 30 times in diameter compared to its visage from Earth; 900 times less in area, luminosity, and warmth.

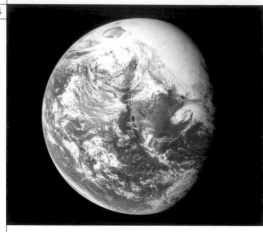

Earth
It's Alive

Planet

Average distance from the sun:
149,600,000 km

Length of year: *365 days*

Length of day: *24 hours*

Diameter: *12, 756 km*

Surface gravity (Earth = 1): *1*

Composition: *nickel-iron, silicates; nitrogen-oxygen atmosphere*

At the turn of the twentieth century, rocket pioneer Konstantin Tsiolkovsky said, "Earth is the cradle of mankind, but one cannot live in the cradle forever." Earth is more than a cradle to us; it has helped shape us. And we are only its most recent product. Geologic studies have shown that Earth has evolved dramatically since it formed some 4,500 MY ago—undergoing changes that have been slow in many cases, rapid in others.

One set of changes is purely geological, driven by the conflict between Earth's brittle, rocky crustal layers—called the *lithosphere* (from the Greek for "rocky layer")—and the churning, semimolten layers below. Earth formed hot, as planetesimals smashed into the growing planet, and the interior quickly became molten—allowing heavy metals to drain to the center and form an iron core, overlain by a partly molten mantle and the thin rock crust. Earth's interior is kept hot by small amounts of radioactive minerals, and this means that sluggish currents of semi-molten rock can slowly circulate—like the hypnotic circulation of material in an aptly named "lava lamp." As geologists discovered in the 1960s, these currents drag on the underside of the lithospheric rock layers, which are about 100 kilometers (60 miles) thick, and split it into continent-sized "plates," which are dragged and pushed around as coherent units. This process is called *plate tectonics*. The discovery of plate tectonics came when scientists mapped the ocean floor for the first time in the 1960s and discovered sea-floor fracture zones, marked by ridges formed by upwelling lavas from the mantle. Continents often split apart along these "rift zones," allowing ocean waters to flood in and fill the seam.

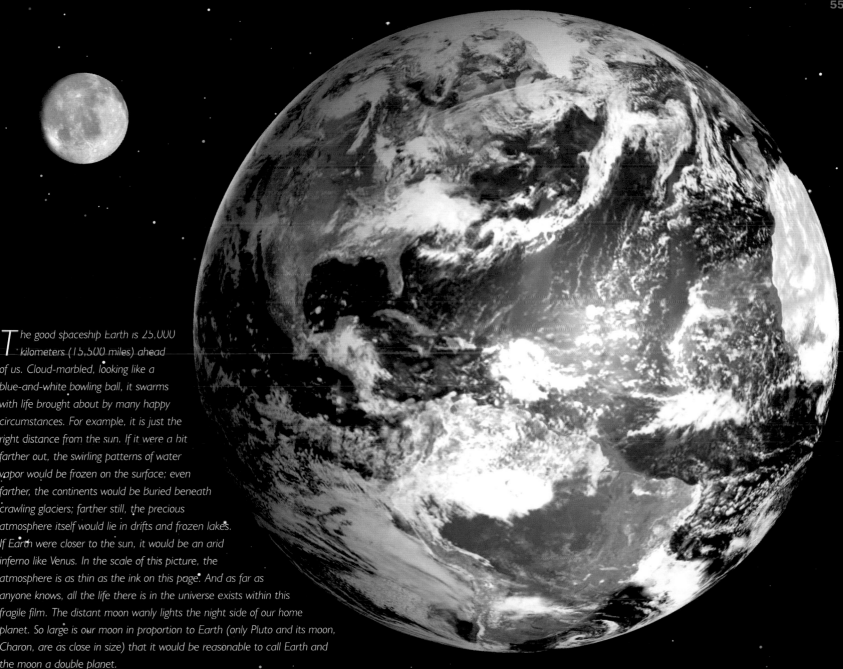

*T*he good spaceship Earth is 25,000
kilometers (15,500 miles) ahead
of us. Cloud-marbled, looking like a
blue-and-white bowling ball, it swarms
with life brought about by many happy
circumstances. For example, it is just the
right distance from the sun. If it were a bit
farther out, the swirling patterns of water
vapor would be frozen on the surface; even
farther, the continents would be buried beneath
crawling glaciers; farther still, the precious
atmosphere itself would lie in drifts and frozen lakes.
If Earth were closer to the sun, it would be an arid
inferno like Venus. In the scale of this picture, the
atmosphere is as thin as the ink on this page. And as far as
anyone knows, all the life there is in the universe exists within this
fragile film. The distant moon wanly lights the night side of our home
planet. So large is our moon in proportion to Earth (only Pluto and its moon,
Charon, are as close in size) that it would be reasonable to call Earth and
the moon a double planet.

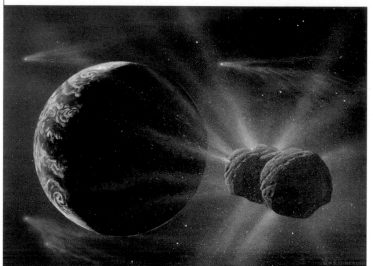

During the late stages of planetary formation, many comet nuclei—ice-rich bodies from the outer solar system—were diverted into the inner solar system and must have hit Earth and other terrestrial planets. Some researchers think the ice from comets provided some of the water in Earth's oceans.

Catching Earth's Drift

Plate tectonic movements have radically changed Earth during geologic time. For example, only about 100 MY ago, North America and Eurasia were joined in a much larger continental mass. Ascending currents in the mantle split the two apart—under what is now the Atlantic Ocean. North America drifted west, relative to Europe, and the Atlantic Ocean widened. This explains the strange fact, noted as early as 1922 by German meteorologist Alfred Wegener, that the coastlines of North and South America nest into the coastlines of Europe and Africa. Iceland, the tiny, volcanic island nation of the North Atlantic, is a piece of the mid-Atlantic ridge, exposed above the waves. Even today, it is being split—its western half is part of the North American plate, and its eastern half belongs, geologically, to Europe.

As the geologic plates of Earth's surface drift around, they jam together in some regions, and the collisions crumple the crustal layers, throwing up contorted mountain masses. The Indian plate, for example, drifted north and "crashed" into southern Asia 50 MY ago, creating the Himalayas, capped by Mount Everest. Many similar ranges of crumpled, contorted, corrugated rock layers can be seen, from the Alps to the Andes, from the Rocky Mountains to the Appalachians. Each marks a locale and a period of plate collision.

For these reasons, Earth's landscapes are very young, geologically speaking. Most of the features we see today formed only in the last few hundred million years—the last 10 percent of the history of Earth and the solar system. Continental configurations in the first three-quarters of our planet's history are difficult to trace. Early Earth was a different place. Similarly, on other planets, plate tectonic activity has been different, and we will encounter very different histories.

Even the atmosphere of our planet has evolved, and the air we breathe today has quite a different composition from that of the past. Earth's early atmosphere, say, 4,000 MY ago, would have been completely alien to us. It was mostly carbon dioxide (CO_2) and water vapor (H_2O). It had negligible oxygen. Why? The main gases, CO_2 and H_2O, are the gases that come out of volcanoes, and volcanism established the early atmosphere. Oxygen comes from plants. They consume CO_2, use the carbon (C), and give off O_2. Early Earth did not have enough plants to create and maintain an oxygen supply!

Starting in the 1950s, experiments showed that under a wide range of simulated early-Earth conditions, organic molecules form rapidly, including complex amino acids—the building blocks of proteins, which in turn are the structural building blocks of cells. Furthermore, complex amino acid molecules have been found in carbon-rich meteorites (fragments of asteroids) and even in interstellar clouds of dust and gas. Additional chemical experiments indicate that in water-based solutions of organic molecules, the organic materials can spontaneously agglomerate into cell-sized globules. It seems likely that the origin of life involved a step in which these globules grew complex enough to reach a size where they split and then took in new material, continuing the process.

For more than half of Earth's history, this process was confined to the oceans. A modern human, magically transported back to Earth of 3,000 MY ago, would find an alien landscape of barren dust, rivers, and mountains, with no animals or plants, and with unbreathable air. Geochemical evidence from ancient soils shows that oxygen did not begin to increase dramatically

Fully a third of Earth's surface is desert—more if the Arctic and Antarctic regions are included. The definition of desert involves lack of rainfall, so a desert can be either hot or cold. Even the polar regions are arid, receiving scarcely 10 inches of precipitation a year. Still, lifelessness is not necessarily a characteristic of deserts. The most hostile of Earth's arid regions, seemingly without a trace of water, encrusted with salts and broiling in temperatures reaching 48 or even 65°C (120 or 150°F), can still support life, and, in some cases, that life even flourishes. The danger of the deserts is that they are expanding as we destroy more and more of our land and its delicate ecological balance. Three-quarters of this planet is underwater, a third of the remainder is desert, and a large portion of what's left is uninhabitable or not useful for one reason or another—mountains, swamplands, and such. We have very little planet to waste.

Earth's Mountain Belts

Right:

*E*arth's rugged mountainscapes seen from two hundred miles in space. Such mountain belts represent eroded cores of zones where rock beds were crumpled by collisions of continent-sized tectonic plates.

Opposite page:

*A*s Earth grew older, its crust buckled and wrinkled. Continental plates collided like sheets of ice in a frozen river. Where plates met, where the crust split and faulted, mountains were born. Volcanoes laboriously built up miles-high cones or broad piles of ash and cinder, layer by layer. The collision of India and Asia created the Himalayan plateau; one of the wrinkles on top of it became Mt. Everest. An enormous block of Earth's crust was gradually bent and uplifted more than 8 kilometers (26,000 feet). Precipitous ranges like the Himalayas and Rocky Mountains are relatively young. But mountains, too, grow old. Millions of years of wind, rain, and plant life can eventually reduce a range like the Andes to the elderly undulations of the Appalachians.

until around 2,500 to 2,000 MY ago, just in the middle of Earth's history, due to the oxygen-producing action of plankton and other plant life in the seas. Faint fossil evidence of algae and other simple life forms have been found from that period, but the same fossil record shows clearly that substantial hard-bodied organisms like trilobites—the kinds of creatures that leave really good fossils—did not begin to appear on Earth until about 600 MY ago. This was after 87 percent of Earth's current history had elapsed. Prominently observable life on land didn't appear until as "recently" as 500 or 400 MY ago. Because Earth's crust has been churned by forces from below,

Pinwheeling anticyclonic clouds over the Pacific Ocean. Winds at the center of the system reached 50 miles per hour. Set spinning by the Earth's rotation, storms in the northern hemisphere turn clockwise while those in the southern hemisphere turn counterclockwise.

continent-sized blocks of crust have drifted, and the modern continents didn't take shape until some 300 MY ago. The Atlantic Ocean opened primarily in the last 100 MY.

A Fragile Partnership

The point of all this is that Earth has been constantly changing. It may have been a water-rich and cloudy world since very early in its existence, but it has never been a passive stage on which we living creatures play out our roles. The stage itself has changed, and so have we. Fortunately, we evolved fast enough to keep up with our changing Earth. However, today, we have the technological ability to alter Earth's environment faster than we can evolve, and we threaten ourselves and other species in the process.

As environmentalist René Dubos pointed out decades ago, our connection to Earth is umbilical. Earth has nourished us, and we are suited to it and comfortable with it. Writers such as Carl Sagan have stressed the beauty of Earth, but this beauty is not an intrinsic or universal absolute. Earth is beautiful to us because we have evolved on it and have adapted to it; it is the only place in the solar system where we can stand naked, breathing the air, feeling the sun, and seeing water trickle over our feet.

Space exploration is helping us to realize that Earth is a fecund paradise, a Hawaii in a universe of Siberias. That realization should provide us with sufficient motivation to try to keep it that way. How beautiful and how varied Earth is! Its active geology has created landscapes of enormous variety—rolling blue seas of liquid water, windy ravines, fields of sand dunes, dark overgrown jungles, barren polar deserts, volcanic explosions, golden prairies, waterfalls, and jagged peaks looming over glacial valleys. Our skies encompass clear blue vistas, white cloud puffs, dusty yellow glows, sunset reds, foggy grays, crystal moonlight, and spectral auroras.

Today there is little doubt that nomadic humans will eventually be able to journey to other planets, build space cities, collect energy, manufacture new tools, and multiply. There is increasing evidence that this may be a way to save our race from some natural or man-made disaster that could make Earth uninhabitable.

The problem for humanity is that our technology has reached the point where we are affecting not just local regions, but our entire planetary habitat. For example, as planetary scientists discovered in the 1960s and 1970s (in part from studies of the atmosphere of Venus!), certain commercial gases used as coolants, such as Freon, contained molecules that were reacting with ozone (O_3) molecules in the upper atmosphere, thinning the ozone layer that protects Earth's surface from the sun's raw ultraviolet radiation. UV radiation damages the molecules in the cells of our skin and can lead to cancer as well as other forms of skin damage (hence the importance of using sunscreen). The scientific alarm led to international cooperation on a treaty to ban the production of those materials and shift to other coolants. A second example is the concern over global climate change.

Research on both the ozone problem and the possibility of global warming has been ridiculed since the 1980s by conservative politicians and commentators, especially in the United States, as "junk science," and yet the ozone problem was certainly real, and the global warming problem now seems undeniable. There are many lines of evidence, and we can cite three:

1. Direct measurements show the increase of CO_2, a greenhouse-effect gas in our atmosphere, since the industrial revolution, due to burning of fossil fuels.

2. Satellite- and ground-based temperature records show a gradual increase in surface temperatures over the last century, with many of the hottest recorded years, occurring in the last decade.

3. Glaciers in most parts of the world are rapidly receding, as is the north polar ice cap.

As a result of this evidence, conservative ideologues have shifted their attack: Instead of saying that global warming is only an illusion created by "junk science," they argue that the observable change is just one of many natural climate shifts, such as the Ice Ages; they argue that if it is not human-caused, it does not merit human intervention, which would require shifts in our patterns of energy production and consumer consumption. These points continue to be debated.

The Gulf Coast of Texas and Louisiana seen from the Gemini I spacecraft.

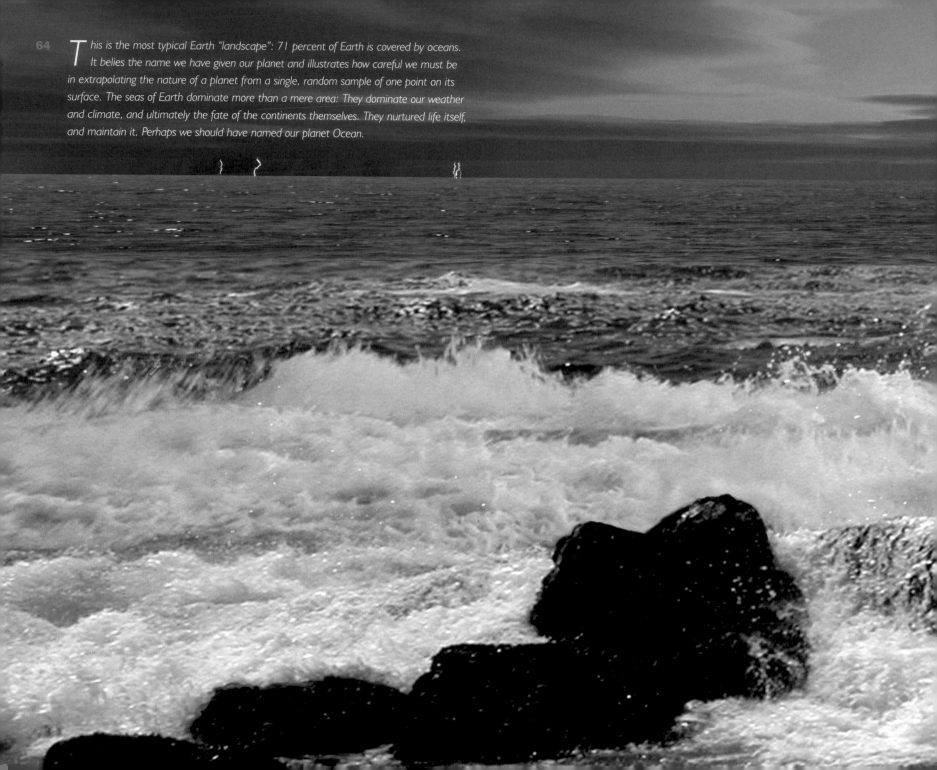

This is the most typical Earth "landscape": 71 percent of Earth is covered by oceans. It belies the name we have given our planet and illustrates how careful we must be in extrapolating the nature of a planet from a single, random sample of one point on its surface. The seas of Earth dominate more than a mere area: They dominate our weather and climate, and ultimately the fate of the continents themselves. They nurtured life itself, and maintain it. Perhaps we should have named our planet Ocean.

Volcanoes from Space

*T*wo volcanoes were caught in mideruption in these photos taken by Space Shuttle crews. On the left is Mt. Etna, on the Mediterranean island of Sicily and on the right is Soufrière, on the Caribbean island of St. Lucia. The long plumes of smoke and ash underscore the fact that volcanoes such as these are major sources of the carbon dioxide in Earth's atmosphere.

Resources in Space

In any case, by moving some of our heavy industry into space, we may be able to reverse the rising tide of acid rain, nuclear waste production, ozone damage, global warming, water pollution, and other results of the activities of a growing population whose appetites for energy and consumer goods are beginning to exceed the planet's ability to sustain them. For example, having exhausted the "easy" sources of ores and fuels in the nineteenth and twentieth centuries, we currently dig deeper and deeper for lower- and lower-grade ores and fossil fuels. We engage in wars that involve jockeying for strategic control of the parts of the world with the last reserves of petroleum. But we now realize—as we will see later—that some asteroids are made of pure metal alloys, and that twenty-four hours per day of "free" solar energy flow through near-Earth space. We may be able to hand the next generations an ability to pursue those resources and reduce pressures on Earth itself.

Space exploration will also help us to determine whether life is rare in the universe, or whether Earth-like conditions, and hence living organisms, are common.

Nineteenth-century beliefs that nearby planets were populated were both overly anthropocentric and incorrect. Recent space flights suggest that we don't share the solar system with

anyone else. Certainly, there are no civilizations on Mars, no dusty cities or even organic sediments. Nonetheless, some meteorites contain the building blocks of life—amino acid molecules—formed probably in moist, subsurface layers of an ancient asteroid or comet.

Earth's most distinctive feature is a moist, warm climate that has persisted for billions of years, allowing such chemicals to assemble into viruses, cells, microbes, and eventually (in only the last 10 percent of planetary history), large living creatures.

Biologists once thought this evolution was slow and steady. But recent research reveals some "abrupt" changes that happened during intervals of only a million years or less.

To take one example, something suddenly changed Earth's environment 65 million years ago. An extraordinary 75 percent of plant and animal species, including dinosaurs, became extinct in only a few million years or less, and mammals emerged from their previous obscurity.

What changed Earth so suddenly? Research in the 1980s provided an unexpected "cosmic" answer. In 65-MY-old strata, geologists found evidence that a meteorite 10 kilometers (6 miles) wide crashed into Earth at that time. The evidence included concentrations of elements associated with meteorite material, plus grains of quartz showing unique shock fractures caused by the giant explosion, and a layer of worldwide soot implying forest fires around the globe.

The effects of the impact were awesome. The blast ejected debris that shot into space and fell back into the atmosphere all over the world, lighting the sky with the glow of a billion meteors. The heat from this glow probably ignited the forest fires and killed many animals in the hours after the impact, except in areas protected by snowstorms and heavy rainstorms. Dust and soot from the explosion and fire settled in the stratosphere,

The Earth has not been immune to the impact of asteroids and meteorites. This mile-wide hole was blasted in the Arizona desert 20,000 years ago by a meteorite only a few hundred feet wide.

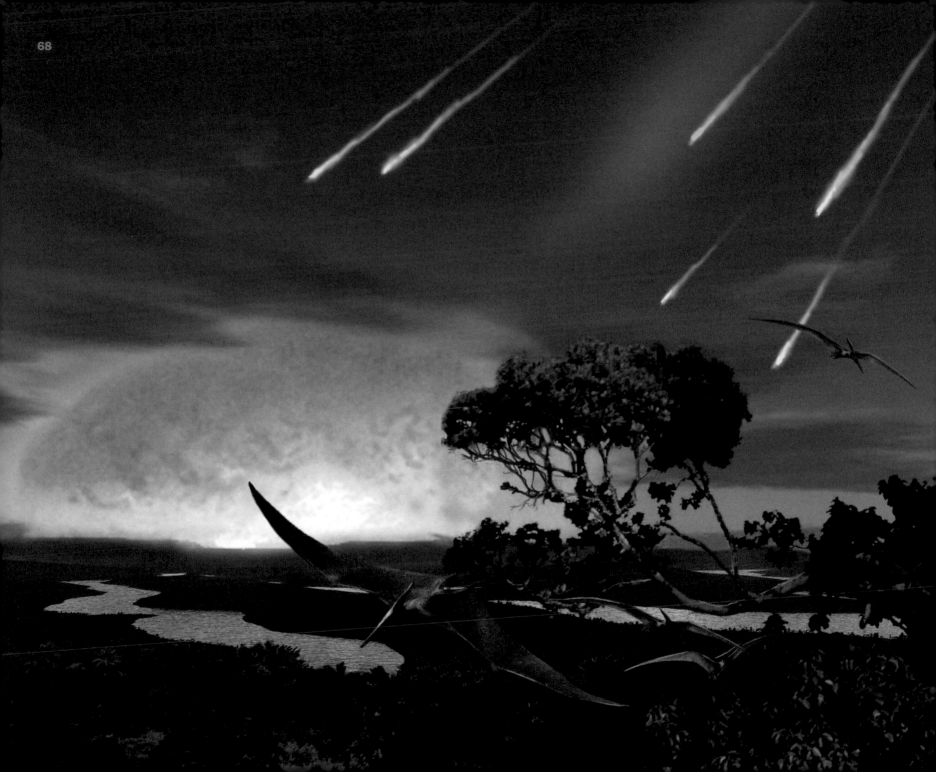

obscuring sunlight for several months. This killed off many surviving plants and disrupted the food chain. Scientists in 1990 announced the discovery of an impact crater 180-kilometers (112 miles) wide, hidden under sediments on the coast of Yucatán. It has been dated at about 65 MY.

This crater marks the site of the impact that wiped out the dinosaurs and changed the history of the world. Earth's environment, we now see, is really part of a large cosmic environment!

Additional mass extinctions of species happened in other epochs, including the most devastating of all, 250 million years ago. Impacts have been confirmed as the cause of some of those extinctions but the cause of many, including the largest one, is still debated. Evidence of different patterns of species extinctions suggests they were not caused by impacts. The case is still considered controversial. Some of the major mass extinctions may have involved some other geological force, such as occasional massive lava eruptions that release large amounts of carbon dioxide and thereby affect the global climate.

Clearly, Earth's environment and biology have had a complex history. Species have evolved not in a linear, preordained way, but along a twisting path, probably involving elements of chance such as climate changes due to random impacts. But always, the species that succeeded in any given era were the ones best suited to the environmental conditions of that time.

This is why we are so uniquely adapted to our planet today. Although Earth's environment was different in the past, most change has been slow. That's why the biggest danger to life on Earth is not change per se, but change that happens too fast. Change occurs throughout a planet's history. We cannot force things to stay as they are. The danger is change that happens faster than species can adapt, such as the increase of industrial carbon dioxide that causes global warming within a century.

Our first duty, as far as planets are concerned, is to nurture this unique Earth, from flowered fields to ripples of desert dunes, from restless seas to the silent play of fluorescent auroras over icy polar wastelands.

As our eyes shift heavenward from these extremes of our own planet, we recognize kindred landscapes on other planets, and we are drawn to explore further. Alien worlds may teach us more about the history of our own planet. We may be tied to Earth, but as the Russian space pioneer Tsiolkovsky reminds us, a species can't survive in its cradle forever.

Opposite page:

*T**he explosive impact of a large asteroid 65 MY ago spelled doom for many species then living on Earth.*

Above:

*O**ur twenty-first-century "environment" includes not only the meadow next door, but our entire inner solar system. The bodies that shaped our evolution are shown in this view, as seen from 54,000 kilometers beyond the moon: Earth itself, the moon in the foreground, and the distant sun. We see the night side of Earth. From nightside Earth, a full moon would be visible in the sky.*

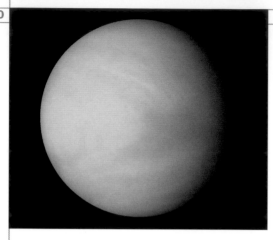

Venus
The Veiled Inferno

Planet

Average distance from the sun:
108,200,000 km

Length of year: *224.7 days*

Length of day:
5,832 hours (243 days)

Diameter: *12,100 km*

Surface gravity (Earth = 1): *0.91*

Composition: *nickel-iron, silicates; carbon dioxide atmosphere*

Venus is the closest planet to Earth, both in proximity and in size, but at the same time it is one of the most unusual and fearsome environments in the entire solar system, with a dense carbon dioxide atmosphere and a surface temperature of 460°C (860°F).

Why is it so different? Venus's proximity to the sun means that it probably contained less water to begin with than Earth; certainly it never had the great oceans of our planet. Long ago, when the interiors of Venus and Earth heated up due to radioactivity, volcanoes and fumaroles erupted on both worlds. Carbon dioxide was one of the most abundant volcanic gases. On Earth this carbon dioxide dissolved rapidly in the oceans, making weak carbonic acid that reacted with the rocky ocean floor, ultimately creating carbonate-rich sedimentary rocks. Most of Earth's vast amount of carbon dioxide thus "disappeared" into the oceans and rocks, and did not accumulate in the atmosphere.

But on Venus there was no ocean, so the Venusian carbon dioxide could not "disappear" into the seas and ultimately the rocks. Venus contains about the same amount of carbon dioxide as Earth, but on Venus all of this heavy gas remains in the atmosphere. Venus, therefore, has a very dense atmosphere, exerting more than ninety times as much pressure at the surface as Earth does. Instead of a familiar 14 pounds per square inch, Venus's air pressure is a crushing 1,260 pounds per square inch! Standing on the surface of Venus, you are subject to a pressure comparable to being over one thousand meters—over half a mile—beneath the surface of the sea.

Venus's excessive amount of carbon dioxide had another consequence, called the *greenhouse effect*. The glass windows of a greenhouse let in sunlight but prevent infrared "heat waves"

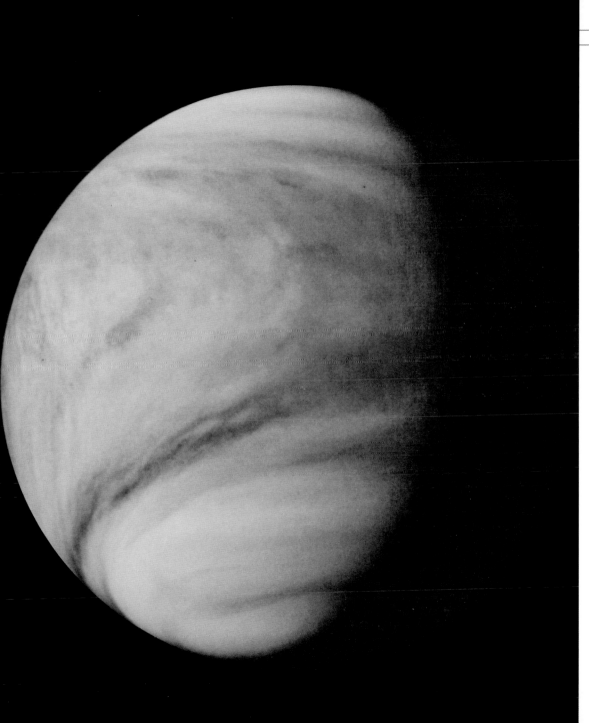

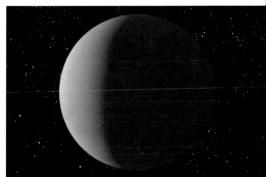

To a naked eye or telescopic observer, the illuminated clouds of Venus are nearly featureless. Sometimes, at crescent phase, telescopic observers have reported a faint glow on the night side. Called "ashen light," its source is unknown.

Venus (yellow) is very nearly the twin of the Earth (blue) in size.

Left:

Ultraviolet photography enhances the contrast of Venus's radiating cloud belts. Seen here are the weather patterns associated with upper-altitude winds circulating at speeds up to 100 kilometers/hour (62 mph).

Metis Regio

Colette

Lakshmi Planum

ISHTAR

Sacajawea

Maxwell Montes

Cleopatra

TERRA

Tethus Regio

Atalanta Planitia

Vesta Rupes

Fortuna Tessera

Sedna Planitia

Guinevere Planitia

Tellus Regio

Leda Planitia

Niobe Planitia

Asteria Regio

Beta Regio

Bell Regio

Ulfru Regio

Sif Mons

Gula Mons

Devana Chasma

Eistla Regio

APHRODITE

Hestia Rupes

TERRA

Ozza Mons

Guinevere Planitia

Ouda Regio

Maat Mons

Nauka Planitia

Tinatin Planitia

Thetis Regio

Atla Regio

Phoebe Regio

Diana Chasma

Dali Chasma

Alpha Regio

Hathor Mons

Eve

Aino Planitia

Artemis Chasma

Themis Regio

Imdr Regio

Helen Planitia

Lavinia Planitia

LADA

TERRA

A global map of the features below Venus's clouds has been completed by Soviet and American space probes. The yellow areas are continentlike uplands, and the gray areas are "planitia," or rolling lava plains something like Earth's seafloors. The highest mountain masses (red and brown, top) are named Maxwell Montes and rise higher than Earth's Mt. Everest. As befitting the feminine goddess of love, most features on Venus are named after real and mythical women. The main "continents" are Ishtar Terra (named for the Babylonian goddess of love) and Aphrodite Terra (named for the Roman goddess of love). The smaller uplands, Alpha and Beta Regio, were discovered by radar from Earth. Also marked are craters named Cleopatra, Sacajawea, Colette, and Eve—the last used fittingly to define the zero longitude meridian, from which other longitudes begin. Many other features have also been named, giving too much detail to mark on this map. Despite the romantic names, the scorching air, volcanic geology, and permanent cloud pall of the planet of love come ironically close to medieval ideas of mythical Hell. Grey blocks were not well observed.

from getting back out. The infrared radiation is thus trapped, warming the air inside. Similarly, carbon dioxide gas blocks infrared heat radiation from a planet's surface, preventing it from getting out into space. So sunlight warms Venus to an extremely high equilibrium temperature.

Venus is completely covered by almost featureless, yellowish-white clouds. Ultraviolet photos reveal swirling cloud patterns, but these are mostly invisible to the eye. Prior to the 1970s, therefore, there was intense speculation on the nature of Venus's surface, beneath the clouds. Suggestions ranged from dusty deserts to swamps inhabited by dinosaurs. Early observers mistakenly assumed that the clouds were made of water droplets and pictured continual, torrential rains.

Probing Venus

The hellish pressure and temperatures at the surface were confirmed by direct measurement when the Soviet Union parachuted the first probes onto Venus in the mid-1970s. This was a difficult feat; the earliest Soviet probes were destroyed by the pressure and temperature before

Landscapes of Venus

The surface of Venus was photographed for the first time by several probes sent to Venus by the Soviet Union between 1975 and 1982. The photo above is one end of a diagonal panorama from Venera 14. At left are two black-and-white photos and one color photo—wide-angle panoramas—from other Soviet lander cameras. The photos show mostly platelike rocks, believed to be slabs of basaltic lava, with a few scattered boulders and patches of gravelly soil. Note the clarity of the air and the bright sky. The dark silhouettes at left are part of the spacecraft.

Beneath Venus's dense, opaque, poisonous atmosphere lies a barren landscape more hostile than anything on its sister world, Earth.

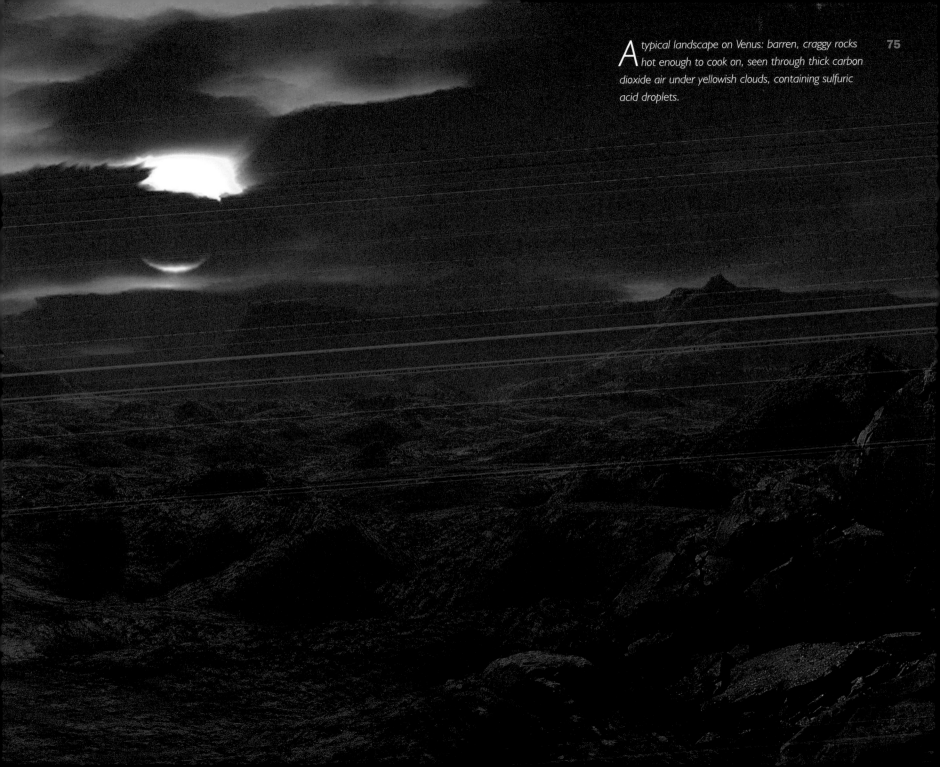

A typical landscape on Venus: barren, craggy rocks hot enough to cook on, seen through thick carbon dioxide air under yellowish clouds, containing sulfuric acid droplets.

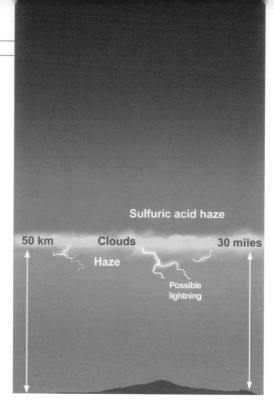

Sulfuric acid haze

50 km Clouds 30 miles

Haze

Possible lightning

Above:

*P*uffy cloud structures in Venus's midlatitudes, photographed from space in ultraviolet light.

Above right:

A cross section of Venus's atmosphere. Beneath a dense layer of heavy, opaque clouds, the atmosphere is surprisingly clear.

reaching the surface. The clouds of Venus consist of sulfuric acid droplets (instead of water droplets, like our clouds), which tended to corrode the instruments on metallic probes. *Venera 7* made the first successful landing (on any other planet) on December 15, 1970, sending atmospheric data.

The Soviet *Venera 9* and *10* missions transmitted the first surface photographs in 1975, answering some of the questions about surface conditions. They showed landscapes of rocky rubble at one site, and dusty, flat rock outcrops at another. The lower atmosphere was remarkably clear. Another Soviet probe indicated granitic and basaltic rocks and soil, similar to volcanic or igneous soils found on Earth.

The United States's *Pioneer* missions to Venus in 1978 parachuted new probes through the clouds and collected more atmospheric data (the U.S. probes were not designed to soft-land or to gather surface data). The clouds are concentrated in a layer at altitudes of 48 to 58 kilometers (30 to 36 miles), much higher than normal terrestrial clouds. The particles in the clouds have a cyclical life history. Sulfur compounds condense into tiny crystals in a layer near the tops

of the clouds. They react to form sulfuric acid droplets, which begin to fall as they grow. However, updrafts tend to catch them and carry them back up through the clouds, just as raindrops in our own thunderclouds may cycle up and down.

Eventually, they get large enough to fall out of the lower surface of the clouds as a "rain" of sulfuric acid, actually detected by *Pioneer* probes just below the clouds at an altitude of around 31 to 38 kilometers (19 to 24 miles). Particles detected by *Pioneer* were microscopic, but larger particles can also form.

The "rain" on Venus never reaches the surface. The temperature increases rapidly from a "pleasant" 13.3°C (56°F) at the cloudtops to 220°C (428°F) at 25 kilometers below the clouds, at an altitude of 31 kilometers (101,711 feet). Therefore, the droplets evaporate as they fall out of the clouds. None survive below about 31 kilometers, and U.S. and Soviet probes observed open air and a surprisingly clear landscape below this level. The light level below the clouds is something like that of an overcast day on Earth.

Exploration of cloud-shrouded Venus took a great leap forward in the 1980s and early 1990s when *Pioneer, Venera,* and *Magellan* (U.S.) orbiters circled the planet and began bouncing radar waves down through the clouds and off the surface. This permitted the first detailed maps of the surface. Crude maps made by the first two orbiters revealed that about 80 percent of Venus is covered by rolling plains with only about a kilometer (3,281 feet) of gentle relief. The implication of the level topography is that, unlike Earth, Venus has had only limited "continental drift," the plate tectonic activity that crumples one "plate" of the crust into another, creating Earth's giant folded mountain ranges like the Himalayas.

Fractured Beauty

Another 20 percent of Venus is covered by a few fractured and contorted Australia-sized plateaus that resemble continents. Parts of these are giant volcanoes, towering as high as 10 to 11 kilometers (about 36,000 feet) above the plains, higher than Earth's Mt. Everest.

In 1990–91 the *Magellan* mission mapped astonishing details of all these features. The volcanic peaks have immense lava flows on their flanks. Much of the ground around them is broken by enormous fractures and chaotic slumped ridges probably caused by the stresses resulting from the pileup of kilometers of lava.

We are looking straight down on Sapas Mons, one of the large volcanoes of Venus. What appears to be an aerial photo is actually an image constructed from radar waves bounced off the planet by the U.S. Magellan orbiter. The almost abstract radial pattern is caused by lava flows of different textures that erupted on the central summit and cascaded down the slopes. The volcano is 400 kilometers (249 miles) across and 1.5 kilometers (4,900 feet) high. Near the summit are two mesas whose smooth, flat tops appear darker than the surroundings. The color was added during image processing to simulate the yellowish light filtering through Venus's clouds.

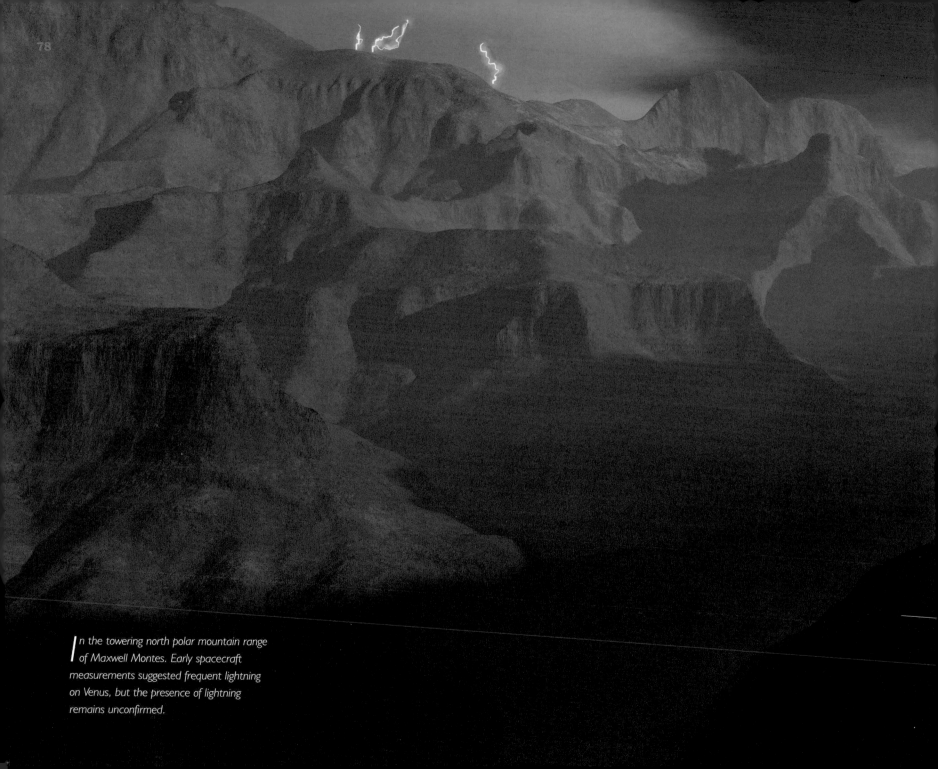

In the towering north polar mountain range of Maxwell Montes. Early spacecraft measurements suggested frequent lightning on Venus, but the presence of lightning remains unconfirmed.

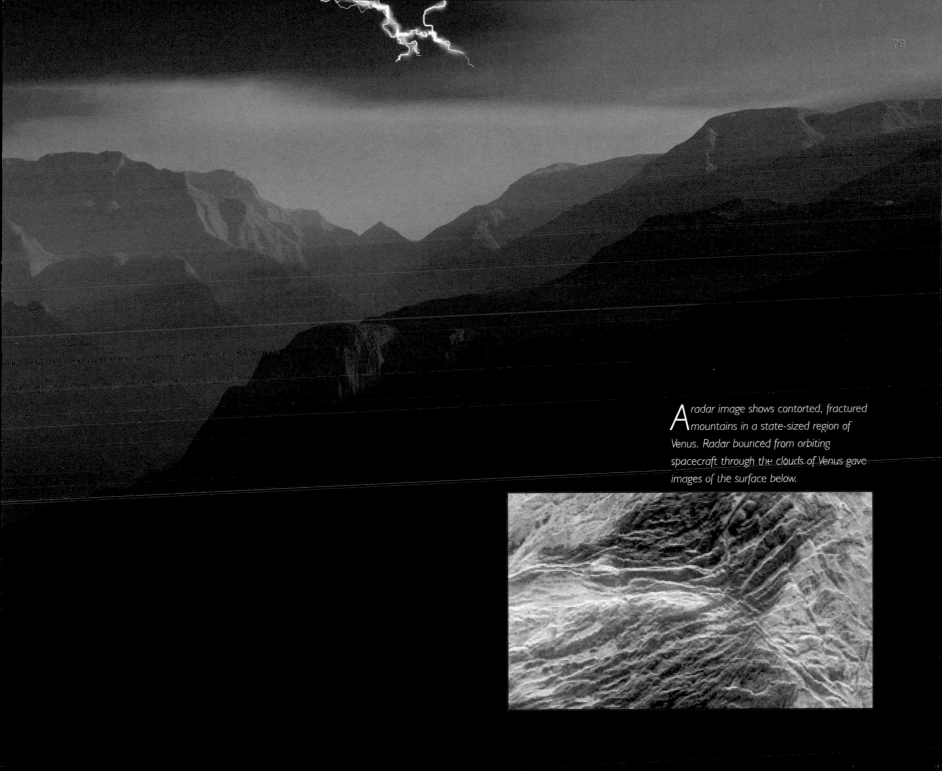

A radar image shows contorted, fractured mountains in a state-sized region of Venus. Radar bounced from orbiting spacecraft through the clouds of Venus gave images of the surface below.

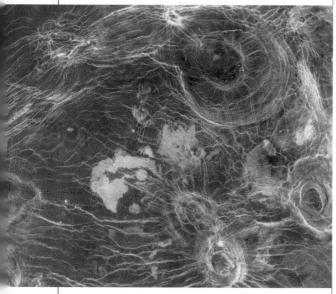

The dramatic volcanoes support the Soviet surface chemical measurements, indicating volcanic lava rocks. In short, Venus is a volcanic planet. Some of the volcanoes are probably active today, but this has not been proven.

How old is the surface, in general? Nature gives us a handy tool for estimating the age of planetary surfaces. Suppose a lava flow creates a new surface. The surface will be exposed to a steady, random bombardment by large meteorites (i.e., asteroids and comets) during geologic time. The older the surface, the more impact craters. By counting impact craters (for example, all craters larger than 1 kilometer, or roughly 0.6 mile, wide) and comparing them to surfaces of known age on Earth and the moon, scientists can estimate ages of surfaces. Earth has few craters because rapid geologic erosion wipes them away. Typical surfaces on Earth are only 100 MY old, in terms of their larger geologic features. A few areas, such as the central plains of Canada, go as far back as a billion years and show numerous scars of eroded impact craters. The lunar plains and highlands, at 3 to 4.5 billion years, show many craters.

Venus's surface shows more craters than Earth, including beautifully preserved double-ring craters up to 200 kilometers (124 miles) across. Scientists estimate that the surface is 200 to 700 MY old on average, with a few younger regions where volcanoes are adding new lava surfaces. Thus, Venus, like Earth, constantly reforms its surface. The lavas in most regions have formed just as its sister planet, Earth, was spawning trilobites, early fishes, and the first land plants.

An interesting feature is that Venus, unlike other planets, has virtually no craters smaller than 2 kilometers across. The atmosphere is so dense that the smallest asteroids shatter into powder before getting through to the surface; they make no craters.

One of the puzzles of Venus is that the larger craters are so well preserved. Of course, Venus has no rains to wash them away, but why don't we see at least some areas crowded with ancient craters partly destroyed by lava flows? Some researchers explain this by saying that all the lava surface formed at once, during one episode of deep lava flows. This might have been due to a massive upwelling of magma from Venus's mantle, the semimolten layer below the rocky crust. If so, the ancient surface was rapidly destroyed and fresh impact craters have accumulated ever since.

Whether or not Venus's present surface formed in one awesome surge of lavas, signs of mantle upwellings and lava outpourings abound. Using the *Venera* radar images, Soviet scientists in the 1980s discovered features called *coronas*—vague bull's-eye-like scars from 200 to

2,000 kilometers (124 to 1,241 miles) across. They seem to be caused by uplift from below, followed by lava emission and then sagging of the central portions.

From such data, scientists conclude that the mantle of Venus has hot, ascending currents called mantle plumes. These may be less active than mantle plumes on Earth, which push around crustal plates, causing continental drift. Instead, the mantle plumes of Venus bring up magma under a given spot, create a corona by deforming that spot, and then break through the surface, initiating volcanism. If enough volcanism occurs, the lavas may cover the corona, pile up, and create a giant volcanic peak. Because the surface of Venus is so hot, the crustal rocks are only a few hundred degrees short of melting. Heat from mantle plumes deforms and melts them, and this may explain the ease with which Venus accumulates massive lava outpourings.

Opposite page:

*C*oronas of Venus are broad, circular fracture patterns, probably caused by magma welling up from the planet's interior, causing the surface crust to crack. These examples range from 50 to 230 kilometers (31 to 143 miles) across. The smaller coronas, with radiating fracture patterns, have also been called "arachnoids" after their resemblance to spiders and cobwebs. The Magellan spacecraft has returned thousands of radar images of strange features on Venus that are still being analyzed.

Left:

A fractured landscape. Many areas of Venus show swarms of parallel fractures marked by straight or slightly curved valleys. The fractures stem from tectonic forces acting in Venus's crust. Here we look down a trough formed by such activity.

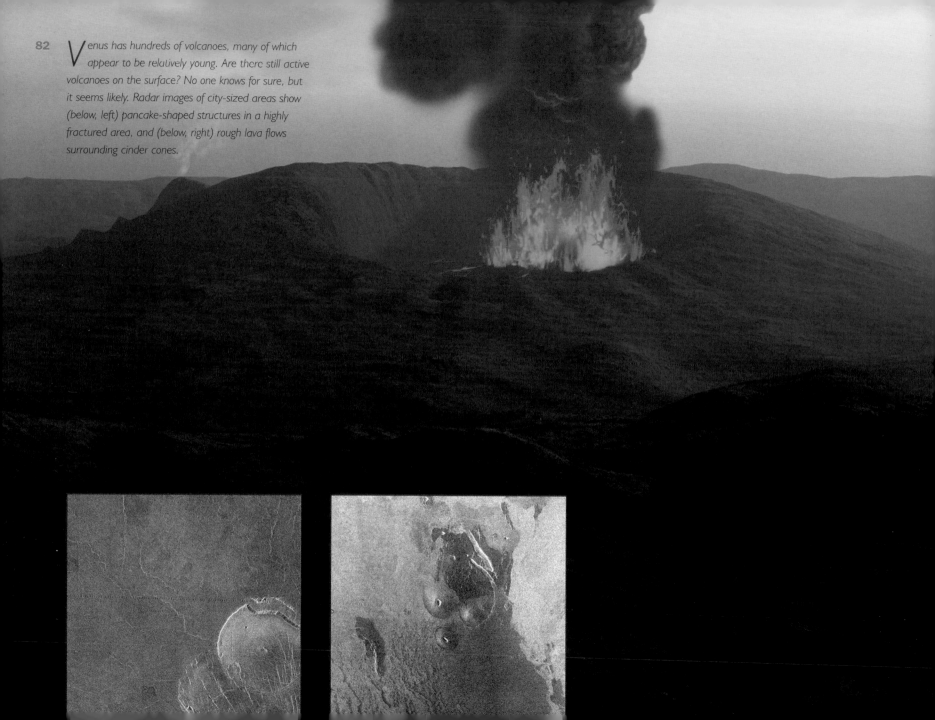

Venus has hundreds of volcanoes, many of which appear to be relatively young. Are there still active volcanoes on the surface? No one knows for sure, but it seems likely. Radar images of city-sized areas show (below, left) pancake-shaped structures in a highly fractured area, and (below, right) rough lava flows surrounding cinder cones.

2,000 kilometers (124 to 1,241 miles) across. They seem to be caused by uplift from below, followed by lava emission and then sagging of the central portions.

From such data, scientists conclude that the mantle of Venus has hot, ascending currents called mantle plumes. These may be less active than mantle plumes on Earth, which push around crustal plates, causing continental drift. Instead, the mantle plumes of Venus bring up magma under a given spot, create a corona by deforming that spot, and then break through the surface, initiating volcanism. If enough volcanism occurs, the lavas may cover the corona, pile up, and create a giant volcanic peak. Because the surface of Venus is so hot, the crustal rocks are only a few hundred degrees short of melting. Heat from mantle plumes deforms and melts them, and this may explain the ease with which Venus accumulates massive lava outpourings.

Opposite page:

*C*oronas of Venus are broad, circular fracture patterns, probably caused by magma welling up from the planet's interior, causing the surface crust to crack. These examples range from 50 to 230 kilometers (31 to 143 miles) across. The smaller coronas, with radiating fracture patterns, have also been called "arachnoids" after their resemblance to spiders and cobwebs. The Magellan spacecraft has returned thousands of radar images of strange features on Venus that are still being analyzed.

Left:

A fractured landscape. Many areas of Venus show swarms of parallel fractures marked by straight or slightly curved valleys. The fractures stem from tectonic forces acting in Venus's crust. Here we look down a trough formed by such activity.

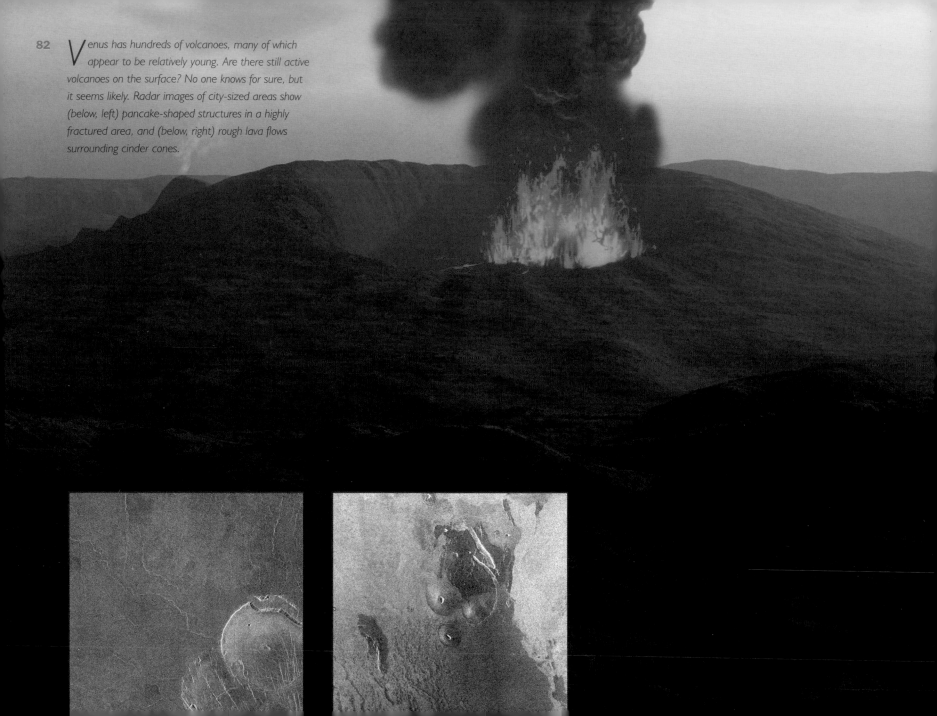

82 *Venus has hundreds of volcanoes, many of which appear to be relatively young. Are there still active volcanoes on the surface? No one knows for sure, but it seems likely. Radar images of city-sized areas show (below, left) pancake-shaped structures in a highly fractured area, and (below, right) rough lava flows surrounding cinder cones.*

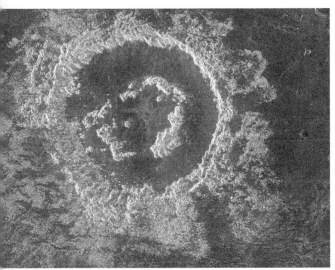 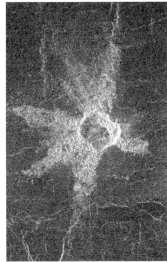

The Orbit Not Taken

Venus provides a vivid indication of the difficulties involved in the creation and mainte-nance of a habitable planet. Here is an Earth-sized globe only 30 percent closer to the sun than Earth is; yet its environment could scarcely be more different or more forbidding to intel-ligent life. Some theorists have calculated that if Earth were only 10 percent closer to the sun, the combination of increased solar heat and the greenhouse effect would have boiled off much of our oceans, leaving more water vapor and carbon dioxide in the air. This in turn would have led to an even stronger greenhouse effect and more warming. Thus, a slight decrease in solar distance (or increase in the sun's radiation output) could have disastrously altered Earth's cli-mate into a "Venus climate." A small change in environmental "input" can be magnified through environmental feedback into a large change in final climatic "output." Venus's searing heat, thick carbon dioxide atmosphere, and fearsome acid clouds make us stop and think about the consequences of our own alterations of Earth's atmosphere, which have already increased its carbon dioxide content and produced acid rains in industrialized regions.

Impact Craters on Venus

Above left:

This 50-kilometer (31-mile) double-ring crater is named Barton after Red Cross founder Clara Barton. Through poorly understood mechanisms of impact explosion, the central peak that appears in smaller craters changes form in larger craters, where it appears as a ring of peaks. The smooth, dark crater floor consists of lava flows that partly filled the crater after it formed.

Above center:

A smaller impact crater, about 10 kilometers (6 miles) across, shows streamers of ejected rubble.

Above right:

A view across a crater, similar to that in the preceding image. Only the largest meteorites and asteroids are capable of penetrating Venus's dense atmospheric shield.

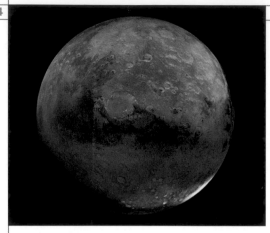

Mars
The Other Earth-like World

Planet

Average distance from the sun:
227,392,000 km

Length of year: *687 days*

Length of day: *24 hours 37 minutes*

Diameter: *6,786 km*

Surface gravity (Earth = 1): 0.38

Composition: *silicates, iron; surface minerals oxidized to rust red; carbon dioxide atmosphere*

Right:

A*stratified hill on dusty Mars.*

Opposite page:

M*ars seen from its smaller, outer satellite, Deimos, a dark lump of rock barely 15 kilometers (10 miles) wide.*

Mars is unchallenged as *the* planet of intrigue. Rovers have crawled its surface, robotic arms have reached out and analyzed its minerals, and orbiters have sent back data from overhead—and Mars just continues to grow more fascinating and provocative, in terms of its possible similarities to Earth-like early conditions.

About half the size of earth, Mars has desert landscapes colored red by the rusting of iron-bearing minerals, similar to those of America's southwestern deserts. As early as 1800, telescopes showed polar ice caps and shifting clouds. Further studies showed streaky markings and dusky patches that darken and lighten during a Martian year. Astronomers realized that Mars is colder than Earth because it is farther from the sun, but many thought that the changing markings must be vegetation.

Around 1895, the colorful American astronomer Percival Lowell put all this together into a magnificent new theory. Mars, he said, was inhabited. Not only was

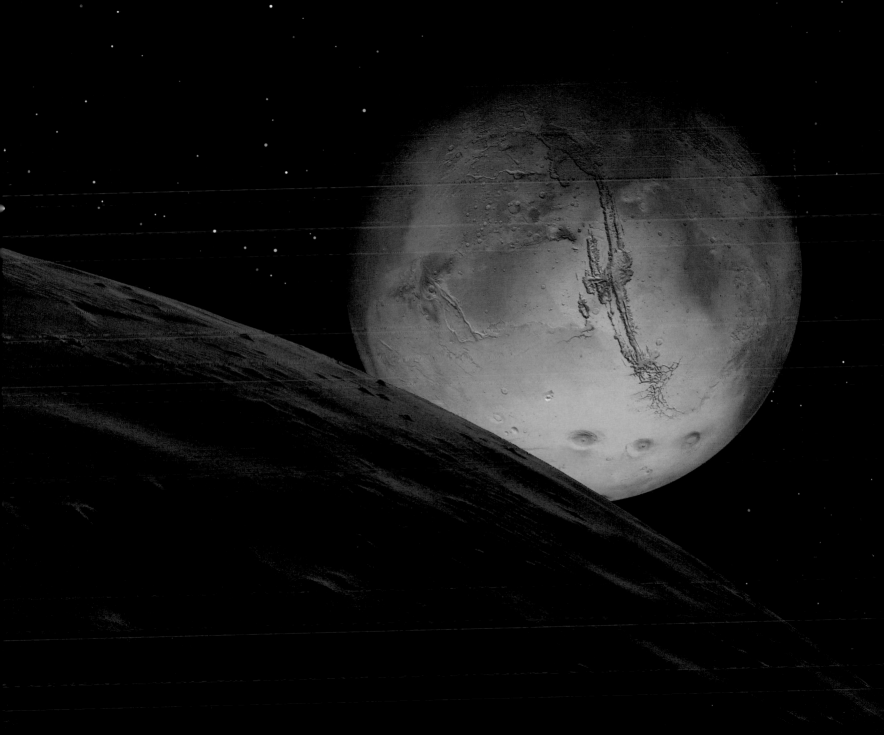

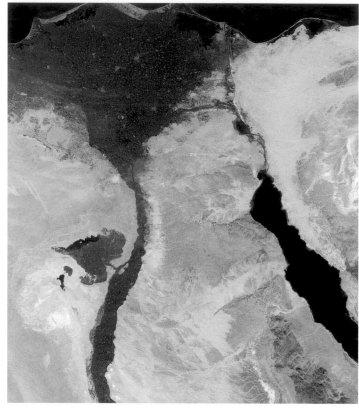

River Deltas: A Tale of Two Planets

These two photos graphically illustrate the similarities between the delta of the Nile River (right) on Earth and an apparent fossil river delta on Mars (left). The Martian delta fans out from the left side and lower left corner toward the upper right corner. The fan deposits are firmly aggregated; erosion has left the deposits standing higher than their surroundings. The Nile delta fans out into the desert, producing a triangle of irrigated vegetation.

there vegetation, but life had evolved to a civilized state. Much of the vegetation was cultivated crops! Lowell supported his argument by noting correctly that Mars itself had evolved. Water vapor and other gases had slowly leaked off into space because of Mars's low gravity, causing the air to be thin and dry. The Martian civilization was dying for lack of water, so they built a system of canals to bring water from polar ice caps across the arctic plains to the warmer equator, where the Martians lived. The streaky markings, which Lowell perceived and drew as straight lines, were bands of vegetation—crops—being grown along the sides of the canals.

Lowell's theory of Martian civilization explained a number of features of Mars, and it electrified the public for 80 years—but wonderful though it was, it had the scientific drawback of being completely wrong. As early as the 1920s, astronomers accumulated evidence that the

Martian air is even thinner and drier than Lowell thought, and that his straight-line canals were only streaky alignments of patchy markings.

The pendulum of Martian theory continued its swing away from Lowell's scenario in 1965 when *Mariner 4* returned the first close-up snapshots during a quick flyby. These few fuzzy images showed no cities or ruins or canals, but lots of moonlike craters. *Mariner 4* analysts jumped to the conclusion that Mars is merely a moonlike world with a little air to blow the dust around.

Not so. The 1971 probe *Mariner 9*, and its first-ever orbital mapping of the entire planet, revealed that the patchy markings and Lowellian canals were patches and streaks of windblown dust, oriented according to prevailing winds. *Mariner 9* found volcanoes, lava flows, sand dunes, layered sediments, canyons, polar ice, craters, fractures, clouds, fogs—a whole list of features.

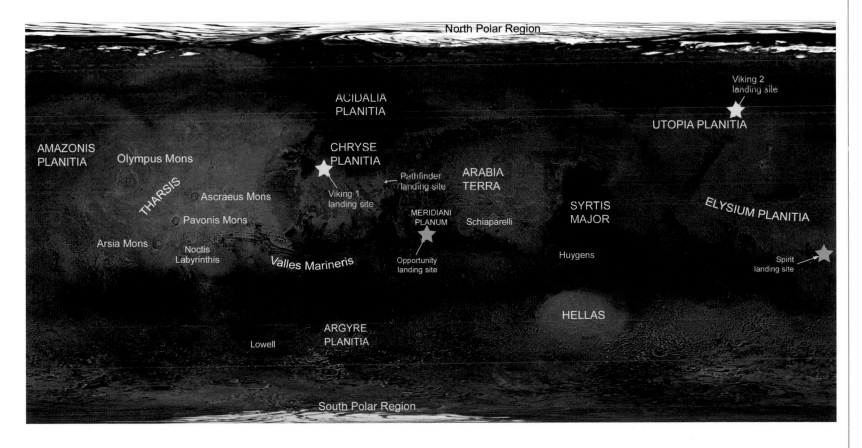

*E*arly morning sun slants across the grandest canyon in the solar system—Valles Marineris. Fog and mist still linger, made of ordinary water vapor that will disappear before the sun rises much higher, just as on a foggy morning on Earth. Here we are viewing a side canyon. At an average lookout point, the far walls of the main canyon are too far away to see clearly. Valles Marineris dwarfs our Grand Canyon. The Grand Canyon stretches some 450 kilometers (280 miles) across plateaus of northern Arizona.

Transferred to the United States, Valles Marineris would stretch across the entire country. With a depth as much as 5 to 7 kilometers (3 to 4 miles), it is about four times deeper than the Grand Canyon.

But the comparison is unfair. This canyon is a cousin not of the Grand Canyon but of the Red Sea, the Gulf of California, or the Great Rift Valley of Africa. On both planets, these regions mark sites where the crust of the planet is pulling apart. Similarly, Valles Marineris may resemble the beginning stages of the Atlantic Ocean 100 MY ago, when the American continents began to pull away from Europe and Africa.

Valles Marineris is so long that when one end is well into night, the other end can still be in sunset. The difference in temperature between the ends may set up winds shrieking down its enormous length. Winds, volcanic deposits, and landslides have all played a role in sculpting the canyon's convoluted walls.

Early Waters of Mars

Below left:

Early water and volcanic heat may have combined to create hot springs such as these. DNA evidence indicates that microbial life on Earth started in similar hot springs or geothermal areas. Could this hot spring, under a leaden, cloudy sky on primordial Mars, have harbored microbial life, as did its cousins on Earth?

Below right:

Many of the channels on Mars originate in chaotic regions where underground ice apparently thawed, creating temporary but massive flooding.

The polar ice caps were found to be more complex than those of Earth. As on Earth, there is a permanent cap of frozen water, but Mars is so cold that in the winter, carbon dioxide (the primary gas in the Martian atmosphere), in addition to the water vapor, freezes out and forms frost. On Mars the polar caps spread to midlatitudes in winter, just as our snowcap spreads south from the Arctic to Ohio—but on Mars this seasonal cap is frozen carbon dioxide—commonly known on Earth as "dry ice." Spacecraft observations show that both the north and south Martian polar caps are built on enormous mounds of thinly bedded sediments. The layers probably mark seasonal and climatic cycles in which ice condenses on dust grains in the atmosphere, falls out, and then sublimes (which means not melting, but changing directly from solid to gaseous vapor), leaving a dust layer behind. These layers may provide a record of past climate variations on Mars.

The western hemisphere of Mars is dominated by a huge volcanic plateau or dome. Named Tharsis, it is larger than Europe and rises about 9 kilometers (29,000 feet) above the mean surface level of Mars. The tallest volcano, named Olympus Mons (Mt. Olympus, after the

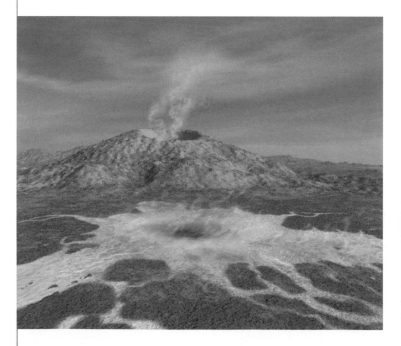

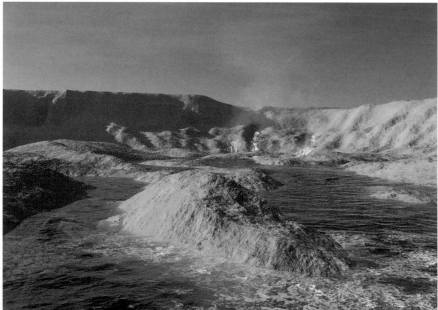

Above:

M any Martian cliffs show evidence of water erosion. On a frosty morning, the steam cloud on the distant cliff marks a spot where release of water has occurred.

Left:

M orning frost condenses at high latitudes on Mars as winter approaches. Although the horizon is level, Viking 2 landed on uneven ground, giving an 8-degree tilt to this picture.

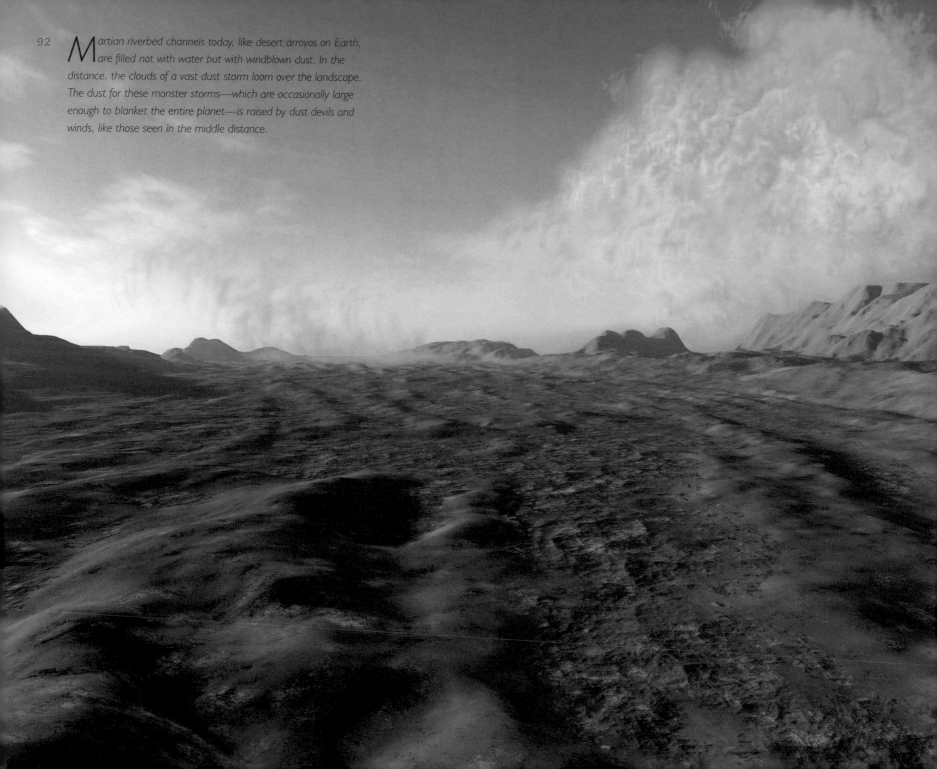

artian riverbed channels today, like desert arroyos on Earth, are filled not with water but with windblown dust. In the distance, the clouds of a vast dust storm loom over the landscape. The dust for these monster storms—which are occasionally large enough to blanket the entire planet—is raised by dust devils and winds, like those seen in the middle distance.

mountain that supposedly housed the Greek gods), towers 21 kilometers (69,000 feet) above the mean Martian surface—about two and a half times the height of our Mt. Everest! Its base is as wide as the state of Missouri. The other three Tharsis volcanoes are nearly as big.

The reason for the enormous size of the Tharsis volcanoes is that Mars lacks the continental drift, or plate tectonics, of Earth, so that when a long-lived volcano erupts on Mars over millions of years, the lavas keep piling up in one spot. In contrast, Earth's crustal plates slide over the hot spots that produce volcanoes, like a tray of pudding dragged over a stove burner, so that first one crustal region spot, then another, experiences the eruption.

This is not to say that the Martian crust lacks any tectonic, or fracturing, activity. Cutting into the Tharsis dome is another amazing feature, a giant canyon as wide as the United States. Named Valles Marineris, it is one of the features that was mapped a century ago as one of Lowell's "canals." It is about the same size as the Gulf of California or the Red Sea, and seems to have been formed by a similar process—a major fracturing of the planetary crust. Just as the Red Sea fans out at one end in the smaller fractures bounding the Sinai peninsula, the west end of Valles Marineris fans out into a smaller complex of canyons with the colorful name of Noctis Labyrinthus—the Labyrinth of the Night. Other smaller, but no less remarkable, fractures have been found, such as the Cerberus swarm of parallel fractures, in the southern part of the Elysium volcanic province.

Proof of Water

Mariner 9 found something still more astounding: Mars, a planet with no known liquid water, is laced with dry riverbeds. They are called *channels*. (The choice of word is a bit unfortunate because they have nothing to do with Lowell's canals.) They widen downhill, are joined by tributaries, show streamlined deposits on their floors, and empty into broad plains, sometimes with fan-shaped delta deposits at their mouths. In short, they look just like dry

Beginning in 1997, Mars Global Surveyor photos, showing features as small as a school bus, began to reveal hillside gullies eroded by water. The gullies in this crater originate at a specific layer and may have formed by release of groundwater to the Martian surface in geologically recent times.

riverbeds in Earth's desert areas. In some of them, the tributary drainage pattern is quite extensive. Others have only short tributaries and meander across the dusty plains as isolated channels. Still others originate in chaotic, box-canyon–like areas where the ground seems to have collapsed. They offer clues that underground ice may have melted, producing water that drained out of the area, causing the overlying rock and soil layers to collapse.

Now the scientific pendulum swung back. Mars once *had* been a planet with liquid water on its surface. True to its reputation after all, Mars gave us a host of exciting new mysteries. How could a frozen, desert planet once have had rivers? How long ago did the water flow? Where did the water go? Were earlier conditions more Earth-like? Could life have started there after all?

On a frosty Martian morning, July 20, 1976—seven years to the day after *Apollo 11* astronauts put the first human footprints on the moon, a parachute opened high in the sky over the dusty, boulder-strewn plain of Chryse. Braking rockets fired, and *Viking 1* bumped onto the Martian desert. It was the first human-built lander to reach Mars and send back data. *Viking 2* followed a few weeks later, landing on a similar, but more northerly plain called Utopia. The mission of these landers was to take the first surface photos, analyze the Martian soil, and look for life. The pictures showed beautiful but barren desert landscapes. The soils turned out to be sterile, with no organic molecules to an accuracy of a few parts per billions. A modest abundance of salts in the soils suggested that they might have been exposed to mineral-rich water, but no compelling evidence for life could be found. The soils did show come curious chemical reactions when exposed to nutrients, but chemists concluded that these reactions were caused not by life, but by unusual soil chemistry, caused by exposure of the soil to the sun's ultraviolet radiation. The harsh surface conditions and complete lack of organic material at both sites convinced most scientists that no life could exist anywhere on the planet. After the *Viking* landings, Mars seemed biologically dead.

Still, there was the nagging question of the role of water, and whether early Mars might have been more hospitable. Earth's abundant water has always seemed to be a key to the origin of life on our planet. Life formed in the oceans. If early Mars had rivers,

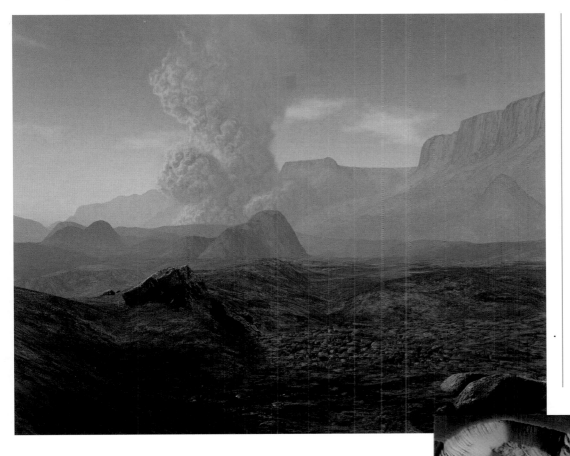

Opposite page:
*T*he meandering course and small central gully in this Martian riverbed suggest that it was formed by water that flowed for some considerable length of time, possibly in multiple episodes.

Landslides of Mars

Left:

A distant landslide collapse of a cliff face raises a plume of dust above the floor of Valles Marineris

Below:

*A*n orbital photo shows three scalloped alcoves in the wall of Valles Marineris, formed when sections of the cliff gave way. From the top of the wall to the valley floor is about 2 kilometers (6,500 feet). Hummocky terrain below is debris that slumped off the cliff and flowed into the valley.

did it have oceans? The history of water thus became the biggest issue in Martian research. By the 1980s, researchers realized Martian water is hidden in three places: frozen water in the north and south polar caps, water bound molecule-by-molecule in mineral crystals, and massive amounts of water frozen underground, as in Earth's arctic tundra. In 1997, NASA's *Mars Pathfinder* mission landed at the mouth of a large river channel called Ares Vallis and photographed a landscape like that at the two *Viking* sites—a rolling plain covered by gravelly soils, boulders, and sand dunes. *Pathfinder* sent out a small rover named *Sojourner* to study nearby rocks,

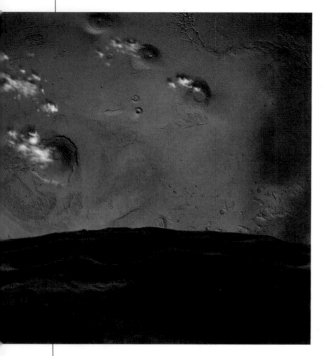

Above:

*M*ars seen from its nearest moon, Phobos, fills the sky of the tiny moonlet. Drifting past our view only about 6000 kilometers below are the giant volcanoes of the Tharsis Ridge, including cloud-flecked Olympus Mons (left), the largest volcano in the solar system.

Right:

*E*vidence from the Opportunity Mars rover suggests that the area in which it landed was once the bed of a shallow sea which may have looked like this 3,000 MY ago.

in hopes of finding evidence of sediments transported from upstream hills. The rocks turned out to be igneous and volcanic rocks, not waterborne sediments, but *Pathfinder* did return pictures suggesting that some of the rocks had been tumbled into place by surging river currents.

Photos from *Pathfinder* confirmed another Martian quirk that had first been suggested from *Viking* orbiter photos: On the horizon, on different days, *Pathfinder*'s cameras sighted swirling dust devils—typhoonlike whirlwinds of dust familiar from terrestrial deserts. It's the dust devils, as well as larger dust storms, that kick ochre-weathered Martian dust into the air, making the Martian sky pinkish-tan in color.

Meanwhile, in the 1980s and 1990s, clues about Martian water had accumulated from another source. Studies of impact craters on Martian plains showed that as they formed by impact explosions, the deeper ones ejected not dry dust and rocks (as on the moon), but a muddy slurry. The depths of the craters gave a clue to the depth of the ice, indicating the top of the ice layer is perhaps 400 meters (400 yards) deep around the equator and 100 to 300 meters at midlatitudes. NASA's *Mars Odyssey,* an orbiter that arrived in 2001, confirmed the existence of abundant underground ice within a few feet of the surface, at high latitudes around 65 degrees north and south. Researchers hope that a radar instrument on Europe's *Mars Express* orbiter, orbiting Mars as of 2004–5, will be able to map the underground ice in more detail.

The underground ice accounts for many of the river channels. If volcanic lava ascends through underground ice, it will melt ice. More subtly, if geothermal heating creates "Martian Yellowstone Parks" and raises the underground temperature even a few tens of degrees, it will melt some of the ice. This may explain jumbled box canyons called *chaotic terrain,* which seem to have produced some of the water flow.

A second process of channel formation, called *groundwater sapping,* is known in arid regions of Earth. If a cliff exposes an underground moist layer or ice layer, the water

can *sublime*, causing the cliff face to cave in and eat its way back into the hillside by successive collapses. An initial river channel can thus develop short, stubby "tributary" side valleys. This type of channel can grow "backwards" from its mouth through the plateau country.

A third, provocative type of channel system has fine "dendritic" networks of tributary systems running down out of hilly country. The valley network pattern led some researchers to propose a third source of water: There must have been rainfall or snowfall in these locations, in order to disperse water over broad regions to create the fillagree of runoff tributaries. The paradox is that rainfall or snowfall at those modest latitudes seems impossible today. The exciting implication, then, is that during some earlier period or periods of its history, Mars was more Earth-like and may even have seen rain and snow at midlatitudes.

Atop Olympus Mons

Below:

Orbital photo of the summit caldera of Olympus Mons. The upper crater is 25 kilometers (16 miles) across, bound by sloping cliffs 2.8 kilometers (9,000 feet) high.

Below left:

A young cinder cone (dark hill) nestling within the enormous caldera of a Martian volcano was built by renewed eruptions. Data from Europe's Mars Express orbiter suggests this may have happened within the last few tens of million years. Do the faint wisps of vapor in the cinder cone's crater suggest that there is still active volcanism on Mars even today?

Many researchers think new eruptions are still possible.

Martian Landscapes

Right:

Panorama from the first successful Martian lander, Viking 1, in 1976, showed beautiful dunes and scattered rocks.

Middle:

The Opportunity rover in 2004 climbed onto the rim of an impact crater, where a panoramic view revealed broken, platey sedimentary rocks on the rim and a patch of sand dunes deposited on the crater floor.

Bottom:

The Spirit rover in 2004 crossed the boulder-strewn floor of Gusev crater (right) to reach hills of sedimentary rock (left).

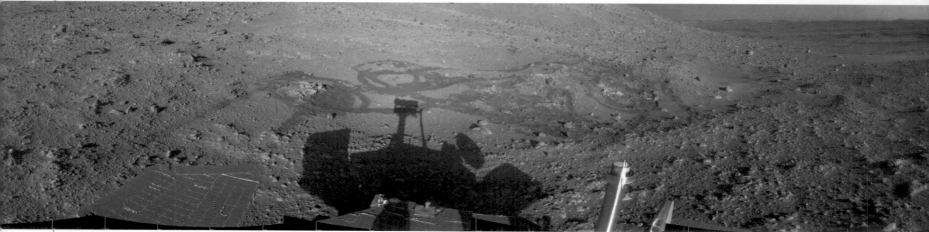

Above:

O pportunity *rover's photo of sedimentary rock layers in a wall of the stadium-sized Endurance crater support the theory of ancient water-laid deposits on Mars.*

The Mysteries of Martian Water

The problem in explaining the Martian riverbeds is that liquid water is not very stable on present-day Mars. How can liquid water be maintained in them, once they start to flow? The present day Martian climate is sub-freezing most of the time and has an air pressure that ranges from only 3 millibars in the high areas to as much as 10-15 millibars in the lowlands—compared to Earth's value of 1,000 millibars at sea level. Because of this extremely thin air, we'd need spacesuits on Mars. Six millibars is a magic number: In higher Martian regions with pressure below 6 millibars, liquid water spontaneously bubbles away. In lower areas, such as canyon bottoms, water would be more stable but would evaporate very fast. So it's hard for water to flow very far, since it is trying to freeze and dissipate at the same time. Paradoxically, a Martian river could extend its erosive lifetime by forming a frozen ice layer on the surface, shielding the water underneath from rapid evaporation.

Salty water would also help. Sufficiently salty brines can stay fluid down to 40 centigrade degrees below freezing (about -40°F, by coincidence). And there is abundant evidence from Martian rocks and soil that water on Mars was salty, similar to terrestrial ocean water in some measured cases. Salty water is likely on Mars, because when water runs across soils or percolates through them, it dissolves salts and other minerals.

Putting the various lines of evidence together, many researchers have begun to suspect that most Martian rivers formed in some era, long ago, when the Martian air was thicker and climatic conditions were different from those of today. Some have even suggested that during that time, the river flow was so abundant that lake accumulated inside craters and the northern lowlands of Mars were filled with seas or oceans.

An exciting step came in 2004 when the *Spirit* and *Opportunity* rovers landed at two sites where researchers had already deduced that water ponded in ancient times. Both confirmed, from chemical soil analyses, that water had been present. The big news was from the *Opportunity* site, a flat lakebed-like area where an unusual deposit of the iron-oxide mineral,

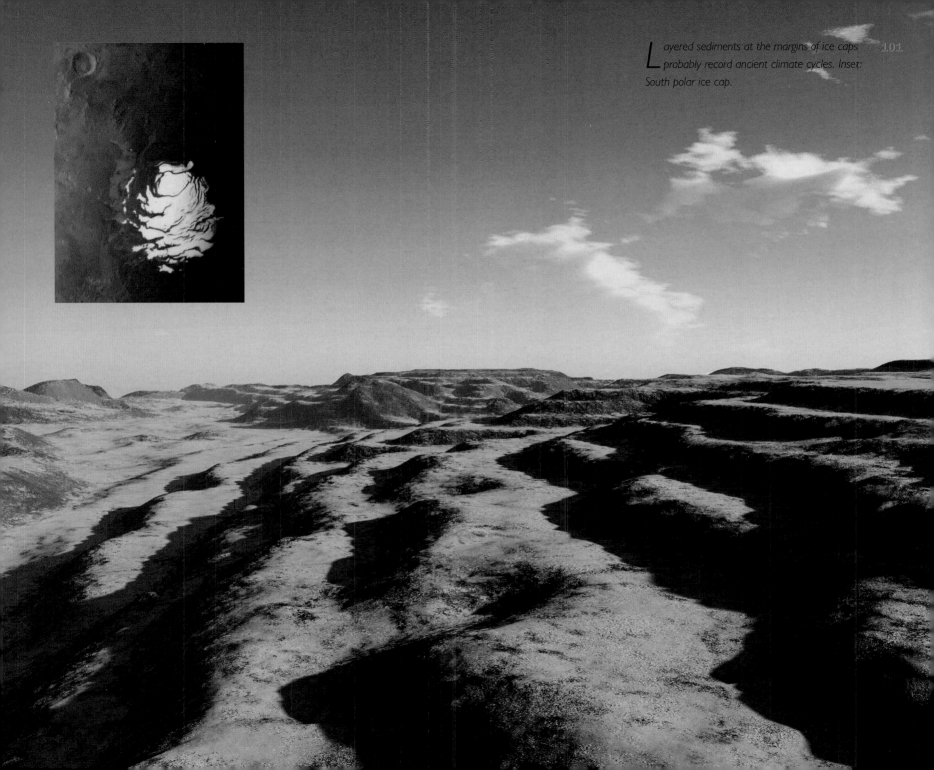

Layered sediments at the margins of ice caps probably record ancient climate cycles. Inset: South polar ice cap.

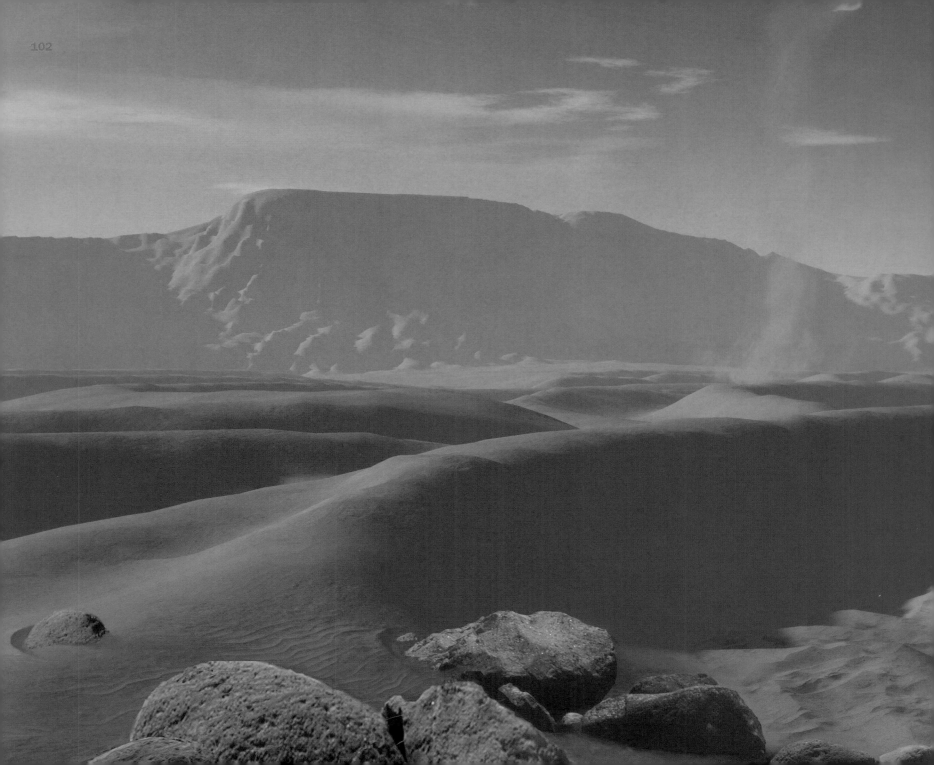

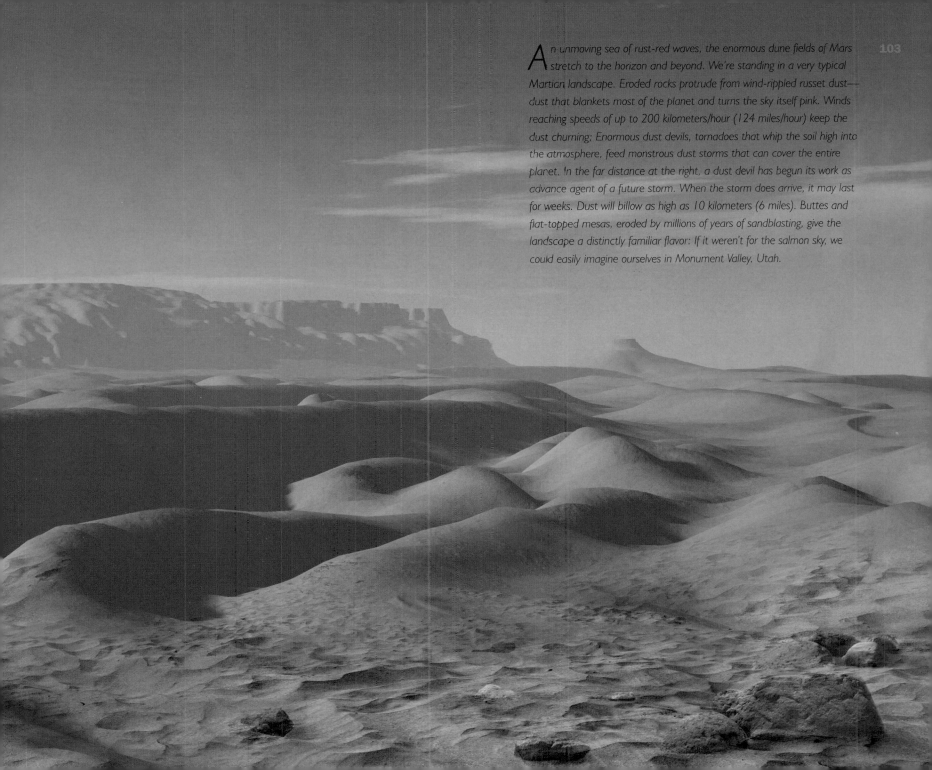

An unmoving sea of rust-red waves, the enormous dune fields of Mars
stretch to the horizon and beyond. We're standing in a very typical
Martian landscape. Eroded rocks protrude from wind-rippled russet dust—
dust that blankets most of the planet and turns the sky itself pink. Winds
reaching speeds of up to 200 kilometers/hour (124 miles/hour) keep the
dust churning; Enormous dust devils, tornadoes that whip the soil high into
the atmosphere, feed monstrous dust storms that can cover the entire
planet. In the far distance at the right, a dust devil has begun its work as
advance agent of a future storm. When the storm does arrive, it may last
for weeks. Dust will billow as high as 10 kilometers (6 miles). Buttes and
flat-topped mesas, eroded by millions of years of sandblasting, give the
landscape a distinctly familiar flavor: If it weren't for the salmon sky, we
could easily imagine ourselves in Monument Valley, Utah.

hematite (often formed in association with geothermally heated water), had already been found. *Opportunity* instruments found that porous rocks at that site were full of sulfates—indicating they had once been soaked in mineral-rich, briny water. The rocks might have formed on a lakebed, or might have been underground when briny water percolated through them. The water itself at this site might have come when a wave of geothermal heat melted underground ice deposits, or, as some climate modelers have proposed, it might have condensed out of water vapor in the air under ancient climate conditions—a local frost deposit that melted in the afternoon sun. *Spirit* found volcanic rocks on the plain where it landed, but in nearby hills it found thinly layered, sulfate-rich sedimentary rocks similar to those at the *Opportunity* site. The rover results seemed to prove that Mars indeed once had standing water and flowing water.

How long ago were the Martian rivers flowing and the lakebeds filled with water? How long did the water last? The number of impact craters on any planetary surface gives an indication of the age of that surface—the older the surface, the more impacts it has accumulated. Crater counts indicate that most river channel floors were last eroded by water about 2,000 to 3,000 MY ago—in the first third or half of Martian time. Thus, Mars may have evolved in much the way Lowell suggested—slowly losing air and drying out. Various lines of chemical evidence from Mars confirm that the early atmosphere was thicker.

At the same time, at least one of the Martian river channel systems, named Marte Vallis, is eroded into unusually young lava plains. Crater counts by a group at Tucson's Planetary Science Institute and an independent group at the University of Arizona, suggest that this river system formed within the last 100 MY, possibly within the last 10 MY—certainly within the last few percent of Martian history. The mixing of lava and water flow in that case probably confirms the idea that lava, ascending

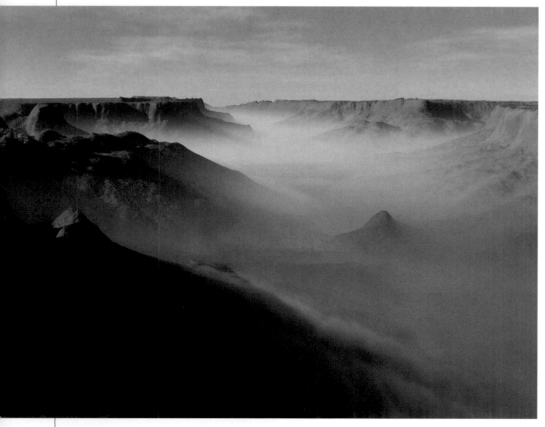

*M*orning and evening fogs are not uncommon in Martian canyonlands.

through underground ice, and produce floods as well as lava.

Tilt Versus Climate

So we have a planet that has been geologically active in very recent geologic time, has produced floods of lava and water, and is generally more intriguing than was thought after *Viking*.

But wait! There's more!

Research in 2000–2004 has revealed that not only the geology, but also the Martian climatic environment is dynamically active and changeable. Mars today has an axial tilt of 25°, very close to the 23.5° value that causes our seasons. (This tilt is measured relative to the orbital plane of the planet). For some years, it has been recognized that while Earth's tilt remains constant due to certain forces exerted by our moon, Mars's tilt wanders all over the place, from 0° to values above 50°, on a geologically "short" timescale of about 10 MY. A French team in 2004 calculated the values further back and found values as high as 81°, with the most common value being about 46°. That raises the stunning realization that the Mars we see today is not the "normal" Mars that has existed in the past. In the past, when the polar axis tipped the polar ice caps more than 40 to 50° toward the sun, sunlight on the summer pole would be so intense that it would "burn off" all the ice, thickening the atmosphere somewhat with CO_2, strongly increasing water vapor, and causing deposition of frost and ice at low latitudes. Snow may have been much more common. Spring thaws may have led to more water runoff than anyone believed possible a few years ago.

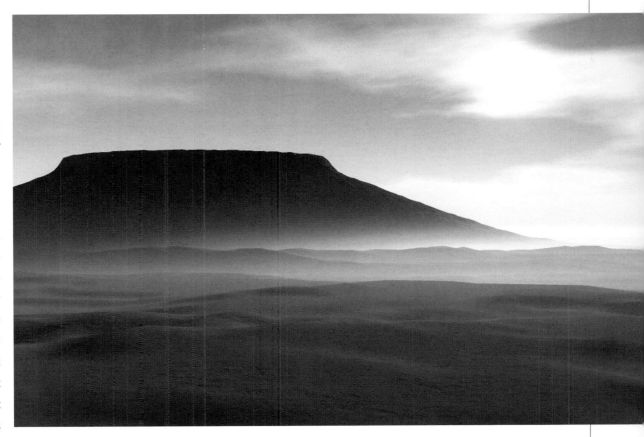

A Martian mesa silhouetted against the afternoon sun. Winds kick up a ground haze of sand and dust particles.

Life on Mars

This climatic surprise combines with a biological surprise from Earth, which changes our perspective on the possibility of Martian life. Ever since the *Viking* landings, scientists have recognized that if we are going to try to find out if life ever started on ancient Mars, we will not be talking about advanced life forms. Life started as single-celled organisms on our home planet, as we saw in our chapter on Earth, and evolved to more complex forms. Even today, underground bacterial life forms add up to more total mass of living material than all the humans, elephants, birds, whales, redwood trees, grass, and other life forms on the surface! On Earth, even areas that look sterile on the surface, like the extremely dry Atacama desert of Chile, or frozen dry valleys in Antarctica, have been found to have colonies of bacteria thriving underground in fractures and pore spaces inside rocks! The recent surprise from Earth is evidence that some bacteria can go dormant for long periods of time and then resuscitate upon exposure to water. One study reported bacteria locked in 250 MY-old salt crystals, which "woke up" when exposed to water. (Other scholars claim that while bacteria can go dormant, none of them could last that long underground because of radiation from natural radioactivity of rock and soil minerals.) If bacteria can go dormant on Earth, why not on Mars? Could microbes have evolved there to survive from one thaw to another?

The door has been thrown wide open to the question of whether life might have started on our next-door planet. And it is a perfect scientific question, because either answer is so profound. If we discover that life did start on Mars—even if it is only microbial life and even if it became extinct in the early days of Martian history—that would be the first time we know life can start on other worlds. For the first time we would know we're not alone in the universe. On the other hand, if we search every nook and cranny on Mars and conclude that life never started there—in spite of all the early water—then maybe we are more alone in the universe than we ever imagined. Maybe something is wrong with our understanding of the origins of life. Either way it will be a profound development in human history. It will help us to understand better our role in the cosmos, and it is that enterprise—not having a bigger car, a bigger bank account, or a bigger bomb—that makes us most fully human.

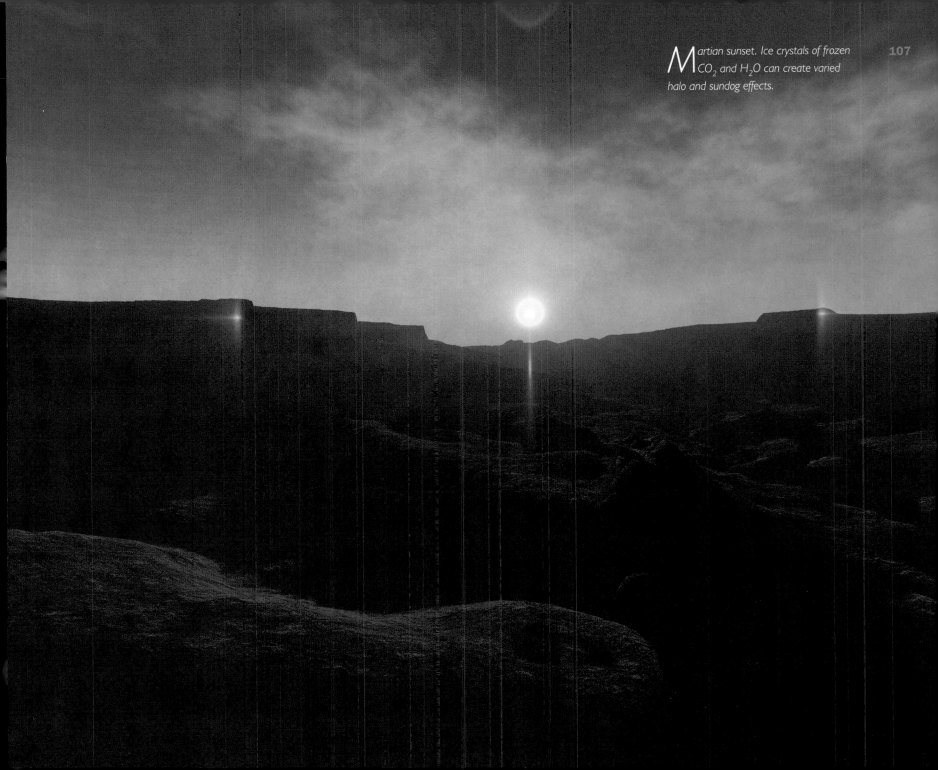

Martian sunset. Ice crystals of frozen CO_2 and H_2O can create varied halo and sundog effects.

Ganymede
A New Wrinkle

Satellite of Jupiter

Distance from Jupiter: *1,070,400 km*

Revolution: *7 days 3 hours*

Diameter: *5,280 km*

Composition:
ice, carbonaceous silicates

A Voyager 1 *photo in 1979 revealed Ganymede as a mottled moon with bright icy regions and older dark, fractured regions. The dark oval at lower left was named Nicholson Regio after an astronomer who studied Jupiter's moons.*

Ganymede, the largest satellite of Jupiter, is also the largest moon in the entire solar system. In fact, it is the solar system's eighth-largest world, with a diameter exceeding those of the planets Mercury and Pluto. Not all worlds are full-fledged planets!

Like most major moons (including ours), Ganymede keeps one face pointing toward its "parent" planet, as if transfixed. Such moons are said to be *synchronous* (because their revolution around the planet is synchronized with their daily rotational spin). Thus, even though the sun rises and sets on Ganymede, Jupiter remains at a fixed point in the sky on the planet-facing side.

Even the largest telescopes on Earth reveal Ganymede as a pinhead with vague markings. These cryptic shadings tantalized generations of astronomers until the age of spacecraft exploration; in 1979, *Voyagers 1* and *2* first revealed the geology of an ice-dominated world. As on most such worlds in the outer solar system, ice and water, respectively, play the roles of rock and lava on Earth. Much

of the surface is ice, impregnated with dark-colored, carbon-rich soil. When internal heat melts the ice, a "magma" of watery material may erupt and freeze, making a fresh surface of bright ice.

One of the best clues about the nature of Ganymede comes from its mean density (its total mass divided by total volume): It is higher than the density of pure ice but lower than that of most rock types. This indicates that the interior is also a mixture of ice and rock. Most of the rock has probably sunk through the ice to form a rocky core surrounded by an ice mantle.

Remember our rule of thumb: Larger worlds are geologically more active; small worlds cool faster and have less internal heat to drive geologic activity. Many scientists had expected that modest-sized, icy Ganymede would show only an ancient, static surface crowded with impact craters from the early days of the solar system. But Ganymede was only the first of many outer-solar-system worlds to surprise the first generation of space explorers. True, like Earth's moon, it has broad regions of ancient craters, but these are broken by swaths of younger furrows—seemingly youthful flows and ice squeeze-ups.

The older, cratered terrain is dark, as if the ice component has been vaporized by countless meteorites, leaving soil behind. Stretching hundreds of kilometers across the ancient cratered

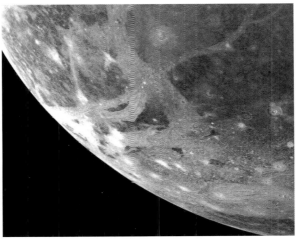

Two close-up views of piebald Ganymede taken by Voyager 2. Both show contrasts between the old dark, heavily cratered terrain, and the light younger, fissured terrain, which appears to be regions of younger, cleaner ice. Recent craters are also surrounded by halos of bright, fresh ice.

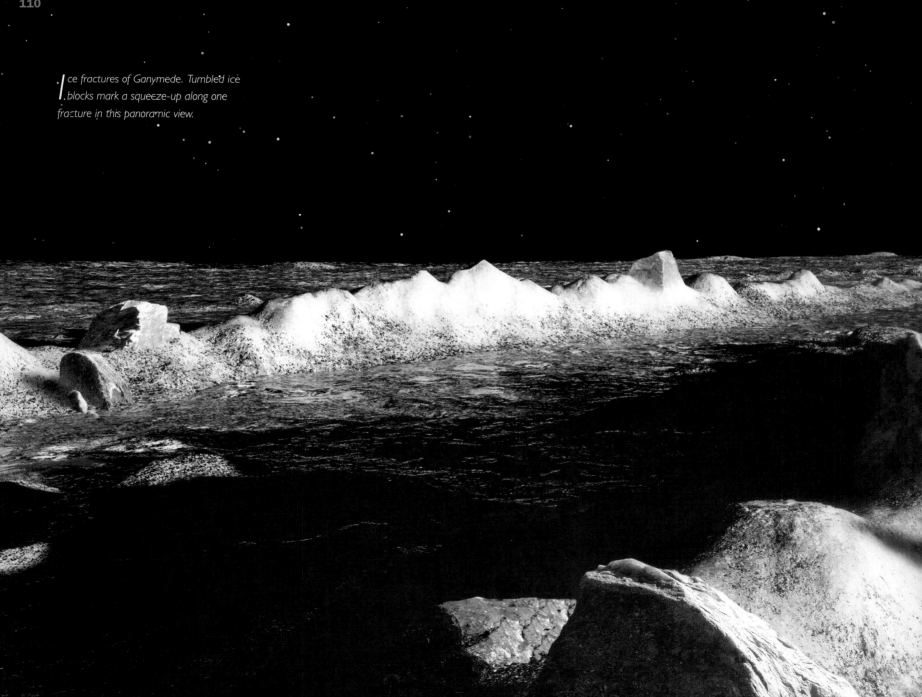

Ice fractures of Ganymede. Tumbled ice blocks mark a squeeze-up along one fracture in this panoramic view.

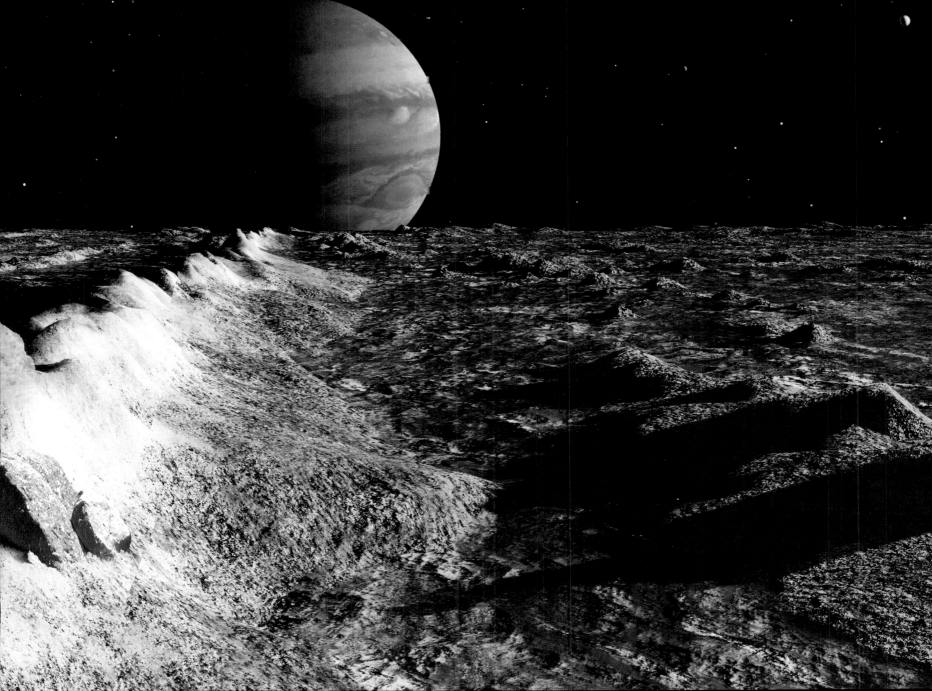

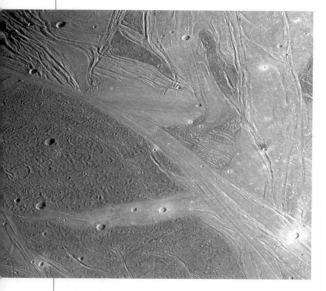

As Ganymede's icy crust (seen here from two angles) shifts and splits apart, water wells up and forms fresh, light-toned swaths of surface. Gradually, the terrain becomes a mixture of old and new features.

areas are giant arcs of parallel furrows a few kilometers wide. These seem to be remnants of giant, ancient impact craters called *multiring basins*. The largest impacts produce not simple craters, but multiple, concentric rings of cliffs, hundreds of kilometers across. They are giant fracture patterns, suggestive of eerie bull's-eye targets inscribed on the sides of worlds by the gods of old. More complete multiring systems have been found on Mercury, our moon, and Ganymede's neighboring moon, Callisto. Strangely, those on Ganymede have been broken and perhaps even shifted in position by the puzzling resurfacing processes.

A Giant Jigsaw Puzzle

Ganymede's surface resembles a giant jigsaw puzzle, in which some pieces have been replaced with newer, brighter material. Most of the original picture is preserved, but a few parts have been replaced by swaths of fresher ice. The newer regions are lighter, wandering in wide bands among the darker polygonal cratered areas. The lighter regions are traversed by intricate systems of narrow fissures, usually arranged in parallel streaks, here and there broken by craters.

Analysts suggest that the original dark crust broke apart due to internal heating and expansion, allowing Ganymede's equivalent of lava—erupting water—to flow out onto the surface

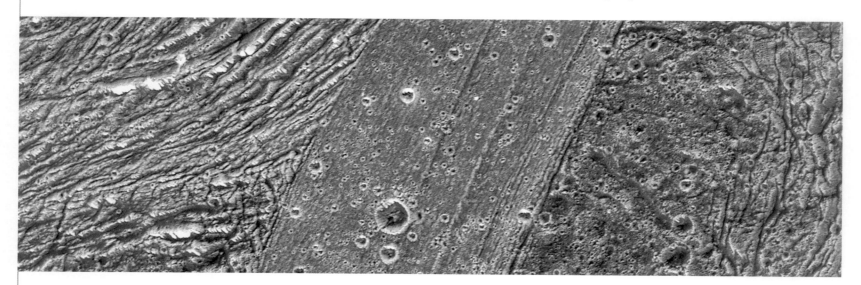

and freeze into ice floes. Subsequent eruptions along the fissures squeezed out new parallel ridges of ice. The same phenomenon also occurs in our Arctic ice floes.

Ganymede may well be showing us an incipient process of plate tectonics, thus adding to our understanding of Earth. On Earth the lithosphere—or solid rock layer—long ago broke into plates that ride on a partly molten lower layer. Dynamic currents in this lower layer, driven by Earth's internal heat, drag the surface plates, causing collisions and throwing up mountain ranges. On Ganymede, the process is not as dynamic. Ganymede's interior may be warm, but it is not as hot as Earth's. The ice "lithosphere" at the surface may have broken into "plates," but the plates have only jostled one another. Little pieces here and there seem to have moved tens of kilometers, offsetting craters and faults, but there have been no large-scale motions or collisions and no folded mountain ranges like the ones found on Earth.

In 1995, the *Galileo* probe went into orbit around Jupiter and began a multi-year tour among the various moons. In May, 2000, for example, it passed only 809 kilometers (502 miles) above the surface of Ganymede, taking high-resolution photos and refining our knowl-edge of the gravitational and magnetic fields in Ganymede's vicinity—which in turn reveal secrets of that moon's interior. One exciting result, announced in 2001, confirms that the icy crust may drift atop a more fluid layer—a buried ocean of liquid water, beginning at a depth estimated at 170 kilometers (106 miles) below the icy surface. This "buried ocean" may be hundreds of kilometers deep and bounded at its base by icy and rocky layers. A related result was the detection (by *Galileo*'s spectrometer) of salts such as magnesium sulfate on Ganymede's surface, suggesting that the waters erupting from the interior were salty due to dissolved minerals, as in Earth's oceans.

Swaths of bright, clean, fresh ice cut through older, more cratered terrain, and careful mapping revealed that the swaths lie about 500 to 1,000 meters (547 to 1,094 yards) lower in elevation than the cratered uplands. All these findings support the idea that the older, icy crust

A series of scarps in the Nicholson Regio of Ganymede take the form of enormous steps. They are part of a bulls-eye pattern of fractures, probably associated with a giant, ancient impact.

is occasionally split and shifted by currents in its deep watery underpinnings, allowing fresh, mineral-rich water to erupt, fill in the rifts, and freeze to form bright fresh ice surfaces.

A Hot Discovery

By 1996, the *Galileo* spacecraft revealed another surprise about Ganymede. The moon, which once had been visualized as a ball of inert ice, has a magnetic field of its own. Normally, planetary scientists consider such a discovery to be proof of a hot interior with a partially molten iron core, in which electric currents circulate and create a magnetic field. The primary interpretation is that Ganymede does indeed have a hot interior, with a metallic core and rocky mantle, overlain by the hundreds of kilometers of ice and the buried ocean. Some researchers have alternately suggested that the electric currents creating the field arise not in an iron core, but in the salty waters of the buried ocean, closer to the surface. In either case, the observations suggest that Ganymede has unexpectedly participated in a process called *tidal heating,* in which gravitational forces, associated with Jupiter and its other nearby moons, slightly deform Ganymede and heat its interior. This process will be clearer when we encounter its most dramatic result—the violent surface of Jupiter's third-largest moon, Io.

Ganymede has other interesting features. Whitish polar caps, seemingly thin water frost deposits, extend down to latitudes around 40 degrees. The caps may mark condensation of water vapor escaping from fractures around the planet.

Most fresh craters have bright radiating rays of ejecta blown out onto the surrounding surface. These craters have probably blown away the darkish surface soil, exposing fresher ice. But occasional small craters, typically 10 to 20 kilometers (6 to 12 miles) across and a few kilometers deep, have dark rays. They probably reflect a layered structure beneath Ganymede's surface. If surface layers ever melted or if "volcanic water" gushed out carrying soil with it, the soil would sink before the resulting oceans froze. Thus, craters penetrating to a few kilometers may tap layers of blackish soil. Ganymede's surface may contain intricate sedimentary layers of ice and rock.

In summary, Ganymede, a moon bigger than Mercury, introduces us to the idea that "mere moons" can be geologically complex worlds in their own right, with active interiors and rich, fascinating surfaces.

Opposite page:

A climb up a long slope, ice crunching underfoot, has brought us to the top of one of a series of curved ridges that wrinkle the surface of Ganymede like a washboard. It's about 10 kilometers (6 miles) to the next ridge, and about 100 meters (300 feet) to the bottom of the valley below us.

Jupiter sits 890,000 kilometers (551,800 miles) away, the Great Red Spot about to rotate onto the night side.

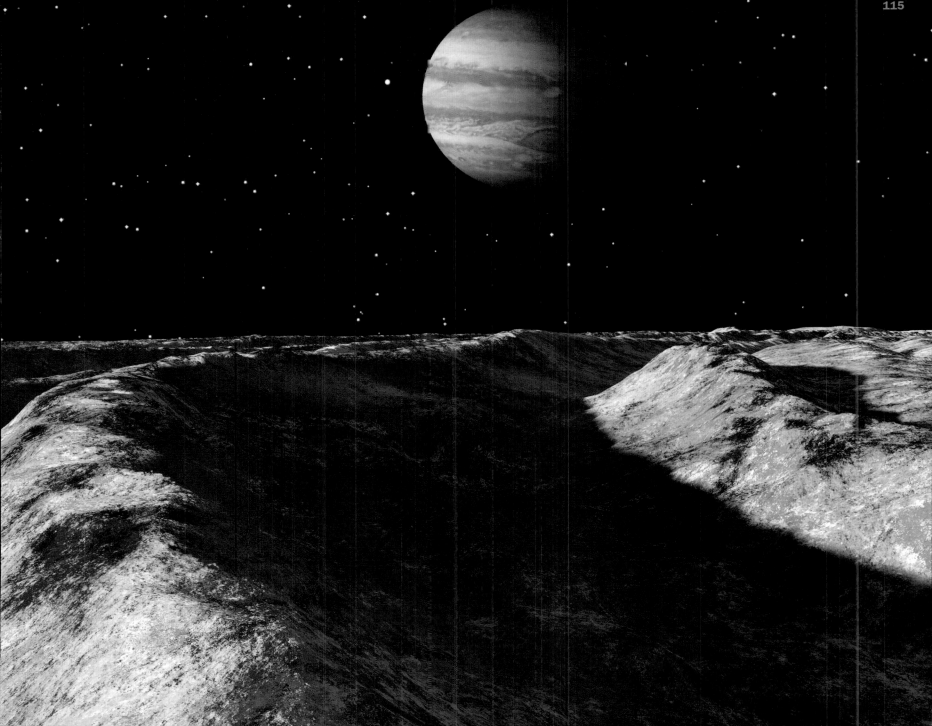

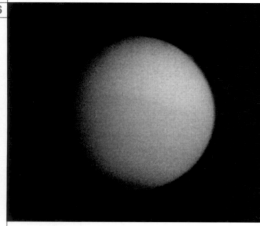

Titan
The Masked Moon

Satellite of Saturn

Distance from Saturn: *1,222,000 km*

Revolution: *16 days*

Diameter: *5,140 km*

Composition:
Organics, nitrogen atmosphere

Changing Concepts of Titan

Opposite page inset:

This view of Saturn seen from Titan was envisaged in 1944 by the pioneer space artist Chesley Bonestell, soon after Titan's atmosphere was discovered. It influenced a generation of space artists and astronomers.

Opposite page:

The blue sky envisioned by Bonestell and early astronomers "disappeared" when orange, smoggy clouds were discovered in the 1980s. The relatively young appearance of the surface as suggested by the Huygens lander in 2005 hint at some processes that may be constantly renewing the surface. The liquid hydrocarbons flowing from the geyser's vent will eventually join the shallow sea, glimmering in the distance.

In 1944 the Dutch-American astronomer G. P. Kuiper wrote a paper called "Titan: A Satellite with an Atmosphere." The title was surprising because, until that time, all satellites had been assumed to be desolate, airless worlds something like our own moon. But Kuiper's spectrographic observations showed strong absorptions of certain colors due to methane gas on Titan. Titan has an atmosphere!

Artists such as Chesley Bonestell quickly recognized the potential beauty of Titan: A clear gaseous atmosphere of methane would scatter sunlight with a sky-blue color similar to that of Earth. In the late 1940s, Bonestell produced stunning paintings of a yellowish-tan Saturn hanging in the beautiful blue sky of Titan over rugged mountains and white snowfields. Unfortunately, observations in the early 1970s revealed that the light we see from Titan is reflecting off clouds or a thick layer of haze. This means, to the dismay of space artists, that Titan's surface probably is completely obscured by clouds, making Saturn invisible to an observer standing on Titan . . . and making the scene in Bonestell's painting impossible.

Meanwhile, astronomers debated the composition of Titan's atmosphere. In some models, methane was the major constituent and the atmosphere was very thin. Other models suggested that nitrogen, probably released from Titan's interior, might form a major portion of the atmosphere. Chemical models suggested that compounds formed from the reaction of these materials would give the clouds their observed orange-red color. Some theorists pointed out that very large amounts of nitrogen might be present in Titan's atmosphere without being observable from Earth. Instead of a wispy, thin atmosphere, Titan might have an atmosphere as dense as Earth's.

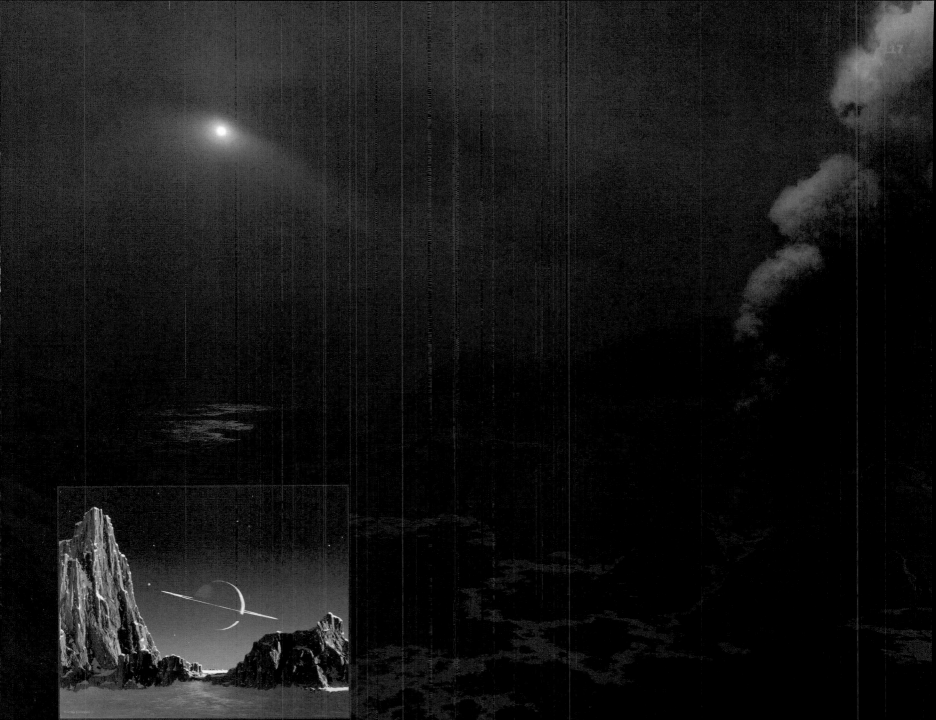

*T*his Voyager image of Titan shows two thin haze layers. The upper haze layer appears to float high in the atmosphere, is thought to begin at altitudes above 400 kilometers (250 miles), where ultraviolet light breaks down methane and nitrogen molecules. The products are believed to react to form more complex organic molecules containing carbon, hydrogen, and nitrogen that can combine to form the very small particles seen as haze. The bottom of the detached haze layer is a few hundred kilometers above the surface; the lower hazy atmosphere scatters blue light, as does our own atmosphere.

Right:

*H*ints of surface detail on Titan are visible through the clouds in this near-infrared photo taken by the Cassini spacecraft in 2004. Streaky patterns may be due to tectonic features or haze. White spots near the south pole are distinct clouds.

★ Some of the more musically inclined scientists and journalists attending the Voyager encounter activities at the Jet Propulsion Laboratory in Pasadena promptly formed a musical group, named the Titan Equatorial Band.

In 1980, *Voyager 1* flew through Saturn's system of satellites for a flyby of Titan. Scientists hoped that its cameras would not only photograph the clouds but also penetrate the haze and reveal the nature of surface features. Would they see a cratered landscape with little geologic activity, or a terrifically active landscape with geysers of water erupting through clouds of methane and steam?

"Titan's Earthly Secret"

*T*he *Voyager* cameras revealed a world disappointing in terms of atmospheric clarity, but terribly exciting as an example of planetary evolution. Titan appeared as an orange ball with no surface features visible and with only a few mottlings in the atmospheric cloud layer. A dark-toned polar cap was visible, long with faint bands or contrast shadings running parallel to Titan's equator.★ *Voyager* instruments strongly confirmed the thick atmosphere. The spectra indicated that nitrogen is much more prevalent than methane. *Voyager* instruments measured pressures at Titan's surface of roughly 1.6 times the air pressure at sea level on Earth. The amazing "bottom line" is that modest-sized Titan, orbiting Saturn in the cold depths of the outer solar system, has a nitrogen-dominated atmosphere that, more than any other world's, is like Earth's!

Many scientists had hoped that if the air of Titan turned out to be that thick, it might pro-duce a warming or blanketing effect similar to the greenhouse effect on Venus and Earth. If this were true, Titan might be considerably warmer than predicted, considering its distance from the sun. However, preliminary measurements from *Voyager* instruments suggest that most of Titan's atmosphere is very cold, with typical surface temperatures around -180°C (-292°F).

Voyager instruments revealed not only methane and nitrogen, but other gases such as ethane, acetylene, ethylene, and hydrogen cyanide. *Voyager* scientist Don Hunten commented that ultraviolet radiation from

the sun "would work on the methane in the upper atmosphere of Titan to produce octane, which is, after all, the main component of gasoline . . . I can imagine it raining frozen gasoline on Titan." Indeed, chemical studies suggest that many of the heavier compounds formed by reactions in its atmosphere would precipitate onto Titan as rain, perhaps intermittently.

Deeper thought about such processes has led to the startling suggestion that the Titan of the past may have been different from the Titan of today. Methane is a greenhouse gas, and calculations by Arizona researcher Ralph Lorenz and colleagues in 1997 suggested that if the early methane rained out of the atmosphere quickly enough, it would reduce the greenhouse effect on Titan sufficiently to cool the atmosphere and surface, allowing nitrogen gas first to rain out into an ocean tens of meters deep, and eventually to freeze out onto the surface as a layer of nitrogen ice. In the words of Lorenz and his co-authors, Titan's atmosphere would have "collapsed," creating a near-airless, icy world more like Neptune's moon Triton (which we will visit later) than like today's Titan. Why, then, the present thick nitrogen atmosphere? Two different effects may have played a role. First, the sun has gradually increased in brightness. Second, as shown by experiment, irradiation of methane and nitrogen ice deposits would tend to darken them, causing more absorption of solar heat. The stronger sunlight and stronger warming would tend to sublime the nitrogen ice back into atmospheric gas. As with any pioneering calculation, this model may not be precise in its details, but it alerts us that Titan may have had radically different environments in its past, including a period with a very thin atmosphere.

In this view taken by the Cassini orbiter, we see Titan's backlit atmosphere illuminated in a ruddy crescent and ring by the distant sun.

Unmasking the Giant

Ever since the *Voyager* encounter in 1980, one question has dominated all speculation about Titan—what strange surface lies beneath the mask of haze? Researchers realized the answer could range from a global ocean of exotic fluids to a solid surface of icy compounds. On Titan's frigid surface, the temperature and pressure may be such that methane (CH_4) can exist either as gas, liquid, or solid ice (or snow)—just as water does on Earth. One *Voyager* scientist in the 1980s characterized the surface as probably being "a bizarre murky swamp [of] liquid nitrogen and hydrocarbon muck." Others proposed a global ocean of liquid hydrocarbons.

By the early 1990s' it became possible to bounce radar signals off Titan. These suggested primarily an icy surface, but they did detect regional variations that might mark lakes or swamps.

In the murky daylight of Titan, a river of methane flows into a lake of liquid hydrocarbons, itself covered by a floating scum of organic compounds. Everywhere we look, the surface is covered with a coating of these yellowish-red compounds, which have been raining down for millenia from the dense clouds overhead.

Would the light of the distant sun penetrate the haze? Titan is 9.5 times as far from the sun as Earth, meaning that even above the clouds, the sunlight would be only about 1.1 percent that of a clear day on Earth. French researchers in 1991 concluded that the light level on the ground, beneath the overcast sky, might resemble the gloom of a thick fog on daytime Earth.

Depending on their composition, some clouds that are opaque to the human eye can be penetrated by specific, selected wavelengths of infrared and visible radiation. Applying this idea in 1996, Arizona researcher Peter Smith photographed Titan with the Hubble Space Telescope at one of these wavelengths. Smith discovered that he could see through the haze well enough to discern vague, patchy surface features. This means the haze is not terribly thick, and also that the surface is not the same everywhere. By 2003, researchers utilized these special wavelengths to study the spectral, or color, properties of the surface, and concluded that the surface features are composed predominantly of water ice. This suggested that, in spite of the indications that an exotic rain or snow of hydrocarbons and organic compounds may wash over the surface from the atmosphere—and perhaps drain into rivers or ponds—a "bedrock" of familiar ice may cover much of the surface.

Curiously, a somewhat different result came later in 2003 from a very different technique. Using the giant radio telescope at Arecibo, in Puerto Rico, Cornell researcher Donald Campbell and his colleagues bounced radar signals off Titan and observed the reflected return signal. In most parts of the surface, instead of observing a diffuse reflection, as might come from a craggy ice surface, they saw a sharp glint off the center of the disk, similar to the reflection off an ocean or from smooth icy plains. A similar glint of sunlight reflecting off Earth's oceans can be seen in photos of our planet from space. A combination of this result with the previous result

suggests Titan's surface might be a mix of slushy water-ice and ponds of water or hydrocarbons, or a watery ocean clogged with icebergs, or perhaps even a vast expanse of smooth, shiny ice.

From Bonestell's ice crags under blue skies to later scientists' and artists' visions of smoggy swamps, Titan's murky landscape has continually provoked our imagination. Here is a world rich in organic molecules, with a nitrogen-dominated atmosphere reminiscent of Earth's. Could geothermal sites create warm ponds of water saturated with organic molecules—the sort of environment that produced life on Earth?

In 2004, questions began to be answered when the American/European *Cassini* Saturn orbiter studied Titan at close range. Its infrared cameras revealed intricate detail of unknown character on the surface. In a grand climax, *Cassini* released the European-built *Huygens* probe, which parachuted through the clouds of Titan and took pictures on the way down to the surface. After a surprisingly soft landing (possibly on porous material?), it sent back more surface data than expected. The aerial images showed clear examples of streambeds or drainage channels with branching tributaries, confirming fluids on the surface. Paucity of craters suggested active erosion

processes. Rounded rocks (instead of craggy rocks as seen on Venus and Mars) again suggested fluid erosion. *Huygens* team members were jubilant at unmasking Titan and planned many months' analysis of data about environment, organic chemistry, and possible seas.

Right:

T he Huygens *lander revealed what appear to be river channels and a coastline.*

Far right:

H uygens *found the surface of Titan to be covered with a thin icy crust. The "rocks" are pebble-sized chunks of ice.*

Mercury
Child of the Sun

Planet

Average distance from the sun:
57,900,000 km

Length of year: *88 days*

Length of day: *1,416 hours (59 days)*

Diameter: *4,880 km*

Surface gravity (Earth = 1): *0.38*

Composition: *nickel-iron, silicates*

Mercury, the tenth-largest world in the solar system, is the next-to-smallest planet and the closest of all to the sun. Only a bit smaller than Titan, it is radically different: Instead of a smog-shrouded world of ice and slush, Mercury is airless and sun-scorched.

Mercury's proximity to the sun means that it formed from only the minerals that could survive high temperatures. Here there were no ices, no minerals with low melting points. The dust from which Mercury aggregated consisted mostly of high-temperature minerals: metals and silicates. Supporting our conjectures is Mercury's average density, which is unusually high for such a small world. Taking into account central compression by the weight of overlying material, analysts calculate that Mercury has a metal core proportionately larger (i.e., larger not in absolute terms, but relative to its size) than the core of any other planet. Mercury probably melted due to heat released by radioactive minerals, and its iron and other metals drained downward to the core.

This melting must have taken place long ago. Mercury's scorched surface has since been battered by meteorites, comets, and asteroids; it is almost entirely covered by impact craters. Only a few small lava plains have survived the bombardment. Geologically, Mercury appears to have been dead for 3 or 4 billion years.

The sun's tides have locked Mercury's rotation into a very slow spin—one day requires two-thirds of its year. Its rotation, relative to the stars, takes 59 days, while its orbit around the sun takes 88 days, using the Earth-centric definition of "day." The combination of motions means

By stepping into the shadow of a boulder thrown onto the rim of a small crater, we can block out the glare of the sun itself, enabling us to see the delicate streamers of the solar corona, the sun's outer atmosphere. Jets of ionized gas ejected from the sun are molded by the sun's powerful magnetic field. The large faint glow across the sky is the zodiacal light—interplanetary dust lit by the sun. In the upper left are two "stars." The brighter one is Venus, and the other is Earth.

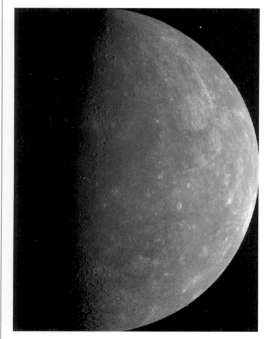

Above:

*M*ercury's rugged surface is moonlike and crowded with impact craters

Below and right:

*L*ight-colored rays, composed of fine, bright dust, spread from relatively new craters.

that the sun moves very slowly through the sky. On average, 176 Earth-days elapse between one sunrise and the next.

The sun's movement in Mercury's sky is not only slow, but also weird. Again, because of the combination of rotational and orbital properties, the sun moves at an irregular rate from one horizon to the other. A visitor, like legendary Joshua, would watch the sun come to a complete halt. It would appear to move backward for a time before continuing in its original direction, having performed a complete loop in the sky. At other positions on Mercury, you can see two sunrises and two sunsets each Mercury "day."

Fire and Ice

Mercury's closeness to the sun and its long afternoons make its surface very hot during the daytime, while the equally long nights get very cold. Afternoon soil temperatures can rise well above 227°C (441°F); at night, the temperature can drop to around -173°C (-279°F). The surface of Mercury closely resembles a sun-blasted, copper-colored version of our own moon. Dust is abundant, created not only by micrometeorite impacts but also from thermal erosion of rocks: Chips flake off as the rocks expand and contract from the extreme day-to-night temperature changes. As old rocks erode, new ones are blasted out by fresh meteorite impacts.

Mercury, unlike our moon, has no friendly blue globe to dominate its black, virtually airless skies. But it makes up for this with two unique sights. In Mercury's night sky, Venus and Earth often appear as brilliant stars—bright enough to cast faint shadows. The sharp-eyed may try to see if they can find our moon, a faint pinprick next to Earth. And, with the sun so very close, Mercury gets singular sunrises and sunsets. There is no atmosphere, so there are no reds and oranges, but the sun's *corona*, or outer atmosphere, extends well above the horizon

just before sunrise and after sunset. A dim glow extends outward from the pearly yellow corona, the faint band of *zodiacal light:* dust concentrated in the plane of the solar system and illuminated by the sun. It is sometimes visible from Earth as well.

Mercury's surface shows interesting distinctive features, including at least one huge multiringed impact basin, 1,300 kilometers (807 miles) in diameter, named Caloris Basin.

Cutting through Mercury's pocked surface like cracks in shattered glass are several enormous cliffs. Up to 500 kilometers (311 miles) or more in length and 2 to 4 kilometers (6,562 to 13,124 feet) high, they pierce mountains, valleys, and craters alike. They are the result of a crumpling of the landscape—a type of feature geologists call a thrust fault—that happened when the planet's surface was cooling and contracting. On one side of the cliff the land has been raised, while on the other side it has been lowered. You can see huge craters that have been split in two, one half rising 2 to 3 kilometers (6,562 to 9,843 feet) above the other.

The whole history of Mercury and its interior is something of an enigma. Scientists in the 1980s realized that the early solar system was a more violent place

Lower left:

A large impact crater on Mercury mimics impact craters on the moon.

Below:

Mariner *photographed one-half of Mercury's 1,300-kilometer (807 miles) Caloris Basin, the series of concentric mountains and ridges on the left side. It is the result of an impact by a moderate-sized asteroid.*

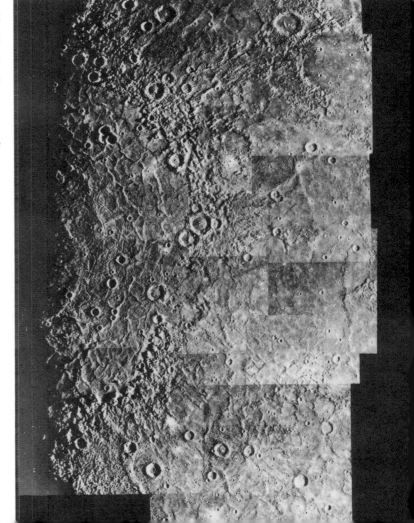

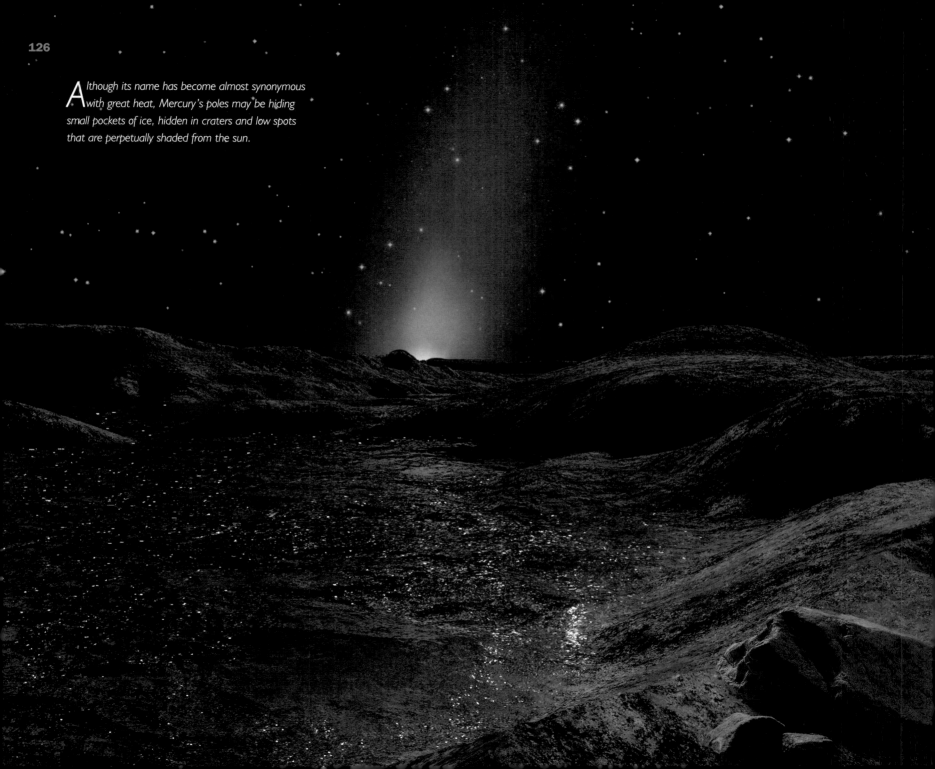

Although its name has become almost synonymous with great heat, Mercury's poles may be hiding small pockets of ice, hidden in craters and low spots that are perpetually shaded from the sun.

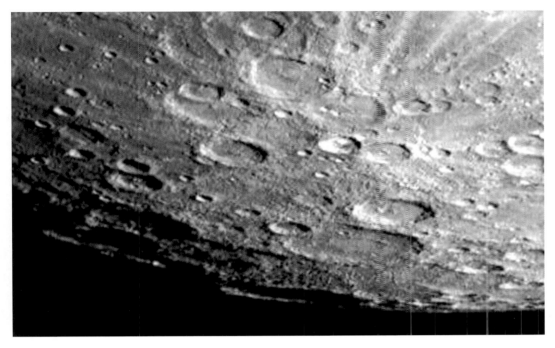

*T*he south polar region of Mercury as seen by
Mariner. The poles may have areas perpetually
shaded from the sun, in which ice may exist.

than they once thought. As planets grew, they underwent many collisions with asteroidlike
neighbors. One leading researcher suggested that the reason for Mercury's unusually high pro-
portion of metal is that a large asteroid blasted off much of its rocky mantle after its iron core
formed. Another suggested that Mercury may have formed in a somewhat different orbit, hav-
ing been deflected to its current location by near-miss encounters with larger planets.

Lastly, an amazing paradox of Mercury: This sun-blasted inferno may have polar ice caps!
Most scientists would have laughed at this idea in the 1980s, but in 1991 radar signals bounced
off Mercury indicated small areas of unusual radar reflection at the poles, explainable by ice.
The sun is so precisely aligned over Mercury's equator that it never shines into cracks or deep
crater floors at the pole. Thus soils in polar low spots are always in deep freeze. If a comet
impact, for example, produced local water vapor, the vapor could condense into ice in these
permanent cold spots. Frost fields of Mercury? In the solar system, there are many surprises!

What a paradox it is that, although Mercury spends much of its time less than one astro-
nomical unit away from us, we know less about it than we do about Jupiter and its satellites, which

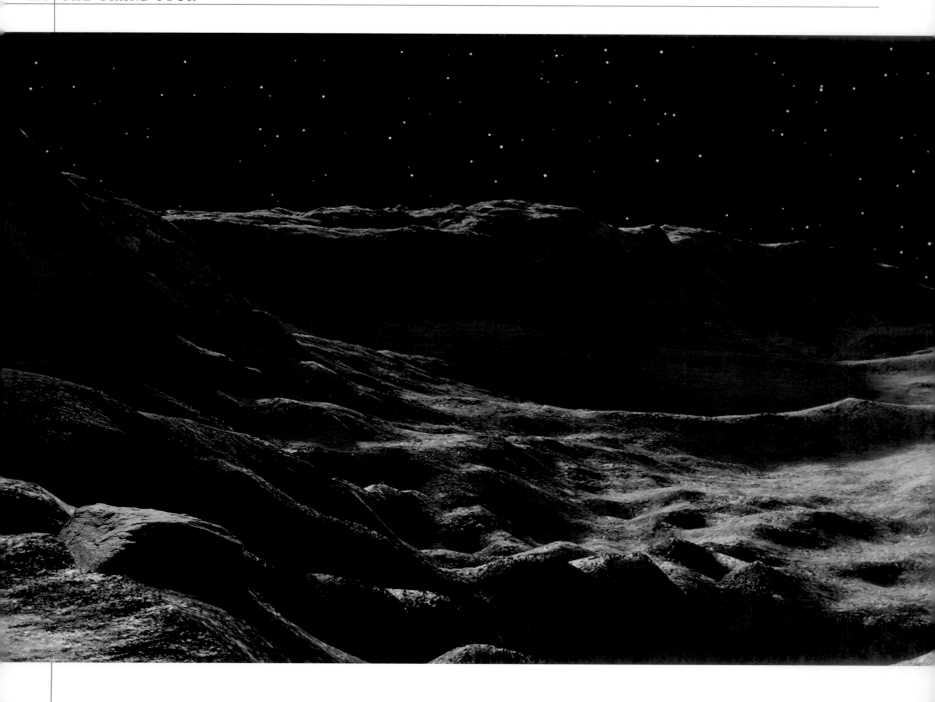

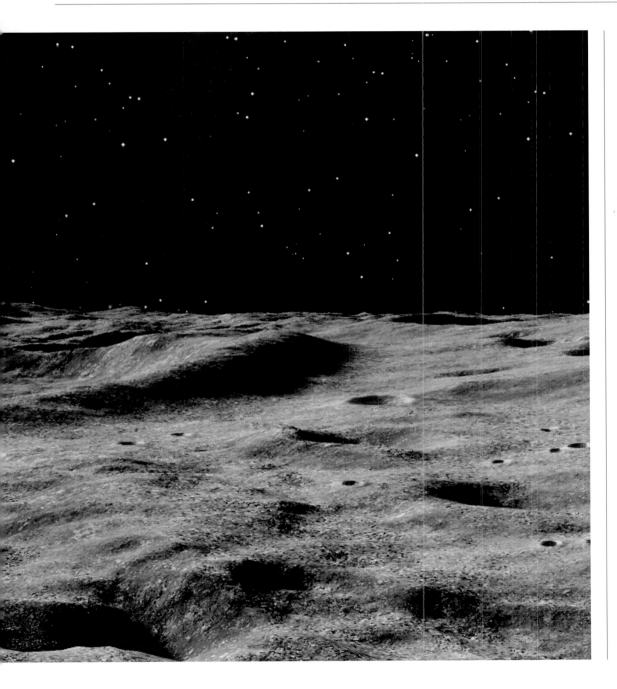

Above:

A cliff, or scarp, more than 300 kilometers (190 miles) long stretches diagonally across Mercury, splitting more than one crater in two.

Left:

From the ground, the fault scarp would appear as a long, nearly straight cliff, splitting craters and plains alike.

*T*wo brilliant "stars" illuminate the night landscape of Mercury. The brightest, on the left, is Venus. The other is the Earth (with its moon just barely visible to its right).

are never closer than about 4 AU away! To set this right, NASA researchers are proceeding with an ambitious new spacecraft mission, called *Mercury Messenger*. After its launch in 2004, it will sail past Earth in 2005, getting a gravitational deflection toward Mercury. It will have two passes by the planet Venus, in 2006 and 2007, followed by three flybys of Mercury—two in 2008 and one in 2009. The flybys alone should complete the crude, low-resolution mapping and give new data on surface composition of the still-unseen half of the planet, but they will also position the spacecraft for the climax of the mission: In 2011, it will go into a near-polar orbit around Mercury, and map the surface and composition in much greater detail, allowing final analysis of the apparent polar ice deposits and close-up study of the formidable Caloris impact basin.

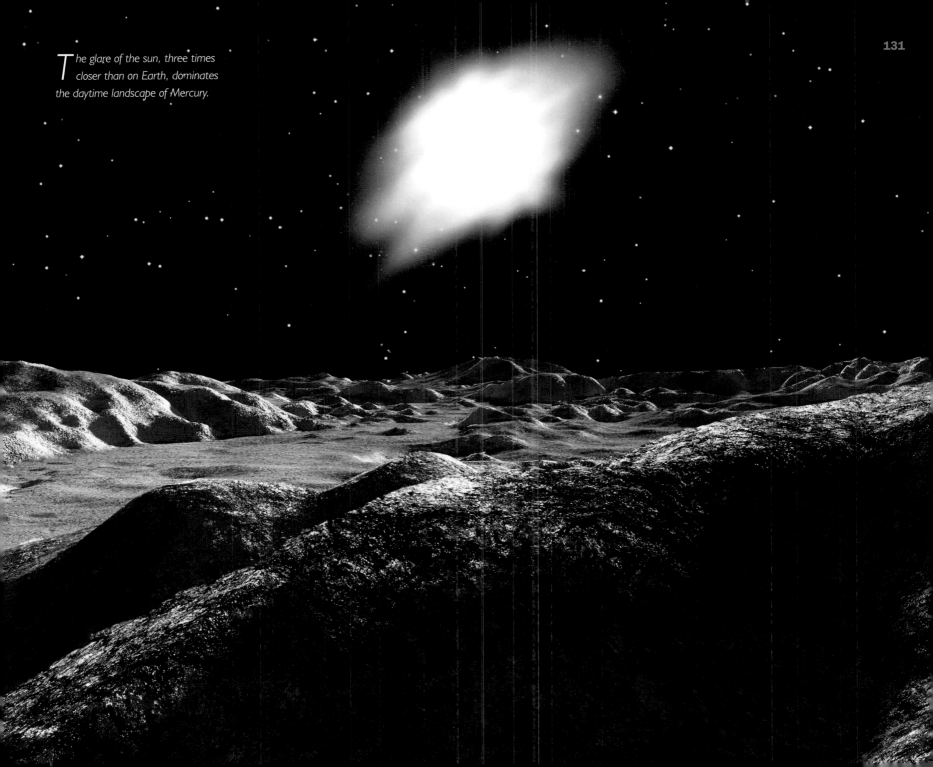

*T*he glare of the sun, three times
closer than on Earth, dominates
the daytime landscape of Mercury.

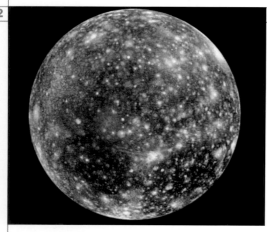

Callisto
Jupiter's Battered Moon

Satellite of Jupiter

Distance from Jupiter: *1,882,600 km*

Revolution: *16 days 16 hours*

Diameter: *4,840 km*

Composition:
ice, carbonaceous silicates

Opposite page:

Giant ice spires tower more than 80 meters (260 feet) above the surface of Callisto. The spires are icy, but also contain some darker dust. They are probably the remnants of hill-like protrusions that have been gradually eroded. In the distance is Jupiter. The three small dots in a row to the right of it are Io, Europa and Ganymede.

With a diameter of 5,000 kilometers (3,105 miles), Callisto is a slightly smaller sister of Ganymede. Like Ganymede, it keeps one face toward Jupiter.

Callisto seems to have lacked the internal energy to drive complex geological processes or fracture the surface. Instead, Callisto's surface is almost completely covered by old craters and has not been broken by eruptions of fresh ice, as has happened on Ganymede. Here and there, huge bull's-eyes mark the sites of the largest ancient impacts that made concentric fractures in the crust.

The bulk density of Callisto is greater than that of ice, indicating an additional rocky component. The data indicate that Callisto consists of about half ice and half black, carbon-rich rock or soil. The surface has a concentration of the dark soil, but wherever an asteroid has hit, it has blown away the dark soil and left a bright scar exposing the fresher ice underneath. This effect is prominent in photos of Callisto. The dark surface soil probably becomes concentrated in the surface layer as micrometeorite impacts vaporize the ice component.

The multiring systems on Callisto are virtually flat; its bigger craters are shallow. The reason for this probably involves Callisto's ice composition. Because its craters are formed of ice, and because ice flows (as glaciers do), the deepest craters have leveled out. This means relief on Callisto is rarely more than a kilometer high. The biggest impact sites, originally marked by deep basins and surrounding vaulted cliffs, have filled out to the point where only ghostly ring scars remain. Small craters preserve their nearly original profiles because they aren't big enough to deform. To put it another way, the ice is rigid enough to hold up small crater rims but not large ones.

In 2001, a very close pass of the *Galileo* probe, only 138 kilometers (86 miles) above Callisto, revealed interesting topographic features, including smooth plains dotted with "spires," and conical, knoblike hills. These hills rise about 80 to 100 meters and seem to be the last remnants of resistant ice left behind as solar heating sublimed 100 meters or so of the dirtier ice, leaving low, "spire"-dotted plains.

When the *Galileo* probe began orbiting among the satellites of Jupiter, it set to work to unravel the mystery of the internal structure of Callisto. Did it have a magnetic field and differentiated interior structure, like its neighbor Ganymede? No. *Galileo's* close approaches to Callisto indicated that it has virtually no magnetic field, that it has only slight internal heating, and that only modest separation of the interior into a rocky core and icy mantle ever occurred. As the outermost of the four large moons of Jupiter, Callisto probably was too far from Jupiter to experience much tidal heating.

Callisto is thus perhaps the largest world to have survived from the planet-forming era without much internal modification.

A remote Jupiter hovers over a cratered landscape on Callisto, the most distant of the four large Galilean moons.

The Galileo orbiter made numerous closeup pictures of the rugged, cratered surface of Callisto.

Left:

Steep cliffs called scarps cut across the surface of Callisto. They are caused when a block of the moon's icy surface is raised above the surrounding area.

Below:

As seen from the surface, a fault scarp on Callisto forms an impressive cliff.

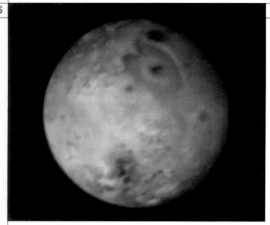

Io
A World Turning Inside Out

Satellite of Jupiter

Distance from Jupiter: *421,800 km*

Revolution: *1 day 19 hours*

Diameter: *3,630 km*

Composition: *silicates, sulfur*

Right:

Io's bizarre, mottled surface has been compared to a pizza or even a bacteria culture growing in a petri dish. The bright colors are due to sulfur and sulfur compounds spewed from Io's many volcanoes, the dark spots peppering its surface.

To those of us who grew up walking on soil derived from silicate minerals, watching trees sway in the breeze under a blue sky, dangling our toes in liquid water pools, throwing snowballs, and watching astronauts play in the rocky deserts of our sister world, the moon, Jupiter's satellite Io must appear to be the most bizarre world in the solar system. Io (pronounced *EYE-oh*★) is almost exactly the same size as our moon, yet its geology and chemistry are dominated neither by the silicate soils of the inner planets nor by the ices of the moons of the giant planets, but rather by volcanic, sulfur-rich compounds.

The first close-up pictures by *Voyagers 1* and *2* in 1979 showed Io to be mottled with orange, yellow, red, and white patches, and pocked with blackish spots. *Voyager* team scientists remarked that they didn't know what was wrong with Io, but it looked as though it might be helped by a shot of penicillin: Io resembled one of those planets we used to laugh at when they appeared outside spaceship windows in grade-C science fiction movies.

★And never "ten," as is occasionally heard from ill-informed newscasters.

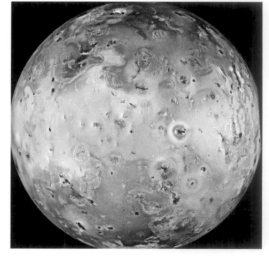

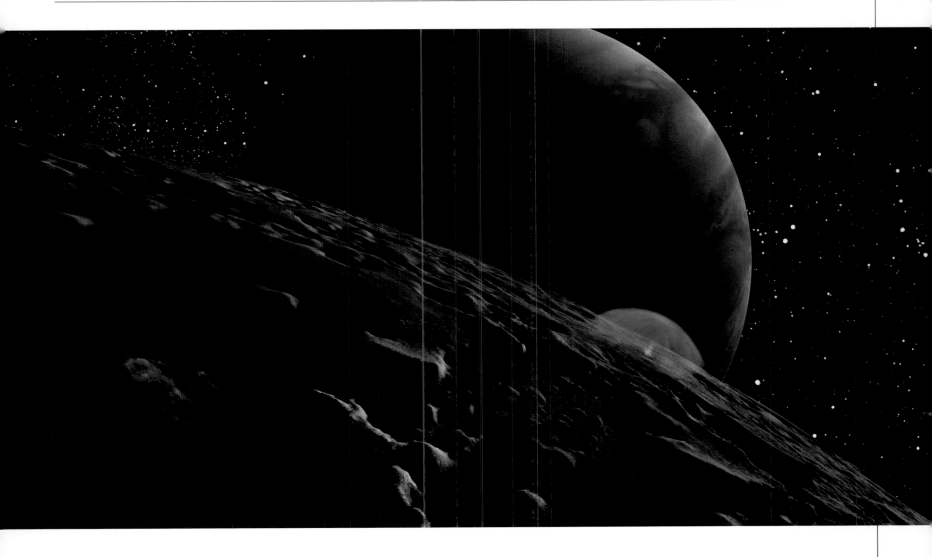

One of the great triumphs of theoretical astronomy came at this time. Just one week before *Voyager 1* got to Io, California planetologist Stan Peale and colleagues published a prediction of volcanoes on Io. They reasoned that any satellite close to a planet is slightly stretched into a sort of football shape with the long axis toward the planet, because of the gravitational pull of the planet.

The plume of an Io volcano forms a greyish umbrella over Io's marbled surface. The force behind these titanic eruptions blows debris hundreds of kilometers into space.

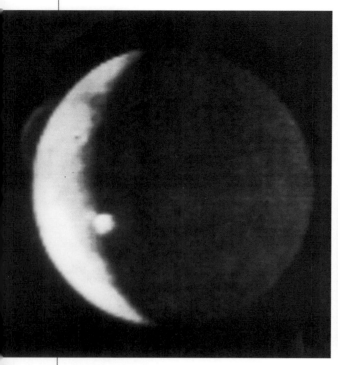

The Most Volcanic World in the Solar System

Above:

The Voyager discovery photo that first revealed the umbrella-shaped plume of an active volcano on Io, silhouetted above the horizon on the left.

Above right:

Examples of spacecraft photos of volcanic plumes on Io, from overhead and silhouetted above the horizon. Several of these views reveal the umbrella shape of the plumes. The darkest material may be molten sulfur, blackish in color.

An Imperfect Circle

Io's orbit around Jupiter is nearly circular; if it were a perfect circle the stretching would be constant, but the gravitational attractions of the other three large satellites keep forcing Io to change its path somewhat, making a slightly elliptical orbit. This leads to constant flexing of Io, which heats its interior, just as a tennis ball gets warm if you keep flexing it. The whole process is called *tidal heating*, as already mentioned in connection with the neighboring moon, Ganymede. Tidal heating explains certain unusual geologic features on many other moons, as we will see. In any group of large moons, just as those of Jupiter, tidal heating is most favored for the innermost moon, because the gravitational tidal forces are strongest closest to the planet.

The Io tidal heating calculations offer a terrific example of the triumph of empirical science over other attempts to learn about the universe. Various stripes of religious fundamentalists and mystics make various false pronouncements about planets. Those who claim to "travel" by psychic

techniques such as the once-popular "astral projection" came up with outrageous descriptions of Jupiter and other planets. So-called creation scientists make ludicrous claims that Earth is only 6,000 years old and lacks geological or biological evolution, claims we could laugh off except that these folks almost keep succeeding in insinuating their extreme religious-based beliefs into the American public school curriculum. Viewed in this context, the successful prediction that Jupiter's moon Io would have volcanoes—a prediction out of the blue, as it were, derived with pencil, paper, and physics—is a brilliant example of how the scientific method, with its testing and rejection of false theories, is humanity's most successful tool in understanding our relation to the cosmos.

The prediction of Dr. Peale and his colleagues was all the more remarkable because, prior to the *Voyager* flybys, most researchers thought all Jupiter's moons were frozen, dead iceballs. Far from being geologically defunct, Io is a volcanic powerhouse. *Voyager 1* saw eight volcanoes erupting, and *Voyager 2*, six months later, found six of them still active, with two new ones. Large, Earth-based telescopes, equipped with sensitive, heat-detecting infrared devices, not to mention the *Galileo* orbiter of the 1990s, have monitored essentially continuous eruptions ever since.

What is the nature of the volcanic lava? Spectra suggested much of it is sulfur compounds, and colors seemed to back this up. Closeup photos tend to show black calderas surrounded by orangish and yellowish lava flows, often on whitish backgrounds. Chemical studies confirm that molten sulfur (melting point 112°C, or 234°F) is black, that it changes colors to orange and yellow as it cools, and that sulfur dioxide frosts are whitish in tone. Even though the normal daytime surface temperature of Io hovers at a frigid level around -148°C (-234°F), the early *Voyager* and telescopic data indicated hot eruptions with temperatures around 325 to 430°C (617 to 806°F), not to mention pleasantly "temperate" warm spots with temperatures around 30°C (86°F). These

Left:

A dark-floored volcanic caldera with radiating flows of brown lava.

Below:

Galileo snapped this oblique view of the Tvashtar caldera, a vast, steep-walled crater filled with molten material.

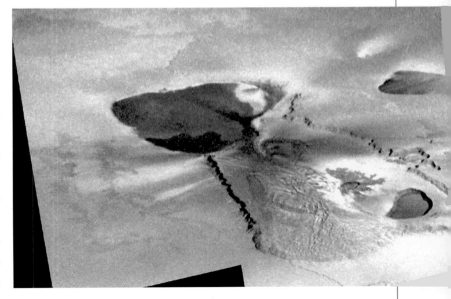

*D*ramatic changes occurred in the five months separating these Galileo images of the volcano Ra Patera. A large, new dark spot—400 kilometers in diameter—has appeared, surrounding the volcanic center known as Pillan Patera (upper right center).

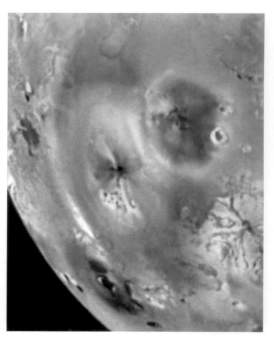

temperatures are just under the boiling point of molten sulfur in a vacuum (442°C, or 828°F), and much less than typical silicate lava melting temperatures on Earth (1,025 to 1,200°C, or 1,877 to 2,192°F), and thus were consistent with the idea that the volcanic "lavas" were basically molten sulfur and sulfur compounds.

Nonetheless, the *Galileo* orbiter in the 1990s detected numbers of vents erupting much hotter lavas, 1,400 to 1,725°C (2,552 to 3,137°F), well above sulfur's boiling point. Remember that you can't heat water much above its own boiling point; if you add heat, it just boils faster. In the same way, researchers concluded that the hottest lavas are unlikely to be sulfur, but are probably ordinary, rock-forming, silicate-based lava. *Galileo* also photographed scattered mountains too high and steep to be made out of sulfur, which is too weak to support their weight. It would be like building a skyscraper out of modeling clay. Nonetheless, the *Galileo* spectrometer confirmed sulfur dioxide and probably other colored sulfur compounds on the surface. According to the current evidence, then, Io is likely to have a rocky, silicate-based crust

(not unlike that of, say, Mars), overlaid by a thinner veneer of colorful sulfurous compounds, such as sulfur dioxide "frost" condensed from sulfurous gases emitted by the volcanoes.

The volcanism of Io explains a fact that had puzzled pre-*Voyager* scientists: the absence of ice on its surface. Jupiter's other big moons are all ice-rich. All these moons probably formed from a mixture of frozen water and rocky material, with minor amounts of sulfur and other compounds. Apparently, Io's volcanism has been so intense that most of the crustal materials have melted, erupted, been covered by later eruptive debris, and perhaps been recycled through this sequence again and again. Volatile materials, such as water, boiled off long ago. This is why Io lacks the ice-rich surface of its neighbor worlds, such as Europa.

Heavy materials, such as silicate rock, sank into the lower layers of Io. The retention of the heavy material and "boil-off" of light volatiles accounts for the fact that Io's density is higher than that of other moons'. Sulfur compounds, the lightest materials that would not boil away, ended up as the dominant "lavas" on the surface. In the absence of water or carbon dioxide on Io, sulfur and sulfur compounds have assumed the role of the most active volatile substance, creating the lowest-temperature liquid (molten sulfurous flows) and frost (sulfur dioxide).

Special Effects

Io has some of the most stunning visual effects in the solar system. Imagine a full "day" on Io, experienced from a single point on its surface. One side of Io always faces Jupiter. On that side, Jupiter dominates the sky, always hanging in the same place. Jupiter subtends an angle of about 20 degrees—forty times the angular size of the moon in our sky.

Because Jupiter covers a large part of Io's sky, the sun spends nearly two and a half hours of each day in total

The flexing caused by tides created by Jupiter is the source of Io's internal heat.

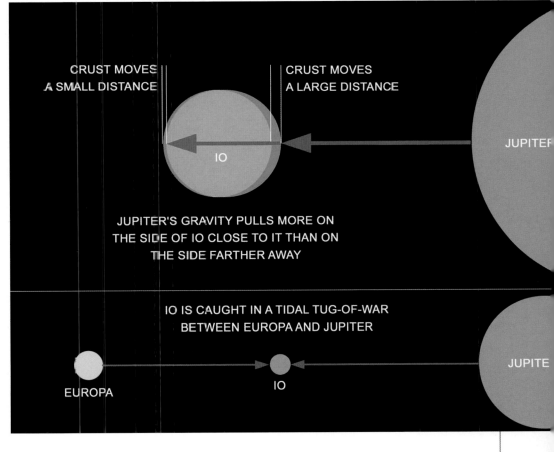

CRUST MOVES A SMALL DISTANCE

CRUST MOVES A LARGE DISTANCE

IO

JUPITER

JUPITER'S GRAVITY PULLS MORE ON THE SIDE OF IO CLOSE TO IT THAN ON THE SIDE FARTHER AWAY

IO IS CAUGHT IN A TIDAL TUG-OF-WAR BETWEEN EUROPA AND JUPITER

EUROPA

IO

JUPITE

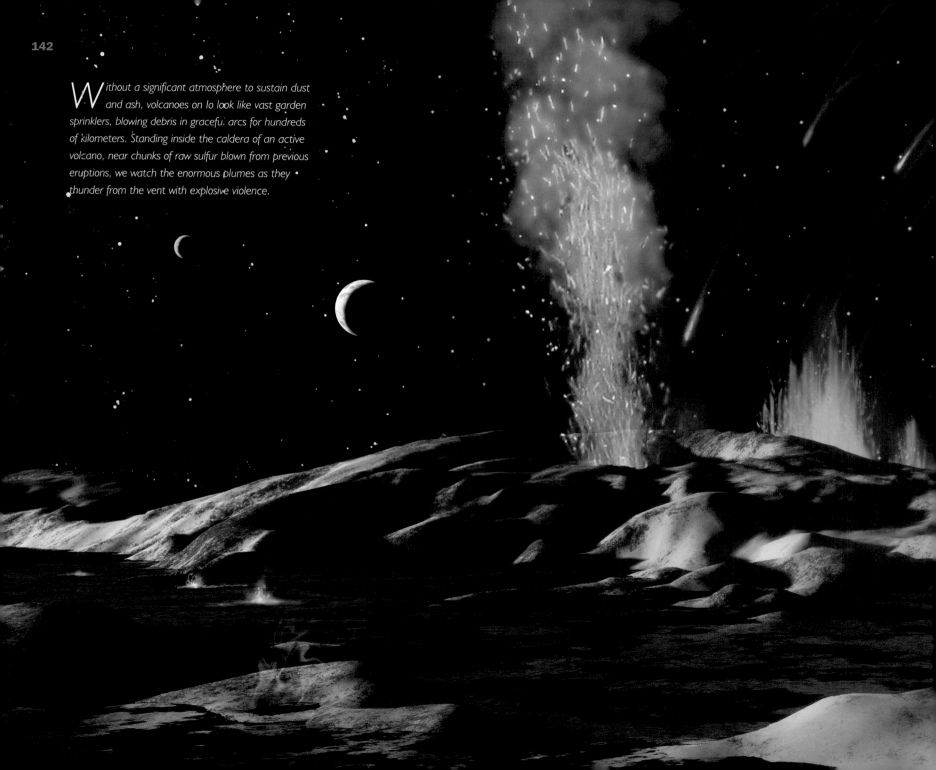

Without a significant atmosphere to sustain dust and ash, volcanoes on Io look like vast garden sprinklers, blowing debris in graceful arcs for hundreds of kilometers. Standing inside the caldera of an active volcano, near chunks of raw sulfur blown from previous eruptions, we watch the enormous plumes as they thunder from the vent with explosive violence.

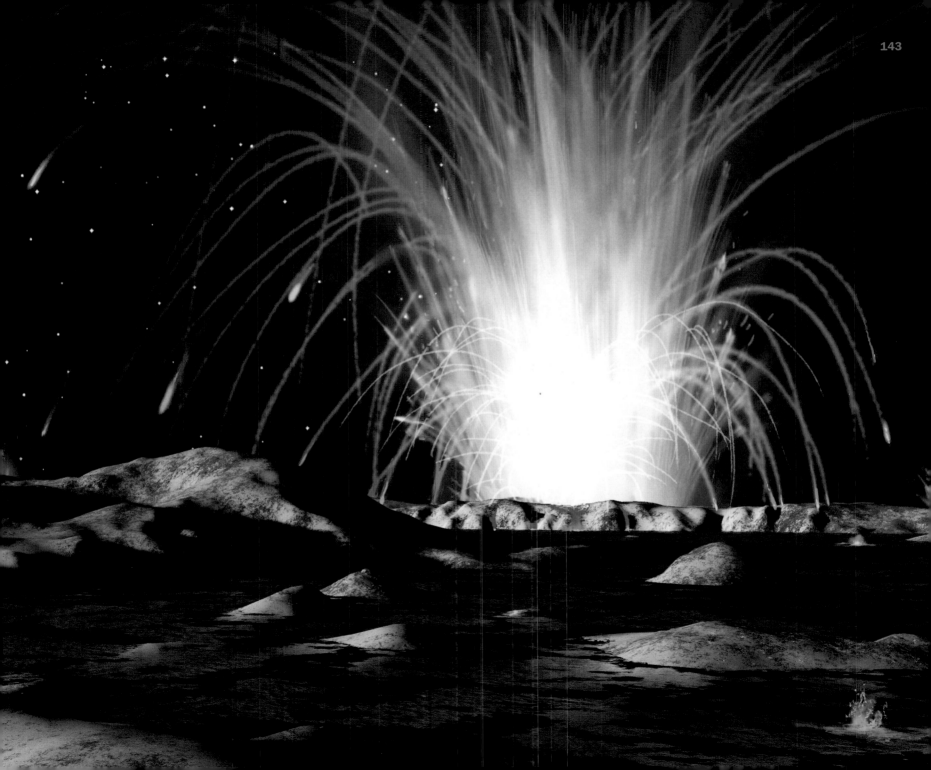

Above:

Activity can be seen in these before-and-after pictures of a caldera, as blue gases erupt from a lake of black, molten sulfur.

Above right:

Io's violent nature is apparent in this view of its night side. Powered by the magnetic and gravitational fields of nearby Jupiter, auroras and volcanoes illuminate the night side of the tortured moon.

eclipse behind Jupiter. When the eclipse ends, the sun comes out from behind Jupiter and begins to warm the landscape, which has cooled markedly during the eclipse. At this moment, another of Io's unusual phenomena occasionally becomes visible: the so-called post-eclipse brightening.

In the mid-1960s astronomers monitored the brightness of Io before and after these eclipses, hoping to discover whether Io had an atmosphere. They hoped that during the cold eclipse period, frost might condense and form whitish deposits if the temperature dropped low enough. Calculations suggested that if several large volcanoes erupt during an eclipse, enough sulfur dioxide might condense on orange or red backgrounds to brighten the overall appearance of Io during the few minutes after the eclipse ends. Sure enough, astronomers observed a brightening of Io, which faded about fifteen to twenty minutes after the eclipse ended, as the surface warmed. A mystery surrounds these observations. The post-eclipse brightening is seen after some eclipses, but not after all of them. Some astronomers claim the whole thing is due to faulty data; others suspect it may depend on the state of volcanic eruptions and the abundance of vapors they produce.

Some ten and a half hours later, when Io has moved a quarter of the way around Jupiter, its sky develops a faint yellowish glow. This effect was first seen from Earth. The explanation is that a large, thin gas cloud of sodium, sulfur, and other atoms surrounds Io. The presence of this cloud has to do with Io's location inside Van Allen radiation belts around Jupiter.

Energetic atoms trapped in these belts strike Io's surface and knock other atoms loose. More may "come unglued" due to Io's volcanic eruptions. As these atoms escape Io, they diffuse into a cloud many Io-diameters wide, stretching forward and backward along Io's orbit. Sunlight striking the atoms excites them. In particular, if sunlight of a certain wavelength strikes the sodium atoms, they absorb and then re-emit this color—a glow called the sodium "D" line, familiar to us as the yellow color in most candle flames. The sodium cloud around Io glows with a faint yellow light—a sodium aurora that resembles a moderate aurora on Earth.

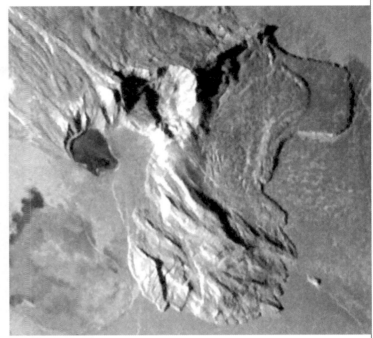

About ten and a half hours later, Io is now halfway around its orbit, between Jupiter and the sun. The sodium glow has slowly faded from the sky. Now Jupiter is in its "full" phase—a dazzling yellow, orange, red, and tan disk with brightly colored cloud patterns, such as the famous Red Spot storm system.

The sun has set at our location after another ten and a half hours. Io has carried us three-quarters of the way around Jupiter, and the planet is in its "third quarter" phase. The yellow sodium glow is back in the sky, perhaps a bit brighter now, depending on the amount of volcanic gases emitted in the last few hours. In the cold of night, the sulfur dioxide frost may have formed again, and the landscape is dully illuminated by the yellow light of Jupiter itself.

So far, no one has stood on the plains of Io to see these views or feel the seismic tremors as its volcanoes explode. But if we humans manage to establish viable interplanetary travel before we imprison ourselves forever on a resource-exhausted planet, the day may come when, heavily shielded from Jupiter's radiation, we will see the sights of Io not through spacecraft instruments or paintings, but with our own eyes.

Images from the Jupiter-orbiting Galileo probe show mountains, calderas, and lava flows on Io.

Io keeps the same face toward Jupiter as it orbits the planet. For this reason, Jupiter seems to hang motionless in the sky, neither rising nor setting. As Io orbits, the giant planet goes through phases, just as Earth would, seen from its moon. Here, from the northern hemisphere on Io, we see the course of a single day. 1. The sun is just coming out from behind Jupiter while the thick atmosphere of the planet is illuminated in a glowing ring surrounding the dimly visible dark side. 2. A few hours later, as Io moves around Jupiter, the sun appears to have moved to the right, and the landscape around us is brightly lit. 3. A little over ten hours into Io's day and Jupiter is in its first quarter phase. The brilliant colors of Io's surface glow around us. 4. Halfway through the day, the sun is now behind us, illuminating the full face of Jupiter. 5. Ten and a half hours later and the sun has now set below Io's horizon. Jupiter is in its last quarter phase. A volcano in the distance has been erupting and the gasses it has released into the thin atmosphere are glowing in a brilliant auroral display. 6. Near the end of the day—the sun is just below the horizon and will soon rise, to pass behind Jupiter again.

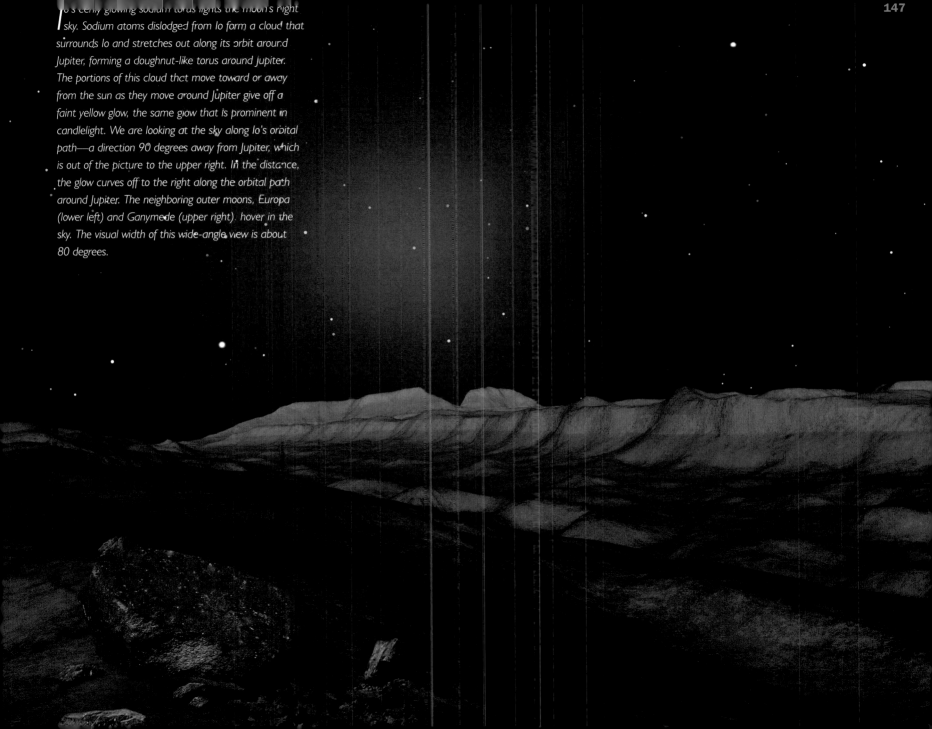

Io's eerily glowing sodium torus lights the moon's night sky. Sodium atoms dislodged from Io form a cloud that surrounds Io and stretches out along its orbit around Jupiter, forming a doughnut-like torus around Jupiter. The portions of this cloud that move toward or away from the sun as they move around Jupiter give off a faint yellow glow, the same glow that is prominent in candlelight. We are looking at the sky along Io's orbital path—a direction 90 degrees away from Jupiter, which is out of the picture to the upper right. In the distance, the glow curves off to the right along the orbital path around Jupiter. The neighboring outer moons, Europa (lower left) and Ganymede (upper right), hover in the sky. The visual width of this wide-angle view is about 80 degrees.

The Moon
Earth's Companion

Satellite of Earth

Distance from Earth: *381,575 km*

Revolution: *27 days 7 hours*

Diameter: *3,476 km*

Composition: *rock, silicates*

The Earth (blue) and the Moon (yellow) to scale. In all the solar system, only Pluto has a moon larger in proportion. So large is the Moon in relation to the Earth that many astronomers consider the two to be a pair of planets orbiting a common center.

The moon is, of course, one of the best-known worlds. On July 20, 1969, *Apollo 11* astronauts became the first human beings to set foot on it. The samples brought back by the *Apollo* explorers and by several Soviet automated landers have revealed a great deal about the evolution of the moon. Lunar rocks are generally older than those found on Earth. For this reason, lunar exploration has been geologically valuable, helping to fill in the gaps in the first billion years of the Earth-moon system's history.

What the moon rocks tell us is that the moon (and probably Earth) began its history 4,500 MY ago with a surface layer that was molten. This molten layer—or *magma ocean,* as it is called—was a few hundred kilometers deep. As it cooled, various minerals solidified and a crust of lower-density minerals aggregated on the surface, accounting for the low-density rock types known as *anorthosites,* which form much of the ancient lunar highlands. By 4,400 MY ago, much of the magma ocean had solidified, although deep pockets of molten material existed under the surface.

Counts of lunar impact craters and determination of rock ages tell us that the rate of meteorite impact was extremely high between 4,400 and 4,000 MY ago. This was probably true on all planets throughout the solar system. Meteorite debris was left over from the formation of

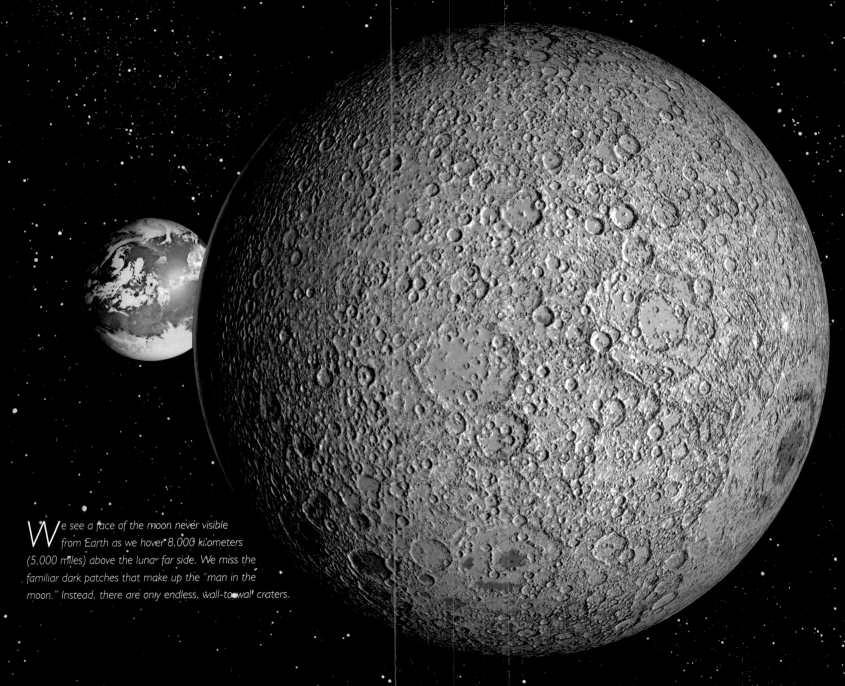

We see a face of the moon never visible from Earth as we hover 8,000 kilometers (5,000 miles) above the lunar far side. We miss the familiar dark patches that make up the "man in the moon." Instead, there are only endless, wall-to-wall craters.

Creating the Moon

Above left:

*H*alf an hour after impact by a Mars-sized interplanetary body, debris is spraying into space. At close of planet formation, interplanetary bodies were common and comets were a frequent sight.

Above right:

*F*ive hours after impact, incandescent material and gas sprayed into an arc around Earth, according to computer simulations of the event.

planets 4,500 MY ago; scattered through interplanetary space, this debris often collided with them. But by 4,000 MY ago, much of the debris had been "collected" by the planets. The impact rate was so great before then that only chips and pieces of lunar rock survive from that time.

The Man in the Moon

Around 3,900 MY ago, heat generated by radioactivity had accumulated inside the moon, melting a layer several hundred kilometers beneath the surface. The largest meteorite impacts, which formed huge craters of the type known as multiring basins, caused fractures that penetrated into this magma layer. Lava ascended to the surface and erupted, covering the floors of the huge basins and some of the larger craters. These lava flows are darker-colored than the ancient highlands and form the dark plains that we see from Earth—the "man in the moon." Galileo Galilei and other early astronomers erroneously thought that these flat areas were oceans and gave them the Latin name for sea, *mare* (plural *maria*). Thus these features bear

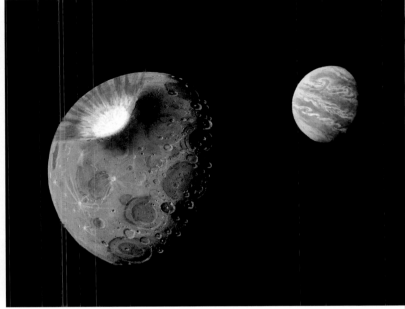

such colorful names as Mare Tranquillitatis (Sea of Tranquility) and Mare Imbrium (Sea of Showers).

Most of the prominent maria, or lava plains, formed between 3,800 and 3,200 MY ago. Their rocks are basaltic lavas, similar to the volcanic lavas found in Hawaii, California, Arizona, and elsewhere.

As life-forms evolved on the fertile Earth (starting at least 3,800 MY ago), the airless moon continued to be belted by a rain of meteorites. Numerous small ones sandblasted the surfaces of the rugged lava flows into smooth, undulating layers of fine dust and rock chips about 10 meters (30 feet) deep. This was the surface our astronauts trod, kicking up dust that dirtied their space suits and sprayed from their rovers' tires in graceful arcs. This dusty layer is called the lunar *regolith*.

Larger meteorites fell at a rate only one one-thousandth as often as they did a few hundred million years before. Their occasional impacts excavated craters through the regolith and ejected rock fragments from the lava layers below, accounting for scattered rocks in the maria plains and the uplands.

Above left:

Within 100,000 years after impact, the moon has assembled beyond Roche's limit, leaving a ring of debris around Earth. The ring later dissipated.

Above right:

During the next few hundred MY after the moon formed, an additional rain of impacts formed countless craters including large impact basins, such as the one being formed here. Similar impacts happened on Earth, but the craters were destroyed by plate tectonic reshaping of Earth's crust.

Above:

*A*n orbital view of the moon's ancient, cratered surface, photographed by Apollo astronauts.

Right:

*S*ome 3,000 MY ago, a dark lava flow emanates from a low cinder cone (center) on the moon. Dates of numerous rock samples from the lava plains of the moon show that eruptions of lunar lavas were strongly concentrated between 3,200 and 3,800 MY ago. Such lavas have been "sandblasted" by the impact of small meteorites until their surface textures are obliterated in a layer of dust and rocky rubble.

Very large impacts blasted out rare, large young craters such as Tycho, whose rays of bright ejected debris stretch outward across the moon. The interiors of such craters have not been sandblasted enough to be smooth, and so are marked by chaotic rubble that must form landscapes far rougher than any we have seen.

Cratered Worlds

Until 1965, heavily cratered landscapes like those of the moon were unknown elsewhere in the solar system because our ships had not yet reached other planets. Today, we know that virtually all the two dozen or so planetary surfaces we have seen at close range are cratered, and that the moon displays the effects of processes that have acted on many worlds throughout the solar system. Orbiting spacecraft and sophisticated geological studies have shown us that

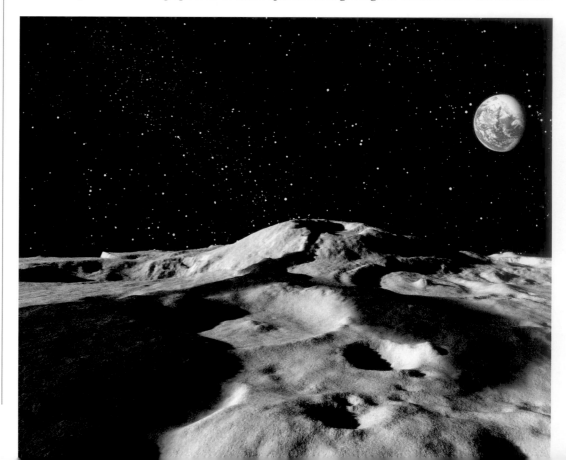

even Earth is more heavily cratered than had been suspected, but erosion and plant life have made even enormous craters difficult to detect by a casual observer on the ground. The largest impact "crater" on the moon may be a vaguely defined, broad depression on the far side, called the Aitken Basin. It shows up on orbiter-derived geochemical maps as an area of ancient basalt lavas, partly masked by debris ejected from more recent craters. Many researchers would like to land a probe to return samples from that region, in hopes of being able to study earlier and more primitive lunar lavas than have been found on

Forbidding badlands convolute the floor of the crater Tycho, bound by the distant, towering cliffs of the crater walls. This ruggedness is an indication of Tycho's relative youth—it has yet to be sandblasted by micrometeorites to match the rolling smoothness of much of the rest of the moon. The crater, the result of a meteorite collision, is the size of Yellowstone National Park. Tycho's central peak is a mountain about 1,800 meters (6,000 feet) high. The crater walls, which rise in a series of stepped terraces, loom 3,600 meters (12,000 feet).

the front side. There is also some suspicion that the front side is "contaminated" with rocks and debris plastered over much of the surface from the last large impacts, which formed the Imbrium and Orientale basins, leading some lunar scientists to suspect that carefully selected far-side rocks might give us new insights.

We have landed on the moon in only a few places, and those were chosen to be relatively flat. We have not yet seen the rugged areas, the fresh craters, the nighttime surface illuminated by Earth-light, or the lunar landscape bathed in the fiery red light transmitted through Earth's atmosphere during an eclipse, when Earth passes between the moon and the sun. Stranger wonders may exist. In 1998 the inexpensive *Lunar Prospector* orbiter mission detected something odd lurking on the floors of permanently shadowed craters at the north and south poles of the moon. From these positions, the sun would be always on the horizon, so that depressions remain full of shadow and therefore extremely cold. Looking down from orbit, sensitive instruments on *Lunar*

We are standing on the rim of a typical large
lunar crater, similar to Tycho. The central peak
rises several thousand feet above the crater floor.

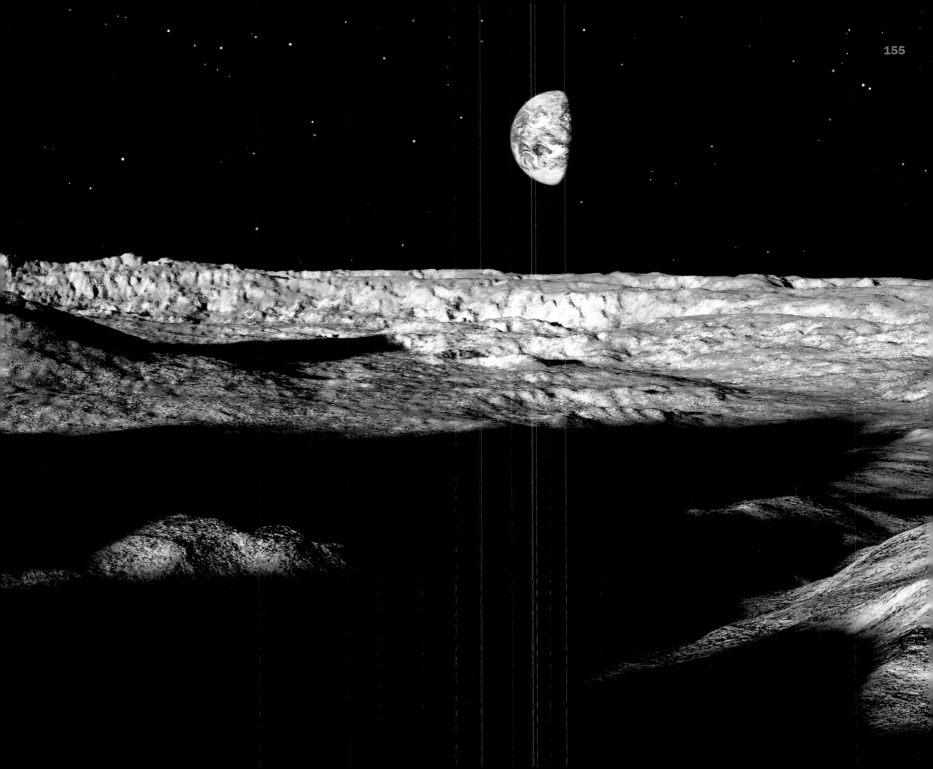

Right:

Tumbled boulders on a crater rim on the moon. Each lunar impact crater marks the site of a giant explosion that blew rocks loose from the lunar crustal layers. This view shows lunar boulders composed of stratified lava deposits on the inner rim of a crater, with a vista across the crater in the background. A rain of micro-meteorites has sandblasted the rocks since the crater's formation.

Opposite page:

In the rough country around the Orientale impact basin, Earth always hangs low over the eastern horizon. Once the sun sets, eerie blue Earth-light is the only source of illumination. Here it catches the top of one of the huge cliff-rings that surround the Orientale Basin. Because this basin is hundreds of kilometers across, we do not have the sense of standing in a crater; rather, the fault-ring appears more like a long, scalloped mountain range. The sun is just below the western horizon, which we face. Since there is no air, there are no glorious sunset colors; but the moon offers a different kind of sunset display. The horizon glows with the outer parts of the sun's corona and a faint band of zodiacal light—the dust of the inner solar system lit by the sun.

Because the moon turns in 29½ days (relative to the sun) instead of 24 hours, the sunset is very slow. The sun actually hangs just below the horizon for hours of corona-lit twilight before the full, 14-day lunar night sets in. But the cliffs are still lit by Earth. They will fade as Earth goes from its full phase (which it is in now, since it is opposite the sun) to a much fainter crescent illumination just before sunrise.

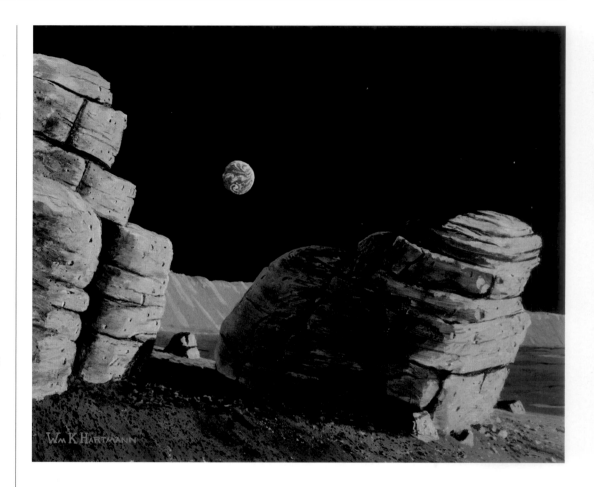

WM K HARTMANN

Prospector detected a concentration of hydrogen atoms in these locations. The interpretation was that the bone-dry moon might have frozen water in the shadows at its poles! Years earlier, California geochemist Jim Arnold had predicted that such deposits might form when ice-laden comets hit the moon, and their H_2O molecules condensed and froze in the shadowy polar "cold traps." More recent observations have left open the question of whether the lunar polar ice really exists, and if so whether there is enough to be a valuable resource for future lunar explorers, who would lack any other water except what they bring with them. In any case, the moon still has unseen vistas that may bring surprises.

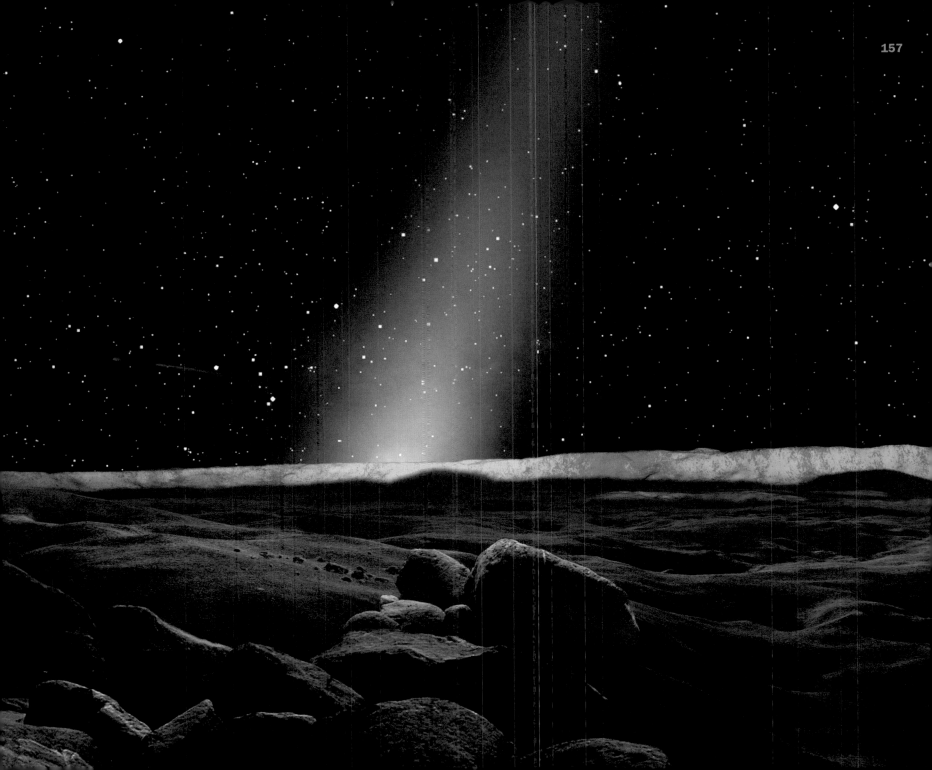

Apollo Vistas on the Moon

Above:

*A*pollo 17 *astronauts visited a large boulder that rolled down a cliff in the moon's Taurus Mountains.*

Right:

*B*roken rocks on the rim of a modest-sized impact crater near the moon's Apennine Mountains at the Apollo 15 *landing site.*

Opposite page:

*L*ooking northwest up Hadley Rille, a relatively shallow, meandering valley formed by lava flows on the Imbrium lava plains, visited by Apollo 15 astronauts.

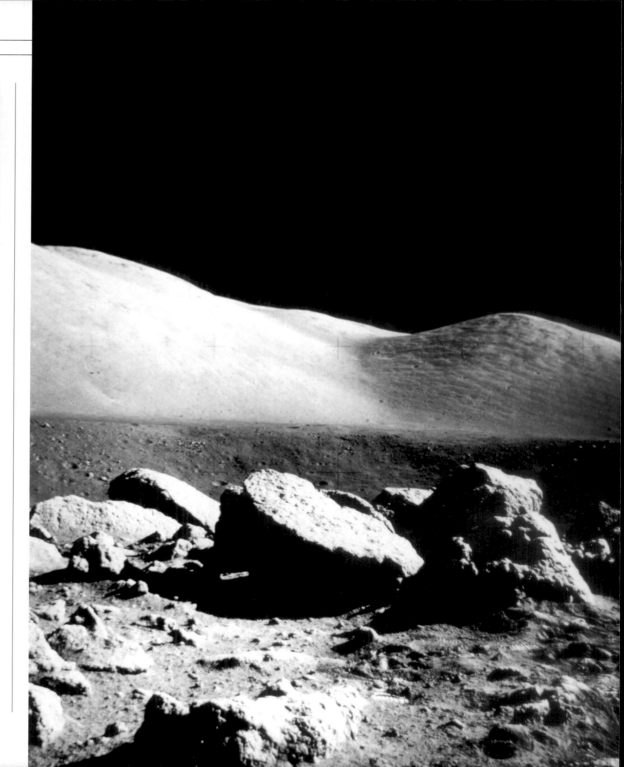

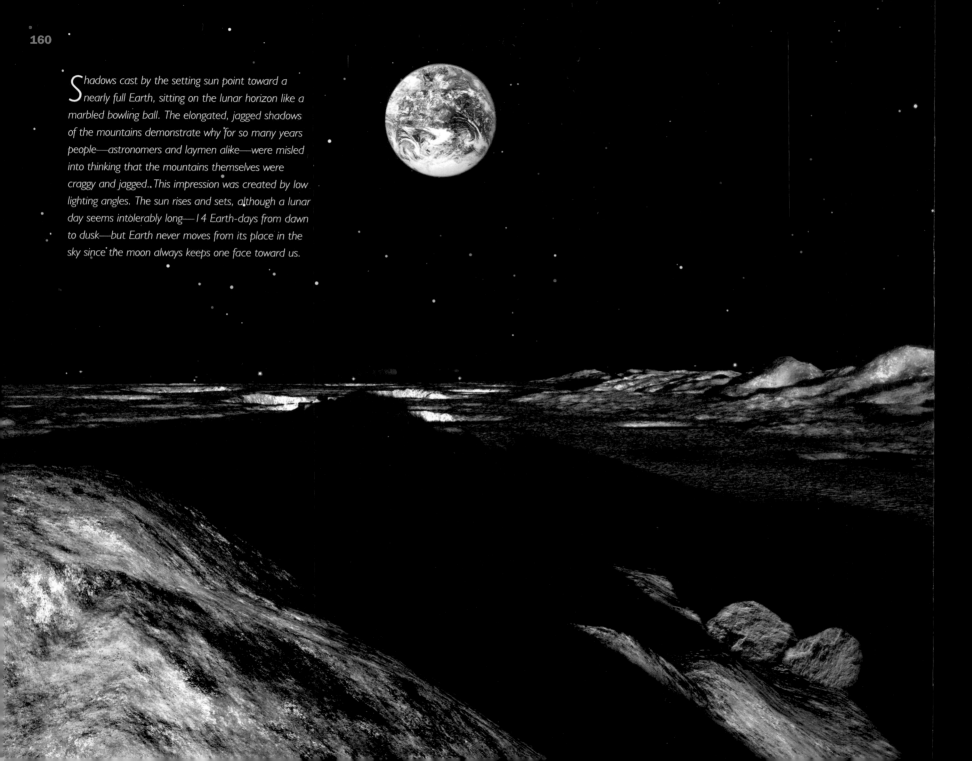

Shadows cast by the setting sun point toward a nearly full Earth, sitting on the lunar horizon like a marbled bowling ball. The elongated, jagged shadows of the mountains demonstrate why for so many years people—astronomers and laymen alike—were misled into thinking that the mountains themselves were craggy and jagged.. This impression was created by low lighting angles. The sun rises and sets, although a lunar day seems intolerably long—14 Earth-days from dawn to dusk—but Earth never moves from its place in the sky since the moon always keeps one face toward us.

The surface of the moon has turned to copper as the blood-red light from an eclipsing Earth washes over the landscape. The backlit atmosphere of Earth, as it passes in front of the sun, is illuminated in an orange-red ring. Sunlight, passing through the atmosphere at such a low angle, turns red just as it does at sunrise and sunset. The reddened sunlight refracted through Earth's atmosphere is what is lighting everything around us.

Pale streamers of the sun's corona fan out from behind Earth while the even paler zodiacal light extends beyond them in a faint band. The sun is about to pass out of eclipse; in fact, the first sunlight is just striking the horizon beyond Earth's shadow.

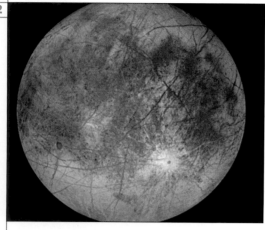

Europa
The Solar System's Secret Ocean

Satellite of Jupiter

Distance from Jupiter: *671,000 km*

Revolution: *3 days 14 hours*

Diameter: *3,130 km*

Composition: *ice*

Two somewhat contrast-enhanced spacecraft photos show the faintly mottled and streaked icy plains of Europa.

With a diameter of 3,130 kilometers, or about 1,944 miles (slightly smaller than our moon), Europa is the fourth-largest of Jupiter's satellites. Even before *Voyagers 1* and *2* sailed by, spectrographic data obtained by Earthbound astronomers showed that Europa's surface is composed mostly of frozen water. These spectral and other observations indicated that Europa's surface is brighter and richer in ice than the surfaces of other satellites, which (in the cases of Ganymede and Callisto) are made of a mixture of ice and rocky soil.

In those days, such data made Europa seem like a perfect candidate to be one of the geologically dead iceballs that astronomers expected to find among Jupiter's moons. But when *Voyagers 1* and *2* flew by in 1997, the rule of surprise in planetary exploration held true once again. Europa joined its larger sisters, Ganymede, Callisto, and Io, in having a surface completely distinct from the surfaces of its neighboring moons.

More Than Meets the Eye

The *Voyager* mission revealed that Europa is the most nearly featureless world known in the solar system. From a distance, it looks like a mottled, cream-colored cue ball, with only faint markings and virtually no large impact craters. The markings are primarily a set

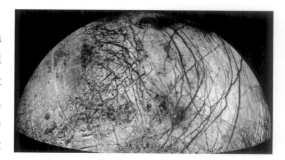

of tan streaks with so little relief that they look as if they had been drawn on Europa with a pale, felt-tipped pen. The streaks are only about 10 percent darker than the surface—enough contrast to be clearly visible but not bold; many images that show the markings as prominent dark streaks have been processed for contrast. Europa's streaks actually resemble the fictitious "canals" that Percival Lowell erroneously drew on Mars. A *Voyager* scientist, seeing the first images of Europa, quipped, "Where is Percival Lowell now that we need him?"

*J*upiter is seen beyond the smooth, cracked surface of Europa.

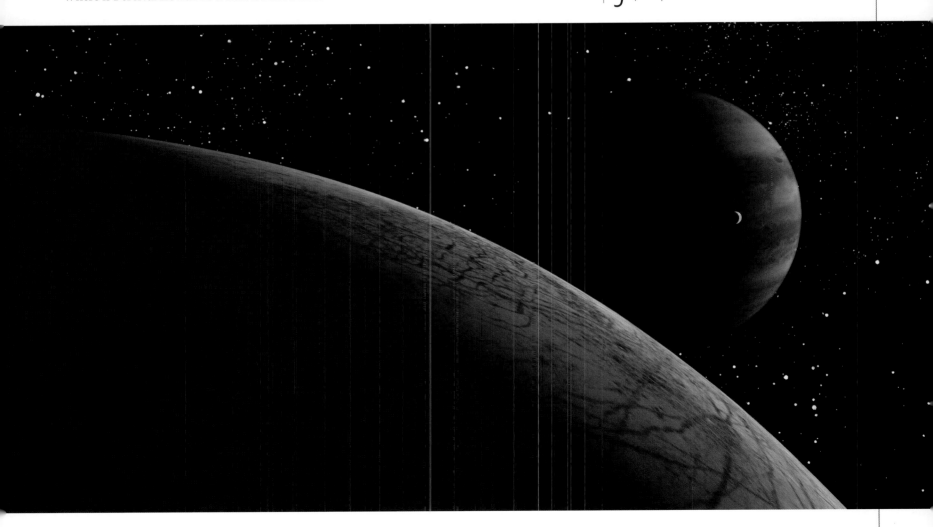

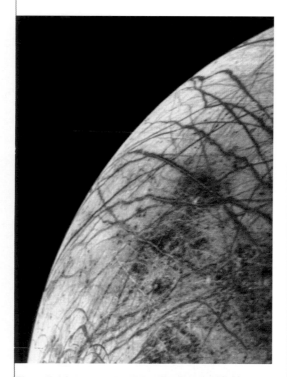

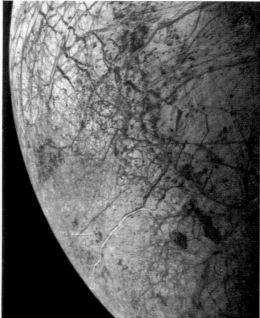

What are the streaks of billiard-ball Europa? Close-up photos by the *Galileo* orbiter, starting in 1996, revealed an astonishing situation. The streaks are fractures in an icepack floating on a hidden ocean of liquid water. After encountering frozen worlds and dry worlds and worlds with insufferable atmosphere, we find in lowly Europa something not too different from our own Arctic icefields! There are various lines of evidence for this conclusion. As mentioned, the spectrometers confirm that bright, whitish surface material is water-ice. The lack of impact craters shows that the surface is constantly reforming itself, by eruptions of liquid water through the fractures. The fractures, which may be tens of kilometers wide, and which can be traced from as little as tens of kilometers to as much as 3,000 kilometers (1,863 miles) in length, separate individual iceberg-like plates; studies in selected regions show that you can shift these various "plates" until they fit together again like jigsaw puzzle pieces. The fractures and their patterns confirm that the ice is floating on an underlying ocean. Along the edges of the fractures are often tan or brown stains of hydrated salt minerals, such as sulfates and carbonates. They indicate that the water in the sub-ice oceans of Europa is mineral-rich and "salty," not unlike the water in Earth's oceans. When cracks open in Europa's ice, water froths forth and evaporates in the near-vacuum conditions, leaving the mineral stains behind. Sulfates and carbonates are, after all, the same tell-tale minerals found in the Martian soils, indicating that water once ran over them.

How deep is the ice shell? Arizona researchers Elizabeth Turtle and Elizabetta Pierazzo used the very few impact craters on Europa to make an estimate in 2001. If the ice layer were too thin, large impactors would simply punch through it instead of making craters, but if the ice were thick craters could form with central rebound peaks, like the craters formed on the moon and Mars. Finding several craters up to 24 kilometers (15 miles) across, with central peaks, they concluded the ice must typically be more than 3 to 4 kilometers (2 to 2.5 miles) across. But in areas with recent fractures, it may be thinner.

Calculations suggest that, as with the volcanoes of Io, tidal heating may be the heat source that keeps Europa warm enough to have an ocean. The mean density of Europa, much higher than ice, is closer to that of silicate rocks, meaning that Europa must be mostly a rocky world. The layer of ice and water may be only 100 kilometers (63 miles) thick, which is to say the ocean could be 100 kilometers deep under a 3-kilometer-thick icepack.

If Not, Why Not?

As early as the *Voyager* era, science fiction writer Arthur C. Clarke pointed out that if Europa is internally heated and maintains a deep ocean, it could be a habitat for life. (Clarke developed this idea further in 1982 as a plot device in his novel *2010*). Biological discoveries since then support the idea that some kinds of microbes can exist underground, in the dark, utilizing minerals and geothermal heat as their ultimate energy sources. Perhaps the question to explore Europa further is not just "Does life exist there?" but (as also in the case of Mars), "If not, why not?"

Opposite page:

Two views of Europa. Veined like a cracked ivory ball, Europa presents the flattest topography known in the solar system. No mountain ranges, large impact craters, or high volcanic cones mar the surface. The lines are grooves, or fractures, in the icy crust.

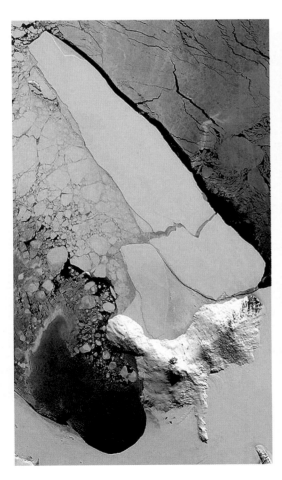 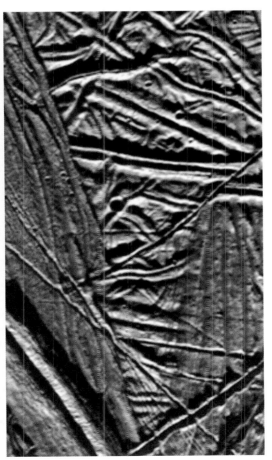

Left:

Sea ice breaking up off the coast of Antarctica may be analogous to the fracturing of Europa's ice-shell crust. (See also photos on page 168.)

Right:

Close-up of ice floes on Europa resembles those seen in the Earth's arctic regions. The icy crust is constantly being split apart while fresh water rises from below and freezes, eventually producing a complex crazy quilt of different patterns.

Europa's surface is fractured by broad fissures such as this one. When water erupted from below and froze into icy squeeze-ups, blocks of surface ice separated and the space between them filled.

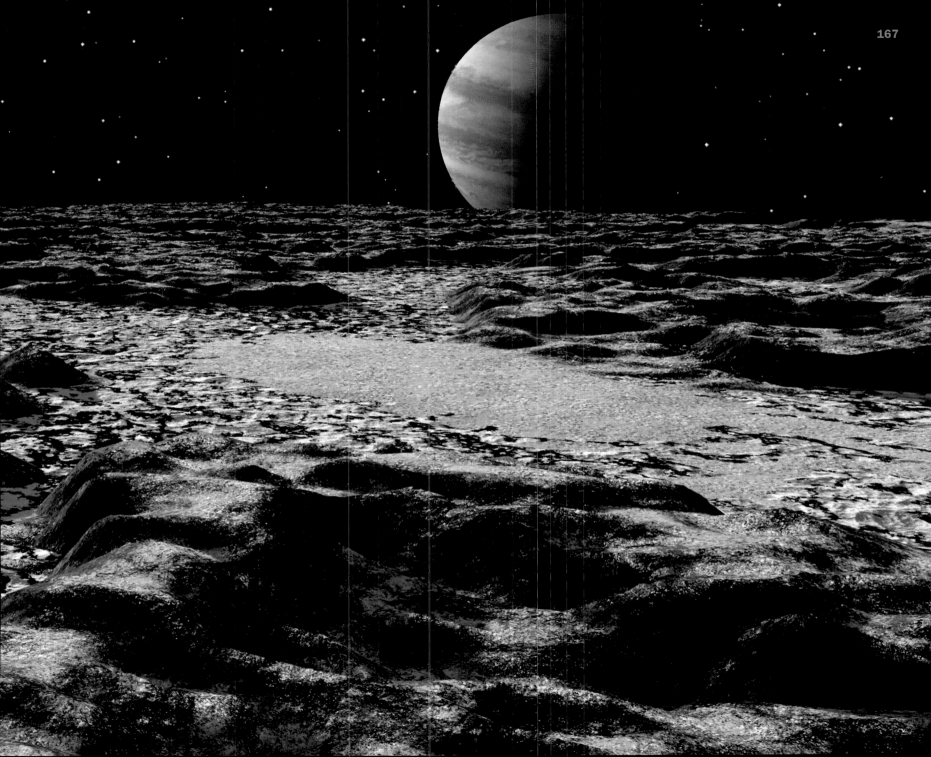

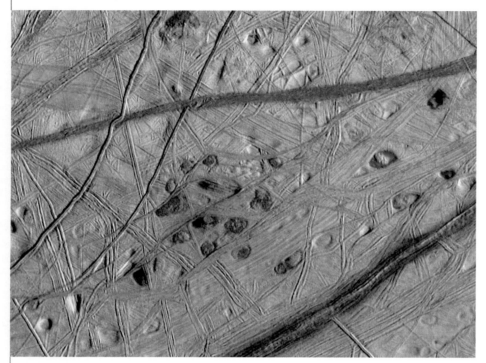

Planetary scientists salivate over the chance to study Europa more carefully. It is perhaps the next-most anticipated destination after Mars. No mission is yet firmly funded, but conceptual studies have looked at the possibility of putting seismometers on the surface to detect tremors in the ice pack, which would allow measurement of the depth to the liquid water underneath. More intriguingly, some researchers have proposed so-called "penetrators"—torpedo-shaped probes that would zap into the ice, leave an antenna package on the surface to transmit signals, then, trailing a cable, penetrate through the ice into the underlying water. Such probes have been used effectively in Earth's Arctic ice, and even rocky sediments. Who knows what they might find in the secret, alien ocean under the Europa's ice?

*T*wo orbital views of Europa clearly reveal how the ice-crust surface has been shattered by fractures into iceberglike blocks and plates. Tannish-brown stains around many fractured areas suggest organic material in the water that erupted from below through the cracks.

Triton
A World Out of Place

eptune's largest moon, Triton, is only a bit smaller than our moon and Jupiter's Europa, but it is as different from each as smooth, icy Europa is from our rock-stewn, cratered moon.

Even before *Voyager 2*'s 1989 exploration of the distant Neptune system, Triton was considered unusual. But, as with other satellite systems, planetary scientists were unprepared for Triton's surprising features.

The main reason Triton was expected to be unusual relates to its orbit. It is the largest moon of Neptune, and it is the only large satellite with retrograde orbital motion (east to west, or clockwise as seen from the north side of the solar system). This means its direction of motion in orbit is "backward," compared to all other major satellites. Its orbit also has an uncommonly high 23-degree tilt off the plane of the planet's equator (see below). Most major moons move over their planet's equator, with 0-degree tilt of the orbit.

All this suggests that Triton's origin is different from that of most other major satellites. Many scientists believe it originated as a separate planetary body, outside the Neptune system, and then was captured by Neptune. In support of this, recent work shows that Triton is quite a bit like Pluto in general properties (see Pluto chapter). Probably there were many Pluto-like bodies in the early outer solar system, and one of them approached near enough to Neptune to be captured into an orbit, which, by a 50–50 chance, was in the "backward" instead of the forward direction.

Such a capture is no easy thing. Triton would have needed to be slowed down, just as it passed Neptune, to go into orbit around the planet instead of sailing on by. Perhaps it was slowed

Satellite of Neptune

Distance from Neptune: *355,000 km*

Revolution: *5 days 21 hours*

Diameter: *2,700 km*

Composition:
two-thirds rock, one-third ices

*T*he relative sizes of Neptune (blue) and Triton (brown) compared to Earth (green) and its moon (yellow). Even though Triton is nearly as large as Earth's moon, it is tiny compared to the planet it orbits.

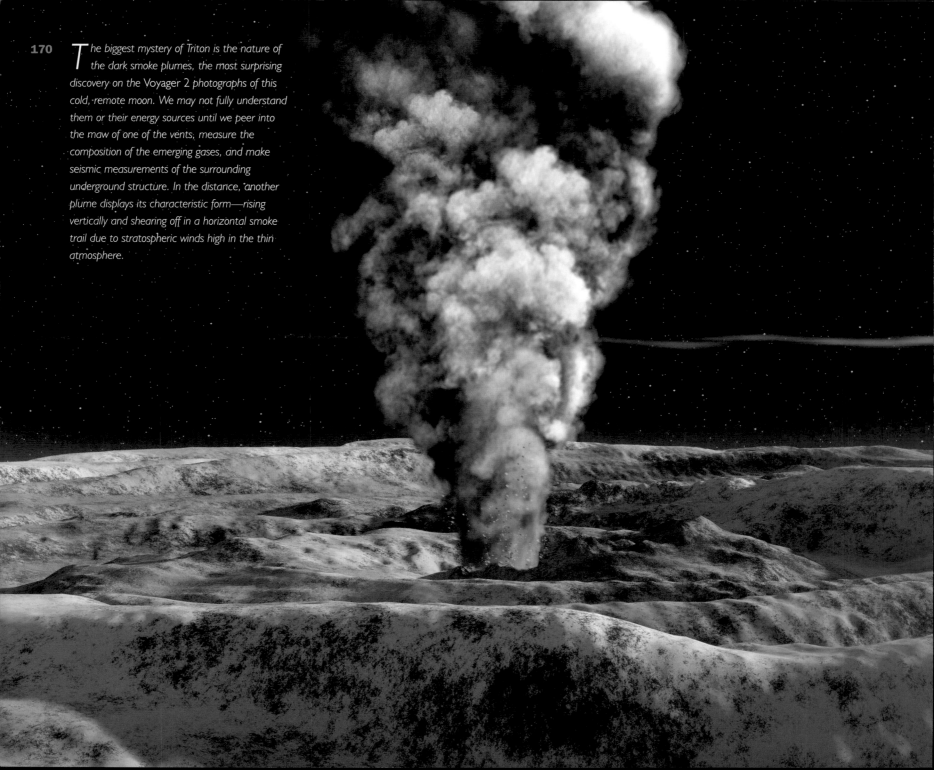

The biggest mystery of Triton is the nature of the dark smoke plumes, the most surprising discovery on the Voyager 2 photographs of this cold, remote moon. We may not fully understand them or their energy sources until we peer into the maw of one of the vents, measure the composition of the emerging gases, and make seismic measurements of the surrounding underground structure. In the distance, another plume displays its characteristic form—rising vertically and shearing off in a horizontal smoke trail due to stratospheric winds high in the thin atmosphere.

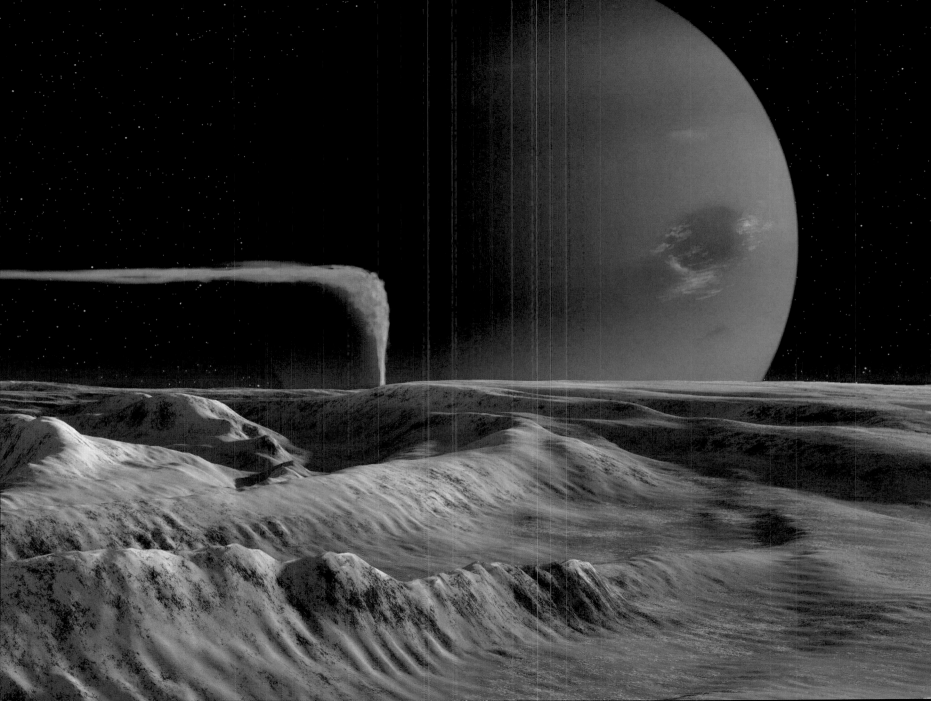

by skimming through the outer part of an extended, primordial atmosphere of Neptune, or perhaps it hit one of the planet's original satellites, smashing it and adding debris to Neptune's system of rings and small moons.

Geyser Surprisers

Another unusual property of Triton attracted attention in 1979, ten years before *Voyager 2's* fly-by. Astronomer Dale Cruikshank, and his colleagues, then at the University of Hawaii, announced that spectroscopic observations through telescopes had revealed faint traces of a thin atmosphere. Modern data indicate the atmosphere, like that of Titan, consists mainly of nitrogen with some additional methanes. Although the atmosphere is barely thick enough to be noticed by an astronaut, it still made Triton only the second satellite (after Titan) known to have a substantial gaseous envelope. Observations indicating possible changes in thin hazes over Triton added to the sense of anticipation as *Voyager 2* approached in 1989. What would the camera tell us? Shouldn't a satellite at Neptune's distance be at last an example of the much-anticipated, geologically dead iceball?

Once again, we were in for a surprise. Not only was a thin haze layer visible above the surface; the surface itself had totally unexpected erupting geyserlike vents, emitting columns of dark smoke that rise vertically as much as 8 kilometers (26,248 feet, a little below the normal height of commercial jets), and shear off in high-altitude winds, making long, horizontal streamers. Instead of an ancient, cratered surface, the *Voyager* pictures revealed a peculiar surface of winding fissures, flat-floored frozen "ice lakes," and knobby-surfaced plains called "cantaloupe terrain," since the texture looked strikingly like the skin of that fruit. The surface seems composed mainly of methane and nitrogen ices, with a seasonal bright winter polar cap

Neptune floats like a blue billiard ball beyond its giant moon Triton, whose unique surface is seen through a very tenuous atmosphere.

of nitrogen frost (frozen nitrogen). In places, the geyser vents are accompanied by black streaks, all running the same direction across the surface; these probably mark deposits of dark dust erupted from the geyser and then blown in a fixed direction by prevailing winds.

Voyager confirmed the existence of methane in the atmosphere but showed that the dominant constituent is nitrogen, as on Earth and Titan. Yet the surface pressure is less than .01 percent of Earth's, and less than 1 percent of Mars's.

Left:

There are few impact craters on Triton, indicating that its unusually textured surface is constantly being reformed. One small, lonely impact crater can be seen at the far right center.

The dark streaks in this Voyager image of Triton are deposits from its geyserlike vents. The streaks all lie more or less in the same direction because the prevailing winds are constant.

Voyager 2 also showed that Triton's surface has a daytime temperature of -235°C (-391°F), the coldest daytime temperature of any world.

The absence of impact craters meant that the surface was relatively young, perhaps only a few hundred million years old. If the surface were older, it would have absorbed more asteroid hits, as seen on the heavily cratered surfaces of other smaller moons of Neptune and Uranus.

What energy source could have provided heat to resurface a cold ice world so far from the sun? Triton's unusual history of capture by Neptune may provide the answer. Triton's initial orbit after capture was most likely elliptical. Tidal forces from Neptune would have circularized this orbit within a few hundred million years. According to calculations in the 1980s by Washington University researcher William McKinnon, Caltech dynamicist Peter Goldreich, and others, accompanying tidal forces could have heated Triton as strongly as modern-day Io and kept its interior molten for a billion years. Resulting eruptions would have created a fresh surface.

But does this explain today's smoking vents? If the capture occurred when the planets formed, 4.5 billion years ago, Triton should be cool by now. Did the capture occur more recently? Or does Triton have unknown energy sources? No one knows.

Triton, last of the large worlds to be explored by space probes, gives one more proof of the unexpected fact revealed to humanity in the 1980s: The worlds of the solar system are surprisingly distinct in their personalities.

Pluto and Charon

A Double World

Lower right:

The Earth (green) and its moon (yellow) compared in size to Pluto (pink) and Charon (gray).

Opposite page:

We are hovering behind the unlit night side of Charon. The sun (lower left) is a virtually heatless point of dazzling light, 1,500 times fainter than when seen from Earth.

Charon and Pluto swing through space like a pair of ponderous waltzers. Locked face-to-face, neither ever appears to move from its place in each other's sky. Only the stars in the background seem to move, coming full cycle every 6.26 Earth-days. Charon, in proportion to Pluto, is an enormous moon, about half the size of the planet; about 19,000 kilometers (11,800 miles) separate the two.

Pluto was discovered in 1930 by Clyde Tombaugh, an astronomer at Lowell Observatory in Flagstaff, Arizona. It was immediately hailed as the ninth planet, the only planet to have been discovered in the twentieth century—a designation it has maintained in astronomy textbooks until today. However, some interesting properties of Pluto have recently come to light, calling into question whether or not it shares the same mechanisms of origin and evolution as the other planets.

For one thing, Pluto is smaller than any other planet—smaller even than our moon. It is only the sixteenth-largest body in the solar system. Present estimates put it close to 2,300 kilometers (1,428 miles) in diameter, only two-thirds the size of the moon, and less than two and a half times the size of the largest asteroid, Ceres. Ceres was first classified as a planet, but later downgraded because it was so small and because it is accompanied by numerous smaller objects in nearby orbits. Pluto may undergo the same fate.

Pluto is now known to be only one of many modest-sized bodies on the fringes of the solar system. Many comet nuclei are located in Pluto's realm, but they are typically only 1 percent the size of Pluto. In 1977, astronomers discovered a larger body in the region between Uranus and Saturn—the unusual object Chiron (pronounced KYE-ron), about 10 percent as big as Pluto. Starting in 1992, they began to observe other interplanetary bodies in the region of Pluto. This meant that Pluto is not a unique worldlet, but

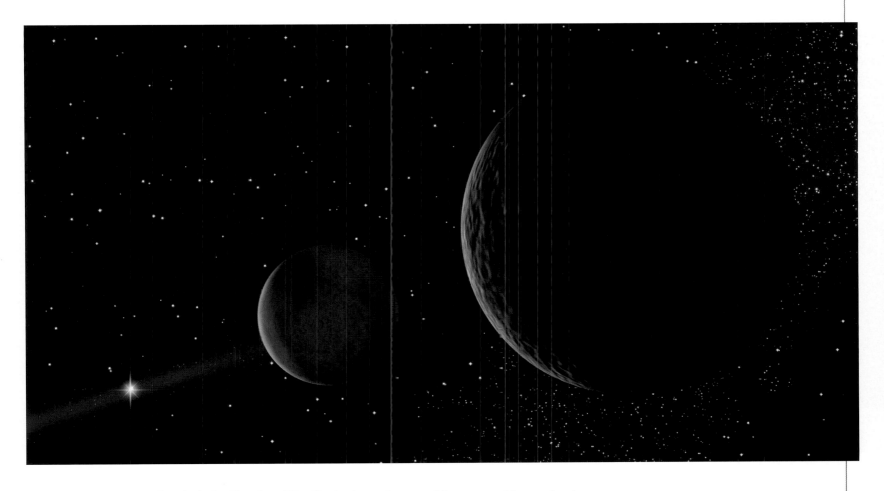

rather only the largest of a whole flotilla of small bodies in the region near Neptune and beyond, just as Ceres is only the largest of the asteroids. Astronomers Dave Jewitt and Jane Luu, at the University of Hawaii, who cataloged many of the first such bodies, even suggested the name Plutinos for them, recognizing that they could be considered little Plutos. Today, these objects are referred to more officially as the Kuiper Belt, as we will discuss in later chapters. The largest of these objects that we know about are estimated to have diameters around half to two-thirds the size of Pluto. Thousands more small ones are believed to exist. Pluto, like Ceres, is not unique, but merely the largest of its clan.

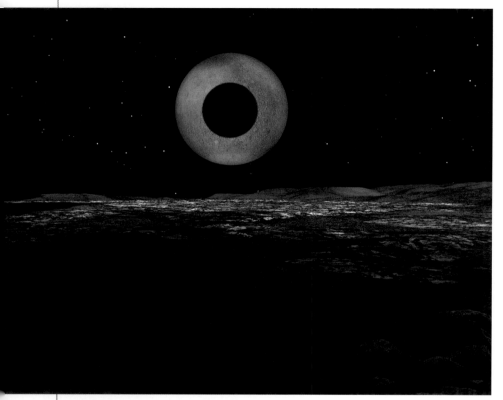

The large size of Charon compared to Pluto is revealed in this strange view, seen as we stand on the surface of Pluto's moon. The sun, which is behind us, is casting Charon's shadow onto the planet, creating a giant bull's-eye in the sky. The shadow is much sharper than Earth's shadow on the moon during a lunar eclipse because the distant sun acts almost like a point source of light.

Unlike "true planets," Pluto and Charon have orbits crossing the orbits of other planets. Pluto sometimes comes inside the orbit of Neptune. In fact, Pluto was closer to the sun than Neptune was during the 1990s.

Thus, given its small size, its neighbors, and its orbit, Pluto is best viewed not as a planet but merely as the largest known example of the interplanetary Kuiper Belt objects of the outermost solar system.

In 1978, astronomers James Christy and Robert Harrington at the U.S. Naval Observatory discovered that Pluto has a satellite, which they named Charon (pronounced *CARE-on*) after the mythical Pluto's underworld associate.

A Curius Place

With a diameter of 1,170 to 1,210 kilometers (727 to 751 miles), the satellite is nearly half Pluto's size. This is unique in the solar system. Our own moon is only a quarter of Earth's size, and all other moons are much smaller, only a few percent or less of their "parent" planet's size. Most researchers conclude that Charon is not a homegrown moon, accreted in orbit around Pluto. It may have been captured or, more likely, generated in a giant collision between Pluto and some interplanetary interloper—meaning that it repeated the violent birthing of the Earth-moon system.

Whatever Charon's origin, it makes Pluto a more interesting place—a true double world. Viewed from afar, Pluto and Charon do a stately dance around each other every 6.4 days—like a ballet couple performing a slow pas de deux.

Viewed from Pluto's surface, Charon offers the largest angular size of any moon seen from its planet. From Pluto, Charon looks about 4 degrees wide, eight times the size of a full moon on Earth.

In this sense, Charon makes up for the lackluster appearance of the sun as seen from Pluto. Averaging some forty times our distance from the sun, Pluto is so remote that the sun's disk seen from its surface covers less than a minute of arc—so small that it looks like a distant streetlamp. Its light is only one fifteen-hundredth the brightness of sunlight on Earth, but is still 250 times

brighter than the light of a full moon on Earth. The sun's pale light warms frigid little Pluto to a daytime temperature measured at a forbidding -237°C (-395°F). On Pluto, it is easy to believe that the sun is just one of the many stars in the night sky.

The fact that Pluto has its own satellite might seem to suggest that it merits planetary status after all. However, studies showed that at least seven out of the first five hundred discovered Kuiper Belt objects—the other interplanetary bodies in Pluto's regions—also have satellites. Once again, Pluto and its moon seem merely to be the largest example of a host of other small worldlets on the outskirts of the solar system.

The mean density of material in the Pluto-Charon system is higher than that of the ice moons of Saturn and Uranus. The figures indicate the two worlds' aggregate composition is about 70 percent rock and only 30 percent ice. This is odd, because Pluto and Charon are farther from the sun and might be expected to be icier. Washington University researcher William McKinnon attributes the ice loss to the large collision thought to have created Charon. If this collision occurred after Pluto's rocky material settled to the planet's center, then the explosion blew off mostly the outer icy material. Some was blown clear out of the system, depleting the system of ice.

In this scenario, Charon would have been made mostly of the icy debris, while Pluto would have retained more of the rocky material. This is supported by recent evidence from the Hubble Space Telescope, indicating that Charon has lower density and is more ice-rich than Pluto.

No spacecraft has visited Pluto and Charon, but nature came to astronomers' aid in the 1980s. Due to the changing perspective as Pluto moved around the sun, a series of eclipses began in 1985, in which Charon passed behind Pluto and then in front of Pluto, as seen from Earth. This allowed scientists to measure many of their properties. For example, the length of time it took for Charon to move behind Pluto helped establish Pluto's size. Spectra taken when Charon was hidden from sight allowed scientists to distinguish between Pluto's spectrum and Charon's, revealing clues about the surface composition of each individual world.

If both Pluto and Charon have ice surfaces, wouldn't you expect the ices to be the same? Observations from Mauna Kea Observatory in Hawaii, from 1976 to 1992, showed that Pluto is covered mostly with frozen nitrogen ice, mixed with a small amount of frozen methane and carbon monoxide. However, observations of Charon show that the methane component is virtually

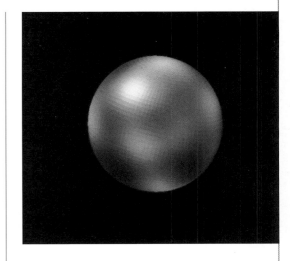

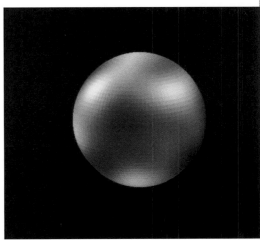

*P*luto is too small and distant to be resolved as a detailed disk, even by the Hubble Space Telescope. However, scientists have been able to take HST views in sequence as Pluto rotates, and then reconcile them into computer-generated views indicating dark regions with brighter areas.

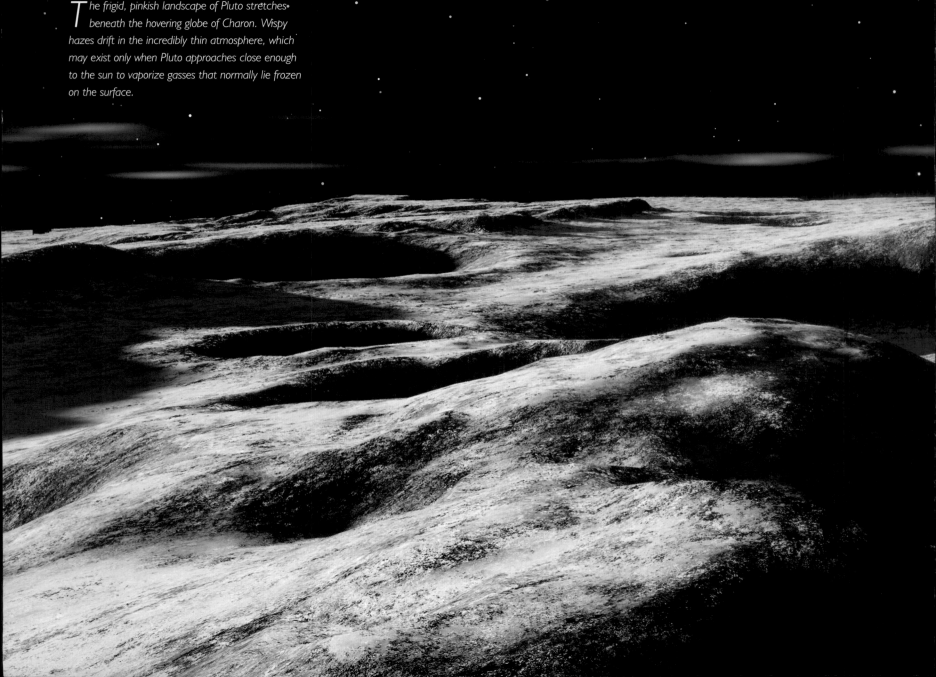

The frigid, pinkish landscape of Pluto stretches beneath the hovering globe of Charon. Wispy hazes drift in the incredibly thin atmosphere, which may exist only when Pluto approaches close enough to the sun to vaporize gasses that normally lie frozen on the surface.

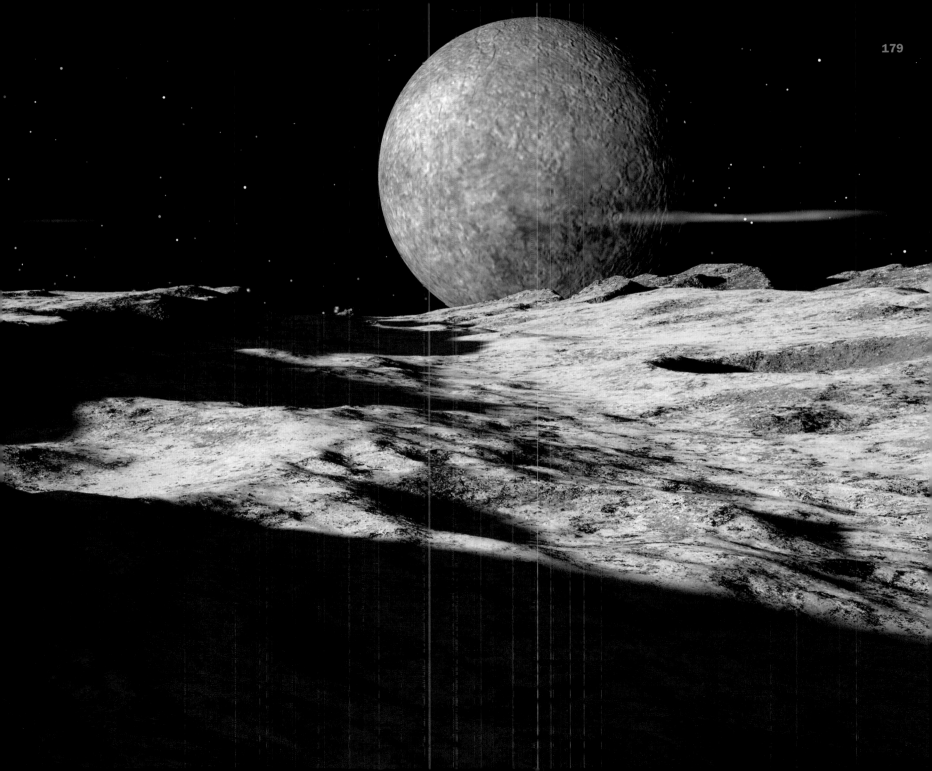

absent there, while frozen water is seen in its place. Pluto's surface is 50 percent brighter than Charon's on average and is faintly orange; Charon's surface is a neutral dark gray.

Why the differences?

A Cosmic Transfer

The current interpretation involves the slow loss of gas molecules from the surfaces of each world, due partly to meteorite impacts and partly to normal sublimation of the ice. Suppose Pluto and Charon started with equal components of frozen water and methane. The methane molecules, liberated by impacts or sublimation, are lighter and faster-moving than the water molecules, and thus would escape more quickly from Charon, with its weaker gravity, than from Pluto. As they fly off into space, some would hit Pluto and accumulate there. In other words, low-gravity Charon is constantly losing its methane, relative to its water and dark soil.

As pale as a moonlit skull, pinkish Pluto hangs in the sky of frigid Charon, its giant moon and only companion as it ponderously rolls through the comet-haunted darkness at the edge of the solar system. So close do the two huddle that Pluto appears 17 times the size of a terrestrial full moon.

Over eons of "sandblasting" by small meteorites, Charon's surface has been depleted of methane ice, leaving water ice and dark soil behind. Amazingly, Pluto's surface has actually accumulated some of Charon's methane molecules, making it relatively enriched in methane. A cosmic transfer has gone on between these two worlds as they dance around each other.

Pluto's orbit is so elliptical that the ice is warmed significantly more when Pluto is closest to the sun than when it is farthest away. At maximum heating (which is still incredibly cold by our standards), more ice sublimes and creates a transient atmosphere that may reach an appreciable fraction of the surface pressure of Mar's atmosphere. As on Triton, a major constituent of this atmosphere is nitrogen. But during Pluto's "winter," when the planet is far from the sun, the gas recondenses into ice and Pluto seems almost as airless as the moon.

A similar cycle would have worked on initially icy Charon, but Charon's gravity is too weak to hold on to the gas in the form of an atmosphere. As described above, Charon's gas molecules leaked off into space, and some fraction of them transferred to Pluto.

This process may have ended on Charon, but it continues on Pluto. In this sense, Pluto acts like a giant comet, producing a gas halo at its closest approach to the sun.

The seasonal recondensation of the atmosphere into fresh frost on the surface may help explain why Pluto is so much brighter than virtually airless Charon.

Intriguingly, Pluto (or the Pluto-Charon system) and Triton may be linked in terms of their origins. Pluto and Triton have similar sizes and densities. They both probably have rocky cores and mantles of frozen water, and surface frosts involving methane, ammonia, carbon dioxide, and water in various proportions. Pluto is classed as a planet, and Triton as a satellite, but both should probably be visualized as unusual interplanetary bodies, Triton having been captured into its present Neptunian orbit.

If you are offended by downgrading Pluto to a cometlike body, remember that it is smaller than our own moon and that it is literally interplanetary, as its orbit crosses Neptune's; it can pass between Neptune and Uranus. In this sense, Pluto is also reminiscent of the still-smaller icy world Chiron, which orbits between Uranus and Saturn, and which we will discuss later.

Instead of saying that our solar system has nine planets and a number of lesser moons, it now seems more realistic to say it has eight planets and a number of icy Pluto-, Triton-, Charon-, and Chiron-class worlds, not to mention the host of still smaller asteroids and comets.

Titania and Oberon
Largest Moons of Uranus

Below:

Titania's cratered surface and meandering canyons were photographed by the Voyager spacecraft.

Right:

The best image of Oberon taken by Voyager.

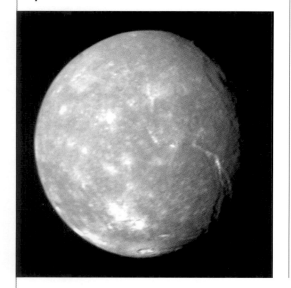

Titania and Oberon are the largest of Uranus's many moons and the outermost two of the 5 five large moons discovered from Earth.

The diameters of Titania and Oberon are respectively 1,580 and 1,520 kilometers (981 and 944 miles), compared to a range of 470 to 1,170 kilometers for the next biggest three moons and a mere 50 to 150 for the ten small moons found by *Voyager 2*.

The surfaces of these two moons are moderately bright and heavily cratered. Spectroscopic studies indicate that they are composed of a mixture of water ice and darker soil, probably carbonaceous in character. The geology of these moons is not very distinctive—they resemble some of Saturn's moons. (For once, we encounter worlds that do not seem unique!) Some fractures arc across the side of Titania that was photographed by *Voyager 2* cameras, and some of Oberon's craters display dark floors, as if they were flooded by dirt-laden melted ice.

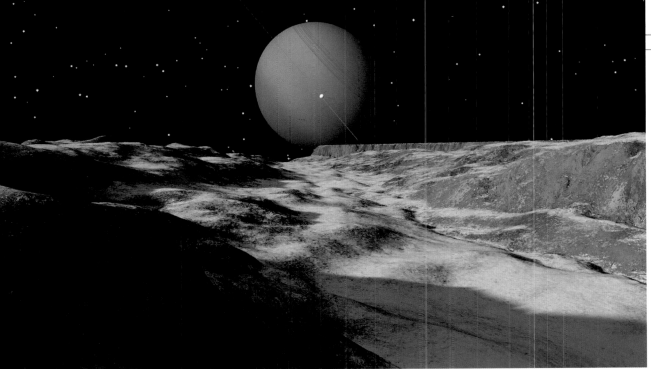

A view of Uranus from within one of the great rifts that scar the surface of the tiny moon Titiania. The rings are seen edge-on because the satellites all orbit in the plane of the ring system.

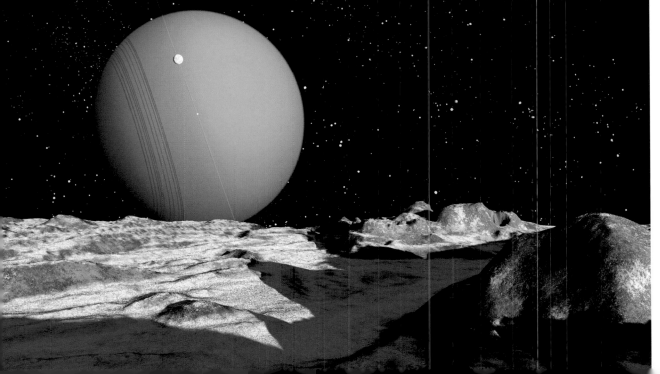

A view of the crescent-lit Uranus from the snowfields of Oberon. Uranus covers 5 degrees in Oberon's sky—about 10 times the size that our moon appears from Earth. One of the inner moons can be seen in front of the planet and rings.

Rhea

Crater-Crowded Moon of Saturn

Right:

Two Voyager views of the heavily cratered surface of Rhea. Some of the craters are as large as 75 kilometers (47 miles). Many have sharp rims and appear to be fresh, while others are shallow and degraded and are probably very old. The smallest features seen in these photos are about 2.5 kilometers (1.6 miles) across.

Rhea is a little less than half the size of our own moon—only 1,530 kilometers (950 miles) in diameter. It is in the middle of Saturn's satellite system, one in from Titan. Spectroscopic observations show that it has no atmosphere at all and that its surface is a bright material reflecting 60 percent of the sunlight falling on it—mostly frozen water and a small amount of darker soil. On a scale of inches, this surface, eroded by meteorites' sandblasting, may look like creamy white, finely crushed ice.

Close-up photos taken by *Voyager 1* reveal a wilderness of craters; Rhea is one of the most crater-crowded worlds in the solar system. It looks as though the bombardment has gone on at random since the formation of the planets 4,500 MY ago. The surface appears as if it has been hardly disrupted by internally generated geologic activity or tidal heating. It lacks Ganymede's swaths of grooves, Europa's resurfaced ice plains, Io's volcanoes, and Triton's geysers. Nonetheless, there are a few narrow, sinuous fissures and ragged rays of bright white material, like sprays of spilt kitchen flour. Some investigators think these may be frost deposits from water vapor emitted along narrow fractures.

The density of Rhea is low, only 1.3 grams per cubic centimeter, compared to densities of 1.0 grams per cubic centimeter for pure ice and around 3 grams per cubic centimeter for rock. The numbers imply that Rhea is a giant snowball! Saturn's moons, generally, have the lowest density of any moons. In this zone of the solar system, the world-building material was mainly ice, not rock. Rhea gives us a good opportunity to learn about the evolution of a fairly large world whose geology is controlled by frozen water instead of familiar lavas and soils.

The remote calm of the icy moons of the outer solar system is shattered on rare occasions by collisions with interplanetary debris. Though rare, such collisions are inescapable as comets and asteroids circulate among the planets. Here, a flash of light illumines the night side of Rhea as a bit of cometary material crashes onto the surface, adding one more crater to the heavily cratered ice world.

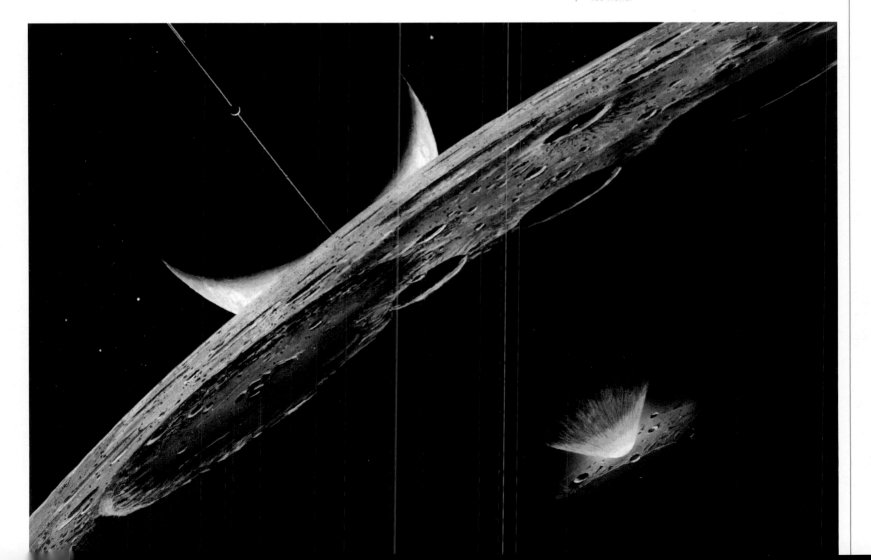

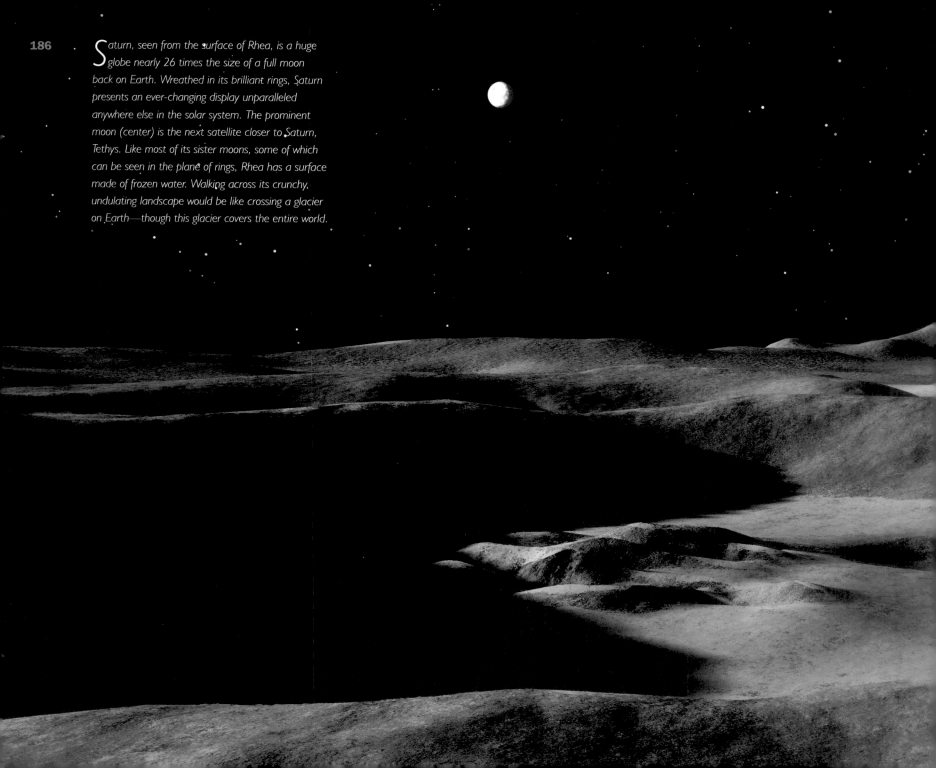

Saturn, seen from the surface of Rhea, is a huge globe nearly 26 times the size of a full moon back on Earth. Wreathed in its brilliant rings, Saturn presents an ever-changing display unparalleled anywhere else in the solar system. The prominent moon (center) is the next satellite closer to Saturn, Tethys. Like most of its sister moons, some of which can be seen in the plane of rings, Rhea has a surface made of frozen water. Walking across its crunchy, undulating landscape would be like crossing a glacier on Earth—though this glacier covers the entire world.

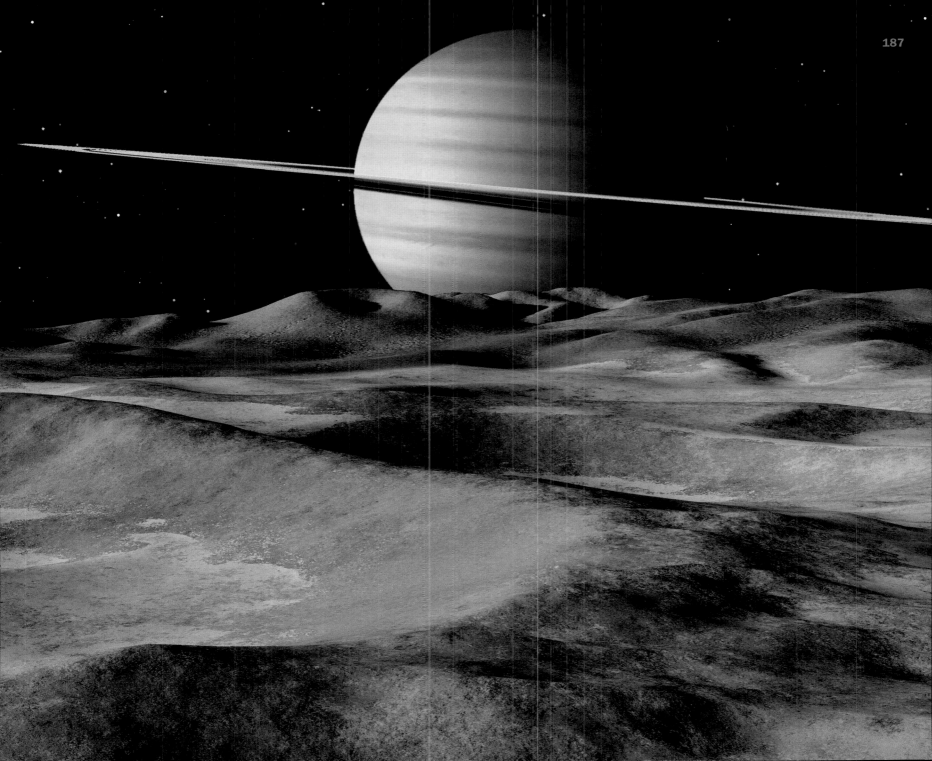

Neptune's orbit

Kuiper belt

Oort cloud

Sedna
At the Outer Limits

I n 1930, while Clyde Tombaugh was searching the outermost parts of the solar system for a hypothetical tenth planet, he discovered Pluto, the small "planet" that usually lies just outside the orbit of Neptune—but whose orbit crosses inside Neptune's orbit at some points. For years the story seemed to end there. However, an entirely separate and parallel thread emerged in recent years. The outermost solar system, beyond Neptune, turns out to be full of small bodies, some approaching Pluto in size.

The discovery started with the work of Dutch astronomer Jan Oort, who, around 1950, was studying comet orbits. He recognized that many comet orbits loop from the inner solar system out beyond Neptune and Pluto for enormous distances. He then realized from the number of comets passing into the solar system that thousands and even millions of inactive cometary bodies must exist far beyond Neptune. Neptune's mean distance from the sun is 30 astronomical units (i.e., thirty times as far as Earth's mean distance from the sun); Pluto's mean distance is 40 AU, but Oort found that a swarm of comets runs from about 20,000 AU to as much as 50,000 AU from the sun. This swarm of bodies is called the *Oort cloud,* which can be visualized as an extended, spheroidal swarm of icy objects swarming around the solar system like bees. More recent discoveries, including the discovery of Sedna, suggest that the inner parts of the Oort cloud may be closer than Oort thought, as close in as 1,000 AU. Individual objects in the Oort swarm are too far from the sun to be seen, but weak gravitational forces (even from nearby, passing stars) can deflect them into the inner solar system where we see them as comets.

This thread of work was further spun out in the 1950s when Dutch-American astronomer Gerard Kuiper, who studied the origin of the planets, hypothesized that another swarm of primitive planetesimals was likely to be left over, just outside Neptune's orbit, after the formation of the planets. These asteroidlike or cometlike bodies were too widely scattered ever to aggregate into a planet, according to Kuiper's estimates, and should still exist today just beyond Neptune. Starting in 1992, imaging equipment on large telescopes became so sensitive that some of these small bodies began to be discovered, principally by astronomers David Jewitt and Jane Luu at Mauna Kea Observatory in Hawaii. This Neptunian asteroid belt came to be known as the Kuiper Belt. Bodies in this belt may be smaller versions of Pluto, and were initially called "Plutinos" by Jewitt, but are more commonly called Kuiper Belt objects (or sometimes KBOs by the more acronym-prone astronomers.)

Big Body

Instruments are improving at such a rate that new, fainter, and more distant Kuiper Belt objects are being found each year. Currently, the largest known such body is the one discovered in 2003. Its temporary discovery designation is 2003 VB 12, but the unofficial name Sedna has been proposed, and is likely to be officially adopted once the orbit is well-measured. "Sedna" refers to the Inuit goddess of the sea, imagined as living in the frigid deeps of the Arctic Ocean.

Sedna is fascinating for a number of reasons. Its diameter is estimated to be between 1,500 and 1,700 kilometers (932 to 1,056 miles)—the largest body so far found in the Kuiper Belt region, and perhaps two-thirds the size of Pluto. As mentioned briefly in the chapter on Pluto, if such bodies had been known in 1930, Pluto would never have been considered a full-fledged planet. Sedna also has a spectacular orbit. It is much more distant than the usual Kuiper Belt object—so distant that it has been called an "inner Oort cloud object" as opposed to an "outer Kuiper Belt object." Its closest approach to the sun is at 76 AU, but it loops out to a reclusive 988 AU on its highly elliptical orbit—twenty times Pluto's greatest distance.

Sedna's composition and surface nature are uncertain because it is too far away to be seen clearly. As with other outer solar system small bodies, it is believed to be composed of a mixture of ice and dark, dusty soil. The ice includes not only frozen water (H_2O) but also frozen methane (CH_4) and frozen carbon dioxide (CO_2). The soil is likely to be carbon rich, again as with other outer-solar-system objects. Observations of nearer, brighter objects, in the region of the Kuiper Belt, indicate that many of them have a brownish or even reddish color. This may be due to the intrinsic color of the carbon compounds, or possibly chemical reactions that create reddish organic compounds (i.e., compounds made from molecules with the C-H, carbon-hydrogen, bond). The reactions are likely to occur when high-energy cosmic rays hit the CH_4-bearing ices. Temperatures at these distances are so low, however, that no one has any expectation that the organic molecules precipitate any biological processes.

Pinkish Sedna orbits in the distant, comet-haunted darkness at the frontier of the solar system.

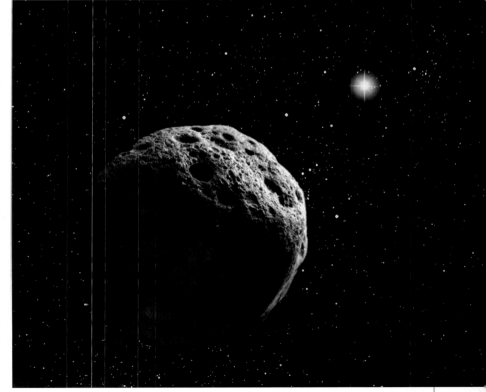

2004 DW
Pluto's Rival

The object known as 2004 DW is far more typical of the Kuiper Belt than Sedna, in terms of orbital position. Its odd name is a catalog code, specifying that it was one of a number of asteroidlike objects discovered in 2004. As with all objects in the asteroid catalog, like Sedna, it will get a more popular wordname, suggested by its discoverer and officially adopted by the International Astronomical Union—but only after its orbit is carefully measured. As of this writing, only the catalog number, 2004 DW, is official.

The surface compositions of the faint, remote objects of the Kuiper Belt are poorly known. However, observations of a neighboring Kuiper Belt object, 1993 SC, by Arizona researcher Robert H. Brown and colleagues using state-of-the-art equipment at the Mauna Kea observatory in Hawaii indicate that the dominant ice on the surface is frozen methane (CH_4), probably with additional frozen nitrogen, and with a reddish-brown color possibly produced by organic (CH-bearing) molecules derived from the methane. In terms of the methane/nitrogen evidence and reddish tinge, all derived from the spectra, there is a similarity to Pluto and to Neptune's moon Triton—both of which reside in the same part of the solar system.

2004 DW is a classic Kuiper Belt object, meaning that its orbit lies close to Pluto's realm (as opposed to the much more distant realm of Sedna, for example). 2004 DW's closest approach to the sun is 31 AU and its farthest distance is 48 AU. Compare these figures to the very similar figures for Pluto: 30 AU and 49 AU. The comparison shows that 2004 DW moves in the same vicinity as Pluto. The inclination of the orbit of 2004 DW to the plane of the solar system is 21 degrees, compared to a similar 17 degrees for Pluto. This compare to a well-behaved

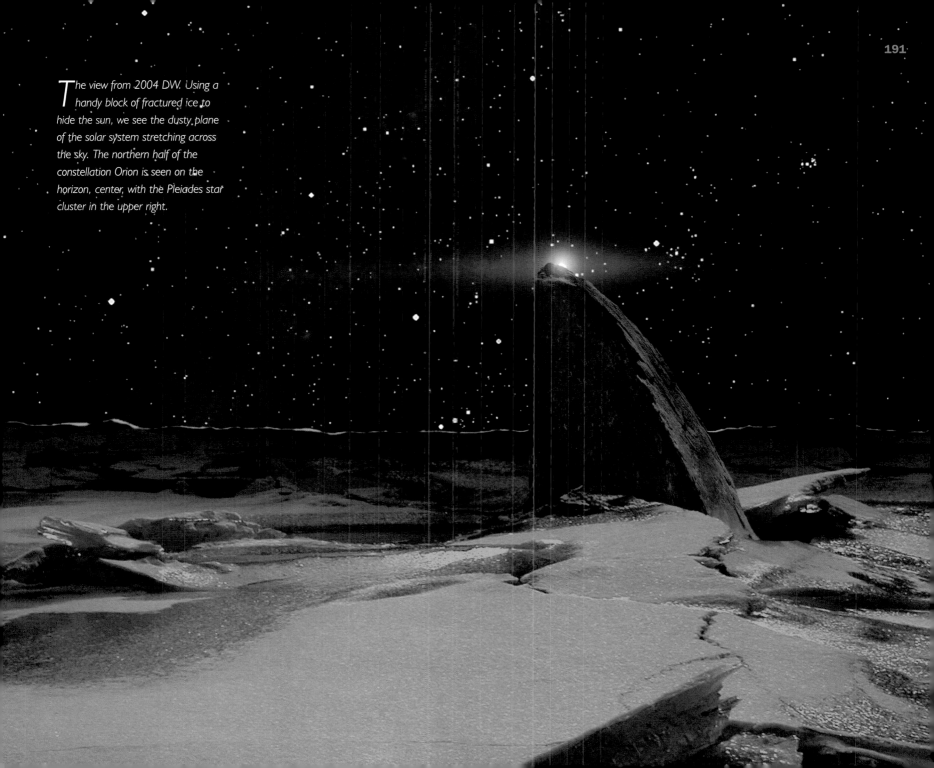

The view from 2004 DW. Using a handy block of fractured ice to hide the sun, we see the dusty plane of the solar system stretching across the sky. The northern half of the constellation Orion is seen on the horizon, center, with the Pleiades star cluster in the upper right.

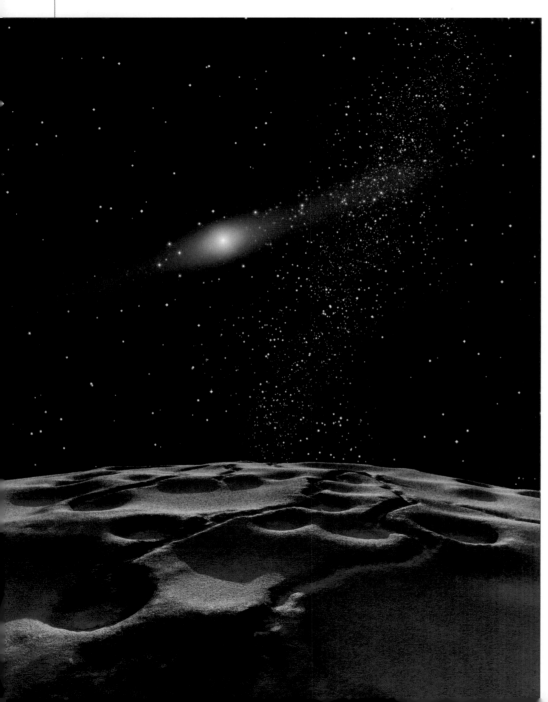

1.7 degrees for nearby Neptune; no other planet strays more than 7 degrees out of the solar system's plane.

2004 DW is a sizable object. Yet from Earth, it appears only as a faint point of light, and astronomers estimate the size by using assumptions about how much sunlight it reflects. The outer-solar-system objects whose reflectivities have been measured turn out to be dark, apparently due to the abundance of brownish-black, sootlike carbon-rich compounds in that region of the solar system. Assuming this low reflectivity, the diameter of 2004 DW is between 1,000 and 1,500 kilometers (621 to 932 miles), roughly 43 to 65 percent of the diameter of Pluto itself.

These figures further emphasize that Pluto is more accurately called "King of the Kuiper Belt" than the "ninth planet." It is merely the largest example (so far known) of the myriad interplanetary objects in that Neptunian region of the solar system, objects including 2004 DW and others nearly as large, such as Quaoar (listed at about 1,000 to 1,400 kilometers diameter) and Ixion (listed at 900 to 1,230 kilometers diameter). One of the earlier ones discovered, Varuna (listed at about 900 kilometers diameter), was given the special catalog number 20,000. This number is impressive—it means that more than 20,000 asteroids have now been discovered since January 1, 1801—the fateful night when the Italian observer Giuseppe Piazzi discovered the first known interplanetary body, asteroid number 1, otherwise known as Ceres.

Quaoar is a typical large Kuiper Belt Object. As its great distance from the sun, light levels are low, and stars (including the Milky Way) would be prominent.

Survival of the Biggest

The same description raises another interesting point. Think about the process of planet formation, outlined at the beginning of this book. Small bodies collide with each other and aggregate into bigger bodies. As small ones disappear into the bulk of big ones, they are commemorated only as craters on the surfaces of their hosts. In any zone of the solar system, the second-biggest body—if it grows too large—is always a threat to the biggest local body. If it grows too large, it could collide with the biggest body, smash it, and restart the whole process. In a sort of planetary Darwinian competition, the biggest bodies gradually consume the smallest, sweeping the solar system free of debris.

In the case of Earth, the planet is believed to have been hit in its first 50 MY by something nearly the size of Mars (53 percent of Earth's size), blowing off enough material to make the moon. In the Kuiper Belt, as well as the main asteroid belt between Mars and Jupiter, the growth process was never completed, so we can see the preserved, fossil remnants of this process. In the case of Pluto, we actually see a second-largest body, 2004 DW, probably roughly half as big as the "planet." In the case of the main asteroid belt, as we will see, the second-largest body is 55 percent the size of the largest asteroid. Taking all these cases together, we see an intriguing suggestion that nature allowed the second-biggest body to grow to a size around half the diameter of the biggest body

In this sense, 2004 DW was truly a rival to Pluto. As we discussed already, Pluto may have suffered a collision large enough to blow off material and make its satellite, 1,190-kilometer Charon. If the collision had destroyed Pluto entirely, 2004 DW could have become the largest body in that zone. As human sociology and planetary evolution played out their roles, Pluto came to be listed as a "planet" and 2004 DW went down in obscure catalogs as one of many Kuiper Belt objects. But in planetary terms—to paraphrase Marlon Brando's famous line of dialogue in the film *On the Waterfront*—2004 DW "coulda been a contender." Had a few random conditions been different, 2004 DW might have grown into the largest Kuiper Belt object, or Pluto might have been discovered in the same month as 2004 DW. The whole semantic argument about whether Pluto is a planet might have been avoided, and our conception of the solar system might have been different.

Iapetus
The Two-Faced Moon of Saturn

This photograph of Iapetus, taken at a distance of 3.2 million kilometers (2.0 million miles) by Voyager 1, dramatizes its amazing asymmetry. The dark portion is not the night side, but rather a sunlit view of the side covered by black soil. Iapetus's leading hemisphere is to the left and is four or five times darker than its other hemisphere, an asymmetry first noted from Earth.

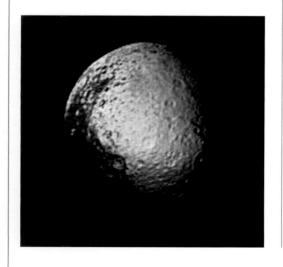

Iapetus (pronounced *eye-AP-i-tus*), an outer satellite of Saturn, has been a puzzle since its discovery in the 1600s. In 1671, the Italian-French observer Jean-Dominique Cassini was astonished to find that he could see the 1,440-kilometer (894-mile) moon when it was on one side of Saturn, but not when its orbit carried it around to the other side of the planet. Later observations revealed why. Like our own moon, and indeed most satellites, this 1,440-kilometer moon keeps one face toward its parent planet. Iapetus's trailing hemisphere, which faces Earth when it is on one side of Saturn, is as bright as ice and very visible. But the leading hemisphere is only one-fifth as bright—as dark as bare rock or sooty dust. It is simply too dark and faint to have been seen in early telescopes.

Iapetus is a world divided. One side is surfaced with frozen water, the other with blackish, rocky material. The boundary between the two is ragged but sharply defined, as seen in the photo at left. From either the bright or the dark part of the Saturn-facing side, the ringed planet provides a magnificent sight: a pale yellow ball, four times larger in angular size than a full moon back on Earth, surrounded by dazzling white rings. With the exception of even more distant Phoebe, Iapetus is the only one of Saturn's large moons that allows the visitor to see the rings as a wide band, rather than as a thin white line. This is because Iapetus's orbit is tipped almost 15 degrees, so that it passes well above and below the plane of the rings. Traveling across Iapetus, we see Saturn above a landscape of rolling ice. Then, suddenly, we cross the border into the other hemisphere, and Saturn seems to glow even brighter in contrast with Iapetus's dark brownish soil.

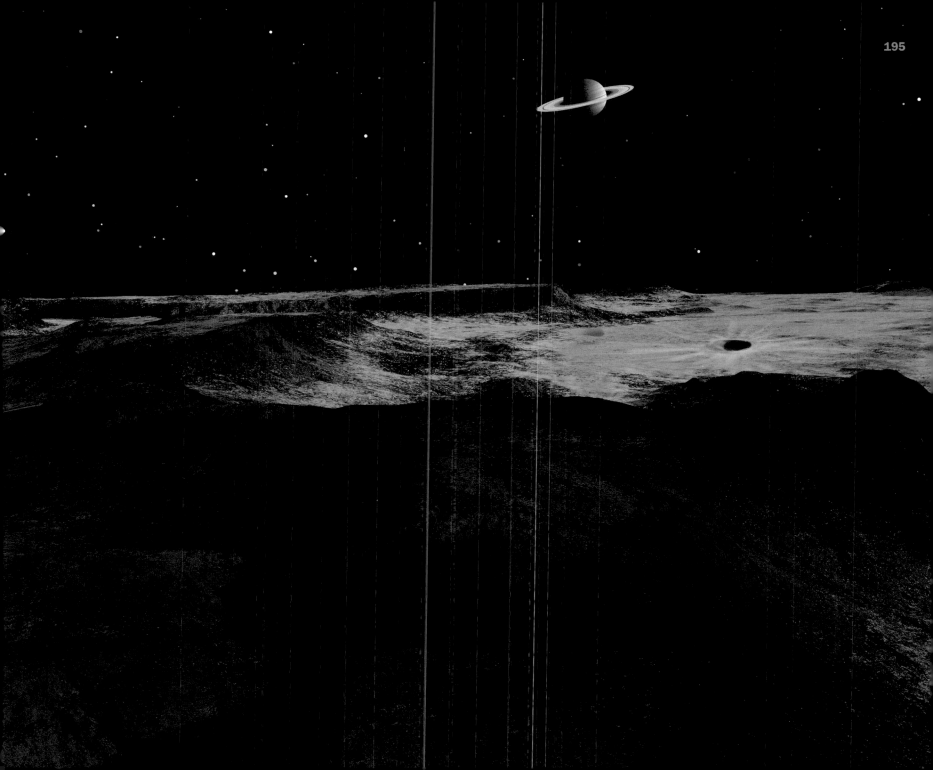

Right:

The view from near Ariel.

Below right:

A towering peak rises from the floor of a large, frost-filled crater on Umbriel.

Below:

In its closest approach to Umbriel, Voyager captured this image of the dark, cratered moon. Bright patches near the pole may be freshly condensed ice.

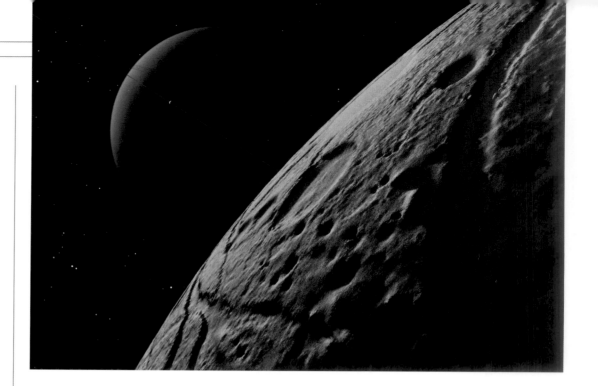

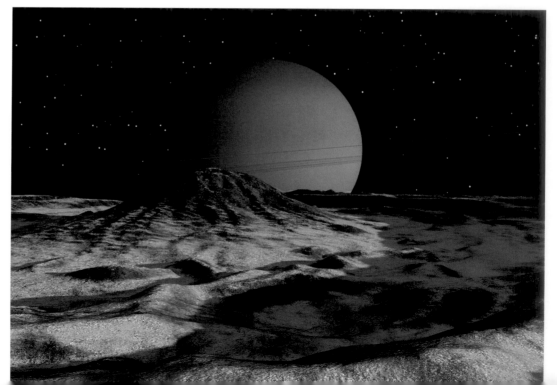

Dione and Tethys
Midsized Moons of Saturn

Dione and Tethys, along with their larger sister, Rhea, are perhaps the most "typical" moons of Saturn—if such a diverse system can be said to have typical members. Their diameters are 1,120 and 1,048 kilometers (695 and 651 miles), close to the 1,000-kilometer (621-mile) cutoff below which most worlds become too small to develop much distinctive, internally generated geologic activity. They are bright, covered with water-ice, and heavily cratered.

Their only remarkable features are patchy areas of darker tone and some swaths of bright material that seem draped across the craters, like a thin, lacy veil. The darker areas are probably regions of soil concentration, and the bright swaths may be frost deposits, although the cause of the brighter and darker areas is really not understood. Fractures have created a few sizable canyons, but geologically old impact craters dominate the landscape. In sum, these worlds seem less complexly evolved than most others we have considered so far. This is in keeping with our rough rule of thumb, that smaller worlds are less heated and less modified by internally generated geologic forces than larger worlds.

Above:

From the Voyager spacecraft, Dione was photographed against the pale clouds of Saturn (left) and against the black background of space (right).

Left:

Large impact craters dominate this view of Dione. The bright radiating pattern may consist of ice deposits along fissures.

_T_wice during Saturn's 29-year trip around the sun,
the sun is lined up with Saturn's ring plane and
satellites. During this "season," the satellites can
eclipse one another. In this view from the north pole of
Dione, we see the next inner satellite, Tethys, passing
in front of the sun. The glow around the sun is its
corona, along with zodiacal light scattered off
meteoritic dust out to the distance of the asteroid belt.
Tethys subtends an angle of about two-thirds of a
degree. To the right is the crescent Saturn, subtending
18 degrees. With the rings backlit and the solar glare
shielded by Tethys, we can dimly see a faint sheet of
dust extending beyond the main rings. Enceladus, in
crescent phase, is in front of Saturn.

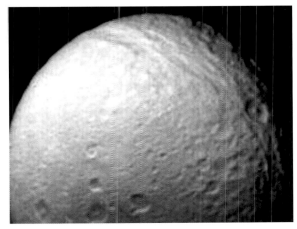

*V*oyager *spacecraft views of the 1000 kilometer-moon, Tethys. The left view shows the heavily cratered globe, and the enlarged view at right emphasizes the great trench that bisects this icy world. The trench, named Ithaca Chasma, may mark a fracture developed due to tidal stresses acting on this moon throughout geologic time.*

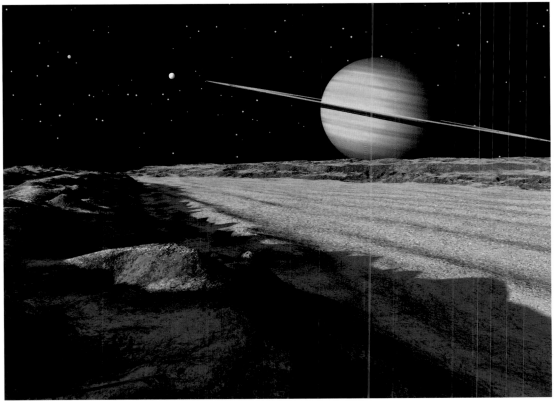

*T*he *enormous trench, Ithaca Chasma, stretches three-fourths of the way around Tethys. Over 100 kilometer wide in places, it reaches depths of several kilometers.*

For all their small size, asteroids, comets, and the smaller satellites may provide vital clues toward understanding the origins of the solar system.

SELECTED SMALLER WORLDS

Enceladus
The Resurfaced Moon of Saturn

Saturn's modest-sized moon Enceladus surprised scientists with its geological complexity. This Voyager 2 photo shows not only ancient, cratered regions, but also much younger, uncratered plains, cut by fractures, grooves, and strange swaths of contorted, ridged terrain. North is at the top.

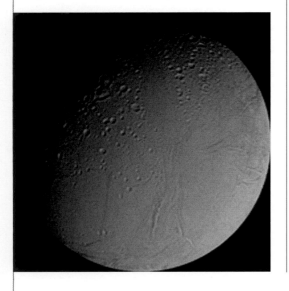

Considering that Enceladus's larger neighboring moons, Rhea, Dione, and Tethys, are heavily cratered iceballs, it is all the more surprising that this modest-sized moon shows the most complex structural geology in Saturn's system. At only 500 kilometers (311 miles) in diameter, Enceladus would just nestle between Los Angeles and San Francisco. It might have been expected to have cooled off and been saturated with impact craters long ago, and thus to show no more signs of internal stresses, thermal activity, or volcanic eruptions than an iceberg. Nonetheless, as shown in the accompanying *Voyager 2* photo, in widespread regions of Enceladus the old cratered terrain has been melted smooth or flooded with watery material that has frozen into smooth ice plains. The lack of craters on the plains shows that they are not nearly as ancient as the cratered surfaces; they must have formed in the last half or last quarter of Enceladus's history. Long, straight fracture lines cross these plains, as if they were scribed at random with a giant's pen. Such flowing and fracturing must have required a heat source in recent times.

The source of the heat is uncertain. Probably it involves the same kind of tidal flexing that drives the volcanoes of Io and heated up the inside of Triton. However, calculations of these forces in the Saturn system have indicated that they are barely able to do the job because of the particulars of the satellite orbits. So Enceladus's resurfaced plains pose a mystery.

Another odd aspect is that the icy surface is extraordinarily bright, reflecting more than 90 percent of the sunlight that hits it. This is the most reflective ice in the solar system. Is it unusually pure, unsullied by the sooty carbonaceous dirt component that is common in outer solar system ices. The implication is that fresh, white frost is continually condensing on the surface,

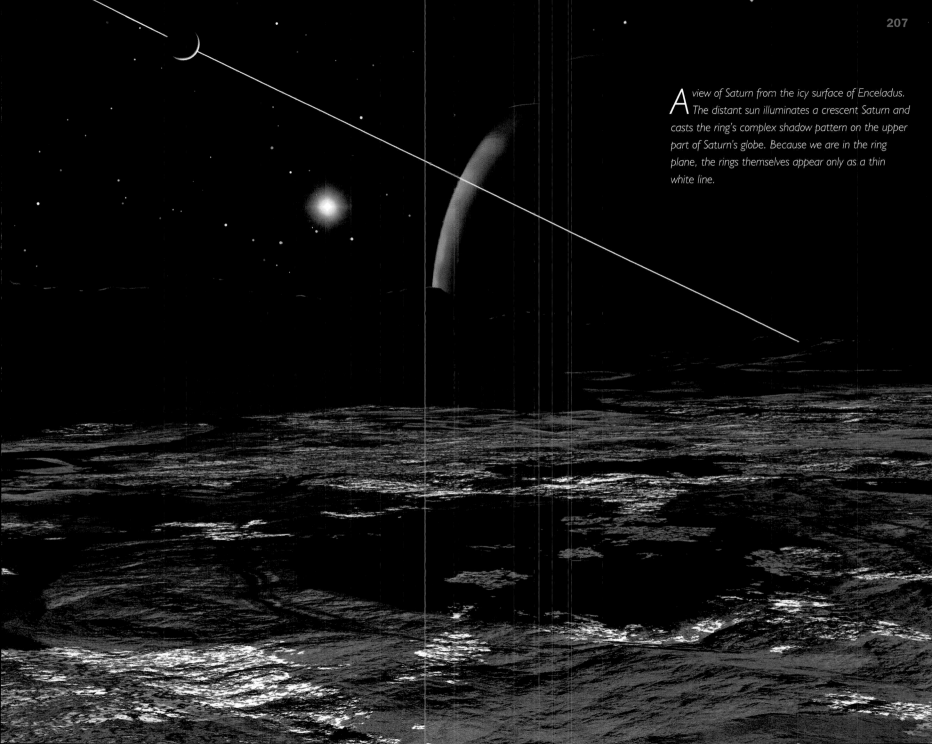

A view of Saturn from the icy surface of Enceladus. The distant sun illuminates a crescent Saturn and casts the ring's complex shadow pattern on the upper part of Saturn's globe. Because we are in the ring plane, the rings themselves appear only as a thin white line.

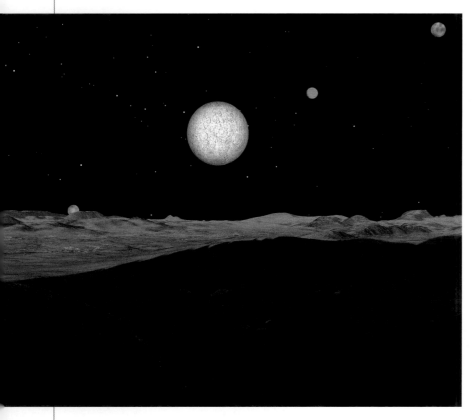

Enceladus, a Saturnian moon, has the best view in the solar system of a flock of neighboring satellites. If we turn away from Saturn and look in the opposite direction, we will occasionally see conjunctions, or groupings, of Saturn's outer satellites. In this view, the sun is behind us. We see the next outer moon, Tethys, subtending an angle of 1.2 degrees, over twice the size of our moon seen from Earth. Beyond Tethys are the moons Dione (upper right) and Rhea (lower left), each about half the apparent size of our moon. In the distance is massive Titan, with its dense atmosphere of ruddy clouds.

which in turn suggests water vapor is escaping from the interior. Answers may come only when humans or machines land on the frozen plains and look at the ice at close range.

The landing might be risky because of a third unusual property of Enceladus. A tenuous ring of tiny particles has been discovered moving around Saturn, along the orbit of Enceladus. It is called the E ring, and the concentration of particles along Enceladus's orbit suggests the particles may have come off the satellite itself. Were they blasted off by a chance meteorite hit? There is a more exciting possibility that ties into the suggestion of water vapor eruptions. The youthful, uncratered appearance of some of the plains suggests that parts of the surface may be very young, and that eruptive activity may occasionally occur. The last *Voyager 2* picture of Enceladus, looking back as the spacecraft receded, shows a faint bright smudge that some researchers think might be an eruption—like one of the plumes on Io. But the data are not good enough to confirm this. Possibly the E-ring particles are blown off Enceladus by occasional volcanic or geyserlike outbursts. In Enceladus's low gravity, debris could easily escape from the moon and go into orbit around Saturn, creating the thin E ring. Thus, future landers may have to approach with caution, on the lookout for debris near the moon—or even for erupting vents. Perhaps some of the smoothest resurfaced plains have been formed in modern geologic times!

Among ice moons, once-obscure Enceladus may give us our best chance to observe, on a single world, various stages of the cryptic processes that produced the range of icy bodies of the outer solar system, from solid-frozen cratered worlds to geologically active worlds. One day, Enceladus might even display these processes in action on a local scale, as watery eruptions burst forth, flooding craters, undermining cliffs, and reducing cratered uplands to fresh, glistening plains of ice. If Jupiter's moon Europa turns out to have biological activity in its buried, tidally warmed ocean, then even Enceladus may show up one day on lists of worlds where underground water may harbor—or may once have harbored—life!

4 Vesta
A Lava-Covered Asteroid

The most peculiar large asteroid is 4 Vesta, the fourth asteroid to be discovered, and first seen in 1807. Telescopic observations of its spectrum indicate that among the 100 or more largest asteroids, Vesta is the only one with a surface of lava-like rock. This produces a puzzle. And to see why it is such a puzzle, let us review ideas of asteroid evolution.

The thousands of asteroids in the asteroid belt feature several different types. As noted before, the outer belt contains soot-black carbonaceous types, most of which seem never to have melted. In the inner half of the belt are a variety of silicate-rich types. One is a primitive type that never melted (brown in the accompanying illustration). Other asteroids did melt, creating different internal zones. Metals, being heaviest, drained to the middle (red in the figures). Dense rocks, rich in the greenish silicate mineral olivine, formed a thick, rocky layer around the core, called the mantel (light gray in the figures). The lightest materials rose toward the surface, and formed a thin crust resembling basaltic lavas on Earth and the moon (dark in the figures).

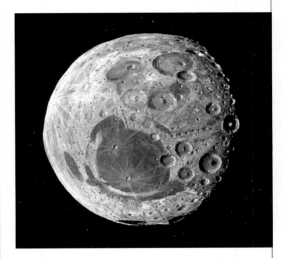

The heating phase ended long ago, as shown by the 4.5-billion-year-old dates of solidification among most meteorites. After that, asteroids chipped away at each other as they collided,

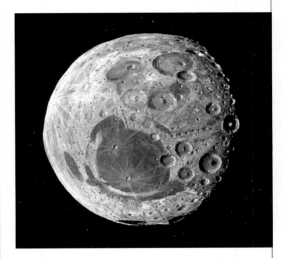

Observations have shown that asteroid 4 Vesta is not quite spherical, and has a surface flooded with lavas. The distribution of lavas may be patchy, since one side shows stronger spectral evidence of lava rocks than the other. This imaginary close-up view shows a large region flooded with darker lavas, similar to the lava plains on the moon.

many of them shattering, the basaltic crusts from most others eroding away. In fact, basalt-surfaced asteroids are rare, mostly confined to a handful of small fragments.

But Vesta, the third-largest asteroid, appears dominated by basaltic rock. Why? Why didn't the basalt layer get blasted away, as was the case with asteroids?

Ground-based telescopes give little help in answering these questions. Even seen through a large ground-based telescope, Vesta appears as a starlike point, whose spectrum reveals the presence of basalt. Watching Vesta as it rotates reveals a patchiness in the basalt—more on one side than the other. In 1997, Cornell researcher Peter Thomas, with a crew of five other asteroid scientists, used the Hubble Space Telescope to take high-resolution photos of Vesta. These fuzzy images revealed an oblate object, 458 to 578 kilometers (284 to 359 miles), with some irregularities and brighter patches. According to their interpretation, there is a crater 460 kilometers (286 miles) across and 13 kilometers (8 miles) deep near the south pole. The images suggest a few other craters, somewhat smaller.

Was Vesta an asteroid whose early lava crust was partly blasted away by impacts, but preserved in some areas, as a statistical fluke? Or was the crust thicker than on other asteroids, allowing it to survive longer? Or is there something unusual about Vesta's bulk composition that produced this unusual surface?

In any case, Vesta is the only asteroid among the hundred or more largest asteroids that has a lava-like crust, and we may have to wait for serious exploration missions to the asteroid belt before we can learn why it is unique in this regard.

These fuzzy Hubble Space Telescope images are the best ever obtained of the asteroid Vesta, although no features smaller than 50 miles across can be seen. The images show Vesta at different aspects during its rotation.

Miranda
Uranus's Reassembled Moon?

The following story of surprising discoveries about Uranus's small moon, Miranda, may sound familiar to readers of this book. When the *Voyager 2* spacecraft got all the way to Uranus, researchers expected that surely, at that distance, a minor object like Miranda—470 kilometers (292 miles) across—would be merely another cratered iceball. By this point in the mission, however, they could expect the unexpected, and they were not disappointed. The larger moons of Uranus (Titania, Oberon, Umbriel, and Ariel) turned out to have familiar dense cratering and a few fractures, but little Miranda displayed bizarre, contorted terrain as strange as any surface in the solar system.

Bits of old cratered terrain are seen, but they are broken by winding swaths of parallel fractures and grooves. Sharply defined segments of crust seem to have been converted from rolling craters to furrowed rock gardens, as if they had been run through an egg slicer. Some of these swaths are discolored, either darker or lighter than the background. Parts of the surface have been described as "jumbled" or "chaotic," as if scientists threw up their hands at reconstructing the geologic history that produced them.

The most outstanding feature is the most dramatic cliff discovered so far in the solar system. A fractured segment has dropped as the crust split along two fractures. The drop created a beautiful scarp, running dozens of kilometers across the planet and rising as much as 5 kilometers (over 16,000 feet) above the valley floor! Many descriptions give the false impression that this cliff rises vertically, but if the photos are properly oriented with the horizon horizontal, the cliff can be seen to be a breathtaking smooth slope, descending at about 45 degrees into the valley below.

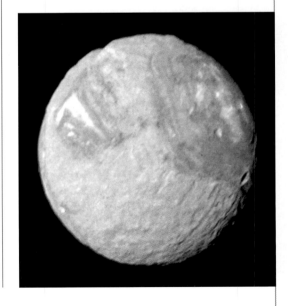

Miranda seems as scarred as a Frankenstein monster, as seen in this Voyager 2 photo. Many researchers believe it was once shattered by an impact and then reassembled like a badly solved jigsaw puzzle.

Below:

Miranda's extraordinary sheer cliff, sunlit and rising about 5 kilometers (15,000 feet) above a shadow-shrouded, faulted valley. The photo has been oriented with the horizon flat (out of frame, at top) to show the true slope of the smooth cliff face. Smallest details are about 700 meters (700 yards) across.

Below right:

Among the tortured fractures, faults, and blocks of Miranda, the most striking feature is the Great Wall, an enormous cliff created when a many-mile-wide block of the surface was raised above the surrounding terrain. Boulders rolling down the slope would take many minutes to reach the bottom, where they would roll onto the valley at speeds of fast trains. Blue-misted Uranus, only 125,000 kilometers (78,000 miles) away, covers an angle 88 times greater than that of the full moon as seen from Earth.

The beautiful and puzzling swaths of wavy, contorted, parallel ridges, valleys, and cliffs should remind us of features we've seen before. Similar swaths of fractures and grooves appear on Ganymede and on Enceladus. They suggest different stages of development of the same process. Apparently, when inner stresses begin to break up the icy crusts of these bodies, one of the first stages is the production of the swaths of parallel ridges. If heating continues, watery material may erupt later and flood the surface, obliterating the ridges with fresh, smooth plains.

In the Line of Asteroid Fire

What caused the stresses? The closeness of Miranda to Uranus indicates that the tidal flexing mechanism, which we discussed in the cases of Io, Triton, and Enceladus, is involved.

However, an additional fascinating complexity may also be involved. *Voyager 2* team scientists calculated the cratering rates at different distances from each giant planet. To understand the result, imagine one thousand asteroids approaching a giant planet from different directions. The planet's

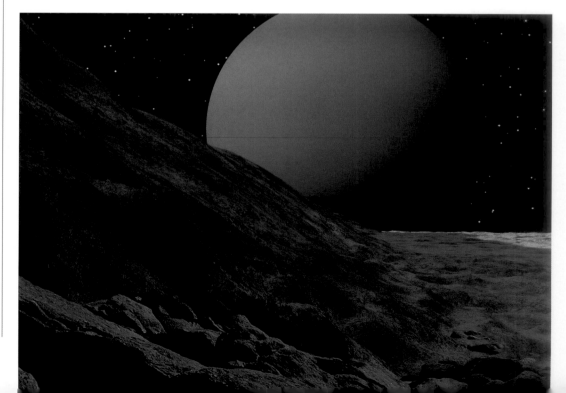

gravity attracts them, and they fall toward the planet, ultimately to crash into its atmosphere. The closer to the planet, the more concentrated the asteroids. An outer moon would have only a small chance of being hit by one of them, but an inner moon, near the target planet, would receive a much greater concentration of hits.

Voyager 2 scientists found that this concentration effect is especially strong in the case of Miranda. It receives an estimated fourteen times as many hits per square kilometer as the outer moon, Oberon. Amazingly, the calculations revealed that, based on the number of larger craters on Oberon, Miranda has probably been hit by objects large enough to smash it to smithereens!

Then why is it there? The pieces would go into orbit around Uranus and eventually reassemble. According to the calculations, this may have happened several times! So, some of Miranda's strange structure might relate to its strange history.

Imagine wandering down the twisting canyons with the turquoise globe of Uranus overhead and the distant sun's cold glare hiding tiny Earth.

Below left:

The parallel-ridged fractures of Miranda create a striated landscape, with bluish Uranus looming on the horizon.

Below right:

Voyager 2 photos showed old, heavily cratered terrain (lower left) broken by swaths of parallel fractures a few kilometers or miles apart (upper right). The fracture systems are less cratered and therefore must be younger than the cratered terrain. The exact cause of the fractures is uncertain.

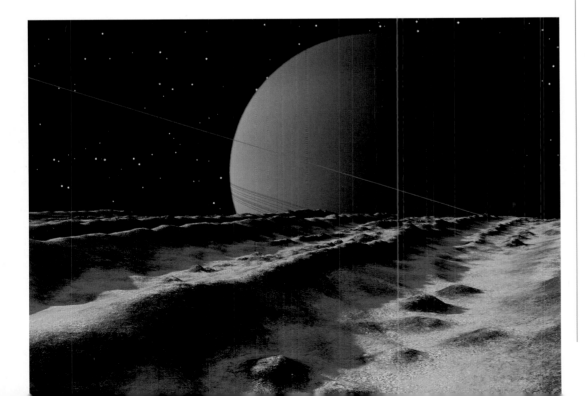

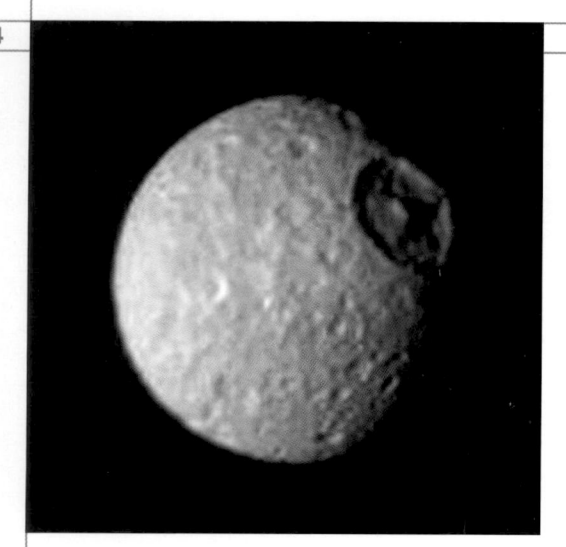

Above:

The 130-kilometer (81-mile) crater Herschel makes Mimas resemble a giant eye in this Voyager photo. This feature is about a third the size of the moon itself—one of the largest crater diameter-satellite diameter ratios in the solar system. The impact that made it was almost big enough to blow Mimas apart.

Opposite page:

Sloping walls nearly 10 kilometers (32,800 feet) high form the ramparts of Mimas's enormous crater Herschel. In the distance is the crater's central mountain peak.

Mimas
Saturn's Reassembled Moon?

Mimas is the innermost of Saturn's large moons, an icy globe 390 kilometers (2,421 miles) wide. Seen from Earth, it is very faint in the glare of nearby Saturn, and yet it was discovered as early as 1789 by Sir William Herschel.

Before the days of space missions, the mass and density of Mimas were hard to measure. Some researchers thought the density was less than that of ice, and that Mimas might have an unusual porous texture. But the *Voyager 2* flights confirmed that Mimas, like its neighbor satellites, consists mostly of solid ice. Like Rhea, Dione, and Tethys, it is very heavily cratered, and it lacks the resurfaced plains and possible geologic activity of its neighbor Enceladus. The very fact that Mimas hasn't been heated enough to be resurfaced resurrects the problem of internal heating of planets and satellites. Recall that Enceladus, the somewhat larger moon farther from Saturn, has been widely resurfaced by relatively young, bright icy plains, suggesting that tidal heating melted ice that erupted and resurfaced low areas. But calculations suggest that because Mimas is closer to Saturn than Enceladus, Saturn would have raised much stronger tides on Mimas and caused about twice as much tidal heating.

So why doesn't Mimas show signs of recent melting or resurfacing? One answer may be that the internal structure of the moons is different, so that tidal flexing dissipates heat differently inside them. Other possible answers might involve different doses of radioactive minerals, or the gravitational effects of other nearby moons, which disturb orbits and promote tidal heating. The thermal histories of moons and planets are still somewhat mysterious. Perhaps some young reader of this book will one day bring us a clearer understanding of the heating processes inside alien worlds.

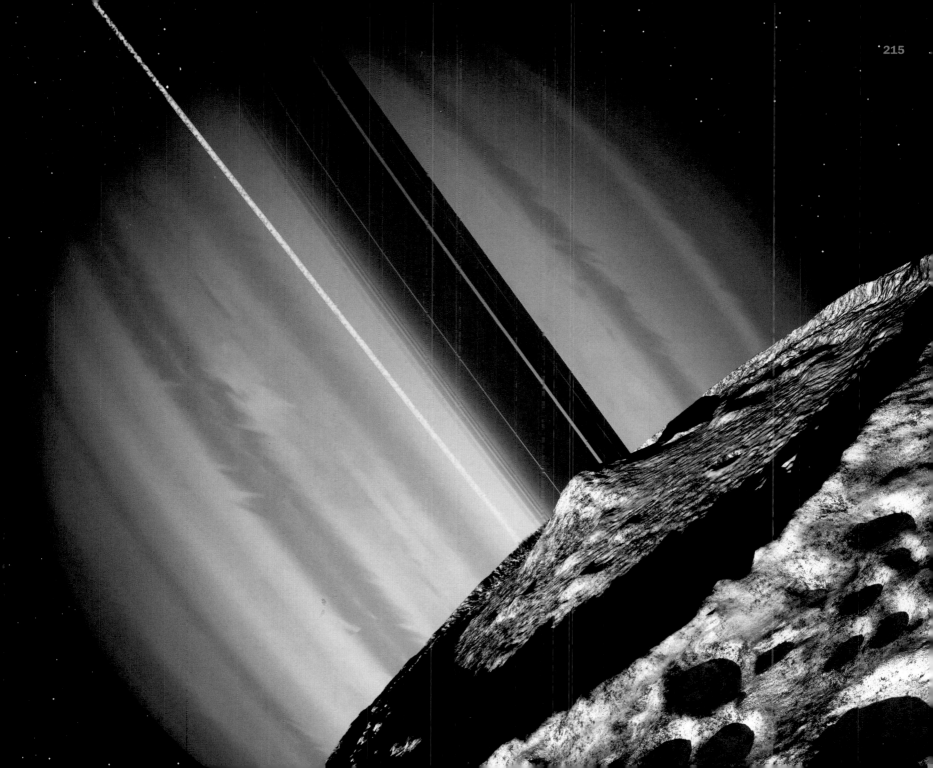

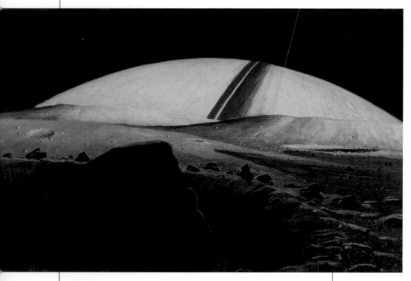

Above:

Mimas dawn. Overlapping impact craters form a rolling landscape as seen from the surface.

Right:

Another Voyager *photo of Mimas shows another side of the satellite, emphasizing that the surface is saturated by craters and lacking any other geologic features except for a few fracture-induced valleys.*

A Big Hit

Even though Mimas hasn't had any recent resurfacing, it doesn't lack striking features. Its largest impact crater, named Herschel, after the early English astronomer/composer, is about one-third the diameter of Mimas itself. It appears to be moderately fresh, is well-formed, and lies on the leading side of the moon. About 130 kilometers (81 miles) across and 9 kilometers (5.6 miles) deep, it has a broad central peak 4 kilometers (over 13,000 feet) high. It is similar in form to, but slightly larger than, the familiar lunar craters Tycho and Copernicus—both of which are about the size of Yellowstone National Park. It is so large in relation to Mimas that its formation must have severely damaged the satellite.

This gives us a clue to Mimas's history. Like Uranus's moon Miranda, Mimas suffers concentrated bombardment, because it is close to giant Saturn, whose strong gravity attracts impactors. *Voyager 2* scientists calculated that Mimas gets about twelve times as many hits as the outermost moon of Saturn, and that there is a good chance that Mimas has been blown apart and reassembled. Indeed, such smash-ups of Mimas or other (now destroyed) inner moons may have contributed the debris that forms Saturn's famous rings. Herschel itself was almost big enough to do the job, confirming that such smash-ups are not merely wild speculations of the theorists.

Mimas is of further interest because of its gravitational influence on particles in Saturn's rings—the effect called resonance. Mimas goes around Saturn in 22.6 hours. Particles in the central part of the rings go around Saturn twice in this time. This means that particles in that particular region of the rings encounter Mimas—and its gravitational pull—every other trip around Saturn. The repeated pull due to gravity (resonance) makes the particles move farther and farther from Saturn; random pulls would not have this effect. This effect clears ring particles out of the region in question, called Cassini's Division.

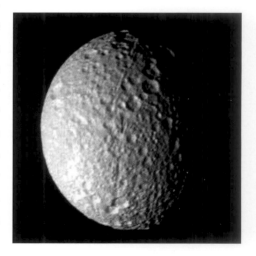

Nereid
A Captured Moon of Neptune?

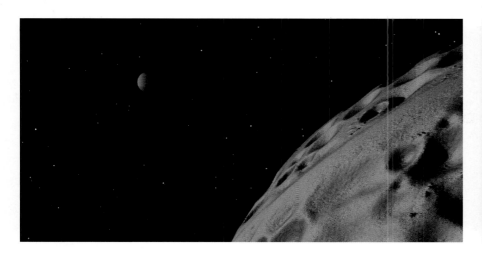
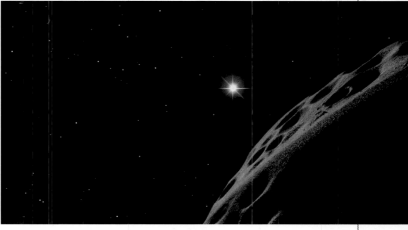

N ereid, the outermost large moon of Neptune, was discovered in 1949 by the Dutch-American astronomer Gerard Kuiper. Like the outermost moons of Jupiter and Saturn, Nereid—with a diameter of 340 kilometers (211 miles)—may be a captured interplanetary body. The evidence comes not from a retrograde orbit, as in the other cases, but from the extreme elliptical shape of the orbit, and its great distance from Neptune, where a capture would be relatively easy. The elliptical orbit takes Nereid from nearly 10 million kilometers (6,210,000 miles) to only 1.4 million kilometers (869,400 miles) from Neptune.

Not much is known about Nereid. In a sense, this makes it more intriguing than the well-photographed worlds. *Voyager 2* obtained a distant picture, showing the moon only as a fuzzy blob. Spectra show a neutral gray color, about as reflective as our moon. Nereid might have some similarity to the slightly smaller world Chiron, which we will come to later.

T wo views of Neptune from a spot above Nereid, Neptune's most distant moon. One view shows the scene when Nereid is at closest approach to Neptune, 1.4 million kilometers (870,000 miles) from the planet. Neptune would cover 2.1 degrees, looking four times as big as the moon in our own sky. The other view shows the same scene when Nereid is farthest away, a whopping 10 million kilometers (6 million miles), when Neptune subtends only 0.3 degrees, looking only about half as big as our moon (right). Nereid's orbit inclination of 29 degrees allows us to look "up" and "down" into the ring system.

624 Hektor
Largest Compound Asteroid?

Above:

Calculations by Planetary Science Institute astronomer Stuart Weidenschilling suggest that, given Hektor's rotation rate, it has deformed into two egg-shaped lobes if it is composed of weak or rubbly material.

Right:

The Trojan asteroids, which include Hektor, comprise two swarms in the orbit of Jupiter. Dynamical forces conspire to hold one swarm 60 degrees ahead of Jupiter and one swarm 60 degrees behind it.

Although most asteroids are located in the asteroid belt between Mars and Jupiter, some, ranging in size from small to moderate, orbit the sun in other parts of the solar system. Among the most interesting of these mavericks are two groups that follow the same orbit as Jupiter—one 60 degrees ahead of Jupiter and the other 60 degrees behind. The gravitational forces of both the sun and Jupiter conspire to hold them in place.

Since astronomers named these asteroids after heroes in the Trojan Wars, they have become known as the *Trojan asteroids*. There are as many asteroids among the Trojans as in the main belt. One survey published in 2000 estimated more than 160,000 larger than 1 kilometer—and that was in only one of the two swarms.

The largest and brightest Trojan is 624 Hektor. Even though it is the brightest Trojan, Hektor is hard to observe in all but the largest telescopes. Nonetheless, it offers the best chance to explore an intriguing question: What are the compositions of the Trojan asteroids? Are they like the main belt asteroids? In 2000, Dale Cruikshank and several

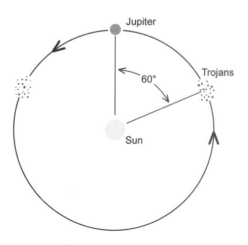

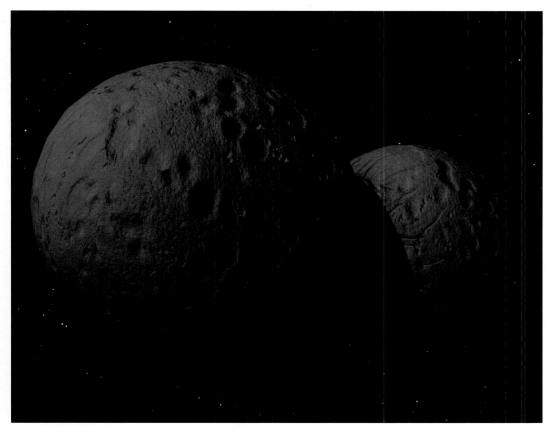

An astronaut approaching Hektor would have a striking view of the double-lobed asteroid.

colleagues marshaled new observations to explore this question. Hektor has a very dark, brown-ish-black color, which has long suggested that it is dominated by sooty-black carbon-rich material, like that found on Ceres and among most asteroids in the outer asteroid belt. However, Hektor's stronger reddish-brown tone suggests it may contain more complex carbon compounds, many of which are reddish-tinged. Cruikshank's group found that the best match for Hektor's surface material would include carbon, the familiar rock-forming mineral pyroxene, from 4 to 5 percent water hidden in minerals like serpentine (with such minerals being as much as 30 percent of the total), and small amounts of more complex organic molecules, such as HCN polymers. (Such organic molecules do not imply life, but only chemical processes that build up complex molecules around the C-H chemical bond.)

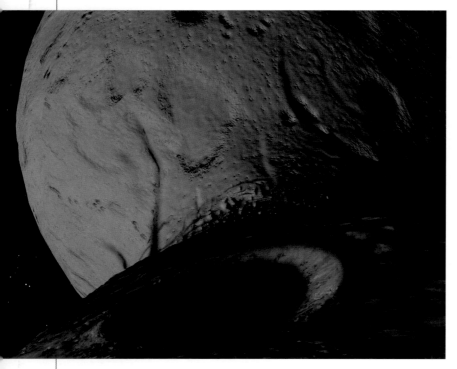

The view from the surface of Hektor has to be one of the strangest in the solar system. We are approaching the "saddle" where the two lobes join—a kind of bridge between two small worlds.

Hektor has long been puzzling because of an unusual property: When viewed from Earth, it varies in brightness by a factor of three. Such variations are not unprecedented, but in this case some strange conclusions resulted.

A Strange Shape

When other asteroids vary in brightness (and usually by much smaller amounts), there are generally one or two suggested explanations. First, the asteroid might be elongated, tumbling end over end and presenting first a broad side and then a small end. This theory has proven correct in some cases. These objects, usually much smaller than Hektor, are probably splinter-shaped fragments, broken off by collisions between larger "parent" asteroids. Second, the asteroid might be round but with one dark and one light hemisphere, much like Saturn's Iapetus.

In the mid-1970s, the author (Hartmann) and astronomer Dale Cruikshank proved that the first theory applies: Hektor is strongly elongated. Since Hektor is the largest Trojan, and its neighbors are no more than half its size and are round, we suggested that Hektor might have formed in an unusual, low-speed collision where two "normal" Trojans stuck together in a "peanut" shape.

Other studies have suggested that, allowing for gravity, tidal stretching, rotation, and weak, fractured material, Hektor would have distorted into a shape like two eggs stuck end to end. We called this a "compound asteroid." Perhaps an initial collision produced a loosely consolidated, fragmented mass, which then deformed into the weird compound configuration.

Alternatively, Hektor may be binary, its two halves slightly separated and orbiting around one another. We may not truly understand the secrets of Hektor's strange shape until some man-made vehicle approaches it and takes photographs and samples. Perhaps when we do visit this odd little world, it will turn out to be twin-lobed. We'll be able to hike to the contact region, where a mountain of rock 150 kilometers (93 miles) wide will hang directly over our heads, and leap (in a gravity less than 1 percent that of the moon) across the unearthly valley from one worldlet to another.

Amalthea
Football-Shaped Moon of Jupiter

Amalthea is a small moon, much closer to Jupiter than are any of the larger Galilean satellites. In shape it is rather like a football, 270 by 166 by 150 kilometers (168 by 103 by 93 miles). Its long axis is lined up toward Jupiter, pulled like a compass needle by the powerful tidal forces, one end always pointing at the planet as it swings in its twelve-hour orbit.

The scarlet coloring of Amalthea may be a layer of sulfur-rich contaminants blown off Io by meteorites and volcanic eruptions. Such volcanic debris would spiral in toward Jupiter, and some would be intercepted by Amalthea. Japanese observations in 2004 suggest water-bearing or organic materials as well.

Data from the *Galileo* probe indicated a low density of less than 1.8 grams per cubic centimeter, lower than coherent rock, suggesting that Amalthea may be the shattered remnant of an originally larger body.

Below left, center:

Three images snapped by Voyager 1 as it went past Jupiter show Amalthea to be very elongated in shape and reddish in color. The color may be due to a coating of sulfur compounds transferred off the neighboring moon, Io. Bright spots are probably hills or locations of fresh impact debris.

Edge-on drawing of the Jupiter system shows the relative spacings of the planet, the main ring system, and the inner satellites, including Amalthea. The sizes of Jupiter, the rings, Io, and the satellite distances are to scale, but other moons are enlarged in order to show them. Their diameters are in parentheses and the order is as follows: 1, Metis (40 kilometers); 2, Adrastea (24 kilometers); 3, Amalthea (270 x 150 kilometers); 4, Thebe (100 kilometers); 5, Io (3630 kilometers).

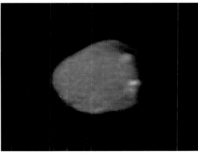

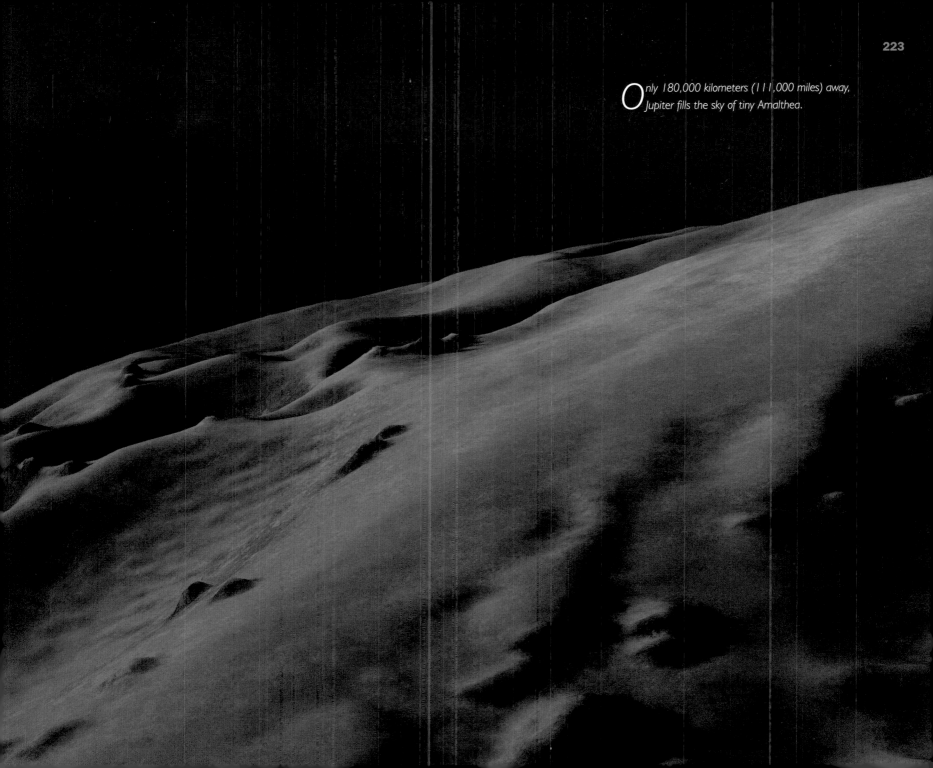

*O*nly 180,000 kilometers (111,000 miles) away,
Jupiter fills the sky of tiny Amalthea.

2060 Chiron

The King of Comets

Chiron (pronounced *KYE-ron*) is the oddest interplanetary body, and one of the most interesting targets for future exploration, although its distant orbit guarantees a wait of decades before we see it up close. Its story is full of unexpected twists.

Chiron was discovered in 1979 by astronomer Charles T. Kowal. Appearing only as a starlike point on the original photographs, it was cataloged as an asteroid, number 2060. However, "asteroid" 2060 Chiron was immediately recognized as unusual because its orbit, lying between Saturn and Uranus, is much farther from the sun than any other known asteroid.

Observations in following years established a neutral gray color for Chiron but gave slight discrepancies in brightness. This led several astronomers to keep an eye on it.

In February 1988, the author (Hartmann) and Hawaii astronomers Dave Tholen and Dale Cruikshank were spending several cold nights observing asteroids with a large NASA telescope atop 14,000-foot Mauna Kea, in Hawaii, when we discovered that Chiron was nearly twice as bright as it was supposed to be. We announced this surprising result at once, using the international network of astronomical telegrams. The brightening was confirmed by other observers during the following weeks.

The brightening continued for months, reaching nearly three times the "normal" brightness. What was causing this? We knew that Chiron was slowly moving toward the sun. Based on certain properties of the brightening, we concluded that Chiron contained ices and that as it warmed during its orbital motion toward the sun, some of the ices changed to gas, throwing off a cloud of gas molecules and dust. In other words, Chiron had turned into a comet. The bigger

Above:

Orbit of Chiron (red) relative to orbits of other planets. Note that Chiron moves all the way from the orbit of Uranus to a position inside the orbit of Saturn.

Above right:

Close-up view of eruptions on Chiron. Jets of gas and dust that produce Chiron's coma may issue from fracturelike vents on the surface.

the cloud, the brighter the comet. Sure enough, in April 1989, astronomers Karen Meech and Michael Belton obtained images showing an expanding coma, or cloud of dust, around Chiron.

The unusual asteroid had become a full-fledged comet! Then, over many months, its brightness faded, as if the cometary eruptions had declined.

Various observations indicate that Chiron has a very dark surface of soot-blackened ice, like other comets, and that it must be fairly big to reflect the amount of light that is seen. The observations place the diameter at about 180 to 300 kilometers (112 to 186 miles), with 250 kilometers (155 miles) being a likely value. This turns out to be by far the largest comet known.

Reexamination of old photos suggests that Chiron underwent a similar eruption ten years before, in 1979, just after it was discovered. Probably, gas is slowly released by the warming ice, and collects in the spaces between ice grains of the surface soil. When the pressure of this gas gets great enough, it may go poof! and erupt in a cloud of dust. This could explain the sporadic outbursts. Sure enough, by 2000, indefatigable observers Jane Luu, David Jewitt, and Chad

Trujillo, who use large telescopes and state-of-the-art detection instruments at Mauna Kea, reported the detection of frozen water in the spectrum of Chiron.

Because Chiron is larger than other comets, the dust and gas is not blown away immediately in a tail, as on other comets, but is held somewhat by Chiron's gravity. Michael Belton pointed out that the dust forms a long-lasting dust cloud around Chiron after each eruption.

Unstable Orbit, Uncertain Fate

As soon as Chiron was discovered, dynamicists checked its orbit and revealed another interesting fact. Its orbit is unstable. Every few thousand years it comes close to Saturn, and within a million years or so it may pass so close that Saturn's gravity will radically change Chiron's orbit. Chiron will eventually be thrown out of the solar system, or it might be thrown into the inner solar system, to pass by Earth as one of the brightest comets of all time.

By the same token, Chiron cannot have been in its present orbit for much of the solar system's 4,500-MY history. Astronomers believe it has arrived in its present orbit "only recently," that is, within the last million years or so, and that it arrived in this orbit by being deflected out of the Kuiper Belt by gravitational forces, perhaps during a close approach to Neptune. Such objects, deflected from the Kuiper Belt into the region of Uranus and Saturn, have been called *Centaurs,* and the first ones discovered have been named after various of those mythical beasts from Greek folklore. Chiron may thus be a "new" comet, experiencing its first passes inside Saturn's orbit, and this may mean that it is still burning off various ice layers that were once stable in the Kuiper Belt, but find it too warm near Saturn to remain as ice. Based on these ideas, we can speculate that all Centaur objects—even though they are cataloged as asteroids—are potential "crossover bodies" that look like asteroids when inactive, but that can flare up into comets if they receive too much solar heating.

When Chiron's "crossover" status was verified, some commentators suggested Chiron's name should be changed from asteroid designation (2060 Chiron) to reflect its new status as a comet. But the distinction between comets and asteroids is more semantic than physical. Asteroids are bodies of rock and dirt; comets simply have more ice. No new name has been accepted, and for now, as discoverer Kowal has said, "Chiron is simply . . . Chiron." And many more such "crossover bodies" have since been found.

5145 Pholus
Fugitive from the Kuiper Belt

As telescopes and optical devices get better and better, astronomers keep discovering more small bodies in interplanetary space. The distribution of sizes is clear: For every large object there are multitudes of small objects. To be more specific, for every body that is 500 kilometers (311 miles) across, there are typically hundreds of bodies 50 kilometers (31 miles) across. For this reason, we can't describe all the small bodies. Nonetheless, we can't claim to have toured the solar system without stops at some of the more interesting among them.

Pholus, discovered in 1992 and cataloged as "asteroid" 5145, is a great example. It has a respectable diameter, estimated at about 175 kilometers (109 miles), and in terms of its orbit, it is not unlike "asteroid" 2060 Chiron. Its greatest distance from the sun is 32 AU, comfortably within the Kuiper Belt. But it has an elongated orbit that comes in as close as 8.8 AU—inside the orbit of Saturn. Like Chiron, it is thus classified as a Centaur object—one of the objects that was deflected from the Kuiper Belt inward by gravitational influences of the outer planets.

Remember that Chiron was first classified as an asteroid when it was discovered, but was later found to "erupt" into cometary activity.

Pholus has not yet been seen to have cometary activity; perhaps it has been traveling on this orbit so long that the most exposed ices have long ago been burned off by the sun's heat.

A Color Surprise

But Pholus has another claim to fame. Because it comes so far into the solar system, it gets much stronger solar illumination than it would in the Kuiper Belt, so that its colors and spectral properties can be well measured by astronomers. Surprisingly, it is red—one of the reddest interplanetary bodies ever observed. From studying Pholus and other interplanetary bodies, we have learned that beyond the asteroid belt, virtually all the objects you might encounter would look blackish-gray, dark brown, or reddish brown. At greater solar distances, reddish-brown objects seem to be more frequent. It terms of its visual appearance, if Pholus could be seen from modest distance, it would look as red as Mars!

The red color is surely produced by different processes than on Mars, where the red materials are iron minerals rusted by exposure to water. As mentioned earlier, some experiments have shown that methane ice (CH_4) and related compounds, if exposed to cosmic rays (including energetic atomic particles coming through space from the

sun), can undergo reactions that form reddish organic compounds. Perhaps Pholus has not only burned off its surface ices, but has gradually accumulated a reddish crust of organic materials, by this mechanism. Certain spectral features have been interpreted by Dale Cruikshank and his coworkers as evidence of water ice and methanol (CH_3OH), and they have proposed that the surface materials are a mixture of sooty carbon, the rock-forming mineral olivine, frozen water, methanol, and other organic compounds.

The story is not that simple, however, because different Centaurs have different degrees of redness, and at least one Centaur (cataloged as 1997 CU26) has a surface dominated more clearly by water-ice rather than the organics thought to produce the red colors. So different individual worldlets among the Centaurs and Kuiper Belt objects may have had different histories or origins. Some may have erupted with comet activity, blowing away the accumulated reddish organic crust.

Some of them may hold special secrets. Some day a spacecraft will be sent to Pholus, and perhaps by that time sample-return missions may be routine. Living material is very unlikely in the cold, reddish ice of Pholus, yet, perhaps that enigmatic material has preserved some clue to the missing link in the story of how cosmic processes can produce organic materials that are concentrated enough and complicated enough that they eventually produce living organisms.

The sun appears to be little more than a dazzling point of light when seen from the aphelion distance of Pholus.

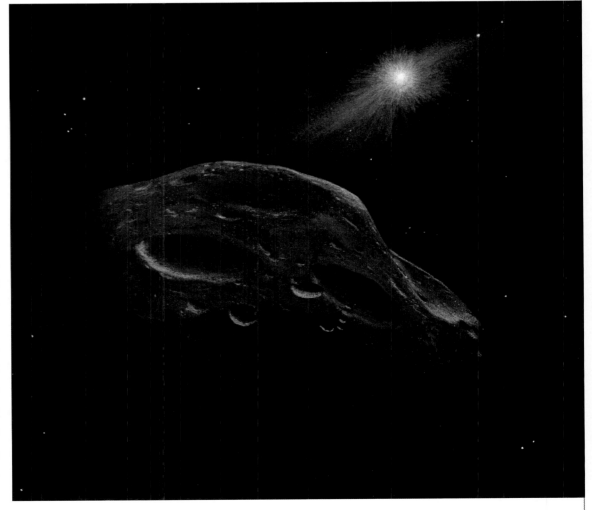

Janus and Epimetheus
Co-Orbital Satellites of Saturn

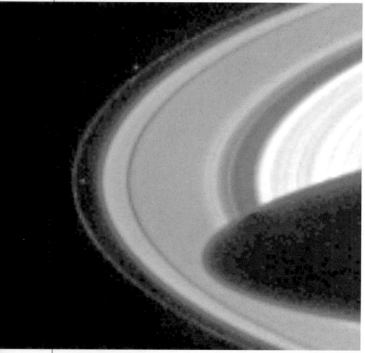

A*nother pair of Saturn's shepherd moons, Prometheus and Pandora, are visible flanking the narrow F ring in this Voyager 2 image.*

Some of the smaller worlds are remarkable not so much for their own properties but because of their relationships to other worlds, either large or small. One of the most curious relationships exists between two of the small, innermost moons of Saturn, named Janus (pronounced *JAY-nus*) and Epimetheus (pronounced *ep-ee-MEE-thee-is*). They move in circular orbits around Saturn, at almost exactly the same distance from the planet. To put it another way, they occupy almost the same orbit, just on the fringes of the rings. They are called *co-orbital satellites*, or sometimes just "co-orbitals."

Janus was first observed from Earth in the 1960s by the intrepid French balloonist/astronomer Audouin Dollfus, and by astronomers in Arizona. Once *Voyagers 1* and *2* reached Saturn, it took some effort to compare orbits and determine which of the many small moonlets near the rings was the original "Janus" that had been spotted years earlier. Measurements suggest the two moons are made of ice and have low density and similar size. Janus is about 220 by 160 kilometers (137 by 99 miles) in size, and Epimetheus about 140 by 100 kilometers (87 by 62 miles).

Because they occupy virtually the same orbit, Janus and Epimetheus often come close together, and it is their motions at these times that make them remarkable. There is not much chance of their hitting; a 1989 study indicates that they don't get much closer than 21,000 kilometers (13,041 miles) apart, at which time Janus would look about 0.6 degrees in angular size

from Epimetheus—a bit bigger than the apparent size of our moon. The reason they don't get much closer is that they do a fantastic dance around each other and end up exchanging paths!

Dance of the Co-Orbitals

To understand how this works, consider the two satellites approaching each other. By chance, one or the other will always be slightly closer to Saturn. As clarified by Johannes Kepler in the 1600s, a moon closer to a planet moves faster than one farther away. Thus, the inner moon catches up to the outer one. Imagine that Janus is closer to Saturn and is catching up to Epimetheus. It comes up from below and behind. As they approach each other, their gravities attract. Janus is pulled upward toward Epimetheus, and Epimetheus is pulled downward toward Janus. Following Kepler's laws, Janus thus slows down (because it is now in a higher orbit), and Epimetheus speeds up. What was a gradual approach of the two bodies, as they moved around Saturn, comes to a standstill! But this is not all. Janus, now rising to a higher orbit, moves into a slightly higher orbit than Epimetheus, as Epimetheus drops to a slightly lower orbit. In fact, they have essentially exchanged orbits! Janus, now moving slower, drops back out of sight.

In other words, if you were riding on Epimetheus, you would see Janus approach from below and behind, growing to the size of our moon but lumpy in shape. Then it would begin to drift away again, now in a slightly higher orbit. Conversely, if you were on Janus during this exchange, you would see lumpy Epimetheus approach from in front and above but then slow down, drop below the horizon formed by Saturn, and begin to recede into the distance.

Later, Epimetheus, now in the lower orbit, would move up to Janus from behind, and the roles would be exactly reversed. The two would exchange orbits a second time, bringing us back to the starting configuration.

Two independent dynamical studies suggest Janus and Epimetheus have extremely low densities—less than that of ice. They may be more like crushed ice: assemblages of fragments with small empty space between the fragments.

Because Janus and Epimetheus are irregular in shape, low in density, and share the same orbit, some researchers think they are crushed fragments of a once-larger icy satellite, like nearby Mimas, that orbited in this vicinity. As described earlier, satellites so close to a giant planet are at risk of being fragmented by asteroids or comets attracted toward the planet. The

A peculiar moment on Epimetheus was photographed by Voyager 1. The satellite passed through the straight-line shadow of the outer part of edge-on Saturn's rings. In this pair of photos, separated by 13 minutes, the shadow moves from one edge of the moon to the central part of its daylit side.

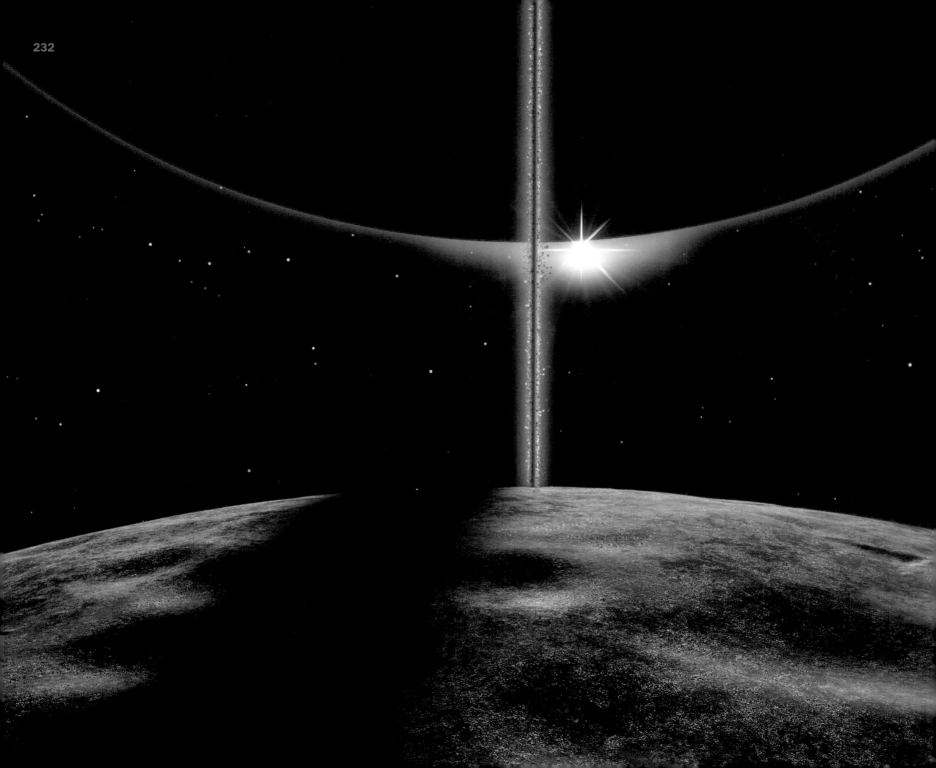

ancient satellite may have been blasted apart, creating Janus, Epimetheus, and some of the other, smaller nearby moons.

These ideas expand our revolutionary new view of ring/moon systems. Instead of being leftovers from the beginning of the planet formation process, they may evolve continuously. The number of moonlets on the outer edge of a ring system, and the brightness of the rings themselves, may depend on the amount of fragments and dust injected into the region by sporadic collisions within the last few hundred million years. This could explain why Saturn's rings are so much brighter than the rings of other giant planets.

Janus and Epimetheus are so close to the main ring system that the outer edges of the rings, as seen in the sky of either moonlet, would stretch about 135 degrees across the sky. Only the widest-angle lens could capture an image of Saturn and its full ring system as seen from either Janus or Epimetheus.

Opposite page:

We are hovering near Epimetheus. The sun is eclipsed behind the rings, visible as a sinister dark band, dimly backlit by the sun. The darkest part of the shadow is only about 100 meters (or yards) wide, reflecting the thinness of the rings themselves. The eclipse will repeat occasionally during the moon's 16½-hour trip around Saturn, but occurs only during the few weeks every 15 years when the sun aligns with Saturn's ring plane.

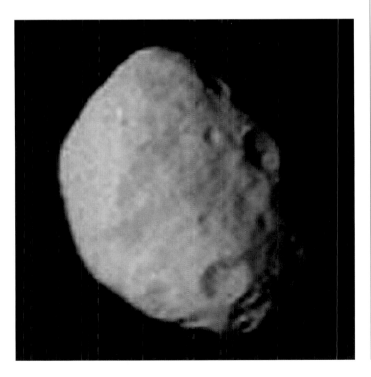

Left:

Even a satellite as small as 200-kilometer Janus shows the effects of the ubiquitous impact cratering that occurs throughout the solar system

Thebe
Under the Volcanoes

After *Voyagers 1* and *2* flew through Jupiter's satellite system in 1979, scientists studied the *Voyager* photos carefully and discovered three new moons. Thirteen moons had been previously charted. An image of an apparent fourteenth moon had been photographed from Earth in 1975 and was carried in books for a while as satellite "J14," but later searchers failed to recover it; it may have been only a temporarily captured comet.

Two of the newly discovered small moons orbit at the edge of Jupiter's ring, are about 35 to 40 kilometers (22 to 25 miles) across, and may be the sources of some dust in the ring.

But the third, Thebe (pronounced *THEE-bee*), is larger, about 100 kilometers (62 miles) across, and is located farther out from Jupiter, between the orbits of Amalthea and Io. The interesting thing about Thebe is that, as the satellite closest to Io, it therefore offers a close look at the changing phenomena of that strange world. When Io is at its nearest approach to Thebe, it covers one degree in that moon's sky, twice the angular size of our moon seen from Earth, and Io's patchy sulfur lava flows are easily visible. At this point, Thebe is just "under" Io, that is, closer to Jupiter. When Io is a crescent, sparkling glows mark volcanic explosions on its dark side, and sunlight illuminates umbrellas of ash shooting out in clouds along the edge of Io's disk. At other times, Io's surrounding cloud of sodium atoms emits its characteristic yellow glow.

The surface properties of Thebe are uncertain because it has not been studied at close range by the *Voyagers* or the *Galileo* Jupiter orbiter. However, Amalthea, the next moon inward from Thebe, has an unusual reddish color attributed to atoms and molecules of sulfur and sulfur compounds that were blown off Io, spiraled inward, and were plastered on the neighboring inward satellites. Indeed, Thebe ought to be in an even better position to catch debris from Io and may have a similar crust of sulfurous material over the older rocky material from which it was originally formed.

Though it is interesting to speculate about visiting Thebe and the other innermost moons of Jupiter, we must remember one of the special perils of Jupiter's system. Jupiter's magnetic field, which extends out to the region of its inner satellites, contains many high-energy atomic particles similar to those trapped in Earth's magnetic field in the Van Allen belts. Much higher concentrations of these particles are trapped in Jupiter's belt.

Here we are hovering above the shadowed floor of a three-kilometer (two-mile) crater on Thebe, looking away from Jupiter. We see the satellite Io passing by. Io is surrounded by the cloud of glowing sodium that stretches along its orbit. The sun is below the horizon, but the far crater rim is dimly lit by light from Jupiter, which is above the horizon behind us. In the farther distance, at the left, are Europa with its bright, icy surface and Callisto with its darker soil. The visual width of this telephoto-like view is 25 degrees.

Naiad
Within Neptune's Rings

When *Voyager 2* flew through the Neptune system in 1989, it discovered a bountiful harvest of six previously unknown moons, too small and far away to be seen from Earth. All of the moons are close to Neptune, and some orbit within Neptune's system of thin rings and ring arcs. Suitably, names proposed for them came from mythical characters related to Neptune and the sea.

We choose Naiad (*NIGH-ad*) to discuss here because it is closest to Neptune and offers extraordinary views of the giant bluish planet. In fact, along with three of the other new moons, it is well within Neptune's ring system. Such moons may act as "shepherds" that guide the ring particles into the complex system of thin rings with concentrated ring arcs (see discussion of Neptune). The other three new moons are somewhat outside the rings.

Two of the small new moons were photographed closely enough to show potatolike shapes and craters on their dark surfaces, which reflect only 5 or 6 percent of the incident sunlight. Naiad is believed to have a similar dark surface, and based on its observed brightness, it is believed to be a similar object, about 50 kilometers (31 miles) across.

Naiad takes only 7.2 hours to go around Neptune. Like many moons, it may keep one face toward Neptune, unless it has been set wobbling by a recent impact. The possibility of an impact is suggested by a peculiarity. Virtually all satellites close to ring systems have orbits in the same plane as the rings, which is also the equatorial plane of the planet. But Naiad has an orbit inclined about 4.5 degrees to that plane, so that it rises "above" the rings on one side of Neptune, then crosses the ring plane to orbit "below" the rings on the other side. Given time, such a moon would be expected to move into the ring plane; thus, a recent impact may have bumped it into its present inclined orbit.

The view from Naiad would be stunning. Filling 54 degrees of the sky is the pale blue orb of Neptune, its translucent sky color broken here and there by whitish and darker blue clouds and storms, such as the Great Dark Spot. The storms develop and subside, coming and going over the course of years. Looking in the direction away from Neptune, we would see a double thin line crossing the sky—the outer two narrow rings, viewed from within. The best view would come every 3.6 hours, when Naiad climbs farthest "above" and "below" the ring plane. Between these times, as Naiad crosses the ring plane, the rings would merge into a thin, razor-straight line dividing the sky in two.

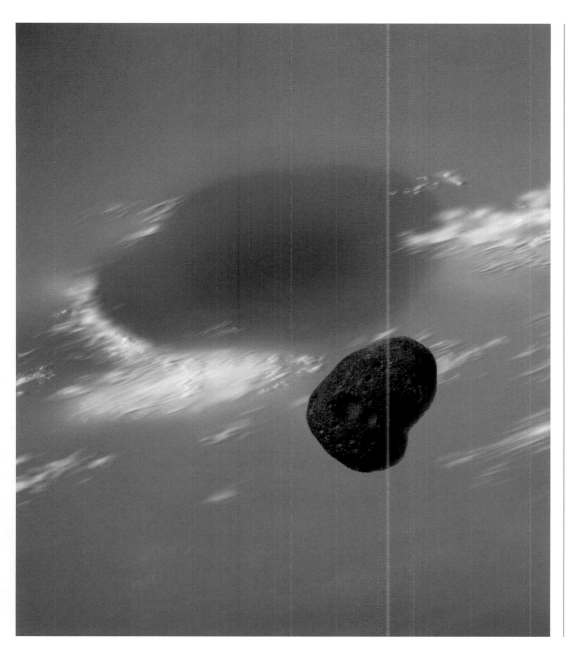

Neptune's innermost known moon, Naiad, viewed from a point 200 kilometers (120 miles) outside its orbit. This moon is so close to Neptune that the blue planet fills the background of this view, which has 40 degrees angular width. The Great Dark Spot, the large storm fringed with lighter clouds and lying at about 22 degrees south latitude, dominates this view.

Comet P/Schwassmann-Wachmann 1

A Comet with Intermittent Outbursts

One of the most intriguing comets in the sky is unfamiliar to the general public, but notorious among astronomers. It is Comet P/Schwassmann-Wachmann 1, discovered by two German observers in 1908. In the official name, the "P/" designates that it is a periodic comet; that is, it approaches its closest point to the sun at known periodic intervals. (Many comets come from the Oort cloud, the most remote part of the solar system, beyond Pluto, dipping into the inner solar system only once and then returning to the depths of nearly interstellar space.) Periodic comets officially carry this "P/" designation before their names, though it is often dropped in informal discussions. The number "1" is given because the observing team of Schwassmann and Wachmann discovered three comets in all.

Schwassmann-Wachmann 1 is so little known because it is too far away and too faint to be prominent. It moves around the sun in a near-circular orbit, approximately at the distance of Jupiter, which is much farther than bright comets. The reason for its notoriety among astronomers is its odd behavior in terms of brightness: Usually it is extremely faint (about 18th magnitude on the astronomers' "magnitude" scale of brightness, where larger numbers imply fainter objects and 6th magnitude is the faintest the eye can see), requiring a huge telescope even to detect. But every year or so it suddenly erupts, throwing off a cloud of debris and brightening by as much as three hundred times! At that time it can be seen in a modest telescope (being about 12th magnitude).

After the comet erupts, the cloud of debris dissipates, and the comet fades in a month or so, until the next unpredictable outburst many months later.

In its faint state, the comet somewhat resembles one of the black-color asteroids. Studies have placed its diameter at approximately 40 kilometers (25 miles), with some uncertainty. This comet completes one trip around the sun every fifteen years.

A Key to Comet Eruption Mechanisms

The cause of the eruptions is the big mystery of Schwassmann-Wachmann 1 and particularly intriguing because it probably holds the key to the entire mechanism of comet activity. It also interests scientists because, unlike comets that rarely come by Earth, it is always there, allowing us to study the start-up and fade-out stages of the repeated outbursts.

What is the recharge mechanism of these eruptions? Whatever theory we concoct, it must provide a recharge mechanism, so that the outbursts can recur at quasi-periodic intervals. The best guess is that comets have a loose, porous surface layer of blackish, carbon-rich debris—the so-called regolith—left behind as ices have sublimed from solid to gaseous phase, then dissipated. This regolith may have a firm, crusty character, just as dried soil can weld into a firm, crusty dirt layer. As the comet nucleus moves around the sun, sunlight heats the surface, and this heat eventually warms the ice beneath the surface, turning it to gas. The gas filters upward toward the surface, building up pressure in the pore spaces of the surface regolith. When the pressure is great enough to overcome the weak strength of the regolithic crust, the crust goes poof! It breaks open. The gas rushes out, carrying loose dust particles. Under the weak microgravity of such a small body, the debris is carried clear off the comet and creates a so-called "coma" of floating debris around the comet. This is the brightest stage, as seen from Earth. The gas pressure has now been released, the gas eruption stops, and the virtually weightless debris drifts away in a month or so. Now the crust is depleted of gas pressure, but the cycle starts over again as new gas collects.

One of the most instructive ways to learn about comets would be to "park" a space vehicle on or near Comet P/Schwassmann-Wachmann 1 and watch as its eruptions break forth, throw off a coma, and eventually die out.

Opposite page:

Comet P/Schwassmann-Wachmann 1 is known to cometary observers as a "ring-tailed snorter," named after a character in Al Capp's "Li'l Abner" comic strip of the 1960s. Photos of this comet from Earth, taken soon after an outburst, often show a distinct apostrophe-shaped configuration. Apparently the solid nucleus of the comet is rotating, and the eruption of gas and dust occurs on one side. As the comet rotates, the jet of debris acquires a spiral curve, like the spray from a garden sprinkler. At the closest point to the sun in the near-circular orbit, the comet can pass not too far from Jupiter, which is seen in the lower left with its four large moons.

433 Eros
The First Asteroid Landing

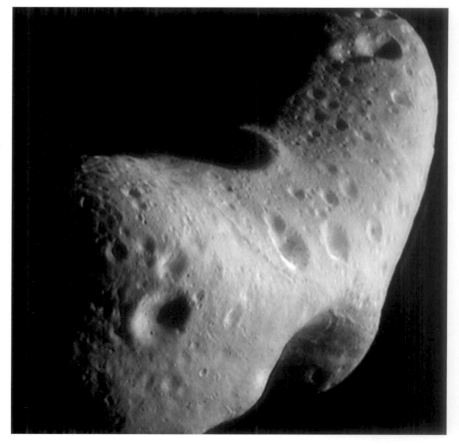

Among the enduring mysteries of asteroids is the nature of their surfaces. What would we find if we could see them at close range? If they are fragments of once-larger parent bodies, like 1 Ceres or 4 Vesta, broken off in catastrophic collisions, should we expect jagged surfaces of broken rock? Since some of them expose the insides of once melted mini-worlds, should we expect chunks of nickel-iron sticking out of some of them? What has been the toll taken on the surface by a billion years or more of exposure to direct solar radiation, cosmic rays, and micrometeorites?

There is another, more subtle mystery of greater importance to planetary scientists. Asteroids' colors and spectra can be observed from Earth, and it turns out there are recognizable types. The great majority of rocky asteroids (i.e., the ones that are neither metal, nor black, carbonaceous material), are grayish-tan stony material, as shown by their spectra. They have been unimaginatively called "type S"—think of the *S* as standing for stone. (Other types were given other letters, according to their spectra: *M* designated a type thought to be metal-rich, *C* the carbonaceous types, and so on.) Meanwhile, planetary geologists

had long known that around 80 percent of meteorite falls on Earth are a grayish type of primitive, never-melted stone called chondrites. The simple-minded conclusion was that *S*-type asteroids are the parent bodies of the chondrite rocky meteorites. But . . . there was a problem: The spectra of *S*-type asteroids did not match the spectrum of the chondrites. For example, S asteroids were more reddish-tan.

The only way to resolve this issue was to hypothesize a process of "space weathering," in which exposure to solar radiation, cosmic rays, and/or micrometeorites somehow altered the surface (the top millimeter—0.04 inch—or so that reflects sunlight and creates the spectrum). According to this idea, the "space weathering" would cause the material to alter its spectral properties and

look redder, in much the way that weathering of exposed rocks on Earth alters their appearance. The idea of space weathering was very controversial, even though somewhat similar effects had been observed years before, during the *Apollo* expeditions to the moon. Nonetheless, the questions were crucial to the understanding of the panoply of asteroids. And understanding asteroids may be crucial fifty years from now, when the world finally begins to understand that there are metals and other mineral resources in space, not to mention twenty-four hours a day of "free" solar energy.

Above:

Close-up views of the asteroid's dusty, boulder-strewn surface, taken as the NEAR lander approached.

Opposite page:

The cashew-shape of Eros is apparent in this view from the approaching NEAR spacecraft in 1999. The asteroid's odd shape suggests that it may be a fragment broken from a larger body.

Strange Vistas

Above and right:

*B*izarre *landscapes are created on Eros by the asteroid's cashew shape as seen by the NEAR mission camera looking from one end toward the other. In each view the foreground lobe is in the lower left half of the picture. Boulders can be seen littering the surface in the view to the right.*

Rendezvous in Space

To answer these questions a "Near Earth Asteroid Rendezvous" spacecraft was launched in 1996 and rendezvoused with 433 Eros in 1999. This was not to be a quick flyby with a few photos, as had already been accomplished on a few other asteroids (see later chapter on 951 Gaspra). Rather, the *NEAR* spacecraft, as it came to be known, was designed to approach Eros, fire its engines, and go into a lazy, looping orbit around the floating rock, and study it with many instruments for about a year. These tricky maneuvers were carried out with great success in February 2000. Around this time the spacecraft was renamed for the widely respected and beloved pioneering planetary geologist, Eugene Shoemaker, who had participated in *Apollo* lunar mission planning, and had studied asteroids, comets, and the craters studied by their impacts.

With its affectionate but unwieldy new name, *NEAR-Shoemaker* made many discoveries. Eros was found to be almost wiener-shaped, 34 by 13 by 13 kilometers (21 by 8 by 8 miles). The surface was not rough, but sandblasted by countless micrometeorites, like a smooth, rounded pebble. The gravity was so low that a good pitcher could throw a rock clear off Eros into interplanetary space. The gravitational effects on the orbit showed that the interior structure of Eros was relatively uniform, with a mean density of 2.67 +/– 0.03 grams per cubic centimeter, which would be consistent with impact-fractured chondritic meteorite rock, where the fractures created cracks and pore spaces in 10 to 30 percent of the volume. The proposed internal fractures could have been caused by impacts because hundreds of craters were visible. One prominent young crater, 7.6 kilometers (4.7 miles) across, was also named after Dr. Shoemaker. A few still-larger depressions were seen, including a saddle-shaped depression 10 kilometers (6 miles) wide, in the middle of the object, probably an older, degraded impact crater.

In an interesting way, the visit to Eros confirmed the general concept of space weathering.

The general surface of Eros had the brownish color of *S*-type asteroids. But impact craters exposed fresher, brighter materials, and the steep inner walls of craters had landslides that exposed even more fresh material—and the fresher the material, the more closely it matched the spectrum of chondrite meteorites. This convinced most researchers that the *S*-type asteroids really are the parent bodies of chondrites, and that exposure of such material in space really does cause a gradual "space weathering" by which energetic photons and atomic particles subtly alter molecular structure, color, and spectra.

An Intimate Look

After a year of observing Eros from orbit, the spacecraft was beginning to age, and a bold plan was conceived to climax the mission. By firing the engines carefully with the remaining fuel, it would be possible to bring *NEAR-Shoemaker* down onto the surface of Eros! It would be the first landing on any asteroid in the solar system. There was no plan to try to keep the spacecraft working after it hit Eros, but the

Mid-distance photo from the NEAR spacecraft shows that the overall shape of Eros is rounded by eons of micrometeorite "sandblasting," but is also pocked by small, sharp craters.

pictures sent back on the way down would be the most detailed ever received of any interplanetary body. In February 2001, the descent was made. The last image before impact on the surface was made from an altitude of 129 meters (423 feet), and shows details as small as roughly 10 centimeters (4 inches) across. Project scientists bid good bye to their plucky spacecraft.

Something surprising emerged from the final pictures. Crater floors were often smooth, flat deposits of dust, as if dust had migrated and filled depressions. But what could cause dust to migrate on an asteroid? There is no air, no wind. The best theory is that the charged atomic particles zipping outward through space from the sun create electrostatic charges on the dust

Above:

One of the most detailed images taken of an asteroid—from only 250 meters away—just before the NEAR *spacecraft touched down on Eros. It shows football-sized rocks and gravelly debris from impacts.*

Right:

Human *explorers, in this imaginary depiction, may one day visit asteroids, perhaps as advance agents, for their resources, such as nearly pure nickel-iron alloy and other minerals.*

particles in the surface material of the asteroid. This allows the dust particles to hop, or migrate downhill, or stick to surfaces. In the same way, if you try to wipe off the display space on your computer or car dashboard, you may create an electrostatic charge that attracts more dust particles than you had in the first place. In any case, the whole concept of "downhill" is weird on a wiener-shaped asteroid. On a sphere, "down" is vertical, toward the center of the world. But on an elongated body, in areas toward one end or the other, "down" is toward the center of mass, which is not vertical to the surface, but somewhat "sideways," at an angle to the vertical. So a ball on an asteroid might roll in unexpected directions, and in the low gravity, and the endlessly quiet days and nights, electrostatically charged dust may migrate in unexpected ways.

243 Ida and Its Moon
An Asteroid with a Bonus

When the 1990s *Galileo* probe was being launched on its multiyear voyage to Jupiter, mission controllers recognized that it would have the first opportunity in history to fly past one or more asteroids, while it was on the way to the giant planet. This was years before the landing on 433 Eros, described in the last chapter. During the 1970s and 1980s, scientists had speculated about what asteroids might look like at close range. The general idea was that if they were fragments of shattered parent bodies, orbiting around the sun for 4,500 MY, most of them would be irregular-shaped bodies and heavily cratered, not unlike the small satellites of the planets. *Galileo's* first encounter with an asteroid—the first in history—came in 1991 when it zipped past the stony S-type worldlet, 951 Gaspra, and confirmed that it was a city-sized pebble (about 20 by 11 kilometers, or 12 by 7 miles). Spectra and colors confirmed the rocky composition pocked with impact pits.

Galileo's second asteroid encounter, in 1993, took it past another seemingly typical asteroid, an S-type stony example named 243 Ida—but this time, nature provided an unexpected bonus. Ida itself turned out to be a potato-shaped rocky world similar to Gaspra, but bigger. Its dimensions were 30 by 13 by 9 kilometers (19 by 8 by 6 miles), and, once again, it was crowded with impact craters. But the photos showed something else. In the black sky surrounding

*A*steroid 243 Ida, photographed in 1993 by the Galileo *probe, shows a shape molded by eons of impacts of smaller asteroids.*

the asteroid was another object—a small satellite of Ida, only about 1.5 kilometers (1 mile) in diameter. *Galileo* scientists scurried to find some name that might connect with the parent body, Ida. In Greek mythology, infant Zeus was hidden by a nymph named Ida on her mountain, Mount Ida. Ida and her mountain were protected by a race of beings called Dactyls. The satellite was given the name Dactyl.

As the idea of the satellite sank in, asteroid researchers recognized that hints of asteroid satellites had glimmered in the past. Back in the 1970s and 1980s, for example, astronomers obtained asteroid orbit information so precise that they could predict when the asteroid would pass in front of a star, and from what part of Earth such events would be visible. Amateurs as well as professionals organized teams to go to those areas and observe the phenomenon, and in a few cases, some of them reported seeing the star blink out not just once, but twice—implying two objects had passed in front of it! The problem was that virtually none of these observations were confirmed by other observers.

Double Trouble

Nonetheless, researchers related the observations to a century-old puzzle: In a few cases, impact craters on the moon and Earth seem to be double. A pair of craters could be seen that seemed to have the same age, as if two meteoritic objects crashed to the ground at about the same time. Could these double craters mark impacts of asteroids with satellites? The crater statistics suggested that a small percentage of asteroids might have satellites. Commenting on these instances, the author (Hartmann) published an analysis in 1979 suggest-

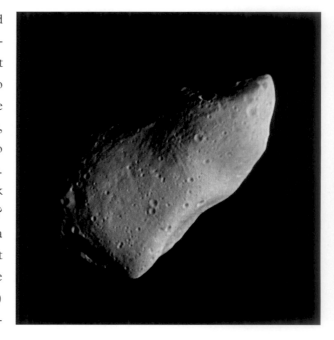

Asteroid 951 Gaspra, photographed by the Galileo spacecraft in 1991 while on its way to Jupiter. This color view shows the general brownish-tan color, but also more whitish tones, especially around some fresher craters.

ing that when catastrophic smash-ups disrupt asteroids, random pairs of fragments might be ejected in the same direction at similar speeds, and could either fall together to make a compound, dumbbell-shaped object, or could go into orbit around each other to make an asteroid with a moon.

The discovery of Dactyl spurred much more interest in all these ideas. In 1996, planetary scientist (and fellow astronomical artist) Daniel Durda, then in Arizona, theoretically analyzed the physical details of catastrophic asteroid collisions and concluded that this mechanism would indeed produce both compound asteroids and asteroid satellites. At the same time, Arizona researchers William Bottke and Jay Melosh looked at Earth's impact craters more carefully and noted that of the twenty-eight largest structures, about 11 percent are double. Research continued on these topics. In 2001, French astronomer Patrick Michel and colleagues affirmed that catastrophic disruptions produce fragments made of reaccumulated rubble, and that some of these end up as satellite pairs. In 2002, Caltech researcher J. L. Margot and seven coauthors concluded that some of the satellites form when "rubble-pile" fragments spin so fast that they split into two. By that time, they were able to tabulate that a radar survey of about fifty Earth-approaching objects indicated that 16 percent had satellites. In 2004, Durda (now in Colorado) worked with six coauthors to present 161 different computer simulations of catastrophic asteroid breakups, confirming that a substantial number of fragments form satellite pairs as a result of being ejected on parallel paths.

Satellites of asteroids have sometimes been given the name *minor satellites*, in parallel with a term that is sometimes used for asteroids, *minor planets*.

Visiting asteroids, future astronauts may frequently encounter two for the price of one. Given the fact that some kinds of asteroids will have valuable resources of iron, other metals, or water, it will be interesting to learn whether the satellites are always the same material as the main asteroid, or sometimes offer an opportunity to sample different materials, perhaps from a different part of the same, shattered parent body.

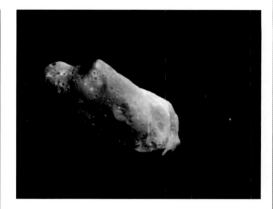

A color image of Ida and its minuscule moon, Dactyl (the small dot to the right of Ida).

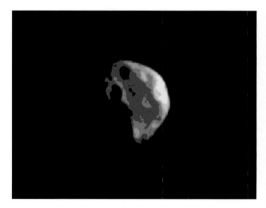

Tiny Dactyl is only a mile wide. Intensive computer processing had to be used to bring out detail.

Phobos and Deimos
Moonlets of Mars

Viking *orbiter photo of the outer moon, Deimos, shows a surface smoothed by micrometeorite "sandblasting," but also pitted by midsized craters.*

Phobos and Deimos are curious, potato-shaped lumps of dark, rocky material. Phobos is 27 by 21 by 19 kilometers in diameter (17 by 13 by 12 miles), and Deimos is a bit over half that size, 15 by 12 by 11 kilometers (9 by 7.5 by 7 miles). Both have nearly black surfaces, darker than an asphalt parking lot, that reflect only about 4 to 5 percent of the sun's light. In composition, they are believed to resemble the dark, carbonaceous asteroids and carbonaceous meteorites, rich in carbon compounds and chemically bonded water. In 1989, the Soviet *Phobos 2* probe showed that the surface of Phobos does not contain such water, but moisture or ice may have been driven off by repeated impacts. If the subsurface layers contain water-ice, it could be an important resource for astronauts studying Mars from orbit. The fact that carbonaceous bodies are native to the outer half of the asteroid belt suggests that Phobos and Deimos did not form in orbit around Mars, but were asteroids captured in a Martian orbit during the closing days of planetary formation.

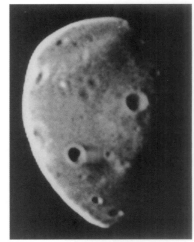

Phobos is pocked and sculpted by craters. Large chunks of its surface have been blasted away by impacts. The largest crater, Stickney, stretches 8 kilometers (5 miles) across— one-third the diameter of Phobos itself. It's the result of an impact nearly large enough to have split Phobos in half. Grooves that stretch in a parallel pattern around the little

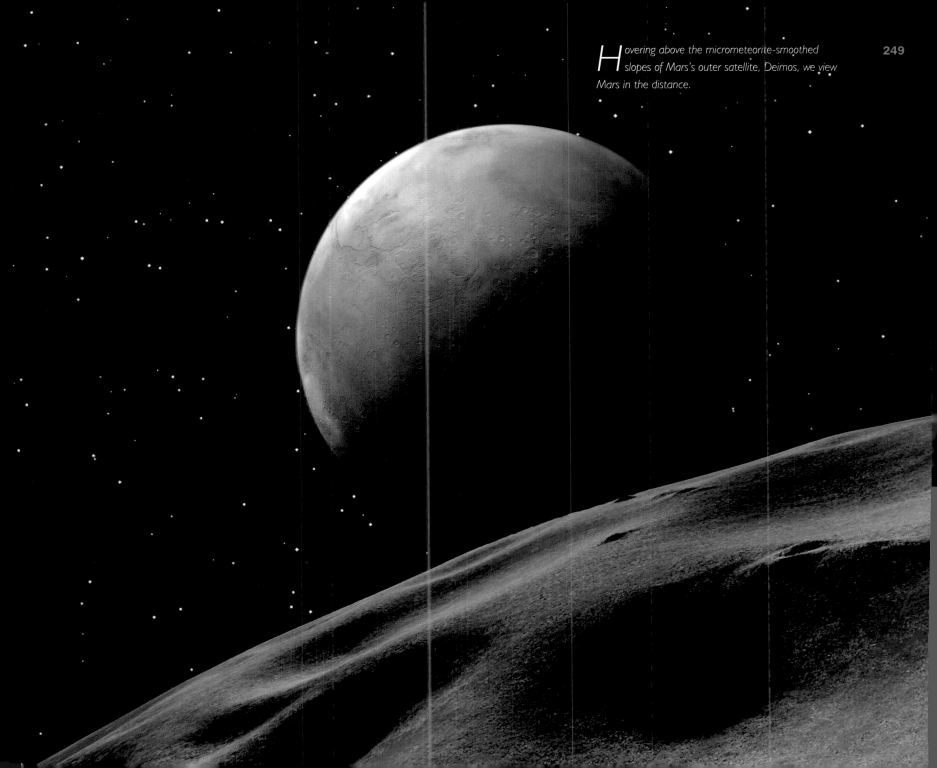

Hovering above the micrometeorite-smoothed slopes of Mars's outer satellite, Deimos, we view Mars in the distance.

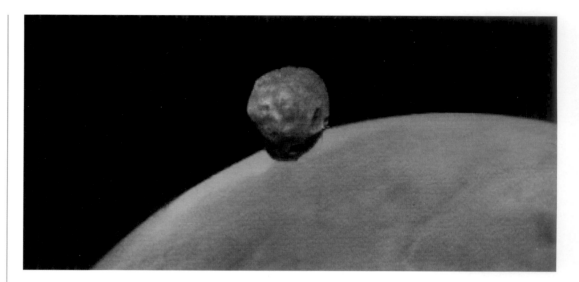

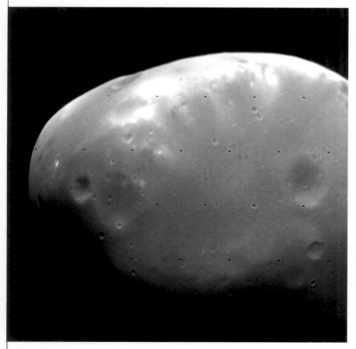

moon, and radiate from Stickney, may be evidence of the fracturing that must have resulted from this world-threatening impact.

Strangely, the grooves are not uniform, but are pocked by little craters with raised rims. Some grooves are essentially chains of craters. The craters don't seem to be simple collapses (which have flat rims) or impact sites (which happen at random). They look like the sites of minor eruptions. Perhaps Phobos once had enough water or ice in its interior to generate gas pressure. The Stickney fractures may have been the sites of eruptions that blew away puffs of surface dust. Thus, there may have been a period in Phobos's history when it displayed cometlike activity. This might have been in the closing days of planet formation. At that time, Phobos and some other dark asteroids may have been kicked out of their original home in the outer asteroid belt by certain dynamical effects of Jupiter's gravity and probably first came into the inner solar system, soon to be captured by Mars. In any case, Phobos and Deimos will give future explorers of Mars an incredible "free bonus"—a chance on the way to Mars to learn about the history of asteroidlike bodies that originated much farther from Earth—and may hold clues to comet histories as well.

Surface Differences

Although Phobos and Deimos seem to be made of the same sort of dark rock, their surface structures seem strangely different. Phobos has a lumpy shape, very large craters, and some small, sharp craters. Deimos is more muted, shaped somewhat like a potato, and its craters have lower, rounded rims. It lacks crater chains. In the rolling tracts between its craters are scattered, house-sized boulders.

Why should two neighboring satellites, with nearly identical compositions and virtually no internally caused geologic activity, have such different-looking surfaces? One reason may be that debris knocked off the moons by meteorite impacts goes into orbit around Mars and ends up hitting each satellite again in anywhere from one hundred to ten thousand years' time. The reaccumulation rates and speeds are somewhat different for each moon and might explain their dissimilar surfaces.

Alternatively, one satellite may have been hit more recently, allowing less time to build up a smooth, powdery surface by means of micrometeorite sandblasting.

If you pick up a rock, hold it at eye level, and let it fall on Deimos, it won't plummet to the surface as it would on Earth. It also won't hang in front of you, as it would on board a free-floating spacecraft. In Deimos's weak gravity, it will settle slowly toward your feet, as though it were being lowered on an invisible thread. Some thirty seconds after you let it fall, it will reach the ground—fifty times longer than it would take back home.

A Giant Crater on Phobos

One end of Phobos is dominated by a large (8-kilometer) impact crater, Stickney, almost big enough to have fractured the moon.

Below left:

A view of Phobos by Viking 2 *from 612 kilometers (380 miles) away shows Stickney (top) and swarms of radiating fractures.*

Below right:

A closer view from Mars Global Surveyor *looks over Stickney's rim.*

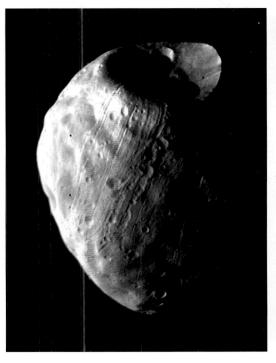

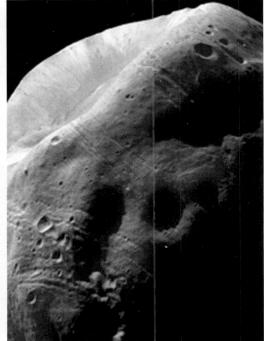

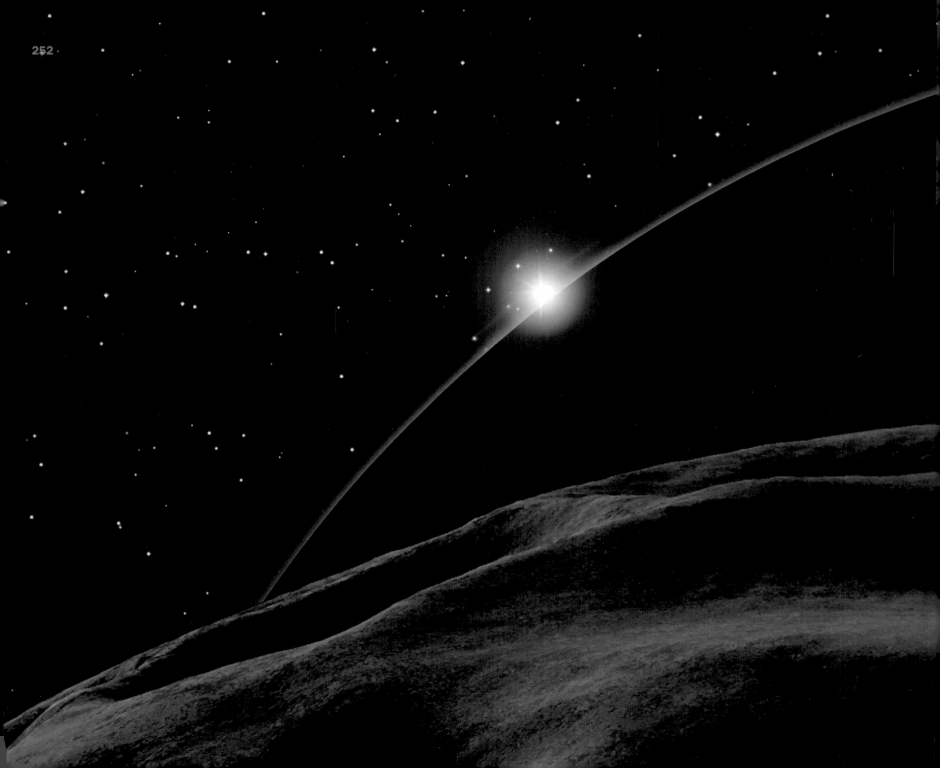

*U*ntil a few moments ago, the sun has been
eclipsed by the vast bulk of Mars. But now it
has just come into view, illuminating the rolling
landscape of Phobos in the ruddy light of a Martian
sunrise. The sunlit atmosphere of the nearby planet
can be seen as a backlighted, red, threadlike curve,
with barely visible concentric layers of dust and haze.

Halley's Comet
The Most Famous of Them All

As a comet approaches the sun in its orbit, a tail of gas and dust grows behind it as ices are vaporized by the sun's warmth. The solar wind—gases rushing out from the sun—pushes the tail material away from the sun, regardless of the direction the comet is traveling.

Although we have described two comets so far (the erupting "asteroid" 2060 Chiron and Comet P/Schwassmann-Wachmann 1), Halley's Comet is the most widely known and the one that fits the popular image of a comet.

Physically, the other two are much larger bodies, but they stay so far out in the outer solar system that they are too faint to see except in the largest telescopes. Halley's Comet, or Comet P/Halley as it is technically known, travels in a more typical comet orbit, from the outermost solar system into the inner solar system, crossing Earth's orbit, looping around the sun at about Venus's distance, and then returning to the outer solar system's depths. This trip takes about seventy-six years.

When the comet comes within the orbit of Jupiter, a glorious thing happens. The sunlight heats it, and its ice sublimes furiously into gas, creating a bright, glowing "coma" of gas and dust, and a long, streaming tail.

The tail, a comet's most famous structure, is created by an effect of the sun. Hydrogen gas streaming away from the sun, plus certain effects of sunlight itself, carry gas and dust from the coma in a direction away from the sun. Thus, contrary to appearances, the tail does not necessarily stream out behind the comet in its orbital motion. In fact, when the comet is returning to the outer solar system, the tail actually extends to the front, like the long hair of a girl riding a bike in a strong tail-wind. Remote cometary bodies like Schwassmann-Wachmann 1 and Chiron do not develop long, spectacular tails because they are too far from the sun. Their outbursts produce only a coma and, at best, a short, faint tail.

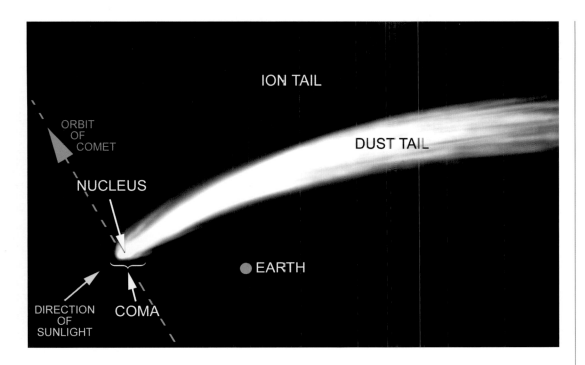

ION TAIL

ORBIT OF COMET

DUST TAIL

NUCLEUS

● EARTH

DIRECTION OF SUNLIGHT

COMA

Left:

The anatomy of a comet. The ionized (electrically charged) gas atoms are caught in the solar wind and pushed straight back from the sun. Dust particles (uncharged) follow curved orbits. The solid nucleus would be too small to see at this scale.

Below:

A cutaway view of the nucleus of a typical comet: a mixture of dirty ice and rocks. A dark layer or crust of dust may develop on the surface as near-surface ices sublime.

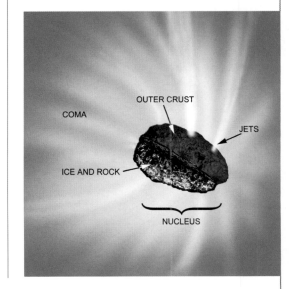

OUTER CRUST

COMA

JETS

ICE AND ROCK

NUCLEUS

In short, bright comets such as Halley's consist of three parts, shown in the accompanying sketch: the tiny, solid nucleus (usually 1 to 20 kilometers, or roughly 0.6 to 12 miles, across, too small to be seen in a telescope), the thin coma (larger than Jupiter), and the vast tail (long enough to stretch from one planet's orbit to another).

Halley's Comet itself has three claims to fame. Its arrival has been recorded during many periods of history, like a faithful friend who drops in on humanity every three-quarters of a century.

Second, Halley's Comet played a pivotal role in the progress of knowledge. The English scientist Edmund Halley (rhymes with "valley," according to his descendants) observed the comet in 1682, at age twenty-six, and plotted its positions from night to night. Years later, after conferring with the father of modern physics, Isaac Newton, Halley used Newton's theory of gravity to prove for the first time that this comet and other comets traveled in predictable, elliptical orbits around the sun. Halley realized that comets seen in 1531, 1607, and 1682 were all the same body, a comet moving around the sun every seventy-six years! He correctly predicted

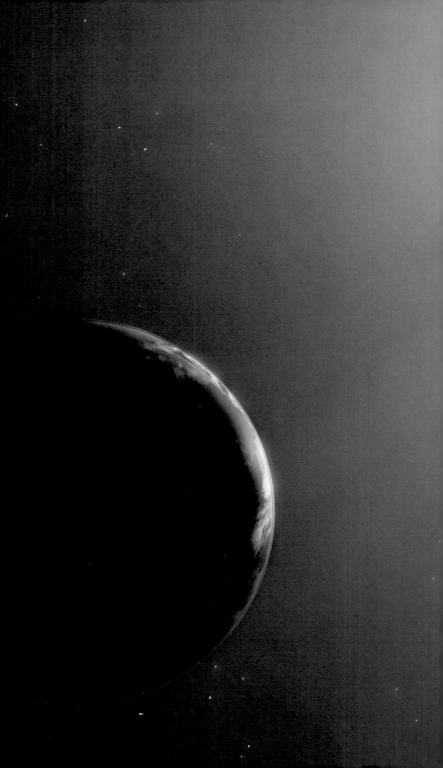

As if caught in a celestial searchlight, Earth and the moon pass through the tail of a comet. The glittering head is a million kilometers away, and the tail continues on behind us for many more millions of kilometers. Our home planet and its satellite are in no danger. As one astronomer put it, comet tails are as close as you can get to nothing while still having something. For all of its enormous size—the end of the tail may extend as far back as Mars's orbit—the entire tail could be packed into a suitcase. It has so little gas and dust in it that any cubic meter of it is a more complete vacuum than we can make in a laboratory.

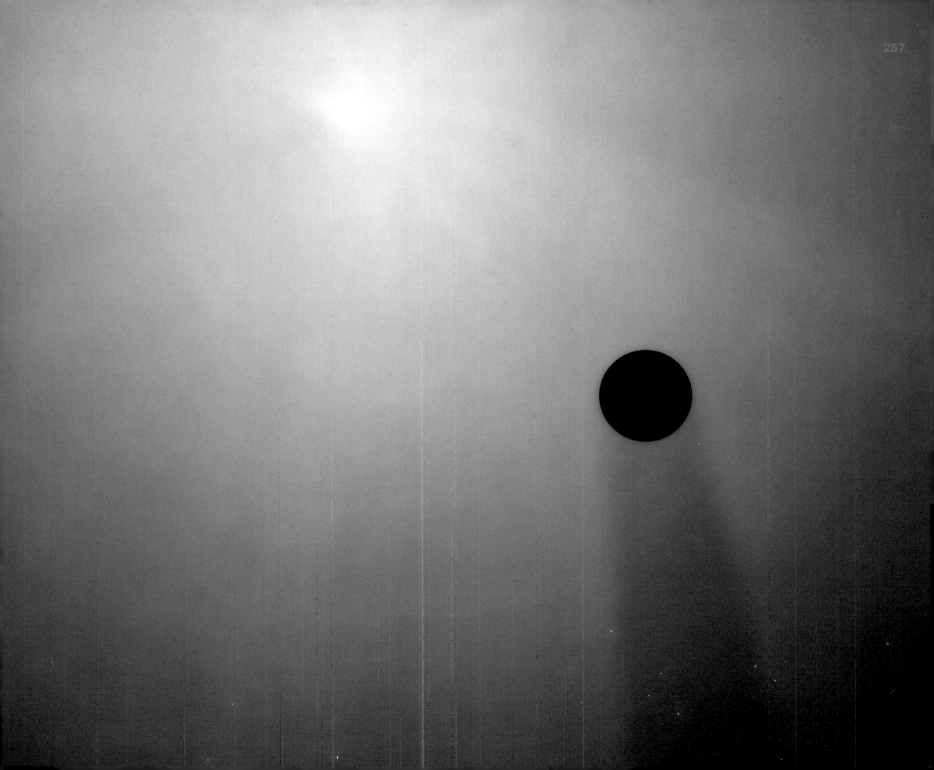

Opposite page:

Jets of gas and dust erupt from all around us as we stand on the dark, crunchy surface of a comet. The sun, which is just out of the top of the picture, is creating a bright halo in the icy crystals that fill the sky.

Below:

Humanity waited centuries to see this image, which is the first clear, close-up photo of the nucleus of a comet. It shows bright jets of gas and dust shooting out of the nucleus. The picture was taken by Europe's Giotto probe as it sped by Halley's Comet in 1986. This image is a composite of 60 images, showing details as small as 100 meters across.

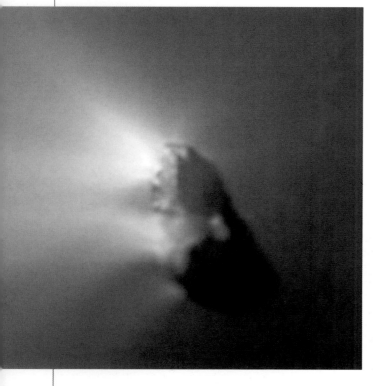

its return in 1758, and it became the comet that bears his name. Halley's work established once and for all that comets were not weird atmospheric phenomena—or omens sent by the gods, as had been believed—but astronomical visitors.

Up Close and Personal

Halley's Comet's third claim to fame is that, in our generation, it became the first comet to be photographed at close range by a spacecraft—and thus the first to reveal the secrets of the cometary nucleus. This happened in 1986, when a flotilla of Japanese, Soviet, and European space probes flew past the comet. (The American Congress declined to fund such a mission.) For the first time, we saw the physical worldlet at the heart of a comet. Scientists for several generations had known that a comet nucleus was a body of soil and ice, and that the subliming ice blew off the gas and dust that formed the coma and tail, but no one knew the details of how the nucleus was shaped, its exact chemical composition, or how the gas blew off its surface. Amazing close-up photos from the two Soviet probes, and the even more sophisticated European probe, *Giotto*, revealed a dark-colored, peanut-shaped nucleus about 15 kilometers (9 miles) long and 7 to 10 kilometers (4 to 6 miles) wide, immersed in a vast, glowing cloud. The photos showed that the comet's gas does not stream off the surface uniformly, but shoots out in bright jets, apparently from isolated vents that may mark fractures.

The *Vega* and *Giotto* probes returned a treasure trove of information about the composition of the vapor and dust streaming off the comet. Most of the ice is apparently frozen water. The photos confirmed Earth-based indications that the material of the comet is not bright, like ice, but as black as black velvet. Apparently, this is because it is rich in carbon-based organic compounds, such as those found in carbonaceous meteorites. Chemical analyzers on the space probes found that the black dust coming off the comet was rich in organic chemical compounds made of the same elements that form living matter on Earth, especially carbon, hydrogen, oxygen, and nitrogen. So rich were they in these elements that they came to be called CHON particles. No one thinks comets contain living organisms, but the CHON particles suggest that Halley and other comets may ultimately teach us something about the origins of organic chemicals in the solar system.

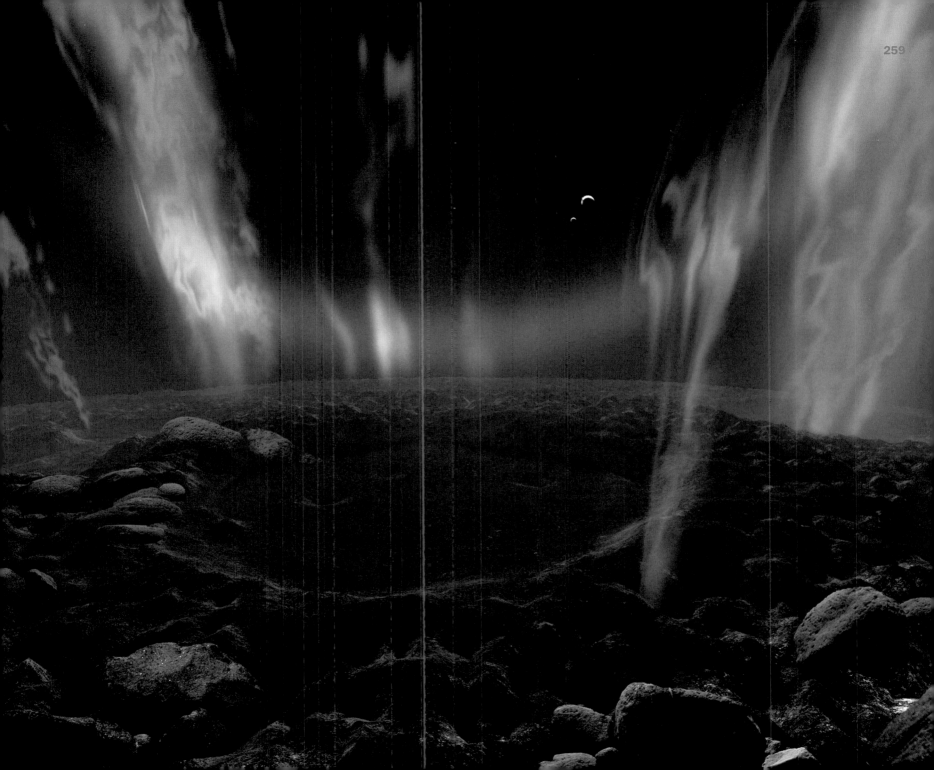

On any single pass around the sun, at a distance inside Earth's orbit, any given comet may lose about a meter (or a few feet) of ice, "burned" off its surface by solar heating. A periodic comet, like Halley's, undergoes this loss every time it goes around the sun. For this reason, astronomers believe that a typical Halley's-sized comet, 1 to 20 kilometers (.6 to 12 miles) across, may last only a few thousand trips around the sun.

Where Comets Go to Die

Then what happens to it? The ice may be depleted, leaving a loosely aggregated mass of rocky, carbonaceous debris. If sighted from Earth, this may end up being cataloged as an ordinary asteroid. One of the interesting goals of near-future space exploration is to find out if some asteroids on Earth-approaching orbits are really "burnt-out" comets, and, if so, what makes up their composition and structure. Are they porous and laced with twisting caves that once housed the ice? Or are they just "dust balls" of loosely compacted particles?

Compositionally, are they like carbonaceous meteorites or are they chock-full of strange minerals and organic compounds that we have not yet seen?

Some comets are known to have very low strength—they actually fall apart! These are comets that have been seen to split up into a handful of fragments. One famous example is Comet Shoemaker-Levy 9, which, in 1992, split into a string of fragments due to tidal stretching forces it experienced when it passed near Jupiter, and then crashed into the giant on a return pass in 1994. More common are cases where

comets dip far into the inner solar system and pass close to the sun. Extreme solar tidal forces create stress on such comets and many of them fall apart as they loop close around the sun. Other comets have been seen to split spontaneously into several fragments, without being close to the sun. Such observations suggest that comets are weak to begin with, and may grow more weakly consolidated as they lose ice.

In the early solar system, as icy planetesimals from the outer solar system were scattered in all directions by close encounters with Jupiter and other giant planets, comets must have been very common. Some researchers believe they may have been a factor in bringing water to primordial Earth, helping to create oceans and an environment favoring life.

Based on our knowledge of Halley's and other comets, we can see that a trip around the sun on a comet would be an extraordinary ride. If we landed and began the trip at a greater solar distance, for example, beyond Uranus's orbit, the comet would be an inert ice ball, like many other small, barren icy worlds. Then, as it approached the sun, the less stable ices, such as frozen carbon dioxide, would begin to sublime. The sky would fill with jets of glowing gas. By the time we passed inside the distance of the asteroid belt, sunlight would sublime frozen water—the main constituent of the "ground" beneath our feet. Jets of gas would spew from cracks and carry dust and debris into the sky for a period of many months. The comet we are riding, like some comets observed through history, might even split into several pieces as it rounds the sun. Eventually, as we head back toward the cold outer solar system, the activity would calm down, and we would wait through a long "winter" of many years, far from the sun, until the next exciting trip around the radiant globe at the solar system's heart.

Opposite page:

A strange view from the night side of Halley's Comet. Here, we are looking away from the sun, in a direction down the tail of the comet. Several unfamiliar phenomena are visible in the night sky. The ions of the gaseous part of the tail stream back toward a vanishing point. The shadow of the comet nucleus itself, on which we are standing, is cast through the coma of gas and dust that surrounds the comet. This shadow forms a weird, black presence in the sky above us.

Left:

Many comets spontaneously break into pieces. Here, a large fragment (foreground) is moving away from a comet. Venus can be seen in the distance.

Below:

A meteor shower occurs whenever Earth passes into a swarm of comet fragments.

1221 Amor & 1862 Apollo
Planet-Approaching Asteroids

As we've seen in the previous chapters, most asteroids are located in the asteroid belt between Mars and Jupiter, but gravitational resonant forces occasionally deflect their orbits toward the inner solar system—the region of Mars, Earth, and even Venus and Mercury.

Asteroids that cross over the orbits of these planets are grouped according to different names. Asteroids crossing inside Mars's orbit are called *Amor asteroids*, named after a prominent example that was one of the first of the group to be recognized. Amor, discovered 1932, is a tumbling, rocky worldlet about 33 kilometers (20 miles) in diameter. Many dozens of Amors are now known. Among other large ones are 422 Eros (34.13 km or 21.2 miles) and 1036 Ganymed (about 25 to 30 kilometers, or 16 to 19 miles, across, and not to be confused with Jupiter's giant moon Ganymede). Others are typically a few kilometers or miles across, and future surveys will continue to add smaller examples.

The fact that Amor asteroids cross the orbit of Mars doesn't necessarily mean that they all come very close to it or are likely to hit it in the next million years or so. At the points where they cross Mars's orbit, moving toward or away from the sun, many of them are far above or below the plane of the solar system and thus don't approach Mars. Some, however, do. In any case, gravitational disturbances by the planets are likely to change Amor orbits slowly over millions of years, so that eventually they will move into configurations in which close approaches and impacts are possible. Those that don't directly hit Mars may be thrown into new courses by close encounters with Mars; these new courses may take them on Earth-crossing orbits, or orbits that allow close approaches to some other planet. Therefore, Amor or other asteroids that venture into the inner solar system are likely to end their days within 10 or 100 MY by colliding with one of the planets, creating large craters on the surfaces of Mars, Earth, the moon, or some other world.

Apollo asteroids are related to Amor asteroids, differing in that they drop far enough into the inner solar system to cross over the orbit of Earth. Their closest approach to the sun (typically 0.5 to 0.9 AU) is inside Earth's orbit, and their farthest from the sun (typically 2 to 4 AU) is usually in the asteroid belt. Apollo asteroids, like Amors, are named after the classic example of their group, 1862 Apollo, a tiny, 1.5-kilometer (1-mile) asteroid. They are sometimes called Earth-crossers, or, more ominously, Earth-grazers; just as some Amor Mars-crossers come close to Mars, some Apollo Earth-crossers can come very close to Earth.

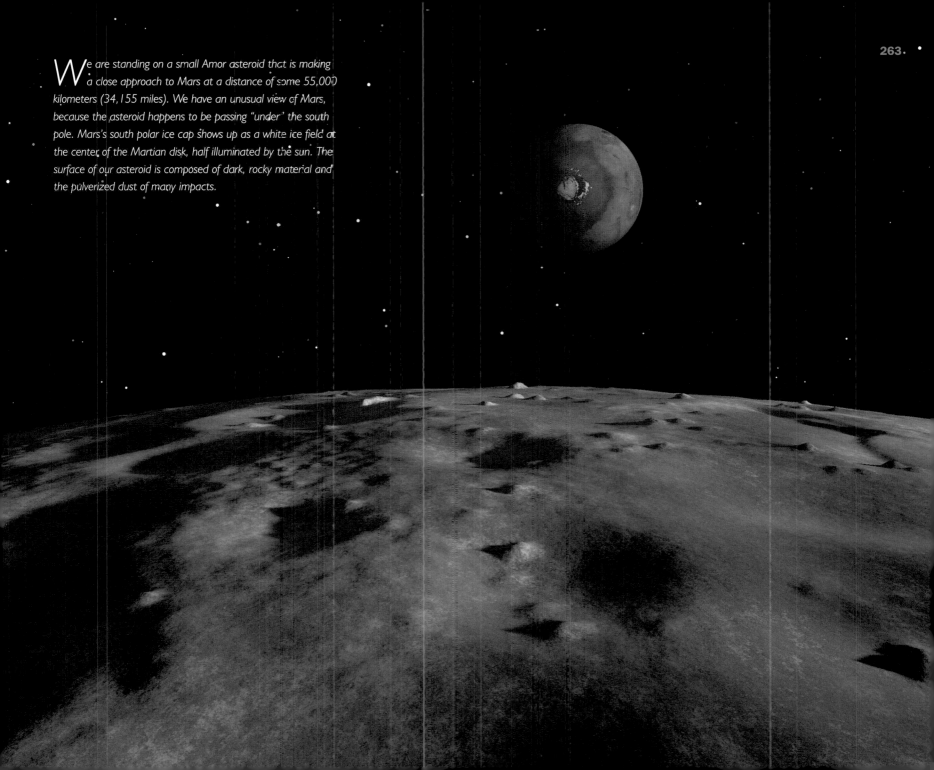

We are standing on a small Amor asteroid that is making a close approach to Mars at a distance of some 55,000 kilometers (34,155 miles). We have an unusual view of Mars, because the asteroid happens to be passing "under" the south pole. Mars's south polar ice cap shows up as a white ice field at the center of the Martian disk, half illuminated by the sun. The surface of our asteroid is composed of dark, rocky material and the pulverized dust of many impacts.

Above:

Venus is seen in the far distance from the asteroid Apollo, one of the rare asteroids that crosses the orbit of that planet. Apollo is influenced by the gravitational fields of both Earth and Venus, and in time may approach either of the two planets.

Opposite page:

The view from an Apollo asteroid with a satellite as it approaches the Earth-moon system. A comet happens to be passing through the inner solar system in the distance.

Apollo asteroids tie in with another phenomenon: meteorites. Apollo asteroids are, essentially, giant meteoroids. Of the many dozen Apollo asteroids now known, the biggest are about 8 to 10 kilometers (5 to 6 miles) across, and nearly all are bigger than 1 kilometer. Many smaller ones also exist, all too tiny to detect with telescopes, but the tiny ones are so numerous that many hit Earth each year, breaking into pieces in the atmosphere and hitting the ground as meteorites.

Although spectroscopic studies of Apollo asteroids reveal many different rock types among them, all these rock types are similar to those of main-belt asteroids and also to those of various meteorites. Some of them almost perfectly match the spectroscopic properties of certain common meteorite types. This means that some of the meteorites in our museums are probably fragments of Apollo asteroids—or at least fragments of the same parent body that the Apollo asteroids are themselves part of.

Earth-Bound Asteroids

Some of the Apollo asteroids are probably fragments of asteroids from the asteroid belt, perturbed into Earth-crossing orbits by gravitational disturbances from Jupiter or Mars, the planets on either side of the belt. Other Apollo asteroids may have a quite different origin. They may be the burnt-out, rocky remnants of comets. Fresh comets are believed to be mostly ice and to contain a certain proportion of rocky material. But often, comets get perturbed by planets into orbits in the inner solar system where the ices eventually evaporate or sublime into space, leaving the rocky material in a loosely consolidated clump. Some Apollos may be such clumps.

Apollo asteroids occasionally crash into Earth, causing monstrous explosions like the atom bomb–sized one in Siberia in 1908. That blast flattened trees in an eighteen-mile radius, knocked a man off a porch thirty-eight miles away, and was heard at a distance of over six hundred miles. Statistics suggest that such impacts may occur every century or so—but they usually take place in the ocean and leave little or no historical record.

Astronomers are still using specially designed telescope systems to survey the inner solar system for Earth-approaching asteroids that might pose a future danger. A survey published in 2001 estimated that the number of Earth-approachers larger than 1 kilometer (1,094 yards) across is probably between 1,130 and 1,400. The technique of making this estimate is interesting. It is based on how many times survey astronomers rediscover the same asteroid over and

over again. If you are a biologist tagging the deer population in a mountain range, and your first one hundred sightings involves one hundred different individuals, you can be sure there are many more to be found. But if your first sample of one hundred sightings involves twenty individual deer, mostly seen several times each, you can bet there are not too many more individuals in that range. The same principle is used by astronomers to estimate the total population of asteroids even before all of them have been cataloged.

Because Apollo asteroids have the potential of crashing into Earth, interest in them has increased in recent years. Several moderately large telescopes have been dedicated to search for them, and NASA engineers have begun to consider schemes for modifying their orbits, if one should be discovered on a collision course with Earth. Newspapers and television have given unprecedented coverage to asteroids as a result of international meetings in the United States and Russia about the asteroid threat.

Despite the media blitz about asteroids' threat to civilization, there may be a bright side to near-Earth asteroids that has received less attention. Asteroids' threat to our civilization is no greater than that posed by the anticipated shortages of raw materials and energy sources in the next century. A more positive response to asteroids would be to remember that some of them are made from pure nickel-iron alloy and other metal-bearing materials. If we pursue ways of detecting asteroids and changing the orbits to avoid the rare threat of collision, we will at the same time be developing the technology to utilize their materials in a stable interplanetary economy.

4769 Castalia & 4179 Toutatis

Apollo Asteroids of Curious Shape

According to analysis of radar signals bounced off the small, Earth-approaching asteroid 4767 Castalia, it consists of two main lobes, as shown in these computer-generated models, based on radar data taken as Castalia sailed past Earth in 1989.

As astronomers discover more Apollo asteroids, they add to the list of bizarre objects in the solar system. An interesting new radar technique allows amazing images of the ones that pass closest to Earth—without using expensive space probes! This technique involves bouncing radar waves off the interlopers. The leader in this field is Caltech astronomer Steven Ostro, who has bounced radar signals off several asteroids and found bizarre shapes among them.

Ostro's first striking result came from an Earth-passing asteroid initially cataloged as 1989 PB (a code indicating discovery date) and later named 4769 Castalia. When Ostro bounced radar signals off it, he got double return, indicating a dumbbell-like body. As shown in the accompanying figure, his technique allowed him to make a crude image of the rotating dumbbell. Castalia consists of two roughly spheroidal bodies just touching each other. It is about 1.7 by 1.0 kilometers in size (1,859 by 1,094 yards) and rotates in about five hours.

By 1992, Ostro's technique had improved and the close pass of Apollo asteroid 4179 Toutatis enabled him to make a photolike radar image of the object. The astonishing image, released in January 1993, shows that Toutatis resembles two lumpy, cratered rocks stuck together. Roughly 4 by 7 kilometers (2.5 by 4.5 miles) in size, it is the slowest-rotating asteroid known, taking about

ten or eleven Earth-days to make one turn. Spectra show a rocky composition.

These surprising radar observations confirm theoretical research from the late 1970s, mentioned earlier, predicting that many asteroids are loose assemblages of fragments, created when larger bodies were smashed but not totally disrupted. During chaotic fragmentation of a larger parent, for instance, two neighboring kilometer-scale fragments flying out of the explosion might find themselves on parallel courses and could fall together by their own gravity. This would produce a compound double body like Castalia or Toutatis.

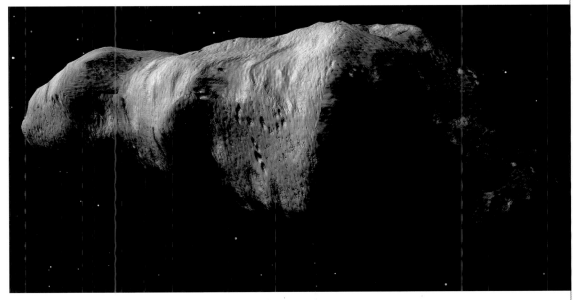

Artist's Conception of Asteroids

Above:

A reconstruction from radar information of the probable appearance of Toutatis, an elongated shape with two main lobes.

Left:

Three more of the many asteroids that possess strange shapes. From left to right: 216 Kleopatra, 1620 Geographos, and 6489 Golevka. These images are based on radar measurements of the asteroids. The shapes involve complex histories of fragmentation and erosion by impacts.

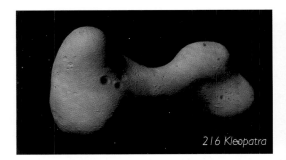

216 Kleopatra

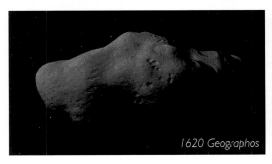

1620 Geographos

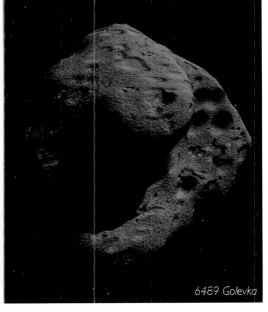

6489 Golevka

Asteroid 6178
Heavy Metal in the Sky

When astronomers began to study the spectroscopic properties of asteroids, they noticed one class of objects that seemed to have the spectral properties not of rock, but of metal. This was not unreasonable; if nickel-iron meteorites fall out of space onto Earth and end up in our museums, then there must be some asteroids out there that are their metallic parent bodies. The suspected metallic asteroids were designated as class M.

Are M asteroids really made out of metal? Could it be that mountain-sized masses of pure nickel-iron alloy are really floating around in space? No one was sure until the late 1980s when a remarkable event occurred. In February 1986, a Japanese observer named Minoru Kizawa discovered a small Earth-approaching asteroid, which was to zip past Earth during the ensuing months. It was initially designated 1986 DA, but was later given catalog number 6178 after its orbit was measured.

Such Earth-passing asteroids are visible for only a few weeks or months until they sail away into distant space. In order to observe such an object, astronomers have to hustle to get the coordinates and prepare their equipment. Caltech astronomer Steve Ostro and his radar team scrambled and in April 1986—just two months after Kizawa's discovery—used the giant radio telescope at Arecibo, Puerto Rico, to bounce radar signals off the object. Combining the radar measurements with optical measurements obtained by other astronomers, they estimated that asteroid 6178 is an elongated object about 1.7 to 2.9 kilometers (1.1 to 1.8 miles) across. More importantly, they found some unusual radar properties. The nature of the radar signal indicated that the surface bounced back an unusually strong radar signal, and that it is unusually rough. These properties were inconsistent with a rocky asteroid, or an asteroid covered with pulverized soil or dust. Instead, the only interpretation that made sense was that 1986 DA is bare metal, possibly twisted into grotesque fine-scale shapes due to impacts.

Iron Mines in the Sky

Here, then, is an amazing and under-appreciated result of space exploration. Over our heads, in space, we have 2-kilometer-scale masses of relatively pure nickel-iron alloy—iron mines floating in the sky! Societies are usually slow to grasp the meaning of new discoveries, but the result is beginning to sink in. Space contains potential natural resources. A 2-kilometer chunk of iron would contain over 10 billion tons